REFRAMING THE ALHAMBRA

Edinburgh Studies in Islamic Art
Series Editor: Professor Robert Hillenbrand

Series titles include:

edinburghuniversitypress.com/series/esii

REFRAMING THE ALHAMBRA

ARCHITECTURE, POETRY, TEXTILES AND COURT CEREMONIAL

Olga Bush

EDINBURGH
University Press

Edinburgh University Press is one of the leading university presses in the UK. We publish academic books and journals in our selected subject areas across the humanities and social sciences, combining cutting-edge scholarship with high editorial and production values to produce academic works of lasting importance. For more information visit our website: edinburghuniversitypress.com

Edinburgh University Press Ltd
The Tun – Holyrood Road
12 (2f) Jackson's Entry
Edinburgh EH8 8PJ

Typeset in Trump Medieval by
Servis Filmsetting Ltd, Stockport, Cheshire,
and printed and bound in Malta by Melita Press

A CIP record for this book is available from the British Library

ISBN 978 1 4744 1650 4 (hardback)
ISBN 978 1 4744 1651 1 (webready PDF)
ISBN 978 1 4744 1652 8 (epub)

Contents

Figures

Series Editor's Foreword

Edinburgh Studies in Islamic Art is a venture that offers readers easy access to the most up-to-date research across the whole range of Islamic art. Building on the long and distinguished tradition of Edinburgh University Press in publishing books on the Islamic world, it is a forum for studies that, while closely focused, also open wide horizons. Books in the series, for example, concentrate in an accessible way, and in accessible, clear, plain English, on the art of a single century, dynasty or geographical area; on the meaning of works of art; on a given medium in a restricted time frame; or on analyses of key works in their wider contexts. A balance is maintained as far as possible between successive titles, so that various parts of the Islamic world and various media and approaches are represented.

Books in the series are academic monographs of intellectual distinction that mark a significant advance in the field. While they are naturally aimed at an advanced and graduate academic audience, a complementary target readership is the worldwide community of specialists in Islamic art – professionals who work in universities, research institutes, auction houses and museums – as well as that elusive character, the interested general reader.

Professor Robert Hillenbrand

Acknowledgements

It is my pleasure to be able to thank the institutions, colleagues and friends who have contributed greatly to this book, long in the making.

I wish to express my gratitude to the Program for Cultural Cooperation Grant between Spanish Ministry and United States' Universities for supporting my preliminary research on site, and the Kunsthistorisches Institut in Florenz-Max-Planck-Institut for supporting my writing in its final stages. I am grateful for two research fellowships in the Department of Islamic Art at the Metropolitan Museum of Art, which were indispensable for both the study of the Nasrid arts and the opportunities to discuss objects in the collection with my colleagues there at the time: Daniel Walker, Stefano Carboni, Navina Najat Haidar, Maryam D. Ekhtiar, Qamar Adamjee, Elena Phipps and Nobuko Kajitani. I thank the Barakat Foundation for a grant that allowed me to undertake the on-site photography of the Alhambra and Edinburgh University Press for its generous support towards the publication costs of this book.

Over the years of working on the Alhambra, many colleagues have supported me in more ways than I can count, above all: Avinoam Shalem, Finbarr Barry Flood, Dede Fairchild Ruggles, Gülru Necipoğlu, Priscilla P. Soucek, Rebecca Shapiro Molloy, Jerrilynn D. Dodds and Oleg Grabar (may he rest in peace). I have benefited from their generosity, challenging questions, practical advice and friendship. I am fortunate that many colleagues in Granada, including Myriam Font Ugalde, Concepción de la Torre de Benito, José Tito Rojo and Silvia Segarra Lagunes, have become my friends. Unstintingly, they have opened their libraries, photographic archives and homes for me during my many summers in Granada. My gratitude goes to Antonio Orihuela Uzal for sharing his knowledge of Nasrid architecture and archaeology in conversations over the years and for his permission to publish his drawings. I wish to thank María Bárbara Jiménez Serrano, Soledad Martinez Berbel, Javier de Pablos Ramos and Purificación Marinetto Sánchez, colleagues at the Archivo del Patronato de la Alhambra y Generalife and the Museo de la Alhambra, for their help with archival photographs

for the illustration of the book. Anna Cinquemani, visual resources wiz at Bard College, skilfully improved many drawings, plans and images, my thanks for her help. I am very grateful to my friends at Vassar, Anne Gardon, Mihai Grunfeld, Eileen and Peter Leonard, Yvonne Elet, Andy Davison, Himadeep Muppidi, Deborah Dash Moore and Mac Moore, who cared about me and my book enough to hear about its progress blow by blow, and on whose good humour and home cooking I relied in moments of stress.

I wish to express my deep appreciation for the work of my colleagues at Edinburgh University Press: Robert Hillenbrand for his rigorous reading, insightful comments and helpful criticism; Nicola Ramsey for keeping things on track; and Ian Davidson for making my images look their best. My thanks go to the three anonymous manuscript readers, from whose probing remarks I have benefited greatly.

My extended family supported me along the way. No words are adequate to express my gratitude to my sons, Daniel and Sasha. I have always felt their interest in and support of my work, especially in our travels throughout Spain and the summers spent in Granada. This book would not have been possible without the love of my husband Andy and his profound commitment to my intellectual endeavours. My best travelling companion, the most rigorous, but gentlest of critics, Andy listened to my ideas for the book as it took shape, read every draft and pushed me to sharpen my arguments. This project and I have been sustained by his encouragement, patience and care.

This book is dedicated to Andy,
my Rock of Gibraltar.

Introduction

IN THE SUMMER of 1832, the youngest son of Ferdinand VII of Spain (r. 1808 and 1813–33), the *infante* Francisco de Paula, and his wife Luisa Carlota, made a visit to Granada, and, following hasty efforts to rehabilitate some of the dilapidated precincts, they were lavishly celebrated in the palaces of the Alhambra on the Sabīka hill overlooking the city (Figure I.1).[1] It was almost precisely 340 years since the Catholic Monarchs Isabel of Castile and Ferdinand of Aragon (r. 1474–1516) had taken possession of the Alhambra on 1 January 1492 as a sign of the final defeat of the Nasrids (r. 636–897/1237–1492), the last Muslim dynasty in Iberia. More immediately, it was nearly two decades since Napoleon had been forced to withdraw from Spain and Ferdinand VII was restored to the throne in 1813. For the French troops, the Alhambra had been little more than a barracks, and an explosion of their munitions had done great damage to the site, adding injury to the insult of the occupation. The festivities for Francisco de Paula and Luisa Carlota represented a reassertion of the centuries-old claims of royal patrimony, and a reaffirmation of the legitimacy of the Spanish dynasty and its political control over the whole of the national territory. And even now, in democratic Spain, each year on 1 January, the city of Granada continues to celebrate the *toma*, that is, the taking of the Alhambra, a site of memory of national identity, still defined in part against the shadow of the Islamic past of al-Andalus, or medieval Muslim Iberia.[2]

In the same year, 1832, American writer Washington Irving (1783–1859) published *The Tales of the Alhambra* simultaneously in England, France and the United States.[3] Irving had resided in the Alhambra in the spring of 1829 and he recorded both his impressions and his fantasies in his tales of a place that he found to be 'imbued with a feeling for the historical and poetical, so inseparably intertwined in the annals of romantic Spain'.[4] The book is still on sale in the Alhambra and throughout Granada in editions in many languages, as an enduring expression of the Orientalising imagination. Taken together, the visit of the royal family and the publication of *The Tales* in 1832 – an embodiment of real sovereign power and its oblique reflection in romanticised fiction – mark the character

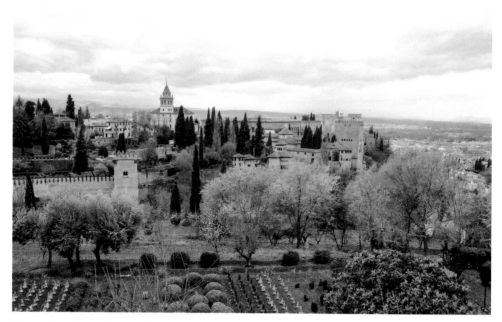

Figure I.1 *Alhambra and the city of Granada, view from the Generalife* (photograph: Olga Bush)

of what might be called the modern Alhambra, a UNESCO World Heritage Site since 1984 that now attracts over 8,000 visitors daily.[5]

Irving was not wrong in saying that the historical and poetical – and one may add the aesthetic and commercial – have been intertwined in the modern Alhambra. Among the many visiting artists who drew the palaces as early as the 1770s, the British architect Owen Jones (1809–74) is the pre-eminent figure at that crux. In contrast to the Orientalist artists of the Romantic period, who rendered palatial ruins to evoke the aura of the exotic past, Jones executed scrupulous on-site studies of the architecture and its decoration in 1834 and again in 1837. His historical appreciation of the Alhambra was reflected through his widely disseminated publications of 1842–45 and 1856.[6] On the other hand, Jones' experimentation with materials and modes for reproducing historical architecture and the practical application of his colour theory led to his design of the 'Alhambra Court' in the Crystal Palace in Sydenham, England in 1854, which made him a leading contributor to the fabrication of Alhambresque simulacra. The Alhambra became a major point of reference for Orientalist architecture in the United States, Europe – and even Egypt! – from palaces, hotels and banks to granaries and railway stations, movie theatres and synagogues.

The thrust of contemporary scholarship, dating back to the foundational work of Leopoldo Torres Balbás (1888–1960) during his tenure as preservation architect of the Alhambra from 1923 until

1936, has been to strip away the poetical, in Irving's sense – always a projection deeply inflected by European colonialism – and to restore a clearer view and better understanding of the historical Alhambra. In the briefest of outlines, this is what is known about its development. The first Muslim dynasty in Iberia, the Umayyads (r. 92–423/711–1031), had their seat of power in Córdoba, but built a fortress on the Sabīka hill in Granada, as one of many defensive strongholds in their widespread dominions. The Umayyad fortress was known as *al-qalʿa al-ḥamrāʾ* or the red castle (*al-Ḥamrāʾ* or the Red) already in the third/ninth century, referring to the colour of the clay used in its constructions. After the breakup of the Umayyad caliphate into petty kingdoms during the *mulūk al-tawāʾif* or *taifa* period (423–79/1031–86), the fortress was enlarged by the local Zīrid dynasty (r. 403–83/1013–90). It was the Nasrids, however, who created the palatial city that came to occupy the entire crown of the Sabīka hill, measuring 740 m × 220 m, an architectural complex whose majestic silhouette stands out against the backdrop of the mountains of the Sierra Nevada (Figures I.2–I.4). First, they erected a new fortress (*al-qaṣaba*) on the foundations of the earlier fortifications at the west end of the escarpment. The royal *madīna*, or city, then extended eastward, comprising buildings for the court administration, palaces with courtyards, pools and gardens, a congregational

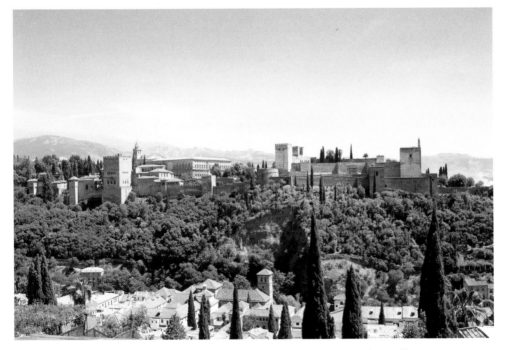

Figure I.2 *Alhambra, general view from the Mirador de San Nicolás, Albayzín* (photograph: Olga Bush)

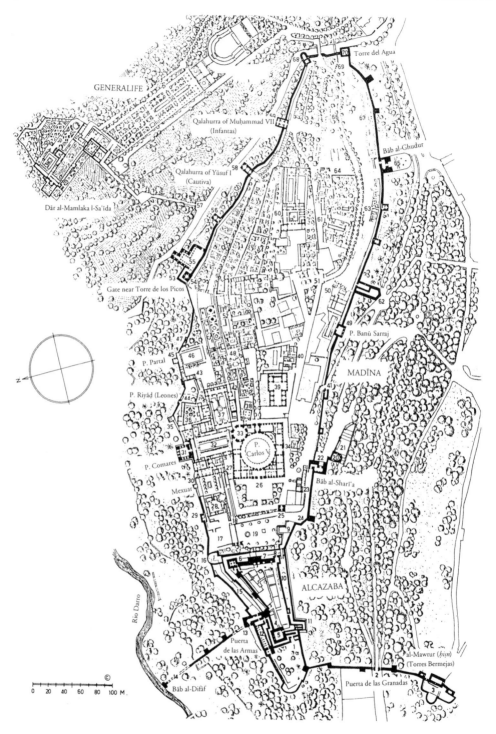

Figure I.3 *The fortress and* madīna *of the Alhambra, and the Generalife, general plan (after Antonio Fernández-Puertas,* The Alhambra*)*

Figure I.4 *Key to Figure I.3 (after Antonio Fernández-Puertas,* The Alhambra*)*

mosque, oratories, baths, a royal cemetery and, at the east end of the hilltop, the industrial zone that encompassed the royal workshops for the production of luxury goods for the consumption of the court. Two main streets running in the east–west direction and secondary streets between them provided communications among the different parts of the Alhambra. A complex irrigation system supplied the water necessary for the daily functions of the city, including the cultivation of orchards. The palatial city was enclosed by a curtain wall with both upper and lower sentry walks that reached to the fortress on the west, forming a well-integrated defensive system. In fact, the Nasrid Alhambra was never taken by storm. The numerous, massive towers and gates overlook the steep slopes of the hill, the city of Granada and the surrounding landscape.

The Nasrid Alhambra developed gradually over the course of the two and a half centuries of the dynasty's reign, serving as the centre of its military and political power in the kingdom of Granada.[7] The architectural projects initiated by the first sultans

were modified or altogether replaced by their successors. The dating and attribution of patronage of some buildings, or particular precincts within them, remain an issue for ongoing research. Consensus supports the following summary of major extant constructions, often commonly identified by their post-Nasrid names: the Partal Palace dating to the reign of Muḥammad III (r. 701–8/1302–9); the Palace of Comares, originating under Ismāʿīl I (r. 713–25/1314–25) and subsequently enlarged and modified under Yūsuf I (r. 733–55/1333–54) and Muḥammad V (r. 755–60/1354–9, 763–93/1362–91); the Palace of the *Riyāḍ*, or Palace of the Garden, now called the Palace of the Lions, built by Muḥammad V; the tower-palaces of the *Qalahurra* of Yūsuf I, popularly known as the Tower of the Captive, and the *Qalahurra* of Muḥammad VII, now called the Tower of the Princesses, erected by Yūsuf I and Muḥammad VII (r. 794–810/1392–1408), respectively. The Palace of Comares and the Palace of the Lions are the most famous palaces in the Alhambra complex, owing to their size, state of preservation and continuous conservation efforts. Other constructions, such as the Palace of the Abencerrajes, the Palace of the ex-Convent of San Francisco, the Palace of Secano, the Palace of Yūsuf III and two residences situated west of it, are known today mainly through their archaeological vestiges.[8] The present-day UNESCO site also includes the Palace of Generalife, known under the name *jinān al-ʿarīf* (Garden of the Architect) when it was built during the reign of Muḥammad II (r. 671–701/1273–1302) as a summer retreat on the Santa Elena hill, across a deep ravine from the Sabīka hill and the Alhambra (Figure I.5). The Generalife was altered under Muḥammad III and then renovated by Ismāʿīl I, during whose reign it came to be called *dār al-mamlaka al-saʿīda* (The Felicitous House of the Kingdom). Further up the Santa Elena hill, above the Generalife, there once stood the palaces of Alijares and *dār al-ʿArūsa*, demolished in post-Nasrid times, with only scant remains visible today.

The foregoing survey represents the fruits of the work of a long and distinguished array of modern scholars, all of whom have confronted the same intractable dilemma.[9] There are virtually no available archival documents concerning the design and construction of the Alhambra, nor the court life of the Nasrid administrative, religious and cultural centre. Whether such texts were carried off by the Nasrids when they left Granada and the Iberian Peninsula in 1492, or were destroyed over the centuries when the Alhambra, the Generalife and all other properties of the Nasrid royal family in Granada and elsewhere became part of the patrimony of the Catholic Monarchs and their successors, cannot be determined. The one vital exception is a first-hand account of a ceremonial in the Alhambra in 764/1362, at the outset of the second reign of Muḥammad V; it has received important scholarly attention and will figure in the

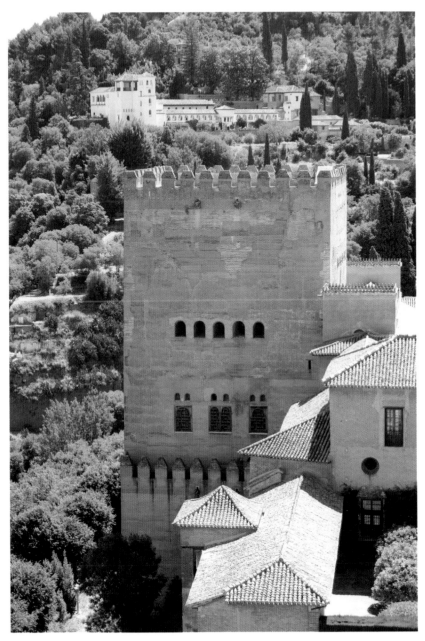

Figure I.5 *Generalife, seen in the middle ground, a view from the fortress of the Alhambra (photograph: Olga Bush)*

conclusion of this book. But the absence of other documents produced by the Nasrid court is an obstacle at every scholarly turn, and has oriented all research to date towards the extant material evidence of the architecture itself.

That orientation is beset with its own problems arising from the current state of the material evidence. The passage of more than five centuries has made for inevitable deterioration in the architecture, in large measure a result of neglect. The Alhambra never became a primary royal residence nor the capital city of the newly consolidated realms of Castile and Aragon (or later, of Spain). It remained, rather, a property in a far-off provincial city administered by governors appointed by the Royal Chancery for centuries. By the time of Washington Irving, the palaces were home to squatters – Irving himself among them – whom the Romantic painters habitually included in their depictions as an element of local colour for the sake of picturesque effect. The visit of Francisco de Paula and Luisa Carlota was a truly unusual sign of royal attention, but also, the over-painting of architectural elements for their reception was a perilous step in a history of faulty restoration.

Furthermore, it needs be recalled that starting in 1492 the Alhambra was occupied by a hostile, Christian power, intent on converting the site into a commemoration of its own triumph and a symbol of the defeat of Islam in Iberia – what Spanish historiography continues to view as the *Reconquista* and the inauguration of the modern nation. Hence, there was also deliberate destruction in the Nasrid Alhambra. The most notable example was the obliteration of a substantial portion of the royal *madīna* to make room for the Renaissance palace built for Charles V (r. 1516–56). Although the project, begun in 1533, was abandoned unfinished in 1637, the Palace of Charles V is the largest standing structure in the Alhambra, and the prior Nasrid buildings and roadways on its site are buried beneath its gigantic footprint (Figure I.6). At present, the very popularity of the Alhambra as a tourist destination discourages extensive excavations.

Despite the many instances of destruction, neglect and alteration of the buildings, the Alhambra presents what is perhaps the best-preserved medieval Muslim palatial city anywhere and, certainly, the outstanding example of Nasrid palatial and military architecture. The material evidence available for study is abundant and impressive. Measurements of standing structures have yielded important insights into the principles of architectural design, and the decorative vocabulary has been documented. Archaeological investigations have clarified the chronology of how the urban fabric of the Alhambra developed. Expanded technical analyses have aided in the dating of particular structures, and in the conservation of buildings and architectural decoration. Comparative research in architectural history has established the typology of its buildings – their reception halls and courtyards with pools and vegetation – within the tradition of the medieval palatial architecture of the Muslim courts of al-Andalus and the Maghrib.

Yet in their strict focus on the material evidence, those various approaches, each a valuable effort to strip away the poetical in

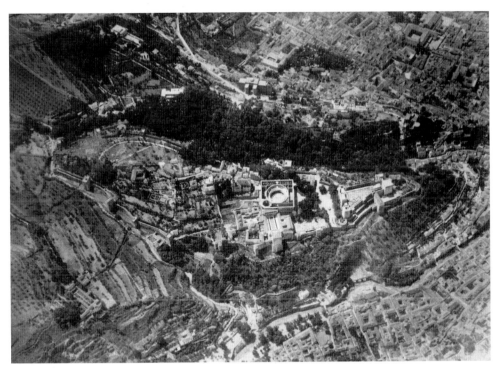

Figure I.6 *Alhambra, aerial view (photograph: Archivo de la Alhambra)*

search of the historical, have largely reduced the Alhambra to a set of empty rooms. Even a cursory view of court life during the medieval and early modern periods anywhere, especially in Muslim polities, will suffice to indicate that palaces were the setting for the performance of elaborate ceremonials in which the social construction of power was framed by, but by no means limited to, architecture. It could not have been otherwise in the Nasrid Alhambra. Like the archival documents, the pertinent material evidence is absent – no luxury objects remain in situ – but it is no mere poetical fantasy to say that the architectural spaces of the Alhambra would have been fully furnished and full of life in Nasrid times. In fact, luxury furnishings attributed to the Nasrid production are now located only a few steps away from the empty palaces; divorced from their original setting, they are on display in the glass cases of the Museum of the Alhambra.

The poetical, as a name for that fullness, may be valuably entwined again with the historical, if not in the way that Irving understood the terms, by what, in other contexts, has been called a spatial turn. Initiated by cultural geographers, and later adopted and further developed in art history and the study of material culture, such work has approached architecture as a setting for social constructions, mediated by the objects it contains and the movement of people that

unfolds within it. These scholars have come to speak of spatiality, rather than space, as a scene of reciprocal relations.[10] Architecture informs lived experience and at the same time it is informed by that experience, which is to say, by the reception and activities of the beholders, grounded in their social, cultural and historical context.

In the field of Islamic art and architectural history, the theoretical premises of such reciprocal interaction between architecture, objects and beholders have long since been developed by Oleg Grabar in his conceptualisation of the role of ornament as a crucial mediator of the aesthetic experience. Grabar developed his thesis in *The Mediation of Ornament* primarily through separate studies of three modes of decoration — writing, geometry and vegetal motifs.[11] In the Alhambra, the three modes typically appear together in the same architectural space, and frequently overlap. As the present study will demonstrate, each mode, in turn, serves as a mediator for the others. This further elaboration of the *interrelationships* of ornament has two corollaries that orient the whole of the book ahead. First, a careful reading of the epigraphy, and especially the numerous poetic inscriptions so characteristic of the Alhambra, serves to emphasise that this interrelationship itself was a self-conscious key to design. In this book, special attention is given to poetic epigraphy as an explicit expression of aesthetic principles in the verses composed by the accomplished court poets and illustrious Nasrid viziers, Ibn al-Jayyāb (673–750/1274–1349), Ibn al-Khaṭīb (713–77/1313–75) and Ibn Zamrak (734–96/1333–93). And, second, such integration is not limited to the three modes of architectural decoration, but rather extends to the reciprocal relations between architecture and the other artistic media that comprised the aesthetic experience of the Alhambra. A single book could hardly take up all of these aspects, so here the focus will be limited to three major components and their multidirectional mediations: architecture, poetic texts, and textiles – the first, always the centre of Alhambra studies; the second, much undervalued; and the third, textiles, almost always left entirely out of account.

The absence of archival documents, compounded by the absence of furnishings in situ, present this approach with much the same obstacles as all others. This book seeks to resolve this difficulty through comparative discussions of better-documented ceremonial life at other medieval courts and analysis of pertinent luxury objects ascribed to Nasrid workshops among the holdings of the Museum of the Alhambra and other collections worldwide. In this latter regard, it is worth stating here at the outset that adducing those examples is not intended as an argument that would locate a particular object in a specific space in the Alhambra. But the extant objects – disseminated as gifts and commercial exports by the Nasrids or appropriated by their Christian conquerors – illustrate the aesthetic principles underlying the coherent interrelationships between different media,

which I will refer to as *inter-medial* design. The study of furnishings suggests a different model of the Alhambra, that is, of a multimedia built environment.

One further methodological issue needs be articulated clearly in broad strokes. Irving's error, characteristic of the nineteenth century, was not the effort to reimagine the Alhambra as a living environment, but rather the imposition of the cultural predilections of his own times onto its architectural spaces. It is above all the anachronistic Romantic Alhambra – which is also the colonial Orientalist Alhambra – that modern scholarship has sought to sweep away in its pursuit of history. Unfortunately, the names and biographies of Nasrid architects and artisans are unknown today, and, likewise, no information is available on the transmission of theoretical or practical knowledge, such as craftsmen's manuals, in the Nasrid royal workshops. Yet it is still possible to historicise the poetical by turning to the intellectual currents of the medieval Muslim world that are known to have reached al-Andalus and would therefore have helped to shape the aesthetic principles of the designers of the Alhambra and the aesthetic experience of the beholder in Nasrid times. The areas of interest are boundless; this book focuses on three main topics: optics, poetics and court ceremonial. These topics open a broad multidisciplinary approach that engages developments in the fields of conservation, literary criticism and psychology of visual perception, in addition to art history, in order to provide a variegated and flexible theoretical framework. The spatial turn moves discussion in the direction of cultural studies.

The organisation of the book might be outlined in two different sets of terms. First, as the subtitle reads, the opening chapter concentrates on architecture alone, poetic inscriptions are added to the analysis of architecture in Chapters 2 and 3, and textile furnishings in Chapter 4. The fifth and final chapter pursues the analysis of the one extant account of a Nasrid ceremonial in the Alhambra, mentioned above, which integrated all three media. Alternatively, the book follows the path of the optical theory discussed in Chapter 1 that formulates vision as a process leading from perception to cognition across the necessary bridge of the imagination. In this light, Chapter 1 emphasises perception and the concluding chapter cognition. Among the stages of vision, it is imagination that has received the least attention in the study of the Alhambra, and so the middle chapters are all devoted to elaborating on its workings as they are documented in the poetic inscriptions. Rather than offering an overview of all the buildings in the Alhambra, the discussion proceeds through studies of specific architectural spaces, selected because they have received relatively little attention or because they are sites of unresolved controversies and enigmas.

Chapter 1 centres on the uses of colour in the design of the Alhambra and on the visual effect that colour combinations would

have made on the Nasrid beholder. Today the architecture of the Alhambra appears mostly devoid of colour. As a result, scholarship has concentrated on the material evidence of the geometry that underlies the elevation of buildings as well as their decoration. The recent work of conservators, however, demonstrates that the interior spaces of the Alhambra in Nasrid times were vibrantly coloured from floor to ceiling and in all of their diverse materials: stucco, wood, marble, glass and ceramics. This focus offers the occasion to work back through nineteenth-century restoration, particularly in the controversial space of the baths of the Palace of Comares, to the historical Alhambra and to re-establish the balance between colour and geometry in the original design. This renewed understanding is grounded in the widely disseminated optical theory of the medieval Muslim scientist Ibn al-Haytham (c. 354–432/965–1040). His optical principles concerning perception help to explain the aesthetics of the Alhambra, and he lays out the fundamental trajectory from visual perception through imagination to cognition that informs the book as a whole. An examination of the *muqarnas* vault in the Hall of the Abencerrajes in the Palace of the Lions and the dadoes of ceramic tile mosaics in the Palace of Comares serves to illustrate the optical relationship between a static geometry and the kinetic effects of colour in accordance with the work of Ibn al-Haytham. That relationship is supported by the experimental findings of the contemporary psychology of visual perception. It will have ongoing repercussions in the subsequent chapters as the relationship is enacted by the beholder in the interplay of movement and arrest, and also in the combination of the permanent and the transitory in the construction of ceremonial space.

Chapter 2 opens the discussion of poetic epigraphy, concentrating on the relatively little-studied Sala de la Barca, a threshold space that precedes the audience hall in the Palace of Comares. It is necessary to begin by setting the poetic inscriptions within the broader decorative programme, including its other epigraphic modes, namely, Qur'ānic and formulaic inscriptions. Questioning the understanding of inscribed poetry as literal descriptions of the architecture, José Miguel Puerta Vílchez has contributed greatly to its interpretation from the perspective of semiotics.[12] The present study further contests the earlier inclination towards mimetic reading. Poetry is distinctive amongst the epigraphic modes in its emphatic and self-conscious use of *figurative* language, which both exemplifies and also often reflects upon the transformative force of the imagination.

Following a historical outline of the use of poetry in inscriptions on architecture and luxury objects within a comparative Mediterranean context, this chapter concentrates on a frequent, but unremarked, poetic figure: the trope of prosopopoeia, which creates the fiction that an otherwise inanimate object is speaking in the first-person voice. The understanding of the imaginative function of

prosopopoeia is aided by contemporary literary theory, and is introduced here through the analysis of a paradigmatic example inscribed on one of the 'Alhambra vases'. The choice of this ceramic object also adds a further dimension to the inter-medial approach of the book. The use of the first-person voice in the poetic inscriptions in the Sala de la Barca, and many other precincts, allows the architecture to speak, figuratively, for itself, and to address the beholder directly. In this manner, the inscribed verses served explicitly as a guide to the beholder's experience. Here, the effect is to arrest the ceremonial movement through the space of the Palace of Comares and to urge a contemplative pause in which the imagination comes to heighten an awareness and understanding of power in the audience hall.

Chapter 3 broadens the scope of the relevant poetic figures, taking as a point of departure an explicit reference in the poetic epigraphy in the *Qalahurra* of Yūsuf I to some of the most important tropes in the tradition of medieval Arabic *badīʿ* poetics. What one gathers from these tropes as they are employed in the poetic inscriptions is the emphasis on interrelationship, conceived in varied forms. This small tower-palace is little known to the general public, since it is usually closed to visitors, and its architecture and decoration have also received little scholarly attention, hence the need to begin with an examination of its architectural features and the history of its partial destruction and restoration. As in the preceding chapter, the architectural analysis follows the movement of the Nasrid beholder, which here is from the exterior into the interior. The main hall is the chief site of the decoration: it illustrates the characteristic layering of decorative modes (vegetal, geometric and epigraphic) upon a single grid, and also a separate and extensive programme of poetic inscriptions. Composed by Ibn al-Jayyāb, the four main interlinked poems have been largely dismissed by scholars as redundant with regard to their content, offering nothing more than a straightforward mimetic representation of the decoration. This chapter argues otherwise, holding that the self-reflexive enumeration and deployment of typical *badīʿ* tropes articulates the complex relationship between the integrated decorative elements, as well as the overall structure and function of the hybrid tower-palace.

Chapter 4 pursues the aesthetic principle of overlapping interrelationships between architecture, poetic texts and textiles. A historical overview of the tradition of inscribing verses on Islamic luxury textiles leads to a neglected point of intersection in the cultural production of al-Andalus. A specific type of Nasrid textile and also a certain, ingenious Andalusī poetic genre were both designated by the same term, *muwashshaḥ*. More than a lexical peculiarity, the shared term indicates that this type of striped cloth and this type of dialogic poetry – and more generally, textiles and poetic texts – were recognised in Andalusī culture to have common constitutive features and a shared aesthetic value. A group of striped luxury textiles are

here identified as *muwashshaḥāt* (pl. of *muwashshaḥ*), and a related
group of textiles, referred to by scholars as the 'Alhambra silks',
is then compared with the decoration of the Façade of Comares in
the Cuarto Dorado of the Palace of Comares.

While decorative motifs shared by textiles and stucco decoration
have been identified, the importance of stylistic affinities across dif-
ferent media has not been thoroughly examined. Ibn al-Haytham's
articulation of the value of harmony in the perception of beauty
provides the grounds to look beyond visual resemblances. If, as he
argues, the harmony between elements is more important than the
beauty of the elements in themselves, then his optics lays the foun-
dations for an integrated approach to the design of an architectural
space. In this light, transitory furnishings, like textiles, contribute
to the harmonious coherence of the spatial design of the permanent
architectural structures. The movement of bodies through space
is another aspect of this analysis, leading to the proposal of the
concept of 'textile architecture' to discuss the use of textiles to
serve the architectural functions of temporarily obstructing sight
lines or controlling movement. The peculiar configuration of the
Cuarto Dorado, with its monumental façade looming over a small
patio, may be illuminated by consideration of that role of textile
furnishings.

Chapter 5 is devoted to the study of the only extant text of a Nasrid
beholder's experience of the Alhambra: the first-hand account of
the celebration of the *mawlid al-nabī*, the commemoration of the
birth of the Prophet Muḥammad, on 12 Rabīʿ II 764 (30 December
1362), authored by Ibn al-Khaṭīb. The text is well known and has
served scholars in the tasks of architectural history – the historical
reconstruction and even restoration of spaces, and their dating –
though some of these issues remain in doubt. Discussion of earlier
and contemporary celebrations of the *mawlid al-nabī* in the Muslim
East and North Africa provides helpful historical comparisons,
bringing to the fore the role of processions in court ceremonials.
The interplay between mobility and stasis so crucial to the aesthetic
experience of the Alhambra, as seen in the preceding chapters,
is embodied in the *mawlid* ceremony by the juxtaposition of the
transitional space and transitory structure of an enormous royal
tent – the grandest form of luxury textiles and the clearest example
of textile architecture – and the permanent buildings. The same
issues recur in the poems recited as part of the celebration, which,
much as is the case of poetic inscriptions, give voice both to the
aesthetic principles of the ceremony and to the expression of power.
Thus, Ibn al-Khaṭīb's text offers a contemporary testimony of the
self-conscious integration of architecture, poetry and textiles in
the construction of ceremonial space in the Alhambra.

In sum, proceeding through a series of case studies, the present book
seeks to bring attention to undervalued historical resources – modes

of knowledge (optics and poetics), alternative forms of documentation (inscriptions), and dispersed luxury objects (ceramics, textiles) – that might enable us to re-imagine the architectural spaces of the Alhambra as the living environment of Nasrid times. It is my further hope that the theoretical framework and the corresponding methods of inquiry will also prove suggestive for the study of other architectural monuments from the medieval Muslim world and beyond.

Notes

1. For an account of the reception for Francisco de Paula and Luisa Carlota in the Alhambra in 1832, see Juan Manuel Barrios Rozúa, *Alhambra romántica: Los comienzos de la restauración arquitectónica en España* (Granada: Universidad de Granada/Patronato de la Alhambra y Generalife, 2016), pp. 53–8.
2. On the concept of sites of memory, see Pierre Nora, 'Between Memory and History: *Les Lieux de Mémoire*', trans. Marc Roudebush, *Representations* 26 (1989): 7–24.
3. In its first editions, the book was titled *The Alhambra: A Series of Tales and Sketches of the Moors and Spaniards* (London, Philadelphia, Paris: Colburn & Bentley, Carey & Lea, Galignani, 1832).
4. Washington Irving, *The Tales of the Alhambra* (Leon: Editorial Everest, 1974), p. 33.
5. According to María del Mar Villafranca, the director of the Alhambra from 2004 to 2015, the year 2014 was 'the best tourist year in the history of the Alhambra', during which 2.4 million people visited the site, with a record of 9, 329 visitors on 1 May 2014. See at: http://www.thelocal. es/20150112/alhambra-visitor-numbers-hit-record-high, last accessed 30 August 2016.
6. See especially, Owen Jones and Jules Goury, *Plans, Elevations, Sections and Details of the Alhambra. From drawings taken on the spot in 1834 by the late M. Jules Goury and in 1834 and 1837 by Owen Jones Archt. With complete translation of the Arabic inscriptions and an historical notice of the Kings of Granada from the conquest of that city by the Arabs to the expulsion of the Moors, by Mr. Pasqual de Gayangos* (London, 1842–45); as well as Owen Jones, *The Grammar of Ornament* (London, 1856).
7. Among the monographs on the history of the Nasrid Sultanate, see María Jesús Viguera Molins (ed.), *Historia de España Menéndez Pidal, vol. VIII: 4, El reino nazarí de Granada (1232–1492). Sociedad, vida y cultura* (Madrid: Espasa Calpe, 2000); Rachel Arié, *L'Espagne musulmane au temps des Nasrides (1232–1492)* (Paris: E. de Boccard, 1973); Aḥmad Mukhtār al-ʿAbbādī, *El reino de Granada en la época de Muhammad V* (Madrid: Publicaciones del Instituto de Estudios Islámicos en Madrid, 1973); and Leonard Patrick Harvey, *Islamic Spain, 1250 to 1500* (Chicago: University of Chicago Press, 1990), which still remain the most comprehensive and complete in their analyses of the primary sources.
8. In her overview of alterations suffered by the Alhambra in the post-Nasrid period, D. Fairchild Ruggles notes that the Sabīka hilltop was not fully excavated before it was converted into a parking lot for the

visitors several decades ago. The loss is significant, since partial archae-
ological vestiges give evidence of an Islamic palace that once stood on
the site. See D. Fairchild Ruggles, 'Inventing the Alhambra', in David
Roxburgh (ed.), *Envisioning Islamic Art and Architecture: Essays in
Honor of Renata Holod* (Leiden: Brill, 2014), p. 4.

9. Works of scholarship will be cited in the context of the discussions
 to which they are directly pertinent. Three principal works stand
 out, however, and need be cited here: Oleg Grabar, *The Alhambra*
 (Cambridge, MA: Harvard University Press, 1978); Antonio Orihuela
 Uzal, *Casas y palacios nazaríes: siglos XIII–XIV* (Barcelona: Lunwerg,
 1995); and Antonio Fernández-Puertas, *The Alhambra* (London: Saqi,
 1997). The research agenda set by Grabar has been pursued by a genera-
 tion of scholars; for a valuable review of recent contributions on the
 historiography on the Alhambra, see Lara Eggleton, 'History in the
 Making: The Ornament of the Alhambra and the Past-facing Present',
 Journal of Art Historiography 6 (2012): 1–29.

10. For theoretical articulations of the 'spatial turn', see, for example, Mike
 Crang and Nigel Thrift (eds), *Thinking Space* (New York: Routledge,
 2000); Luke Lavan, Ellen Swift and Toon Putzeys (eds), *Objects
 in Context, Objects in Use. Material Spatiality in Late Antiquity*
 (Leiden: Brill, 2007); Barney Warf and Santa Arias (eds), *The Spatial
 Turn: Interdisciplinary Perspectives* (New York: Routledge, 2009);
 Joseph Maran, Carsten Juwig, Hermann Schwengel and Ulrich Thaler
 (eds), *Constructing Power: Architecture, Ideology and Social Practice*
 (Berlin: LIT Verlag, 2009). The list of critical studies oriented by the
 'spatial turn' in the context of Christian polities is immense, and is
 now growing with regard to Muslim courts, though comparisons in the
 interconnected medieval and Renaissance world call for more attention.
 For a succinct summary of contributions to the study of space in cul-
 tural studies and cultural geography, and for viable directions to which
 they point for medievalists, see Gerald B. Guest, 'Space', *Medieval Art
 History Today: Critical Terms*, special issue, *Studies in Iconography* 33
 (2012): 219–30.

11. Oleg Grabar, *The Mediation of Ornament* (Princeton, NJ: Princeton
 University Press, 1992), is a pervasive influence on the whole concep-
 tion of the present study.

12. José Miguel Puerta Vílchez' specific contributions to the study of the
 epigraphy of the Alhambra will be acknowledged throughout the book.
 Among his many works, Puerta Vílchez, *Leer la Alhambra: Guía visual
 del Monumento a través de sus inscripciones* (Granada: Patronato de la
 Alhambra/Edilux, 2010), is an invaluable source for the present study,
 providing all the texts in Arabic of the entire epigraphic corpus of the
 Alhambra, and, in addition, Spanish translations and some translitera-
 tions, as well as a photographic survey of the texts' precise locations
 and an interpretive analysis of the inscriptions in the Alhambra. In
 all of the subsequent chapters, the Arabic texts of the inscriptions
 in the Alhambra under discussion follow Puerta Vílchez and refer to
 page numbers in *Leer la Alhambra*; the complete Arabic texts of the
 poems that are central to this book are also included in the Appendix.
 All English translations of the inscriptions, and of all other texts cited,
 unless otherwise noted, are my own.

CHAPTER ONE

Colour, Design and Medieval Optics

How can anyone speak of *coloris*? . . . How can we name a
pleasure that eludes all assignation? The defenders of paintings'
dignity as a liberal art have amply deplored this lack since the
Renaissance: the emotion that overcomes the viewer – who is
ravished by the charms of *coloris*, dazzled by the shimmering
ornaments of the vision before him – always show up as a
turbulence in ability to express it. Surprised, arrested, seduced,
the individual is further dispossessed of the powers of speech; his
ruin involves the crumbling of all discursive modes, the sudden
failing of language.

Jacqueline Lichtenstein, *The Eloquence of Color*[1]

I

A contemporary visitor to the Alhambra palaces sees the interiors
of halls and the spacious arcaded courtyards mostly devoid of colour
(Figures 1.1 and 1.2). Yet, originally, the visual experience of the
Nasrid beholder would have been entirely different. The Nasrid
Alhambra shimmered with vibrant colours: doors, ceilings and great
expanses of the walls were vividly painted, and floors and lower
parts of the walls were decorated with polychrome ceramic tiles.
Depending on the intensity and direction, the light reflected in and
refracted from the various coloured surfaces of the architectural
decoration – carved stucco and wood, ceramic tile mosaics, glass and
even carved marble – animated the spaces of the palaces. In sum, the
impact of colour was crucial to the aesthetic experience everywhere
in the Alhambra, so its study, undertaken by conservators but largely
overlooked by art historians, is indispensable.

The general absence of colour in the current state of the Alhambra's
preservation creates conditions that have long favoured schol-
arly attention to geometry, culminating in the work of Antonio
Fernández-Puertas.[2] He demonstrated that the plans, elevations and
architectural decoration of all precincts were conceived and executed
as an integrated whole, unified by their proportional ratios. His find-
ings will be fundamental to the considerations of proportionality in

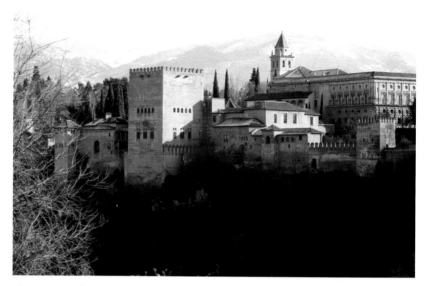

Figure 1.1 *Alhambra, general view (photograph: Olga Bush)*

the architectural spaces studied in the following chapters. Here, his overarching point about the extraordinary coherence of geometric proportionality may be extended to the discussion of colour. If geometric design is understood to be a deliberate principle, why would one expect the treatment of colour to be the result of an uninformed and haphazard empiricism?

This chapter will argue just the opposite: that colour was not only ubiquitous in the Alhambra, but, more importantly, that it was deployed in keeping with the scientific knowledge available to the Nasrids to achieve carefully designed visual effects. The discussion requires two preliminary steps: (1) to determine the material basis for the use of colour through an historical assessment of the extent, variety and sources of pigments used in the Alhambra; and (2) a critical review of the history of restorations to ascertain, as much as possible, the original state of the colours that are now much effaced or entirely lost. Once these matters have been clarified, guided by recent technical analyses, the optical theory of the day will be brought to bear on the design principles and aesthetic experience of the beholder.

The discussion will be wide-ranging in an effort to examine the use of colour in all of the different materials in their various decorative designs. As the examples will be drawn all but exclusively from the two major extant palaces in the Alhambra, the Palace of Comares and the Palace of the Lions, I begin with an overview of those architectural contexts before proceeding to the uses of colour in specific settings. The Palace of Comares is organised around the large

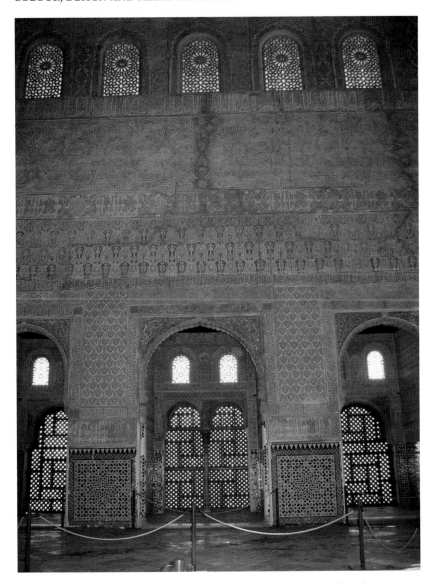

Figure 1.2 *Hall of Comares, interior, Palace of Comares, Alhambra (photograph: Olga Bush)*

rectangular space of the Court of Comares, popularly known as the Court of the Myrtles (Figure 1.3). A long rectangular pool set on the court's central north–south axis and a massive tower, now called the Tower of Comares, which looms over the pool on the short, north side of the court, further accentuate the compositional and visual orientation of the palace. A structure that once stood on the south side of the court and served as a counterweight to the Tower of Comares was demolished to make room for the Renaissance

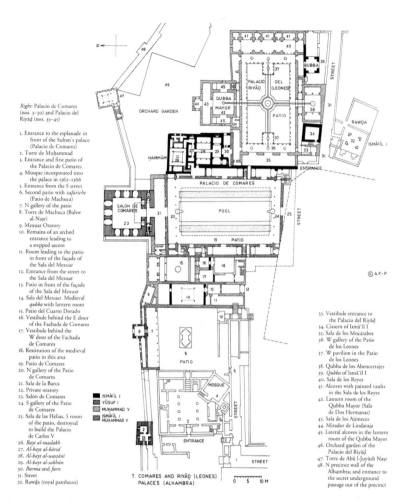

Right: Palacio de Comares
(nos. 3–30) and Palacio del
Riyāḍ (nos. 33–45)

1. Entrance to the esplanade in
 front of the Sultan's palace
 (Palacio de Comares)
2. Torre de Muḥammad
3. Entrance and first patio of
 the Palacio de Comares
4. Mosque incorporated into
 the palace in 1362–1366
5. Entrance from the S street
6. Second patio with *zafariche*
 (Patio de Machuca)
7. N gallery of the patio
8. Torre de Machuca (Bahw
 al-Naṣr)
9. Mexuar Oratory
10. Remains of an arched
 entrance leading to
 a stepped ascent
11. Room leading to the patio
 in front of the façade of
 the Sala del Mexuar
12. Entrance from the street to
 the Sala del Mexuar
13. Patio in front of the façade
 of the Sala del Mexuar
14. Sala del Mexuar. Medieval
 qubba with lantern room
15. Patio del Cuarto Dorado
16. Vestibule behind the E door
 of the Fachada de Comares
17. Vestibule behind the
 W door of the Fachada
 de Comares
18. Restitution of the medieval
 patio in this area
19. Patio de Comares
20. N gallery of the Patio
 de Comares
21. Sala de la Barca
22. Private oratory
23. Salón de Comares
24. S gallery of the Patio
 de Comares
25. Sala de las Helias, S room
 of the patio, destroyed
 to build the Palacio
 de Carlos V
26. *Bayt al-maslakh*
27. *Al-bayt al-bārid*
28. *Al-bayt al-wasṭānī*
29. *Al-bayt al-sakhūn*
30. *Burma* and *furn*
31. Street
32. Rawḍa (royal pantheon)

33. Vestibule entrance to
 the Palacio del Riyāḍ
34. Cistern of Ismāʿīl I
35. Sala de los Mocárabes
36. W gallery of the Patio
 de los Leones
37. W pavilion in the Patio
 de los Leones
38. Qubba de los Abencerrajes
39. *Qubba* of Ismāʿīl I
40. Sala de los Reyes
41. Alcoves with painted vaults
 in the Sala de los Reyes
42. Lantern room of the
 Qubba Mayor (Sala
 de Dos Hermanas)
43. Sala de los Ajimeces
44. Mirador de Lindaraja
45. Lateral alcoves in the lantern
 room of the Qubba Mayor
46. Orchard garden of the
 Palacio del Riyāḍ
47. Torre de Abū l-Juyūsh Naṣr
48. N precinct wall of the
 Alhambra; and entrance to
 the secret underground
 passage out of the precinct

ISMĀʿĪL I
YŪSUF I
MUHAMMAD V
ISMĀʿĪL I
MUHAMMAD V

7. COMARES AND RIYĀḌ (LEONES)
 PALACES (ALHAMBRA) 0 5 10 M

Figure 1.3 *Plan of the administrative precincts, Palace of Comares
and Palace of the Lions, Alhambra (after Antonio Fernández-Puertas,
The Alhambra)*

Palace of Charles V. Two-storied buildings flank the pool on the
east and west sides of the court and contain small rooms within
their interiors on both floors. The north and south side of the court
are framed by elegant arcaded porticos, which are supported by a
marble colonnade. The portico on the north side leads into a narrow
transversal room, known as the Sala de la Barca, which gives access
to the Tower of Comares and its principal room, now called the Hall
of Comares, a grand space of the *qubba* type, that is a square room
with a cupola or vault. The plan of the Palace of Comares, in which
a large hall, usually square in plan, together with a transversal room
form a T-shaped spatial unit of a throne-complex, by a portico (here,
on the short, north side), typologically originated in the palatial

medieval architecture of western Muslim lands.[3] I will return to a more detailed discussion of these spaces in Chapter 2.

The Palace of the Lions is organised around a rectangular court with an east–west orientation, which is divided into four quadrants by running water channels, through which water flows into the basin of the large fountain in the centre (Figure 1.3). The plan of the palace and its quadripartite central court offer another example of a palatial typology developed in al-Andalus within the broader context of the medieval architecture of the Mediterranean basin.[4] A colonnaded portico frames the perimeter of the court, whose longitudinal axis is accentuated by a projecting pavilion on the east and west sides. Square in plan and open on all sides through high *muqarnas* arches on slender marble columns, these pavilions lead into long rectangular halls on the west and east sides of the palace. The north–south axis of the palace is marked by two halls, known by their modern names as the Hall of Two Sisters on the north and the Hall of the Abencerrajes on the south, both of the *qubba* type, and each flanked by a lateral room on the east and west (Figure 1.3: nos. 42 and 38). In addition, the Hall of Two Sisters opens onto a room that leads in turn into a small projecting belvedere known by its modern name, the Mirador de Lindaraja, aligned axially with the hall. The Hall of Two Sisters and the Hall of the Abencerrajes are among the most dazzling of the extant rooms in the Alhambra, celebrated for their striking *muqarnas* vaults, to be considered later in this chapter. I return to the main focus now by noting that there are vestiges of bright colours on the surfaces of the *muqarnas* vaults in both halls, which would have made their original visual effect even more splendid than it appears today.

2

After the conquest of Granada in 1492 by Queen Isabel of Castile and King Ferdinand of Aragon, commonly known as the Catholic Monarchs, the palaces of the Nasrid dynasty in the city and in the rest of the territories that had comprised the last Muslim kingdom of al-Andalus came into royal possession. The Alhambra was undoubtedly the jewel in the crown, with its fortified enclosure, a fortress for an army garrison and its many splendid palaces set amid a cultivated landscape. The Alhambra never became the permanent residence of what remained the itinerant court of the Catholic Monarchs, and it appears that, with very few exceptions, no important court rituals or diplomatic exchanges took place there over the course of the first three centuries of Christian rule. Nonetheless, its symbolic significance in the mythology of the Reconquista was crucial to the monarchy. A governor appointed by the Royal Chancery became the Alhambra's administrator and resided on the site, and the royal treasury supported the upkeep of the city's palaces and gardens. Even

so, in order to accommodate the needs of the Alhambra's various new inhabitants during this period, the architecture and the urban fabric of the city underwent significant transformations. Many buildings disappeared altogether, others were radically modified, and numerous courtyards and landscaped grounds were altered.

Several early historical documents, which have been preserved and dated within the first three years of the fall of Granada, that is, between 1492 and 1495, attest to the interventions made on the site immediately after the taking of the city.[5] These documents, examined in several monographic studies on the Alhambra already in the nineteenth century,[6] continue to inform current research. A trove of other historical documents, especially from the Royal Chancery, and rigorous studies of the Alhambra by scholars from diverse disciplines, further attest to the transformations that took place on the site over the course of the city's long post-Nasrid history.[7] In addition, scientific analysis of building materials and decorative techniques that began in the last quarter of the twentieth century have revealed the areas in the buildings where the preservation efforts of the nineteenth century effected significant alterations. It is not the aim of the present study to provide a comprehensive architectural history of the Alhambra – a complex topic, which, in light of recent findings, deserves to be considered anew. Instead, I will address those propositions and conclusions of art historians and conservators alike with regard to specific spaces, features and aspects that are central to my concerns. One must proceed with caution in distinguishing the Alhambra's historic fabric from the many later interventions, some of which were aimed at reinventing an imaginary splendour.[8]

It is with the work of Torres Balbás as preservation architect of the Alhambra that a new era in the investigations of the palatial city commenced. His work was guided by a critical analysis of post-Nasrid historical archives in conjunction with archaeological excavations and new practices in architectural restoration and conservation.[9] Torres Balbás' principles of 'consolidation, sustainability and preservation'[10] were reflected in the numerous studies that he published during his lifetime, and in his voluminous, meticulously recorded notes, published posthumously in a critical study by Carlos Vílchez Vílchez.[11] This work laid the foundation for the rigorous examination of the site and for scientific practices in heritage conservation. Following Torres Balbás' work, one of the chief goals pursued by scholars in the historiography of the Alhambra has been the identification and dating of original architectural and decorative elements in order to distinguish them from later alterations, as well as establishing a chronology for the changes that occurred during the post-Nasrid period. These investigations have shed light on many aspects of the intricate history of the buildings on the site. On the one hand, structures were modified to serve new functions and to correspond to the taste of the palaces' new inhabitants. On the

other hand, repairs were made to buildings and decorative surfaces
damaged by fires, earthquakes and climatic effects already in the
second half of the nineteenth century and continued into the early
twentieth century. Throughout the twentieth century and up to
the present, such interventions have been undertaken increasingly
with an eye towards meeting the expectations of visitors and both
enhancing and facilitating the experience of this major tourist site.[12]
Scientific research in the field of conservation that was initiated in
the 1970s and extended in the following decades has greatly aug-
mented our understanding of the materials and techniques employed
in construction and decoration at specific historical junctures, facili-
tating more accurate estimates of the nature and date of the build-
ings' transformations.[13] These new scientific methodologies have
proved fruitful in differentiating original materials and techniques
from those employed in the post-Nasrid period.

The analysis of plaster decoration is a typical case. Distinct types
of gypsum have been identified with regard to colour, texture and
chemical composition that make it possible to distinguish between
original plaster panels – both carved and cast – and nineteenth-
century reproductions, which were cast in plaster of Paris. A new
and datable technique of casting white plaster emerged during the
Nasrid period, allowing for a more precise dating of the original
architectural decoration of various precincts.[14] Previously, not only
flat surfaces, such as plaster panels for the decoration of the walls,
but also *muqarnas* arches and vaults, were carved in black plaster in
situ. One extant example has been found, albeit not in the Alhambra:
the rectangular *muqarnas* vault over the entrance arch in the façade
of *al-funduq al-jadīd*, now known as the Corral del Carbon, a corn
exchange and a hostel for traders, built in the centre of Granada most
likely during the reign of Muḥammad V.[15] The technical examina-
tion of this *muqarnas* vault led conservators to conclude that the
Nasrid craftsmen had a profound knowledge of the characteristics
of different types of plaster, black plaster in this case. The crafts-
men were capable of manipulating plaster composition with various
additives so that its drying and hardening processes were slowed
down, thereby allowing the completion of the carving process in
situ. It appears that for some time the two techniques – carving black
plaster and casting white plaster – were used concurrently. Evidence
of the older technique, therefore, is not definitive for dating, but the
presence of cast white plaster establishes a reliable *terminus post
quem*. In addition to the carving and casting of plaster, the tech-
niques employed by the Nasrid craftsmen for affixing the cast plaster
panels to the walls with clay have come to light, aiding further in
distinguishing the original panels from those made in the nineteenth
century.[16]

There has also been significant progress in the study of the pig-
ments used in the Nasrid period. Sources of pigments have been

identified and the techniques of pigment application to surfaces in different media, that is, wood, plaster, marble, ceramics and glass, have been ascertained.[17] The advances made in the in situ analysis of the Alhambra have resulted largely not from a broad comparative sampling taken in different buildings, but rather from the pressing concerns for the conservation of deteriorated architectural elements and decorative surfaces. These studies have to be considered with caution. The conservators' objective is to employ an efficient methodology, limited to 'the minimum sample amount' in the area of deterioration. Only a few plaster panels or a segment of ceramic tile mosaic within a given room might be examined in a given study.[18] The invaluable data obtained in such an analysis provide important answers about that limited area, and often serve to distinguish between original decoration and later alterations. However, since other architectural elements and surfaces often remain unexamined, this necessarily partial information is insufficient for drawing broader conclusions about the chronology of a precinct as a whole.[19] At the same time, better-conserved architectural spaces, which do not require immediate conservation, have not been analysed sufficiently and still await comprehensive studies. The analysis of materials in situ has been supplemented by the study of architectural fragments that allegedly originated in the Alhambra and that have been preserved in museum collections. While these studies yield significant scientific information, more often than not it is difficult to determine with certainty the building or space in which the fragments were originally employed.[20]

Even with the foregoing cautions in mind, this much may be safely said. First, in many areas in the Alhambra, scholars have succeeded in distinguishing original structures from later alterations; and, second, whatever one is to make of the repainting that formed part of the restorations, sufficient traces of original pigments have been found on original elements to conclude that the Alhambra of Nasrid times was richly coloured.

3

To register the shock of colour in the Alhambra, one might well look to the baths situated between the *Qaṣr al-Sulṭān* or *Dār al-Mulk* (House of the Sultan or Royal House), known today as the Palace of Comares, and *al-Riyāḍ al-Saʿīd*, known today as the Palace of the Lions (Figures 1.4 and 1.5).[21] The baths were built most likely under the patronage of Ismāʿīl I, but were further embellished during the reign of his son, Yūsuf I.[22] They were one of many baths constructed in the Alhambra, and, architecturally, the better preserved of the two baths still standing. The building adheres typologically to the plan of medieval Muslim baths in that it is composed of four rooms distinct in their function: *bayt al-maslakh* (room for

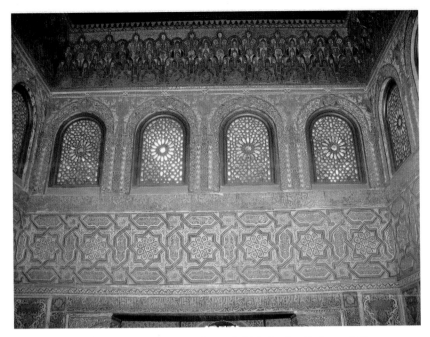

Figure 1.4 *Undressing room (*bayt al-masla<u>kh</u>)*, baths, Palace of Comares, Alhambra (photograph: Olga Bush)*

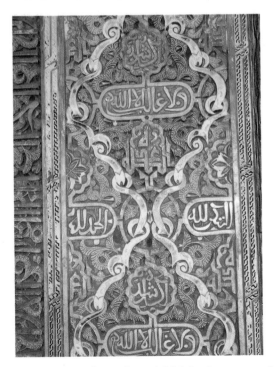

Figure 1.5 *Undressing room (*bayt al-masla<u>kh</u>)*, baths, stucco decoration, detail, Palace of Comares, Alhambra (photograph: Olga Bush)*

undressing and repose or apodyterium); *bayt al-bārid* (cold room); *bayt al-wasṭānī* (tepid room); and *bayt al-sajūn* (hot room). The *bayt al-maslakh* is known today as Sala de las Camas; it owes its post-Nasrid name to an elevated platform built on its west and east side, where a bather could recline and rest (Spanish 'camas' would be English 'beds'). This is the central room of the baths thanks to its function of repose and socialisation, and it would have been distinguished by lavish decoration.

More than anything else, in its current state, this precinct attests to the efforts made in the nineteenth century to understand and restore the chromatic scheme of its decoration. Relatively little is known about the baths' original appearance or the alterations made there prior to the nineteenth century.[23] The earliest documentary reference to the Sala de las Camas dates to 1832, when Luis Muriel, a local artisan, was hired to repaint the plaster work in anticipation of the visit to the Alhambra by members of the Spanish royal family, Prince Francisco de Paula and Princess Luisa Carlota.[24] It is an exceptional case. All other documents indicate that the conservation work in the Alhambra prior to 1836 consisted solely of consolidation and repairs to structures and of affixing fallen fragments of original decoration.[25]

The year 1837 initiated a new era in conservation practices in the Alhambra, when José Contreras Osorio started working on the site in the capacity of contractor. Having been introduced to the process of reproducing plasterwork with the aid of a casting technique, he began the fabrication of new panels that year.[26] Contreras became the architect in charge of the Alhambra three years later, a post he held until 1847. It was at an as yet undetermined date between 1837 and 1847 that he demolished the central cupola and much of the severely deteriorated decoration of the walls of the Sala de las Camas.[27]

José Contreras Osorio was succeeded by his son, Rafael Contreras Muñoz, who was appointed by the queen as 'restaurador-adornista' ('restorer-embellisher') of the Alhambra in 1847, remaining in the post until his death in 1888.[28] Rafael Contreras continued his father's work on the Sala de las Camas. He adhered to the restoration criteria of the era, continuing his father's practices of demolishing deteriorated architectural elements and reconstructing them according to what many scholars now consider the exotic fantasies of the Orientalist aesthetic.[29] Contreras' addition of the glazed-tile domes over the projecting pavilions in the Court of the Lions presents one of the most egregious examples of the Orientalising tendencies in his work (Figure 1.6).[30]

There are important reasons for suspicion and scepticism concerning the practices of Contreras, father and son, in the Sala de las Camas, both in the models used for new panels in plaster and wood for this room, and the vivid colours employed abundantly on all materials of the interior. For in addition to the stylistic prejudices of the era and their ideological underpinnings, the practices of the

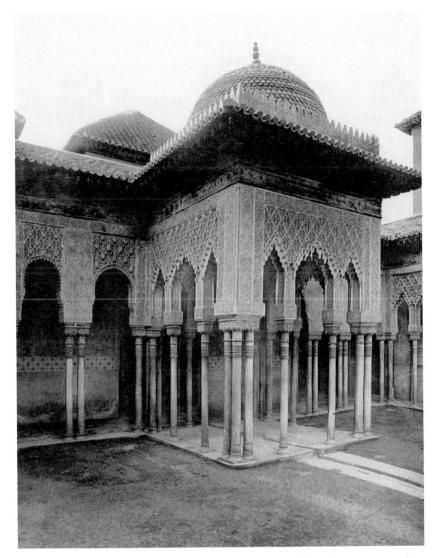

Figure 1.6 *Court of the Lions, Palace of the Lions, Alhambra. Historical photograph from 1899 showing Rafael Contreras' addition of domes over the pavilions (SZ Photograph/Scherl/Bridgeman Images)*

Contreras were intimately connected to their commercial interests. The Contreras had a monopoly on the production of plaster casts of architectural elements in the Alhambra, which they sold in highly coloured models in keeping with contemporary tastes, contributing greatly to the international success of the Alhambra as a focal point of European and American Orientalism.[31] The restoration, if that is what it should be called, of a precinct in situ that supported the authenticity of their reproductions would have been to their financial benefit. The point cannot be overlooked.

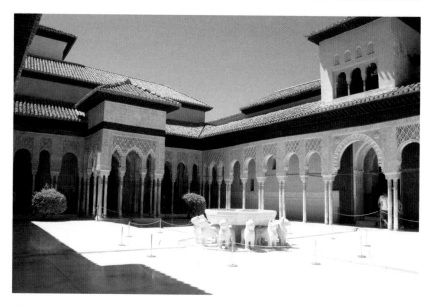

Figure 1.7 *Court of the Lions, Palace of the Lions, Alhambra (photograph: Olga Bush)*

Yet if Rafael Contreras may have erred in the indiscriminate application of colour, especially in the baths, perhaps along the bias of commercial considerations, José Contreras made a crucial blunder in the opposite direction in his restoration work on the Court of the Lions in the Palace of the Lions (Figure 1.7).[32] He mistook the oxidised gold leaf on the capitals of the columns for a residue of accumulated dirt,[33] despite the fact that traces of original pigments were preserved on the marble capitals elsewhere in the Alhambra, for example, in what is known today as the Hall of the Kings, also in the Palace of the Lions, as well as in the council chamber or *mishwār*, the precinct that adjoins the Palace of Comares on its west side (Figure 1.8). As a result, José Contreras eliminated the vestiges of polychromy on 129 of the 130 capitals in the Court of the Lions. The Orientalism of the son, then, like Romanticism more generally, may be regarded as an overreaction against a certain austere neo-Classicism, embodied belatedly in the work of the father.

Rafael Contreras' intervention in the baths began in 1848 and lasted for two decades. At its completion, the plasterwork decoration in the entire room was newly fabricated, a restoration made possible by the casting technique that he had learned from his father. Painted in vibrant colours of red, blue and gold, the interior resembled what one scholar called a 'hall of unexpected marvels'.[34] Since it has been determined that none of the original plaster panels remain visible in situ in the Sala de las Camas,[35] it is impossible to say whether José Contreras and later Rafael Contreras used original panels of this interior, now lost, as models for making their

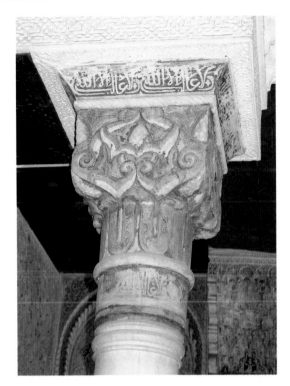

Figure 1.8 *Capital,* mi<u>sh</u>wār, *Alhambra (photograph: Olga Bush)*

reproductions, or whether the reproductions were based on panels in other precincts.[36]

Although it is possible that, in painting the architectural decoration of this interior, Rafael Contreras was guided by the vestiges of colour preserved better in other precincts in the Alhambra,[37] scholars are inclined to suggest a different source. They propose that Contreras followed the work of Owen Jones (1809–74), an influential nineteenth-century English-born Welsh architect, designer and design theorist. Jones visited and studied the Alhambra in 1834 and again in 1837, which is to say, prior to and then, at the latest, contemporary with the earliest interventions of the elder Contreras, and more than two decades before the son began his repainting of the interior of the Sala de las Camas in 1864.[38] Subsequently, Jones produced colour plates of the decoration in the Alhambra in a monograph on the palatial city, co-authored with Jules Goury and published in 1842–5 (Figure 1.9).[39]

The scepticism of scholars with respect to Rafael Contreras' restoration of the Sala de las Camas reflects back on Jones as his source. Jones' careful and accurate scientific approach to the study of the architecture and ornament is generally acknowledged, but his reconstruction of original pigments has been questioned. The discrepancy

Figure 1.9 *Decorative plaster panel on the north, east and west walls between the* qubbas, *Hall of Comares, Alhambra. Owen Jones, chromolithograph (courtesy of Victoria and Albert Museum, London)*

is explained by proposing that the colour plates were not executed as accurate reproductions of the colours that Jones found, at least in traces, on site, but rather that they were intended to serve as illustrations of Jones' own postulations on colour theory.[40]

I repeat that scholars agree that Jones' drawings of plans, elevations and decoration reflect a scientific approach to the study of the Alhambra. He explained the construction of *muqarnas* vaults diagrammatically.[41] Architectural elements and surfaces were meticulously measured and drawn in proportion. Accurate and detailed renditions of the ornamentation were recorded in pencil and watercolour drawings and with paper tracings on site. Above all, it was the drawings and observations made in situ that served as the basis for both the plaster casts that he made in London as early as 1838[42] and the colour plates in Jones' publication, produced with the aid of his pioneering method of chromolithography.[43]

To accept Jones' diagrams and measurements, while dismissing his renderings of colour, is, first of all, a reflection of the priority given to geometry in modern scholarship on the Alhambra. Furthermore, it is to reinforce a contemporary association of colourless architectural surfaces with monumentality and a rejection of vivid colour as

exotic, which is to say, lacking in a proper seriousness. It is then both a neo-neo-Classicism and a neo-Orientalism at once.

Jones' rigorous scientific analysis not only of the design principles, but also of the relationship between the architecture and decoration of the Alhambra, reflects a more general intellectual approach to the arts at the time. This new direction was aimed at giving credence to the aesthetic theories of the arts, including architecture, and elevating their status to that of sciences, such as biology and physics.[44] During his first trip to the Alhambra in 1834, Jones studied the architectural decoration, in which, according to the artist, original pigments were visible despite the accumulated accretion of dirt and calcium deposits. These studies allowed him to propose a hypothesis for the reconstruction of colour schemes in the Alhambra. A decade or so later, in a chapter on the ornament of the Alhambra, in his monograph titled *The Grammar of Ornament* (1856), Jones recorded and analysed the decoration, stating that the plasterwork in the Alhambra was painted in '*red, blue and yellow (gold)*'.[45] In *The Grammar of Ornament*, illustrated with numerous colour plates, the artist avows the authenticity of the colours in his plates, asserting:

> Although the ornaments which are found in the Alhambra, and in the *Court of the Lions* especially, are at the present day covered with several thin coats of the whitewash, which has at various periods been applied to them, we may be said to have authority for the whole of the colouring of our reproduction; for not only may the colours be seen in the interstices of the ornaments in many places by scaling off the whitewash, but the colouring in the Alhambra was carried out on so perfect a system, that any one who will make this a study can, with almost absolute certainty, on being shown for the first time a piece of Moorish ornament in white, define at once the manner in which it was coloured.[46]

Jones claimed to have understood the principles that governed the polychromy of architectural forms, and especially of the relationship between the primary colours – blue, red and gold (for yellow). According to him, the surfaces were carefully chosen not only to showcase each colour, but also so that each colour would 'add most to the general effect'. He concludes that '*On moulded surfaces they placed red, the strongest colour of the three, in the depths*, where it might be softened by shadow, never on the surface; *blue in the shade*, and *gold on all surfaces exposed to light*: for it is evident that by this arrangement alone could their true value be obtained.'[47]

In addition to his observations on the original decoration, Jones commented that if in the original plasterwork the particles of blue pigment were visible 'everywhere in the crevices', in the restorations 'made by the Catholic kings, the grounds of the ornaments were

repainted both green and purple'.[48] Speaking of repainted plaster-
work, he is referring, most likely, to the aforementioned work by
Luis Muriel, in 1832. Even these brief remarks suffice to indicate that
Jones was careful to distinguish between the original polychromy
and the colours employed in the restorations, observations con-
firmed by recent technical analyses. Moreover, he provides early sci-
entific observation and experimentation (scaling off the whitewash)
that determined that the white surfaces of the nineteenth-century
Alhambra, still predominant today, far from being the original state
of the decoration, were the result of restoration practices. Current
conservation once again confirms that white paint was applied to the
deteriorated plaster surfaces.[49]

There is further technical evidence for the view of the Alhambra
as the site of intense, even overwhelming, colour. Recent studies
of the decoration of the Hall of the Kings, for instance, both in situ
and in the laboratory, have identified the use of lapis lazuli and
cinnabar for blue and red pigments, respectively,[50] and traces of
original pigments remain visible on other surfaces in situ and on
architectural fragments preserved in museums (Figure 1.10).[51] Thus,
in looking at the reconstruction of polychromy in the *Qalahurra* of
Yūsuf I, made by William Harvey in his drawing (Figure 1.11) dated
between 1913 and 1915,[52] Fernández-Puertas finds no Orientalist
fantasy. Instead, he declared that Harvey's colour drawing is 'the
best colour section' and the most accurate that was made of the

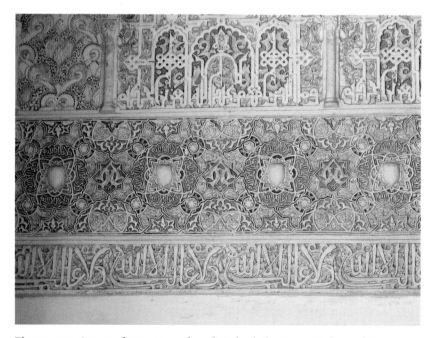

Figure 1.10 *Stucco decoration, detail, Sala de la Barca, Palace of Comares,
Alhambra (photograph: Olga Bush)*

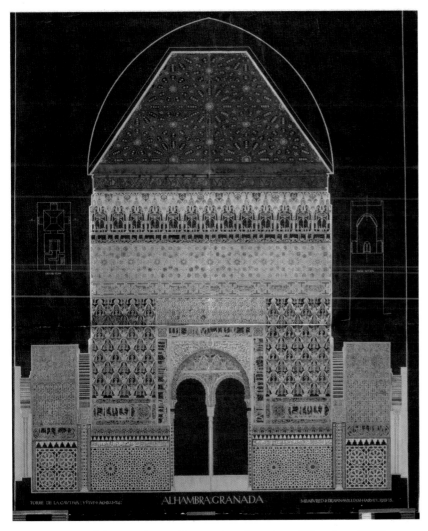

Figure 1.11 Qalahurra *of Yūsuf I, interior elevation, Alhambra. William Harvey, 'Tower of the Captive', drawing, pen and ink, india ink, watercolor and pencil (photograph: courtesy of the Victoria and Albert Museum, No. E. 1274–1963)*

interior of this tower-palace,[53] despite the fact that he thought that the gold leaf used in the plasterwork decoration of the *Qalahurra* of Yūsuf I would not have been as abundant as was depicted in the drawings of Harvey and Jones.[54] What is also clear in Harvey's drawing – as well as in those of Jones – is that the colour scheme in his rendering is consistent with the use of colour throughout the various precincts of the Alhambra with regard to the fore- and background elements.

Rafael Contreras may indeed have been under-informed and over-zealous in his repainting of the Sala de las Camas in the spirit of

Romanticism,[55] especially his use of ultramarine or Prussian blue – the nineteenth-century substitutes for the original blue derived from lapis lazuli – and his extensive gilding. Nevertheless, rather than cast his errors backward to Jones, one needs to read Jones with care as a guide to the Nasrid Alhambra. However shocking, even Rafael Contreras' multicolour extravaganza in the Sala de las Camas offers a closer approximation, not simply to Jones' plates, but to the original aesthetic experience than, say, the white lights illuminating the colourless palaces and patios of today's tourist visit to the Alhambra-by-night. To reconstruct the fourteenth-century beholder's aesthetic experience, then, one must re-imagine great surfaces of rich and varied colours in virtually every facet of the architectural decoration: cupolas, flat ceilings and doors made of wood; glass vaults and the windows of upper storeys; plaster panels covering the expanse of walls and plaster *muqarnas* vaults; marble and plaster capitals; and tile mosaic in the dadoes and on the floors.

Whereas José Contreras' approach to the restoration of the Court of the Lions must now be rejected as a tendentious reproduction of the blanched austerity that is associated in much of the modern period with Western Classicism, Rafael Contreras' restoration of the baths has been largely repudiated as an example of just the opposite tendency, namely, the flagrant Orientalism in vogue in his times. Yet both the repudiated restoration of the baths and Jones' colour reproductions might be much closer to rendering an overall impression of the fourteenth-century Alhambra: a site of intense, even overwhelming, colour, in striking contrast to the Alhambra of today. Even if today's visitor encounters many surfaces throughout the buildings that were repainted in the post-Nasrid period, the technical findings give insight into the bases of original pigment production and application. One may speak with confidence in extending the view of the traditional colour scheme of the Alhambra to spaces where the loss of original pigments is significant, like the interior of the *Qalahurra* of Yūsuf I, a precinct to be discussed in detail in Chapter 3 (see the accompanying figures).

4

One finds testimony to the role of colour in the aesthetic experience of the Alhambra in Nasrid times in the most evident and most overlooked documentary source: the poetic inscriptions on the walls of the palaces. As the Nasrid court poet and vizier Ibn al-Jayyāb declared in verses inscribed in the interior of the *Qalahurra* of Yūsuf I: 'Wherever you look, there are different designs / all of them gilded (*mudhahhab*) and polychromed (*muzakhraf*)' (*mahmā laḥaẓta raʾayta nuqushan wushshiyat/ʾanwāʿuhu fa-mudhahhabun wa-muzakhrafu*).[56] I will devote much attention in the following chapters to the means by which poetic epigraphy speaks to the

Nasrid beholder and for the aesthetic of the Alhambra through the rich and varied resources of poetic figures. Here, I read the verses in the simplest way as a straightforward mimetic description, that is, in classical terms, as an imitation of that which is described. As Jones has helped one to see, Ibn al-Jayyāb's verses were hardly exaggerated, and would have been apt not only to the *Qalahurra* of Yūsuf I in which they are found, but to the extensively polychromed and gilded Alhambra as a whole. Beyond the overwhelming impression of glittering colour in the Nasrid Alhambra, which is to say, beyond the evidence of mere abundance, what Jones teaches, above all, is to think of colour in the Alhambra not as a random distribution of vivid pigments, but as a carefully designed arrangement – parallel to the findings of research on geometric ratios and patterns.

Before proceeding to the theoretical framework of a more integrated aesthetic and its import for the use of colour in the Alhambra, it is well to provide some further details on the materiality of the polychromy. Ibn al-Jayyāb's poetic description has been corroborated by recent technical studies of the plasterwork, in which the pigments and their sources were identified with the aid of Raman and optical microscopy,[57] X-ray diffraction, archaeometry and chemical analysis.[58] These findings may be reinforced, in turn, by further literary evidence.

Red pigment was obtained from one of two main sources: cinnabar, a natural compound mined in Spain, or vermilion, an artificially produced mercuric sulphide.[59] Analysis has also shown that red pigment obtained from grains of hematite (or oxidised iron) was used in the wall paintings in the Alhambra and in other Nasrid buildings.[60] Blue pigment came from lazurite, which forms the bulk of the gemstone lapis lazuli, and which, when ground coarsely and mixed with hematite, produces an intense blue hue.[61] The source of green pigment in both light and dark hues in the Alhambra was malachite.[62] This last finding correlates with conclusions reached in the examination of an earlier Nasrid palace in Granada, where a mixture of ground malachite and copper was used to produce green pigment for plasterwork decoration.[63] As Jones noted in his writing on the Alhambra, red and blue pigments were consistently employed for painting the background elements in the plasterwork decoration. Gold leaf was applied to foreground forms, epigraphy among them; and black, turquoise and green were used for details. The tradition of using these very colours in all their intensity in the foreground and background elements continues even now in the plasterwork decoration that adorns royal palaces, wealthy residencies and madrasas in Morocco.[64]

The use of these primary colours, as seen in the interiors restored by Contreras and others, is confirmed in a contemporary historical source. A chronicle written in 764/1362 by Ibn al-Khaṭīb, recorded that the epigraphy on the walls of the Alhambra was painted with gold, and that lapis lazuli (*lāzaward*) was used to paint the space between the letters.[65] It is of note that the vibrant polychromy in

the decoration of the Alhambra was by no means unique. Cinnabar, lapis lazuli and gilding were used in the embellishment of architecture and sculpture far and wide already in the twelfth century: from the wooden and stone sculpture of the early Gothic cathedrals to the marble decoration in the palace at Ghazna, completed under the patronage of Mas'ūd III (r. 453– 509/1099–1115).[66] As the examination of European medieval illuminated manuscripts demonstrates, the colour pigments for a palette of red, blue, green, yellow, black and white were derived from the same organic and inorganic materials as was employed on the surfaces of stone, plaster and wood, and the pigment recipes were transmitted between scriptoria.[67] These examples suggest that polychromy played a significant role in the built environment of the medieval world in both east and west, as well as giving a first indication of the importance of the relationship of colour to form in the overall decorative scheme of the Alhambra.

Broadening the discussion to other materials, I note that the wooden surfaces in the Alhambra were also originally embellished with vibrant colours. Technical analysis has produced findings similar to those on the plasterwork with regard to the sources of pigments. Several studies have identified some of the material sources of the colours for the background elements: lapis lazuli for blue pigment; mercury sulphite for vermilion red; a mixture of copper, salt and vinegar for dark green; and orpiment for yellow.[68] Details, like those executed in carved plaster, were rendered in greenish blue, black and white pigments, identified as lazurite, vegetal-based charcoal and lead carbonate, respectively. The analysis of pigments in these studies has confirmed some of the earlier data on the colours and pigments employed in Nasrid carpentry. For instance, on the basis of the original inscriptions found in situ, it has been possible to reconstruct the original polychromy of the wooden ceiling in the richly embellished reception hall, known today as the Hall of Comares in the Palace of Comares (Figures 1.12 and 1.13).[69] It is an *artesonado* ceiling – a wooden strap-work cupola – assembled from thousands of elements cut in both regular and irregular rectilinear shapes and fitted together with a tongue-in-groove technique into a complex geometric composition of seven rows of radiating stars. Inscriptions were discovered on the reverse of several wooden elements of the ceiling; they include the term used for each colour, as well as the number of elements to be executed in each colour. Even though the interpretation of specific hues remains uncertain, it appears that the colour scheme of the composition consisted of three different red pigments, a light and a dark green pigment, white pigment, and what appears to be an off-white or a yellowish-white pigment. In addition, gold leaf was used in the rendering of the foreground decorative elements, such as the foliate motifs.[70]

While plasterwork and wood are ubiquitous in the palatial complex, the ceiling of the belvedere known as the Mirador de Lindaraja

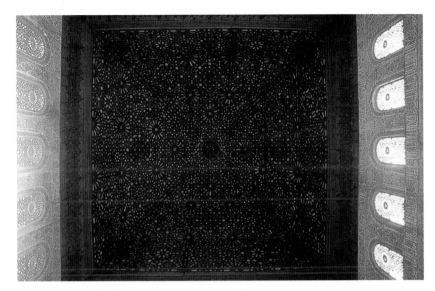

Figure 1.12 Artesonado *ceiling, Hall of Comares, Palace of Comares, Alhambra (photograph: Olga Bush)*

Figure 1.13 Artesonado *ceiling, Hall of Comares, Palace of Comares, Alhambra, reconstruction of colour scheme after Darío Cabanelas Rodríguez (photograph: Archivo de la Alhambra)*

Figure 1.14 *Glass ceiling, Mirador de Lindaraja, Alhambra (photograph:*
Olga Bush)

(Figure 1.14) in the Palace of the Lions is the only precinct in the
Alhambra in which some of the original coloured glass remains.[71]
The number of colours in the glass ceiling is limited to four – red,
blue, yellow and green – corresponding to the main colours employed
in the polychromed plasterwork and wood. Not only is the colour
scheme much the same, but also the sources of the pigments were
probably similar for glass as for the other media.[72] A recently dis-
covered treatise written by the acclaimed chemist Jābir ibn Ḥayyān
(c. 102–99/ 721–815), and thought to have been lost, contains many
recipes for colouring glass, and so indicates that already during the
early ʿAbbasid period cinnabar was used for red and copper for green,
and yellow was produced from arsenic and sulphur.[73] Because the
lower temperature resistance of lapis lazuli renders it unsuitable for
colouring glass, cobalt ore was used to produce a similar blue pigment
in this medium.[74] Indeed, the analysis of a group of lustre ceramic frag-
ments found in the excavations in the Alhambra and which belonged
to palatine production during the fourteenth and fifteenth centuries
determined that the ceramic composition of their bodies was typical
of the Betica region of what is now southern Spain, and that they were
painted with a blue pigment that was derived from cobalt, possibly
mined in the Iberian Peninsula.[75] Jābir ibn Ḥayyān's treatise became
a source for similar works composed in Arabic and Latin during the
next four centuries.[76] Even more striking is that his understanding of

the relationship between pigments and the temperature of chemical reactions allowed him to propose a method for colouring gemstones that was patented in the United States only in 2006.[77]

Acknowledgement of historical precedents, as in the case of Jābir ibn Ḥayyān, is belied in current research by the presupposition that Nasrid craftsmen were primarily guided by trial-and-error methods. The production of lustreware ceramics during the Nasrid period may serve as an example. It appears that the pigments used for colouring glass were also employed in the glazes of tile mosaics, since the polymath al-Bīrūnī (362–441/973–1050), among other writers, noted that 'Glass, enamel, and ceramics are close to each other and they have common techniques in pigments and methods of colouring.'[78] Cobalt, for example, was employed in ceramic production in the Alhambra for both tiles and lustreware.[79] Today's chemists consider lustreware to be 'one of the major technological advances of ceramic production until the twentieth century', recognising Andalusī ceramists for their knowledge of the optical properties of silver and copper to produce metallic reflective surfaces in formulating lustreware glazes, and for their skills in the manipulation of firing components and conditions.[80]

In the twenty-first century, chemists wonder how it was possible for medieval ceramists to apply to the ceramic surface a very thin layer of silver and copper nanocrystals that range from 5–7 to 50 nm in size – a process that is executed today only with the aid of optoelectronic equipment. Their admiration, however, is expressed in these peculiar terms: 'Despite the complete lack of knowledge of chemistry during medieval times (chemistry did not come of age until the 17th century), medieval potters were able to produce thin nanostructured silver and copper metal crystals, with a remarkable degree of success and in very different conditions to those in modern cleanroom laboratories.'[81] More remarkable than the degree of success is the telling parenthetical aside. These researchers propose that what constitutes chemistry, or scientific knowledge more generally, is necessarily Western. That would leave the consistent production of 'a very thin layer of silver and copper nanocrystals' by Muslim craftsmen akin to something like good luck instead of scientific knowledge.

This scepticism is shared by mathematicians in the field of fractal geometry in their research into the geometric decoration of the Alhambra. Having examined the geometric constructions of the dadoes of ceramic tile mosaics, they have found that all of the seventeen possible two-dimensional symmetry groups discovered by Plane Crystallographic Group Theory are employed in the tile mosaics of one or another precinct in the Alhambra.[82] But inasmuch as fractal geometry was unknown to the medieval world and the pertinent developments in crystallography awaited the discovery of X-rays, the same scholars have proposed that the builders and artisans of the

Alhambra were able 'to carry out [the designs] empirically', tanta-mount to concluding that the decoration was a random distribution of trial and error.[83] In the absence of archival documents attesting to knowledge of mathematical principles, contemporary scholars claim no more than 'intuitive knowledge' as a basis for design.[84]

The implicit deprecation of the artistry of the Alhambra is a latter-day Orientalism more extravagant than Rafael Contreras' most extreme interventions. Without explicit documentation that the texts of foundational scientific and mathematical knowledge were in the hands of Nasrid artisans, art historians – no less than chem-ists and mathematicians – cannot *deduce* design principles. But the evidence of artistic achievement is in plain view, and an inductive approach points to the conclusion that the artisans knew what they were doing – that is, they had the requisite scientific and mathemati-cal knowledge to produce consistent artistic results. Their artistry was not haphazard, but rather the result of systematic execution, from which one cannot but conclude, inductively, that it was based on systematic design and systematic production.

That conclusion is reinforced by art history, for the achievements of the Alhambra are not isolated results, but rather form part of the artis-tic traditions of al-Andalus. One finds models for the Nasrids' use of colour already during the Umayyad period in the multi-coloured glass mosaics of the mihrab in the Great Mosque of Córdoba, along with its domes, polychromed wooden ceiling, red and white voussoirs, and marble columns of many colours. During the *taifa* period of autono-mous kingdoms in al-Andalus, polychromed carved plasterwork and red, blue and aquamarine glass were used in the embellishment of the palace of al-Ma'mūn (r. 433–67/1043–75) in Toledo and in a pavilion of coloured glass that he built there as well[85]; coloured glass was also used in the Aljafería palace of Ibn Hūd (r. 473–7/1081–5) in Saragossa.[86] It is not only the technical skills of the craftsmen, but also the aesthetic sensibilities of the beholders of the Nasrid Alhambra that were well grounded in a long artistic legacy.

5

The research of mathematicians on the symmetry groups of the ceramic tile mosaics is typical in another sense: the predilection in contemporary research for isolating geometry as the fundamental mode of design in the Alhambra. A related finding opens up a differ-ent perspective. When geometric patterns were examined through the lens of symmetry-based colouring schemes, scholars concluded that Nasrid artisans had understood and used the principles of what crystallographers term dichroic and polychromatic patterns.[87] The dichroic feature is the property of a surface to reflect light of one colour and to transmit light of other colours. The medieval craftsmen's understanding would have drawn upon fundamental

principles of reflection and refraction that had first been formulated accurately by Ibn al-Hay<u>th</u>am in his ground-breaking seven-volume treatise on optics and visual perception, the *Kitāb al-manāẓir* (*Book of Optics*).[88] The inseparable relation of colour and geometry reflects an understanding of the principles of visual perception as it was conceived by Muslim scientists in the medieval period, and it is to the work of Ibn al-Hay<u>th</u>am that I now turn for an articulation of a theoretical frame for the aesthetics of the Alhambra.

Ibn al-Hay<u>th</u>am was born in present-day Iraq and lived much of his life in Fatimid Cairo, a polymath and experimental scientist with special interests in the fields of geometry, optics, philosophy and aesthetics. The *Kitāb al-manāẓir* was neither his only, nor his most influential work on optics circulating among mathematicians and philosophers of the Muslim world in the eleventh and twelfth centuries. Even so, it has been suggested that some parts of the treatise were known already in the Iberian Peninsula in the late eleventh century, particularly at the court of Ibn Hūd, the *taifa* ruler of Saragossa and himself a mathematician of some repute.[89] It is likely that Ibn al-Hay<u>th</u>am's works on optics were known even earlier at the court of another *taifa* ruler, al-Ma'mūn of Toledo. Ṣā'id al-Andalusī (419–62/1029–70), a philosopher, historian of science and mathematician at al-Ma'mūn's court, records the names of famous Muslim scientists and their main contributions in his *Book of the Categories of Nations*, which he wrote in 460/1068 in Toledo. He mentions Ibn al-Hay<u>th</u>am as the author of a treatise on concave mirrors, that is, another work on optics.[90] Ṣā'id al-Andalusī's book gives plentiful evidence of an extensive exchange of scientific knowledge between al-Andalus and the Muslim East through the travels and studies of Andalusī scholars. 'Abd al-Raḥmān ibn 'Isa, the *qāḍī* of Toledo, for example, met Ibn al-Hay<u>th</u>am in Egypt in 429/1038.[91] It is likely that the *qāḍī* was not only exposed to the scientist's theories, but also may even have brought back works by Ibn al-Hay<u>th</u>am when returning to Toledo.

Ibn al-Hay<u>th</u>am's *Book of Optics* began to circulate anew in a seventh/thirteenth-century translation into Latin, probably undertaken in the Iberian Peninsula and known today under the titles *Perspectiva* and *De aspectibus*.[92] Among the seventeen extant Latin manuscripts, there is one dated 1269.[93] It is possible then to suggest that the *Book of Optics* was translated in Toledo in the scriptorium of the king of Castile and León, Alfonso X (r. 1252–84). Two other works of Ibn al-Hay<u>th</u>am – *Configuration of the Universe* and *Cosmography* – are definitely known to have been translated there.[94]

The translation of the *Book of Optics* had a profound impact on scientific writing in medieval Europe in the 1260s and 1270s, exemplified in the works of Roger Bacon (*c.* 1214–92), John Pecham (*c.* 1235–92) and Witelo (*c.* 1235–75?), thereby further disseminating Ibn al-Hay<u>th</u>am's concepts.[95] In fact, Ibn al-Hay<u>th</u>am's theory

attained such recognition that it was incorporated into the curriculum of medieval European universities.[96] The analysis of medieval painting, especially manuscript illumination in European scriptoria, suggests that artists were aware of new concepts of visual perception in their treatment of aerial perspective and in the modelling of bodies and draperies.[97] During the Renaissance, artists and scientists alike became familiar with Ibn al-Haytham's precepts through the fourteenth-century translation of the *Book of Optics* into Italian[98]; and in the seventeenth century it laid the foundation for Johannes Kepler's (1571–1630) modern theory of vision.[99]

In the Arabic-speaking world, Ibn al-Haytham's treatise also regained prominence at the end of the thirteenth century, when Kamāl al-Dīn al-Farīsī (d. *c.*720/1318) wrote an extensive commentary on it titled *Tanqīḥ al-manāzir* (*Revision of the 'Optics'*).[100] The theoretical concepts presented in the *Book of Optics* were disseminated throughout the Islamic lands through numerous copies of al-Farīsī's *Tanqīḥ*. Taken together, the distinctive *maghribi* script used in some of the Arabic manuscripts of the *Book of Optics*,[101] and the possibility of an Iberian provenance for its earliest Latin translation, suggest that Ibn al-Haytham's theory of visual perception and its aesthetic corollaries circulated in the western Mediterranean in the realms of the Nasrids and the Marinids.

There is as yet no textual evidence to confirm that the architects and craftsmen at the workshops of the Nasrid court had direct knowledge of Ibn al-Haytham's *Book of Optics*. Indeed, virtually nothing is known of the Nasrid royal workshops and the instruction and professional formation of their members. However, writing in the context of the sixteenth- and seventeenth-century Ottoman narrative texts that include descriptions of architecture, Gülru Necipoğlu points out that: 'Regardless of the debate on whether or not theories of vision and aesthetics had an impact on artistic production, such texts offer precious glimpses into widespread sensibilities that framed visual hermeneutics. Despite their often underestimated value, Islamic narrative sources and poetry provide valuable insights into aesthetic values that informed the modalities of the gaze and attitudes toward the visual arts . . .'[102] Some of the principles of the 'widespread sensibilities' that informed the creation of the Alhambra may be articulated coherently by reference to Ibn al-Haytham's optics. In subsequent chapters I will return to the ways in which poetry, too, provides valuable insights into the aesthetic principles of the Nasrids.

Based on ocular anatomy, intromission theory, mathematics, physics and the interrelations of various cognitive processes, and supported by experimentation and testing with the aid of scientific instruments of his own invention, Ibn al-Haytham's theory of optics explained the psychological apparatus involved in seeing and comprehending a visual object.[103] Summarising, he outlined a

two-step process: the first involves the perception of an object by the optical system; the second involves the comprehension of the object through the agency of the psychological operations of cognition that engage *al-quwwa al-mumayyiza*, 'the faculty of judgement' or 'of discernment'.[104] This faculty includes such cognitive processes as 'recognition', 'comparison', 'discernment', 'judgement' and 'inference', which are supported by memory and imagination.[105] Ibn al-Haytham then enumerated the twenty-two visible properties of an object in relation to that two-step process. Light and colour are distinguished from all other properties as susceptible to being perceived through 'pure sensation'. The remaining properties, such as distance, shape and size, or contrasting pairs, such as similarity–dissimilarity and motion–rest, require the subsequent and supplementary intervention of 'judgemental perception', which employs various mental operations, such as contemplation, comparison, deduction and inference.

On the basis of this two-step process combining physiology and psychology in what he calls 'true perception', Ibn al-Haytham offered corollaries with a direct bearing on aesthetics. He postulated that the beauty of an object could be produced in several ways: by a single visible property; by the cumulative effect of several visible properties, each of them beautiful; and, finally, by a harmonious interrelationship of several visible properties that may lack beauty in themselves. He stated: 'Beauty is, therefore, produced by the particular properties, but its completion and perfection is due only to the proportionality and harmony that may obtain between the particular properties.'[106] Taking into account Ibn al-Haytham's training as a mathematician, his reference to 'proportionality of part in regard to shape, size, position' would seem to align beauty primarily with geometric design, and scholarship in Islamic art has indeed tended to assign geometry a leading role. It is worth recalling here that Fernández-Puertas' meticulous studies confirmed that a certain proportion, based on the relationship of the side of a square to its diagonal, governed all architectural and decorative designs in the Alhambra, furthering similar conclusions drawn much earlier by Owen Jones. Jones' formulations on the relationship between proportion and beauty are akin to Ibn al-Haytham's principles, when the former states that in 'every perfect work of Architecture a true proportion will be found to reign between all the members which compose it, so throughout the Decorative Arts every assemblage of forms should be arranged on certain definite proportions; the whole and each particular member should be a multiple of some simple unit'.[107] Jones goes on to say that 'Those proportions will be the most beautiful which it will be most difficult for the eye to detect.'[108]

But if Jones spoke of proportions in strictly geometrical terms, Ibn al-Haytham elaborated the principle by immediately adding: 'and *all the other properties required by proportionality*' (emphasis

added). This statement moves beyond elements conducive to linear measurement to include a broader understanding of *wazn* or commensurability. In this regard it is pertinent to recall that the notion of commensurability had been addressed by earlier Muslim texts on aesthetics and that in addition to the proportionality of shapes and sizes, the fourth/tenth-century treatise, the *Rasāʾl* (*Epistles*), by the Ikhwān al-Ṣafāʾ (Brethren of Purity) specifically mentioned the proportionality of colours needed to render a painted picture beautiful.[109] In contrast to the understanding of light and darkness and of black and white colours in spiritual terms, as expressed by the Ikhwān al-Ṣafāʾ, Ibn al-Haytham examined the phenomenon on a scientific basis, both theoretical and experimental.[110] With regard to the aesthetics of colour, Ibn al-Haytham asserted: 'bright and pure colours and designs are more beautiful when regularly and uniformly ordered than when they have no regular order'.[111] This dictum allows a process of discernment within pure sensation – colours may be more or less pure, for instance – and hence the possibility of perceiving beauty in the first step of the act of physical sensation alone. The single property of colour may be beautiful in its purity, and the cumulative effect of the visible properties of colour and light, combined as luminosity or value, might also be perceived as beautiful. Nevertheless, the completion and perfection of beauty, with respect to colour, will not be achieved through pure sensation in itself, but rather will engage the secondary processes of discernment that are necessary to bring order to colour.

6

It is, then, neither the geometrical patterns in themselves, nor the richly coloured surface, but the coloured surface organised by geometrical design that is the aesthetic foundation of the architectural decoration of the Alhambra. This conclusion upholds the more general observation made by Grabar that geometry plays a crucial role not only in design, but also in determining the *mode* of perception.[112] Ibn al-Haytham's two-step optical process leads to a further postulate and with it to a shift in emphasis. Since the judgements involved in discerning geometric design are secondary to the perception of colour, according to Ibn al-Haytham, one may also study such visible properties as shape, size, position, order, and such pairs as separation and continuity or motion and rest, as dependent upon the use of colour. The Alhambra lends itself to corresponding case studies. Here these are limited to two analyses: one of the tile mosaic dadoes, with their surfaces of vibrant colours; the other in which the foregoing historical reconstruction permits a new understanding of an architectural space.

While concentrating on geometrical variations in the tile mosaic dadoes in the Alhambra, Fernández-Puertas remarked that the geometric designs were transformed through the use of colour,

which generated 'entirely new schemes to the eye, which often, and to a large extent, hide the basic geometric schemes'.[113] This crucial point is clearly borne out in the decoration. One may consider, for example, the dadoes of ceramic tile mosaic in the Sala de las Camas, the undressing room in the baths of the Palace of Comares (Figure 1.15).[114] As has been discussed, Contreras father and son replaced all of the plasterwork in this interior with newly manufactured plaster panels. They chose a different approach to the treatment of the deteriorated ceramic tile mosaics. It has been determined in a recent study that here the Contreras employed three groups of ceramic tile mosaics: original elements that belonged to this interior; original elements that came from elsewhere in the palaces; and new tiles, made specifically for the Alhambra in a ceramic workshop in Granada.[115] (It should be noted that not only Torres Balbás, but also conservators working in the Alhambra in the twenty-first century continue the practice of employing original elements of ceramic tile mosaic from the storage on the site).[116] Despite the Contreras' use of gypsum mortar for affixing ceramic tiles to the walls – a material that contributed greatly to the deterioration of the dadoes in subsequent decades – it has been argued that the Contreras followed the original design in their work.[117]

The panel of dadoes under consideration includes a main geometric element, which, to the modern eye, might be termed 'propeller'. It is composed of horizontal rows of alternating black and green 'propellers', anchored by a row of identical elements in yellow ochre. This ochre row serves as an axis of symmetry in the composition.

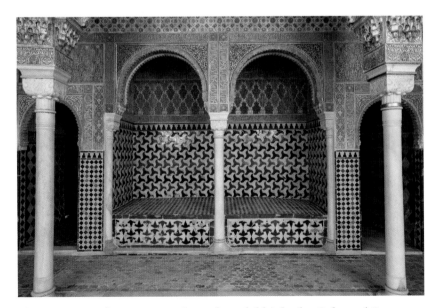

Figure 1.15 *Undressing room (*bayt al-masla<u>kh</u>*), baths, Palace of Comares, Alhambra (photograph: Archivo de la Alhambra)*

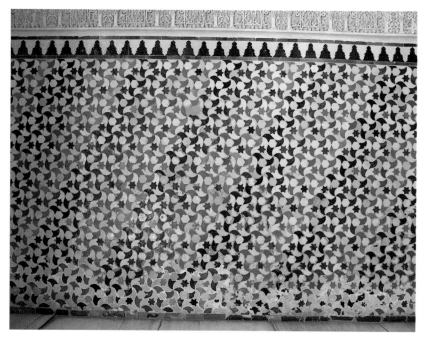

Figure 1.16 *Dadoes of ceramic tile mosaic, west wall, northwest niche, Patio of Comares, Palace of Comares, Alhambra (photograph: Olga Bush)*

Every second row in the panel consists of white 'propellers' perceived merely as a background for the other contrasting colours. While it is possible to discern a pattern of alternating white diagonals, the employment of darker colours, especially black, guides our 'reading' as a pattern of horizontal rows.[118]

This panel makes an interesting comparison with the dado of ceramic tile mosaic in the niche in the northwest corner of the Court of Comares (Figure 1.16), where 'propellers' are employed as well. According to Jones' chromolithograph of the niche in the Court of Comares, which he drew either in 1834 or 1837 and published in 1842, the design of the dado is similar, if not identical, to its appearance today.[119] Jones' drawing predates the Contreras' major interventions in the baths and thus allows the inference that the design of the dadoes with 'propellers' in both spaces is original.[120] In the panel in the niche of the Court of Comares one perceives a distinct design, despite the identical geometric composition. Here the rows of white propellers may be perceived horizontally, but the four colours – black, green, blue and yellow ochre – predominate over the white grid so that the panel appears as a more complex diagonal composition. Since the beholder perceives the pure sensation of colour differing from row to row before registering the similarity in the geometric shape of the 'propellers', the observer's eye races along the rows of colour, recognising a repeated pattern.

Puerta Vílchez proposed that the design of this panel evokes water.[121] This suggestion implicitly links the dado to the effect of ripples stirred on the water by the wind on the surface of the reflecting pool in the same Court of Comares. Describing the tile mosaics elsewhere in the Alhambra in 764/1362, the poet Ibn al-Khaṭīb speaks of an 'undulating sea of tiles' (*māja baḥr al-zillīj*).[122] While one might suggest that the architectural decoration thereby 'captures' permanently an ephemeral perception, it may be argued instead that the use of colour deliberately destabilises a static geo-metric design, introducing a certain dynamism into the architecture.

When colour was manipulated further in the tile mosaics in the Court of Comares, yet another, perceptibly distinct, design emerged. The dadoes of the two lateral niches on the north side of this court-yard are identical except for one panel on the north wall in the niche in the northwest corner (Figures 1.17 and 1.18). In this panel, some of the 'propeller' elements are black, whereas they are executed in various colours in the corresponding places in the design discussed above. As Ibn al-Haytham observed, one differentiates between an object's colour and that of its surroundings[123]; in other words, distinctions in colour serve to mark 'the boundaries of the objects and of the intervals between the boundaries'.[124] The use of black in this panel, whether understood as a distinct colour or an interval between bounded colours, transforms the undulating rows into a

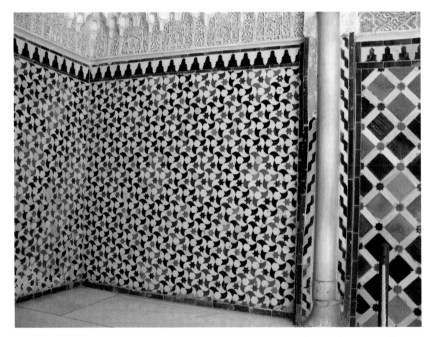

Figure 1.17 *Dadoes of ceramic tile mosaic, north wall, northwest niche, Patio of Comares, Palace of Comares, Alhambra (photograph: Olga Bush)*

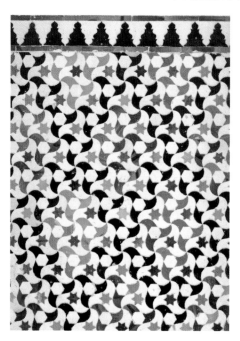

Figure 1.18 *Dadoes of ceramic tile mosaic, detail, north wall, northwest niche, Patio of Comares, Palace of Comares, Alhambra (photograph: Olga Bush)*

lattice grid. In one horizontal row, a cell filled with blue elements alternates with one filled with yellow elements, and in the second row all cells are filled with green elements. The question as to why the panel was executed with a distinct design must be reserved for a separate occasion.[125] What is already clear, however, is that these examples show that differences in colour, especially the use of black and white, lead to different 'readings' of otherwise similar or even identical geometric designs. Reinforcing both my conclusions of the comparative analysis of the dadoes and Ibn al-Haytham's postulations, Jones also observed that a change of colour in a design – whether applied to the background or foreground elements – would effect the perception of its forms and would appear to the eye as an altogether distinct decoration.[126]

With the exception of the dadoes of ceramic tile mosaics, the paucity of traces of pigments in the Alhambra presents an obstacle to the visual reconstruction of the polychromy on the architectural surfaces. Nevertheless, the recollection that the decoration was always polychromed and gilded makes it possible to consider the effect of colour on such surfaces as the *muqarnas* vault in the space known today as the Hall of the Abencerrajes in the Palace of the Lions. Typical of the Alhambra, the architectural surfaces of the Hall of the Abencerrajes are richly embellished in their entirety. In keeping with a well-established decorative scheme, which is also found in the Hall

of Two Sisters, the beholder's eye would have traversed the different areas of the vibrantly coloured elevation from the lower parts of the walls covered with dadoes of ceramic tile mosaic (the dadoes seen today are post-Nasrid), to the upper expanse of the walls veneered with panels of carved or moulded stucco above the dadoes, and, finally, to the immense cupola of the vault (Figures 1.19–1.21).[127] Again, as in

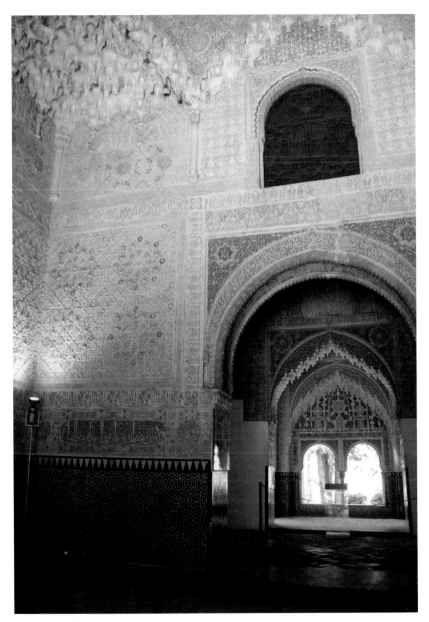

Figure 1.19 *Hall of Two Sisters, interior, Palace of the Lions, Alhambra (photograph: Olga Bush)*

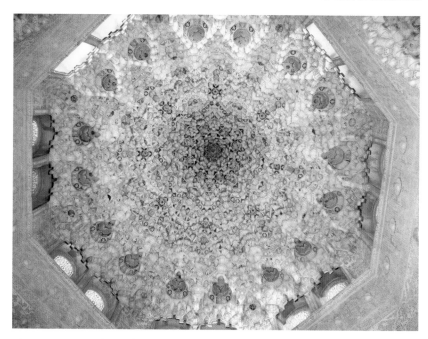

Figure 1.20 *Vault, Hall of Two Sisters, Palace of the Lions, Alhambra (photograph: Olga Bush)*

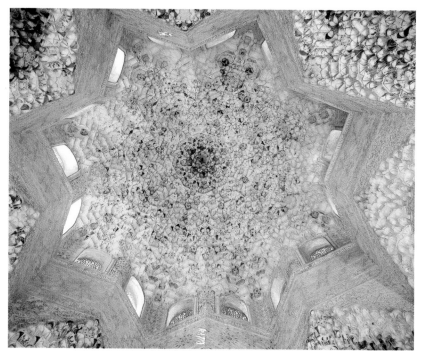

Figure 1.21 *Vault, Hall of the Abencerrajes, Palace of the Lions, Alhambra (photograph: Olga Bush)*

the Hall of Two Sisters, the vault that surmounts the Hall of the Abencerrajes' central space reflects a complex geometric design. The high star-shaped transition zone rests on squinches formed by multiple rows of *muqarnas* elements. In its upper register, the surface of the transition zone is pierced by sixteen windows, and the light that streams through their carved grills makes the vault above appear weightless, as if suspended over the hall below. The lantern vault is composed of multiple tiers of *muqarnas*, which appear to decrease in size along the vault's height, leading the observer's eye in a spiralling movement to the vault's apex.

Ibn al-Haytham's postulations about the effect of light and colour on the perception of three-dimensional constructions provide a valuable complement to the geometry of the vault. He explained that the volume, or solidity as he called it, of an object is perceived because the light it reflects renders the surfaces as bent – convex or concave – so that some parts appear lighter to the eye and others darker or shadowed.[128] The penetration of light through the windows at the vault's base and its movement along the vault over the course of the day would in itself create the effect of alternating lighter and darker areas, enabling the discernment of the *muqarnas* tiers. But the perception of the complex, highly textured surface of the vault would have been greatly enhanced by the application of red, blue and gold pigments, whose traces are visible today.[129] The alternation of colours in the vault also contributes to what Ibn al-Haytham discussed as the separation and contiguity of the constitutive parts of the object,[130] that is, as previously cited, 'the boundaries of the objects and of the intervals between the boundaries',[131] or in this case of individual *muqarnas* elements, setting the numerous and varied volumes in relief. He states: 'Sight therefore perceives the mutual positions of the parts of an object's surface with respect to [their] different directions and their separation or contiguity, and perceives their order, by perceiving the parts of the form produced in the eye for the whole object, and by perceiving the different colours or outlines that distinguish those parts, and as a result of the faculty of judgment's perception of the order of the form's parts.'[132] Following his postulations, it becomes evident that the colour contrast, or what neurobiologists term shape definition by colour-change contours,[133] would contribute to the perception of the multiple relationships between numerous *muqarnas* elements with regard to their size, position, shape and distance, which are the visual properties that Ibn al-Haytham deems essential in the cognition of the visual field. Jones' studies of the Alhambra's decoration bear out Ibn al-Haytham's optical theory in this regard, too, including the geometric construction of surfaces embellished with *muqarnas*. Jones concluded that the perception of various elements in a design, including the differentiation between them and the ground, is greatly affected by light, the use of colours, and the distance between the surface and a beholder.[134]

Knowledge of the geometric construction of arches and vaults based on *muqarnas* elements had been recorded in mathematical treatises and practical manuals for artisans in the Islamic world since the eleventh century.[135] In fact, it appears that in his work titled 'Treatise on Measuring the Paraboloids', now lost, Ibn al-Haytham discussed the mathematical calculations necessary for the construction of various parabolic vaults.[136] (A dome or cupola has a paraboloid profile, irrespective of its height and the circumference of its base.) A *muqarnas* vault has its own paraboloid profile formed by tiers of *muqarnas* elements. Made in plaster in the case of the Hall of the Abencerrajes, these *muqarnas* elements would be affixed to the inner shell of a vault with a paraboloid contour as well. As with his work on optics, therefore, Ibn al-Haytham's mathematical studies would have had immediate bearing upon architecture.

In the vault of the Hall of the Abencerrajes, the simultaneous manipulation of colour and geometry would lead the viewer to the discernment of the complex spatial construction of the vault, in which the tiers of *muqarnas* spiral in a cone-shaped vortex to its apex, producing a dizzying kinetic effect. The experience of the beholder at the time when the colours were intact would have been akin to that attested by Ibn Zamrak's verses inscribed in the Hall of Two Sisters in which he describes the *muqarnas* vault there as 'revolving heavenly spheres', whose beauty is both 'hidden and manifest'.[137] The link between the colours, geometry and the kinetic or *revolving* effect, couched in poetic imagery, was carefully calculated.[138] In the light of Ibn al-Haytham's theory, this verse can be understood to represent the interrelationship of the elements that are 'manifest' and perceived instantaneously, namely, the colours, and those that are 'hidden', that is, the intricate, multipart geometry of the vault's design. The poem is replete with the imagery of the celestial abode, and the metaphors in which the astral bodies are evoked speak time and again about their luminosity and movement.

Judging by the traces of the original polychromy of the cupola of the Hall of the Abencerrajes, it appears that the blue pigment was employed more extensively on the *muqarnas* than the red. It is possible – although it remains to be determined – that the blue pigment was applied in a much thicker layer than the red, as was the case, for instance, on the *muqarnas* in the interior of the so-called González-Pareja house, a building adjacent to the Partal Palace in the Alhambra. Here, the layer of blue pigment derived from azurite is 300 μm thick, while the layer of red pigment derived from white lead is only 25 μm thick.[139] In this case, calcium-magnesium carbonate, used as an extender, was added to the blue pigment in order to give it more volume,[140] a clear indication of the artisans' knowledge of the optical properties of the pigment and of the visual effect this colour might produce if manipulated further with additives.

A technical analysis of the polychromy in the vault of the Hall of the Abencerrajes has yet to be undertaken in order to establish whether the surface painted with blue pigment was equal to that painted with red or, alternatively, an extender was added to it to augment its volume and optical impact. Today, the vault appears to have predominantly blue *muqarnas*. The red pigment has deteriorated greatly and gives the appearance of a less saturated and somewhat darker hue, not dissimilar to that of the decoration of the walls elsewhere in the palaces. The decay of red pigment has been attributed to the instability of both lead oxide and mercury sulphide – the sources from which red pigment is derived – vis-à-vis humidity and light.[141] In its original state the vibrancy of colours in the *muqarnas* vault, as in all Nasrid plasterwork in the Alhambra, was enhanced by multiple applications of calcium sulphite to the surface of plasterwork. The craftsmen understood that the use of this calcium compound would not only render the surface harder and more durable, but that, owing to its translucency, it would also give the surface a satiny gloss[142] and enhance its optical efficacy.

Did the craftsmen know Ibn al-Haytham's *Book of Optics*, or were they trained by master-builders who had access to the text? This unanswerable historical question should not distract discussion from a better understanding of the Nasrid Alhambra. Such fine gradations in technique served a design purpose whose scientific basis and theoretical import were as much a part of the culture of Islamic architecture as the geometry of its designs. If Ibn al-Haytham's text itself was not available, some other much like it or based upon it, such as al-Farīsī's 'Revision of the "Optics"', or some indirect means of transmitting its concepts, must have been.

7

To understand further the visual effects that the polychromed *muqarnas* vault would have had on a beholder, one might consider Ibn al-Haytham's postulations within the framework of current investigations in neurophysiology and psychology of visual perception.[143] His articulation of the ways in which the light and colour impact on the visual perception of an object's form is of particular interest here. Although this is the subject of many scientific studies today, none of them make reference to Ibn al-Haytham's propositions and conclusions. A brief outline of these studies' findings puts into relief the significance of Ibn al-Haytham's theory of visual perception.

First and foremost, neuroscientists have been able to map out nine areas of the visual cortex of the brain responsible for the processing of visual and cognitive information that is received by the 125 million photoreceptor cells in the eye's optical system.[144] It has been generally accepted that a specific area of the brain is responsible for

the processing of a particular visual stimulus: for instance, while an object's colour is processed in one area, its form is processed in another one, and its movement in a third area.[145] A complex brain system performs the task of gathering information from its distinct areas and then processing it to make 'sense' of the different attributes of the visual field. In addition, the attributes or stimuli mentioned above are not perceived and processed simultaneously. For example, colour is perceived before form, and form is perceived before motion, although we are not conscious of the temporal sequence of these processes.[146] We are just as unaware of the processes involved in object recognition that take place in the area of the brain that deals with the mechanisms responsible for the retrieval of memories. In these processes, we can infer the identity of an object we perceive only when it is compared with 'images' stored in the brain's 'photographic archive'. It is important to note that Ibn al-Haytham recognised the existence of the link between a theory of vision and psychology when he underscored that 'vision is not achieved by pure sensation alone . . . it is accomplished only by means of discernment and *prior knowledge*', without which 'sight would achieve no vision whatever nor would there be perception of what the visible object is at the moment of seeing it'.[147]

Ibn al-Haytham's two-step process of the perception of light and colour, followed by the discernment of other visual properties, can be supplemented by recourse to the work of Margaret Livingstone. She neither refers to Ibn al-Haytham, nor to the Alhambra, drawing instead on current neuroscience and the psychology of visual perception, and concentrating on examples of modern paintings. Above all, she demonstrates how different aspects of visual information are processed through two distinct neurological systems.[148] One system, which neuroscientists call the 'What' system, is responsible for the perception of colour and recognition of objects; while the other, the 'Where' system, is responsible for the perception of space, motion, position, depth, figure–ground segregation and the overall composition or organisation of the visual field, in fact, the very same visible properties of objects evaluated and discussed by Ibn al-Haytham in his *Book of Optics*.

Livingstone's explanation of the workings of the 'What' and 'Where' systems leads to a further comment on the contribution of colour to the kinetic effects perceived when one contemplates the vault in the Hall of the Abencerrajes. The masking of the complex geometry of the construction might now best be understood as a disruption of the 'Where' system. A historical source offers a point of departure. In describing his visit to al-Ma'mūn's palace in Toledo, Ibn al-Khabīr reported that if one looked at the figures in the architectural decoration 'fixedly', the beholder was rewarded with the sensation that the forms 'moved or made signs to him'.[149] Recent excavations on the site of the palace uncovered fragments of

plasterwork decoration carved with figural motifs and painted with lapis lazuli and gold.[150] One may imagine alternating colours and an impression of undulation in the decoration at al-Ma'mūn's palace parallel to that described by Ibn al-Khaṭīb on the contemplation of the decoration in the Alhambra.

Livingstone provides theoretical grounds and experimental data to explain the kinetic effect produced by the disrupted 'Where' system in the visual experience of the viewer. Although the colour itself is perceived by the 'What' system, the 'Where' system, which is insensitive to colour, is responsible for the perception of a colour's luminosity or value. When the 'Where' system compares different colours on the basis of their luminosity, it can reach a conclusion with regard to one's perception of depth, three-dimensionality, composition and the motion of an object within the visual field.[151] One may infer that the contemplation of the *muqarnas* vault in the Hall of the Abencerrajes, originally painted with a mixture of intense colours of red and blue, would have caused the 'Where' system to perceive the surfaces as vibrating and unstable.

In her analysis of the decoration in the Alhambra, Valérie Gonzalez attributed the 'animation of the pictorial plane and a vibration of the surface' to geometric design as well as the juxtaposition of primary colours.[152] Contrary to Gonzalez, Livingstone, examining paintings by Claude Monet (1840–1926) and Paul Cézanne (1839–1906), proposes that what Gonzalez terms 'kinetic geometry' is not caused by the difference in hue of the 'primary colours' – red and blue – but rather is the result of observing colours that are equal in 'brightness', that is, luminosity. The effect of pulsating or flickering surfaces in the visual experience of the beholder is the result of the inability of the 'Where' system to assign relative positions in depth to forms painted with equiluminant colours. The experiments undertaken by neuroscientists confirm that when one observes several static forms, it is the relationship of their luminance and not of their hues that is responsible for producing the illusion that the forms move. It has been demonstrated that the illusory motion of static elements painted in equiluminant colours is further intensified 'if fixation [of the eyes on the object] is maintained'.[153] In one study, subjects observed intently a geometrical scheme composed of a repeating series of overlapping concentric circles, each one marked by a striped, spiral-like pattern. The illusion of motion of the static forms was elicited and registered when equiluminant colours were used, even if the hues in the pattern were altered.[154] Psychophysical experiments conducted by neuroscientists have indeed confirmed Ibn al-Khabīr's observation made already in the eleventh century, when he noted the perceived kinetic illusion when one looked 'fixedly' at the polychromed architectural decoration of the palace in Toledo.

Equiluminant colours cause difficulties in the perception of the spatial organisation of the coloured surface, which is to say, in

distinguishing between figure and ground. As a result, the central vision is disabled in locating the focal point of the composition. One's sight is affected by what one scholar defines as 'a kaleidoscopic multiplying of the focal point, or indeed the focal point's dizzying, vertiginous force'.[155] Livingstone suggests that when the focus cannot be located, peripheral vision becomes engaged, and, working in tandem with a compromised central vision, together they enable one's optical system to perceive such a surface.[156] It is the order of visual elements of an object, or, more precisely, the geometry governing their relationship in a composition, that comes to the 'rescue' of the disoriented visual perception. Geometry serves to counterbalance and stabilise the vertiginous force of equiluminant colours.

In the vault of the Hall of the Abencerrajes, where the underlying geometry of the composition is hidden, an elemental form, multiplied in an orderly composition, gives the central vision a point upon which to focus, again and again, and so to achieve a sense of orientation. The shortcoming of the 'Where' system is manipulated to create the flickering balance of two colours, and with it to produce an experience of visually unstable or shimmering surfaces, an important aspect of architectural decoration in the Alhambra. The vertiginous effects of undulating colours would have contested the central vision and the central role of geometry throughout the palace. The kinetically charged, pulsating surface would force the viewer to focus on it more attentively in order to overcome the deliberately impaired 'Where' system and to discern the compositional elements that would stabilise the vibrantly coloured surface.

One further observation relevant to Nasrid craftsmanship may be made here. Recent technical analysis of surfaces in the Alhambra leads to a conclusion that gives a clear indication of the craftsmen's engagement with the science of optics. Plaster, a primary decorative material there, was made from gypsum, to which powdered marble or eggshell was added to make it harder.[157] These additives would also give greater reflectivity to the plaster and hence provide a base that would give greater luminosity to the colours applied to the plasterwork.

The technique of pigment application was also aimed at enhancing further the luminosity of surfaces. Technical analysis has revealed that in the polychromy of carved and moulded plaster in the Alhambra, the pigments, especially blue and red, were painted on top of an intermediate white undercoat, which was applied in consecutive layers, as many as seven in some examples.[158] First, the white undercoat, whose mixture included finely ground gypsum, slaked lime and egg white, served to seal the porous surface of the plaster, making it less permeable to humidity and water. Second, the white undercoat gave a uniform white colour to all plaster panels so that they would not differ in their tonality within a given space. And, finally, the undercoat's smooth, satiny texture and luminous milky

or pearly colour would greatly affect the luminosity of the pigments applied over it.[159] It has been suggested that in the Alhambra the luminosity of gilded elements was also intensified by the application of gold leaf to another metallic surface, such as a sheet of tin.[160]

The Nasrid craftsmen's understanding of the ways in which the visual effects of colours could be enhanced is also evident in other media in the Alhambra. The analysis of Nasrid carpentry shows that in order to give greater luminosity to the finished polychromed surface, it was covered with four consecutive layers: unpolished plaster, burnished tin,[161] lead white and calcium carbonate – all before the blue and red pigments were applied.[162] In deploying the properties of different materials and substances, and creating deliberate optical effects, they continued the artistic tradition practiced centuries earlier in al-Andalus. A study of the polychromed wooden ceiling in the addition to the Great Mosque of Córdoba undertaken between 961 and 970 on the orders of the Umayyad caliph al-Ḥakam II (r. 349–65/961–76), shows that three layers – plaster, lead white and calcium carbonate – were applied to the surface of the wood first, and only then were the vibrant oil-based pigments applied in up to four successive layers.[163] The technique of multiple colour glazes greatly increased the luminous effect of the ceiling's painted design. Furthermore, a chromatic range was achieved through variations in the proportions of white lead added to the same pigment, yielding several values of the same hue. The study also proposes the artisans' empirical or perhaps even theoretical knowledge, since the distance from which different decorative elements were viewed was taken into account in the design: white and yellow pigments were used to paint elements situated further away from both the beholder and the source of light, while red and black pigments were employed for the forms that received more light.

Although documentary proof of such sophisticated scientific knowledge is lacking equally for the tenth-century mosque and for the Alhambra, these findings provide evidence at the level of craft that speaks to the awareness of the science of optics during the Nasrid period and more particularly to the importance of luminosity to the aesthetics of colour. The consequences for visual perception were incorporated into the decoration of the Alhambra. Jones accurately and insightfully observed that in the architectural decoration of the Alhambra, the primary colours were used in the vaults and the upper part of the walls, 'The secondary colours, purple, green, and orange, occur only in the mosaic dados, which, being near the eye, formed a point of repose from the more brilliant colouring above'.[164] The consistency of such colour distribution within the Alhambra suggests that the design was anything but random. On the contrary, craftsmen knew that there was a correlation between distance and colour, and that it could produce particular visual effects on a beholder.

8

When the investigation of colour in the Alhambra attains the same importance as that accorded to the study of geometry, and when technical analysis provides further information on the luminosity of the pigments that remain on such surfaces as the *muqarnas* vault of the Hall of the Abencerrajes, it will be possible to assess more fully the visual impact of the original decoration. It will also be possible to understand better the artistic intent of the creators of the Alhambra and the experience of the contemporary beholder. At present, at least two conclusions seem clear. The artistic achievement of the Alhambra is itself the proof – even without other documentation – of a sophisticated knowledge of visual processes. It must then be emphasised that the Nasrid beholders, no less than the Nasrid craftsmen, would have shared in 'the widespread sensibilities' that underlay visual perception. Second, and of particular relevance to colour, the Nasrid Alhambra, 'always: either polychromed or gilded' – to recall Ibn al-Jayyāb's verses – was designed to endow the architectural decoration with vivid kinetic effects, counterbalanced by the stabilising effect of geometric patterns. The predominant focus on geometry in the decoration has entailed a privileging of stability in keeping with the general conception of architecture as an art of permanent, static structures. A revived sense of the important role of colour in the Alhambra brings a corresponding shift in the fundamental understanding of the experience of architecture and its decoration as a balanced tension between stability and dynamism, static structure and kinetic effect.

Notes

1. Jacqueline Lichtenstein, *The Eloquence of Color: Rhetoric and Painting in the French Classical Age*, trans. Emily McVarish (Berkeley: University of California Press, 1993), p. 194.
2. Fernández-Puertas, *The Alhambra*.
3. While no Fatimid architectural models can be identified, early examples of a *qubba* throne-complex belong to the orbit of the Fatimid world; they are found in the palaces of Ashir and of the Qal'a of the Banu Hammad, which were built under the Zirid dynasty in present-day Algeria some time in the middle of the fourth/tenth century and in the first half of the fifth/eleventh century, respectively. For an overview of the development of the plan exemplified by the Palace of Comares and the permutations of the various features in this typology in the palatial and residential architecture in al-Andalus and North Africa, see Orihuela Uzal, *Casas y palacios nazaríes*, pp. 19–36 and 81–6.
4. Orihuela Uzal, *Casas y palacios nazaríes*, pp. 103–11.
5. J. A. García Granados and Carmen Trillo San José, 'Obras de los Reyes Católicos en Granada (1492–1495)', *Cuadernos de la Alhambra* 26 (1990): 145–68.

6. Among such studies, see José and Manuel Oliver Hurtado, *Granada y sus monumentos árabes* (Málaga: M. Oliver Navarro, 1875); Rafael Contreras, *Estudio descriptivo de los monumentos árabes de Granada, Sevilla y Córdoba, o sea la Alhambra, el Alcázar y la Gran Mezquita de Occidente* (Madrid, 1878); and Manuel Gómez Moreno, *Guía de Granada* (Granada, 1892).

7. See, for instance, M. López Casares, 'La ciudad palatina de la Alhambra y las obras realizadas en el siglo XVI a la luz de sus libros de cuentas', *Revista Española de Historia de la Contabilidad* 10 (2009): 3–130.

8. For a discussion of the perception of the Alhambra's architecture today and the need for judicious discrimination between the authenticity and reinvention in its structures, see Ruggles, 'Inventing the Alhambra'.

9. On the importance of Leopoldo Torres Balbás to the field of historic preservation, see Juan Calatrava and María González-Pendás, 'Leopoldo Torres Balbás: Architectural Restoration and the Idea of "Tradition" in Early Twentieth-Century Spain', *Journal of Historic Preservation, History, Theory, and Criticism* 4(2) (2007): 40–9. The authors enumerate the various roles of Torres Balbás as 'architect, conservator, architectural and urban historian, and theoretician of architectural restoration and historic preservation' (p. 44).

10. Calatrava and González-Pendás, 'Leopoldo Torres Balbás', p. 45.

11. Leopoldo Torres Balbás, 'Diario de obras en la Alhambra 1923–1936', *Cuadernos de la Alhambra* 1(1965): 75–92; 2 (1966): 89–111; 3 (1967): 125–52; 4 (1968): 99–128; 5 (1969): 69–94. See also Leopoldo Torres Balbás, *Obra dispersa*, 9 vols (Madrid: Colegio Oficial de Arquitectos de Madrid, 1981–85); and Carlos Vílchez Vílchez, *La Alhambra de Leopoldo Torres Balbás (obras de restauración y conservación, 1923–1936)* (Granada: Editorial Comares, 1988).

12. See, for instance, José Álvarez Lopera, 'La Alhambra entre la conservación y la restauración (1905–1915)', *Cuadernos de Arte de la Universidad de Granada* 24 (29/31) (1977): entire volume; Juan A. Vilar Sánchez, *Los Reyes Católicos en la Alhambra* (Granada: Editorial Comares, 2007); and Alfonso Muñoz Cosme, 'Cuatro siglos de intervenciones en la Alhambra de Granada, 1492–1907', *Cuadernos de la Alhambra* 27 (1991): 151–90.

13. Publications in the conservation field with regard to the architecture of al-Andalus in general and of the Alhambra in particular have grown substantially in recent decades. Among monographic studies that are pertinent to the discussion at hand and that treat particular media, see, for instance, Ramón Rubio Domene, *Yeserías de la Alhambra. Historia, técnica y conservación* (Granada: Editorial Universidad de Granada, 2010); and María Carmen López Pertíñez, *La carpintería en la arquitectura nazarí* (Granada: Fundación Rodríguez-Acosta, 2006). Other relevant works are cited in the notes to this and other chapters in the book.

14. See Ramón Rubio Domene, 'Mold Techniques Used in Nasrid Plasterwork and their Subsequent Evolution', *I Congreso Internacional Red Europea de Museos de Arte Islámico (REMAI), Alhambra, Granada, 25–27 de abril, 2012. Actas*, pp. 535–45, available at: http://remai.alhambra-patronato.es/es/content/actas-del-congreso-remai, last accessed 15 December 2013.

15. Lourdes Blanca López and María Dolores Blanca López, 'Technical and Material Study of the Plasterwork and *muqarnas* of the "Corral del Carbón" or *al-fundaq al-yadida* in Granada', *I Congreso Internacional (REMAI), Actas*, pp. 662–73, available at: http://remai.alhambra-patronato.es/es/content/actas-del-congreso-remai, last accessed 15 December 2013.

16. See Patricia Catherine Bellamy and María José Calvín Velasco, 'Identification of Decorative Techniques Used in Nasrid Plasterwork through the Restoration of Plasterwork Fragments from the Generalife Palace', *I Congreso Internacional (REMAI), Actas*, pp. 653–61, available at: http://remai.alhambra-patronato.es/es/content/actas-del-congreso-remai, last accessed 15 December 2013.

17. There are numerous studies and they will be cited at the pertinent points in this chapter.

18. For instance, in one study of the pigments in the plasterwork decoration, a total of twenty-four samples were taken in four different precincts, among them: 'three from the east wall of the Hall of the Mexuar . . . three from the façade of the gate of the Mexuar, ten from the interior wall of the east pavilion in the Lions Courtyard', as reported by Carolina Cardell-Fernández and Carmen Navarrete-Aguilera, 'Pigment and Plasterwork Analyses of Nasrid Polychromed Lacework Stucco in the Alhambra (Granada, Spain)', *Studies in Conservation* 51(3) (2006), p. 163.

19. María José de la Torre López, Ramón Francisco Rubio Domene and María José Campos Suñol, 'Mineralogical-petrographic Study of Islamic Plasterwork: Textural and Compositional Aspects', *I Congreso Internacional (REMAI), Actas*, p. 587, available at: http://remai.alhambra-patronato.es/es/content/actas-del-congreso-remai, last accessed 15 December 2013.

20. Victor Hugo López Borges, 'Origen, coleccionismo y uso de cinco fragmentos de yeserías nazaríes en el Victoria and Albert Museum', *I Congreso Internacional (REMAI), Actas*, pp. 17–34, available at: http://remai.alhambra-patronato.es/es/content/actas-del-congreso-remai, last accessed 15 December 2013.

21. For a brief discussion of the names of these palaces during the Nasrid and post-Nasrid periods, see Puerta Vílchez, *Leer la Alhambra*, pp. 27–8, 68, 78.

22. Puerta Vílchez, *Leer la Alhambra*, p. 138.

23. For instance, archival documents attest that the original dadoes of ceramic tile mosaics underwent significant repairs between 1495 and 1500. See María Elena Díez Jorge, 'Los alicatados del baño de Comares de la Alhambra, ¿Islámico o cristiano?', *Archivo Español de Arte* 80(317) (2007), p. 20.

24. Juan Manuel Barrios Rozúa, 'La Alhambra de Granada y los difíciles comienzos de la restauración arquitectónica (1814–1840)', *Boletín de la Real Academia de Bellas Artes de San Fernando*, 106–7 (2008), p. 139.

25. Ibid., p. 135.

26. Rubio Domene, *Yeserías de la Alhambra*, p. 85.

27. Although appointed as architect in charge in 1840, it appears that José Contreras Osorio's career at the Alhambra started earlier, when he was contracted in 1831 or 1832 to repair the damaged walls near the Peinador de la Reina and Partal. See Barrios Rozúa, 'La Alhambra de Granada', p. 137; and Rubio Domene, *Yeserías de la Alhambra*, p. 85.

28. He was appointed to this position in 1847, but started his work in the Alhambra in 1851. See Juan Manuel Barrios Rozúa, 'Una polémica en torno a los criterios para restaurar la Alhambra: Salvador Amador frente a Narciso Pascual y Colomer (1846–1849)', *Reales Sitios* 180 (2009), p. 46. For an analysis of Rafael Contreras' interventions in other precincts of the Alhambra, see Antonio Orihuela Uzal, 'La conservación de alicatados en la Alhambra durante la etapa de Rafael Contreras (1847–1890), "Modernidad o provisionalidad"' in José Antonio González Alcantud and Abdellouahed Akmir (eds), *La Alhambra: lugar de la memoria y el diálogo* (Granada: Editorial Comares, 2008), pp. 125–52.

29. For a synopsis of the 'Contreras era' in the Alhambra, which includes the work of Mariano Contreras Granja, José Contreras' grandson, see Rubio Domene, *Yeserías de la Alhambra*, pp. 83–93. For an analysis of the controversial restorations undertaken by the Contreras in the context of their role in popularising the Alhambra abroad, see Francisco Serrano Espinosa, 'The Contreras Family (1824–1906): Eighty Years of Intervention in the Hispanic–Muslim Heritage and the Dissemination of Alhambrism. New Research', *I Congreso Internacional (REMAI), Actas*, pp. 252–66, available at: http://remai.alhambra-patronato.es/es/content/actas-del-congreso-remai, last accessed 15 December 2013. For a general assessment of the work undertaken on the restoration of the Alhambra in the first half of the nineteenth century, see Barrios Rozúa, 'La Alhambra de Granada', and Barrios Rozúa, 'Una polémica'.

30. Among the earliest historical photographs of the domed pavilions are those made by Charles Clifford, *c.* 1862 and J. Laurent, *c.* 1872, preserved in the Archivo del Patronato de la Alhambra y Generalife.

31. See, for instance, Juan Calatrava, 'Owen Jones: Diseño islámico y arquitectura moderna', in Juan Calatrava, Mariam Rosser-Owen, Abraham Thomas and Rémi Labrusse, *Owen Jones y la Alhambra* (Granada: Patronato de la Alhambra y Generalife and Victoria and Albert Museum, London, 2011), pp. 11–12; and Mariam Rosser-Owen, 'Coleccionar la Alhambra: Owen Jones y la España islámica en el South Kensington Museum', in Juan Calatrava, Mariam Rosser-Owen, Abraham Thomas and Rémi Labrusse, *Owen Jones y la Alhambra* (Granada: Patronato de la Alhambra y Generalife and Victoria and Albert Museum, London, 2011), pp. 49–52.

32. Purificación Marinetto Sánchez, 'La policromía de los capiteles del Palacio de los Leones', *Cuadernos de la Alhambra* 21 (1985): 79–97; José Miguel Puerta Vílchez, 'La Alhambra y el Generalife de Granada', *Artigrama* 22 (2007), p. 215.

33. Marinetto Sánchez, 'La policromía', pp. 84–9.

34. Díez Jorge, 'Los alicatados del baño de Comares', p. 33.

35. Rubio Domene questions the possibility that Contreras placed new plaster panels on top of the badly deteriorated original plaster decoration. See Ramón Rubio Domene, 'La Sala de las Camas del Baño Real de Comares de la Alhambra. Datos tras su restauración', *Cuadernos de la Alhambra* 43 (2008), p. 169.

36. Rubio Domene, *Yeserías de la Alhambra*, p. 91. López Borges proposed that a plaster panel preserved in the Victoria and Albert Museum (I-1883), which he dates to the reign of Muḥammad V, served as a model for some of the panels reproduced by Rafael Contreras for this room. Close affinity in design led López Borges to suggest that

Contreras, most likely, removed the original panel when he was undertaking the renovations of the Sala de las Camas. See López Borges, 'Origen, coleccionismo y uso', p. 26.

37. Owing to the significant erosion of the surface of the plaster panel (Victoria and Albert Museum, I-1883), which might have been used originally in the Sala de las Camas, no pigments have been detected in its analysis. See Víctor Hugo López Borges, María José de la Torre López and Lucia Burgio, 'Caracterización de materiales y técnicas de las yeserías nazaríes a través de la colección del Museo Victoria and Albert Museum', *I Congreso Internacional Red Europea de Museos de Arte Islámico (REMAI), Alhambra, Granada 25–27 April, 2012. Actas*, p. 147, available at: http://remai.alhambra-patronato.es/es/content/actas-del-congreso-remai, last accessed 15 December 2013.

38. López Borges, 'Origen, coleccionismo y uso', p. 26.

39. Jones and Goury, *Plans, Elevations, Sections and Details of the Alhambra*. See also López Borges, 'Origen, coleccionismo y uso', p. 26, and Fernández-Puertas, *The Alhambra*, p. 282.

40. See, for instance, Nicholas Frankel, 'The Ecstasy of Decoration: *The Grammar of Ornament* as Embodied Experience', *Nineteenth-Century Art World-Wide* 2(1) (2003): 1–24.

41. See Jean Marc Castera, 'La cupola a mouqarnas della sala delle due sorelle dell'Alhambra di Granada', Michele Emmer (ed.), *Matematica e cultura* (Berlin: Springer, 2005), pp. 101–10.

42. Carol A. Hrvol Flores, 'Engaging the Mind's Eye: The Use of Inscriptions in the Architecture of Owen Jones and A. W. N. Pugin', *Journal of the Society of Architectural Historians* 60(2) (2001): 159–60; Carol A. Hrvol Flores, *Owen Jones. Design, Ornament, Architecture, and Theory in the Age of Transition* (New York: Rizzoli, 2006). The body of scholarship on Owen Jones' aesthetic theory, formulated largely on the basis of his investigations of the architecture and decoration of the Alhambra, is fast-growing; especially pertinent here for the emphasis on Jones' scientific approach, see Calatrava et al., *Owen Jones y la Alhambra*.

43. Among the studies that discuss the relationship between Jones' theory of ornament and his invention of chromolithography, see Kathryn Ferry, 'Printing the Alhambra: Jones and Chromolithography', *Architectural History* 46 (2003): 175–88; Frankel, 'The Ecstasy of Decoration'.

44. Calatrava, 'Owen Jones: Diseño islámico', pp. 17, 20, 32.

45. Owen Jones, *Decorative Ornament* (New York: Tass Press, 2006), p. 165 (original emphasis); this is a reprint of Owen Jones, *The Grammar of Ornament* (London, 1856).

46. Jones, *Decorative Ornament*, p. 165.

47. Ibid., p. 167 (original emphasis).

48. Ibid., pp. 165–6.

49. Cardell-Fernández and Navarrete-Aguilera, 'Pigment and Plasterwork Analyses', p. 163.

50. See María José Ayora-Cañada, Ana Domínguez Vidal, María José de la Torre López and Ramón Francisco Rubio Domene, 'Plasterwork Research by Infrared and Raman Spectroscopy: Identification of Pictorial Materials *in situ* and in the Laboratory', *I Congreso Internacional (REMAI), Actas*, pp. 640, 642, available at: http://remai.alhambra-patronato.es/es/content/actas-del-congreso-remai, last accessed 15 December 2013.

51. For instance, original pigments of blue and red have been identified on a plaster panel from the Salón de Comares (Victoria and Albert Museum, CIRC.83-1938). See López Borges et al., 'Caracterización de materiales y técnicas', pp. 147, 153.

52. William Harvey's drawing belongs to the collection of Victoria and Albert Museum, London. It was brought to scholarly attention when published by Fernández-Puertas along with some of Jones' plates; see Fernández-Puertas, *The Alhambra* (fig. 154 and pls. 25–34, respectively).

53. Fernández-Puertas, *The Alhambra*, p. 312, n. 1.

54. Ibid., p. 314.

55. Carlos Vílchez Vílchez, *Baños árabes* (Granada: Diputación de Granada, 2001), p. 47; Puerta Vílchez, 'La Alhambra y el Generalife', p. 206.

56. Puerta Vílchez, *Leer la Alhambra*, p. 312.

57. Lucia Burgio, 'Microscopy Analysis of Hispano-Moresque Samples from the Alhambra', *V&A Museum Science Report* (June 2004): 1–23; Victor Borges, 'Nasrid Plasterwork: Symbolism, Materials, Techniques', *V&A Conservation Journal* 48 (2004): 10–14.

58. Rubio Domene, *Yeserías de la Alhambra*.

59. Borges, 'Nasrid Plasterwork', p. 12.

60. Víctor Medina Flórez and Ana García Bueno, 'Técnica pictórica empleada en la ejecución de los zócalos de la Alhambra y del Cuarto Real de Santo Domingo de Granada. Estudio comparativo', *Cuadernos de la Alhambra* 37 (2001), p. 13; Luis Capitán-Vallvey, Eloisa Manzano and Víctor J. Medina Flórez, 'Estudio comparativo de algunos zócalos pintados nazaríes localizados en diversos edificios de Granada', *Cuadernos de la Alhambra* 28 (1992), p. 239.

61. See Borges, 'Nasrid Plasterwork', p. 12.

62. Cardell-Fernández and Navarrete-Aguilera, 'Pigment and Plasterwork Analyses', p. 168.

63. Since the sources of red and blue pigments in the plasterwork at the Cuarto Real de Santo Domingo (*Dār al-Manjara al-Kubrāʾ*) in Granada are identical to those in the Alhambra, it is likely that the mixture of malachite and copper used there was also the source of the green pigment in the Alhambra. See Ana García Bueno and Víctor J. Medina Flórez, 'The Nasrid Plasterwork at "qubba Dār al-Manjara al-Kubrāʾ"' in Granada: Characterization of Materials and Techniques', *Journal of Cultural Heritage* 5(1) (2004): 75–89.

64. André Paccard, *Traditional Islamic Craft in Moroccan Architecture*, vol. 1 (Saint-Jorioz: Editions Ateliers 74, 1980), pp. 60–219.

65. Emilio García Gómez, *Foco de antigua luz sobre la Alhambra. Desde un texto de Ibn al-Jatib en 1362* (Madrid: Publicaciones del Instituto Egipcio de Estudios Islámicos en Madrid, 1988), p. 124.

66. For the employment of polychromy in Western medieval sculpture, see, for instance, Lucretia Kargère, 'The Use of Lapis Lazuli as a Pigment in Medieval Europe', *The Sherman Fairchild Center for Objects Conservation, The Metropolitan Museum of Art – Spring 2003 Treatment and Research Notes* 4(2) (2003): 5–7. Among several of her essays on the subject of Ghazni marbles, see Martina Rugiadi, '"As for the Colours, Look at a Garden in Spring". Polychrome Marble in the Ghaznavid Architectural Decoration', in Pierfrancesco Callieri and Luca Colliva (eds), *Proceedings of the 7th International Congress*

on the Archaeology of the Ancient Near East. April 12th–16th, 2010 (Wiesbaden: Harrassowitz, 2012), pp. 254–73.

67. Paola Ricciardi and Kristine Rose Beers, 'The Illuminator's Palette', and Nancy K. Turner and Doris Oltrogge, 'Pigment Recipes and Model Books: Mechanisms for Knowledge Transmission and the Training of Manuscript Illuminators', in Stella Panayotova (ed.), *Colour: The Art & Science of Illuminated Manuscripts*, exhibition catalogue, *Colour*, Fitzwilliam Museum, 30 July–30 December 2016 (Cambridge, Fitzwilliam Museum: Harvey Miller, 2016), pp. 26–39 and 88–97, respectively. These and other essays in the catalogue present up-to-date research on various aspects of colour pertaining to the illumination of European medieval manuscripts, from recipes and techniques of application to theological precepts in the context of biblical, exegetical and moralising meanings of vision.

68. See Luciano Rodrigo Marhuenda and Jorge Calancha de Passos, 'Cronica de conservación y restauración', *Cuadernos de la Alhambra* 28 (1992): 369–430; López Pertíñez, *La carpintería*, pp. 68–87. The technical analysis of the pigments in López Pertíñez' monograph was undertaken in collaboration with Ana García Bueno.

69. Darío Cabanelas Rodríguez, *El techo del Salón de Comares en la Alhambra. Decoración, policromía, simbolismo y etimología* (Granada: Patronato de la Alhambra y Generalife, 1988), pp. 9–13, 59–80 and pl. XXV. See also López Pertíñez, *La carpintería*, pp. 137–49.

70. Fernández-Puertas, *The Alhambra*, p. 396.

71. Scholars agree that some glass fragments are original, as is the wooden framework in which they are set, while other fragments were replaced after a gunpowder explosion in 1590. See [María] Elena Díez Jorge (ed.), *La Alhambra y el Generalife: guía histórico-artística* (Granada: Universidad de Granada, 2006), p. 178; Pedro Jiménez Castillo, 'Talleres, técnicas y producciones de vidrio en al-Andalus', in Enrique Rontomé Notario and Teresa Carreras i Rossell (eds), *Vidrio islámico en al-Andalus: Real Fábrica de Cristal de la Granja, noviembre 2006–abril 2007* (San Ildefonso, Segovia: Fundación Centro Nacional del Vidrio, 2006), pp. 51–70. Jiménez Castillo provides evidence that lead was also used as a framework for coloured glass in the Alhambra at the beginning of the fourteenth century (p. 67). For a catalogue of the original glass fragments from the buildings in the Alhambra, dated to the fourteenth or fifteenth century and now housed in the Museo de la Alhambra, see Purificación Marinetto Sánchez and Isabel Cambil Campaña, Catalogue entries Nos 106–18 in Rontomé Notario and Carreras i Rossell, *Vidrio islámico en al-Andalus*.

72. Chemical analysis of medieval glass from various architectural sites suggests that pigments from the same sources were employed in European cathedrals as in glass vessels made in the lands of Islam. See Robert H. Brill, *Chemical Analyses of Early Glasses*, 2 vols (Corning, NY: Corning Museum of Glass, 1999).

73. Ahmad Y. al-Hassan, 'An Eighth-Century Arabic Treatise on the Colouring of Glass: *Kitab al-durra al-maknuna* [The Book of the Hidden Pearl] of Jabir Ibn Hayyan, c. 721– c. 815', *Arabic Science and Philosophy* 19 (2009): 121–56.

74. Ibid., p. 137.

75. Trinitat Pradel Cara, Glòria Molina Giralt, Judit Molera Marimon and Purificación Marinetto Sánchez, 'Initial Results of the Analysis

of Glazed Decorated Nasrid Ceramics: Palatine Ceramics (14th–15th Centuries)', *I Congreso Internacional (REMAI), Actas*, pp. 494–509, available at: http://remai.alhambra-patronato.es/es/content/actas-del-congreso-remai, last accessed 15 December 2013. The authors suggest that Iberian mines were probably the source of cobalt on the basis of the presence of iron, zinc and manganese in the cobalt ore in proportions characteristic of the mineral ores found in the Iberian Peninsula.

76. Al-Hassan, 'An Eighth-Century Arabic Treatise', pp. 128–33.

77. Ibid., p. 137.

78. Quoted in ibid., p. 136.

79. María Isabel Álvaro Zamora, 'La cerámica andalusí', *Artigrama* 22 (2007), p. 356; Rubio Domene, *Yeserías de la Alhambra*, pp. 266–9.

80. Mario Vendrell, Josep Roqué, Josefina Pérez-Arantegui and Pilar Giráldez, 'Lustre-decorated Ceramics: A Technical Insight into Medieval Nanotechnology', *I Congreso Internacional (REMAI), Actas*, p. 525, available at: http://remai.alhambra-patronato.es/es/content/actas-del-congreso-remai, last accessed 15 December 2013.

81. Vendrell et al., 'Lustre-decorated Ceramics', p. 532.

82. Among the studies of polychromatic symmetry groups employed in the architectural decoration in the Alhambra, the most pertinent are E. Makovicky and Purificación Fenoll Hach-Alí, 'Coloured Symmetry in the Mosaics of Granada, Spain', *Boletín de la Sociedad Española de Mineralogía* 22 (1999): 143–83; Purificación Fenoll Hach-Alí and Alberto López Galindo, *Simetría en la Alhambra. Ciencia, belleza e intuición* (Granada: Universidad de Granada – Consejo Superior de Investigaciones Científicas, 2003); Rafael Pérez Gómez, '17, 46, . . ., 627, . . . sinfonías para una loseta: los mosaicos de la Alhambra de Granada', in Julio Samsó, Juan Vernet Ginés and Mercè Comes (eds), *Al-Andalus: el legado científico. Palacio de Mondragón, Ronda (Málaga), abril 1–julio 15, 1995*. Exhibition catalogue (Granada: Fundación El Legado andalusí, 1995), pp. 38–67; Rafael Pérez Gómez, Pablo Gutiérrez Calderón and Ceferino Ruíz Garrido, 'La búsqueda y materialización de la belleza. La geometría del poder', in Rafael Pérez Gómez (ed.), *7 Paseos por la Alhambra* (Granada: Proyecto Sur de Ediciones, 2007), pp. 387–542; José María Montesinos Amilibia, 'Caleidoscopios y grupos cristalográficos en la Alhambra', in Manuel Vela Torres (ed.), *La Alhambra* (Granada: SAEM Thales, 1995), pp. 9–30; Silvia López Rodríguez, María del Rosario López Rodríguez, Carmen María López Rodríguez and Diego José López Rodríguez, 'Geometría fractal en la Alhambra', *Cuadernos de la Alhambra* 39 (2003): 37–62.

83. Pérez Gómez, '17, 46, . . . , 627', p. 44.

84. López Rodríguez et al., 'Geometría fractal', p. 37.

85. Jerrilynn D. Dodds, María Rosa Menocal and Abigail Krasner Balbale, *The Arts of Intimacy. Christians, Jews, and Muslims in the Making of Castilian Culture* (New Haven, CT: Yale University Press, 2008), pp. 55–6.

86. Bernabé Cabañero Subiza, 'La Aljafería de Zaragoza', in Gonzalo M. Borrás Gualis (ed.), *Arte andalusí* (Zaragoza: Universidad de Zaragoza, 2008), p. 122.

87. Makovicky and Fenoll Hach-Alí, 'Coloured Symmetry'.

88. See Ibn al-Haytham, *The Optics of Ibn al-Haytham. Book I–III. On Direct Vision*, ed. and trans. Abdelhamid I. Sabra, Studies of the

Warburg Institute 40, 2 vols (London: University of London, 1989). Sabra's introduction, commentary, glossaries, concordance and indices constitute the second volume of this edition, and they have been an invaluable resource. References to these contributions will be cited under Sabra's name and the title *The Optics of Ibn al-Haytham*, vol. 2. For the discussions of the translations of Ibn al-Haytham's book into Latin, see A. Mark Smith, 'Alhacen's Theory of Visual Perception: A Critical Edition, with English Translation and Commentary, of the First Three Books of Alhacen's "De aspectibus", the Medieval Latin Version of Ibn al-Haytham's "Kitāb al-Manāzir": Volume One', *Transactions of the American Philosophical Society*, New Series 91(4) (2001): entire volume; A. Mark Smith, 'Alhacen's Theory of Visual Perception: A Critical Edition, with English Translation and Commentary, of the First Three Books of Alhacen's "De aspectibus", the Medieval Latin Version of Ibn al-Haytham's "Kitāb al-Manāzir": Volume Two', *Transactions of the American Philosophical Society*, New Series 91(5) (2001): 339–819; A. Mark Smith, 'Alhacen on the Principles of Reflection: A Critical Edition, with English Translation and Commentary, of Books 4 and 5 of Alhacen's "De aspectibus", the Medieval Latin version of Ibn al-Haytham's "Kitāb al-Manāzir",' 2 vols, *Transactions of the American Philosophical Society*, New Series 96 (2/3) (2006): entire volume. For a summary of Ibn al-Haytham's postulations on the role of cognition in perception, see Nader El-Bizri, 'A Philosophical Perspective on Alhazen's Optics', *Arabic Sciences and Philosophy* 15(2) (2005): 189–217.

89. Abdelhamid I. Sabra, 'The "Commentary" that Saved the Text. The Hazardous Journey of Ibn al-Haytham's Arabic *Optics*', *Early Science and Medicine* 12 (2007), p. 128; Jan P. Hogendijk, 'Discovery of an Eleventh Century Geometrical Compilation: The *Istikmal* of Yusuf al-Mu'taman Ibn Hud, King of Saragossa', *Historia Mathematica* 13 (1986): 43–52; Jan P. Hogendijk, 'Al-Mu'taman's Simplified Lemmas for Solving "Alhazen's Problem"', in J. Casulleras and J. Samsó (eds), *From Baghdad to Barcelona. Studies in the Islamic Exact Sciences in Honor of Prof. Juan Vernet*, 2 vols (Barcelona: Anuari de Filologia XIX–Instituto 'Millás Vallicrosa', 1996), vol. 1, pp. 59–101.

90. Ṣāʿid al-Andalusī, *Science in the Medieval World. 'Book of the Categories of Nations'*, ed. and trans. Semaan I. Salem and Alok Kumar (Austin: University of Texas Press, 1991), p. 55.

91. Ibid., pp. 55, 58–78.

92. Sabra, *The Optics of Ibn al-Haytham*, vol. 2, p. lxxiv; Sabra, 'The "Commentary"', p. 122. Nader El-Bizri attributes the translation into Latin to Gerard of Cremona and dates it to the end of the twelfth century; see Nader El-Bizri, 'Classical Optics and the *Perspectiva* Traditions Leading to the Renaissance', in Charles Carman and John Hendrix (eds), *Renaissance Theories of Vision* (Aldershot: Ashgate, 2010), p. 11.

93. Sabra, 'The "Commentary"', p. 122 and n. 12.

94. Julio Samsó, 'Alfonso X', in Thomas Hockey et al. (eds), *The Biographical Encyclopedia of Astronomers* (New York: Springer, 2007), pp. 29–31.

95. David C. Lindberg, *Theories of Vision from al-Kindi to Kepler* (Chicago: University of Chicago Press, 1976), pp. 58–86.

96. Ibid., p. 121.

97. Stella Panayotova, 'Colour Theory, Optics and Manuscript Illumination', in Stella Panayotova (ed.), *Colour: The Art & Science of Illuminated Manuscripts*, exhibition catalogue, *Colour*, Fitzwilliam Museum, 30 July–30 December 2016 (Fitzwilliam Museum, Cambridge: Harvey Miller, 2016), pp. 304–15.

98. Gülru Necipoğlu, *The Topkapı Scroll: Geometry and Ornament in Islamic Architecture* (Santa Monica, CA: Getty Center for the History of Art and the Humanities, 1995), p. 166; El-Bizri, 'Classical Optics and the *Perspectiva*'.

99. Lindberg, *Theories of Vision*, pp. 78–208.

100. Sabra, *The Optics of Ibn al-Haytham*, vol. 2, pp. lxiv–lxxiii.

101. The five extant medieval Arabic manuscripts of the *Kitāb al-Manāẓir* are all preserved in libraries in Istanbul; see ibid., II, p. lxxxi.

102. Gülru Necipoğlu, 'The Scrutinizing Gaze in the Aesthetics of Islamic Visual Cultures: Sight, Insight and Desire', in Olga Bush and Avinoam Shalem (eds), *Gazing Otherwise: Modalities of Seeing*, special issue, *Muqarnas*, 32 (2015), p. 40.

103. For an excellent synopsis of Ibn al-Haytham's theory of optics, see Abdelhamid I. Sabra, 'Ibn al-Haytham's Revolutionary Project in Optics: The Achievement and the Obstacle', in Jan P. Hogendijk and Abdelhamid I. Sabra (eds), *The Enterprise of Science in Islam. New Perspectives* (Cambridge, MA: MIT Press, 2003), pp. 85–117; and also José Miguel Puerta Vílchez, *Historia del pensamiento estético árabe: Al-Andalus y la estética árabe clásica* (Madrid: Ediciones Akal, 1997), pp. 686–719.

104. Sabra, *The Optics of Ibn al-Haytham*, vol. 2, pp. 128–38.

105. Sabra, 'Ibn al-Haytham's Revolutionary Project', pp. 104–5; Gérard Simon, 'La psychologie de la vision chez Ibn al-Haytham', in Gérard Simon, *Archéologie de la vision, l'optique, le corps, la peinture* (Paris: Seuil, 2003), pp. 114–30; A. Mark Smith, 'What is the History of Medieval Optics Really About?' *Proceedings of the American Philosophical Society* 148(3) (2004): 180–94.

106. Ibn al-Haytham, *The Optics*, I, p. 205.

107. Jones, *Decorative Ornament*, p. 6.

108. Ibid., p. 162.

109. Ibn al-Haytham, *The Optics*, I, pp. 99–100.

110. For a further discussion, see ibid., II, pp. 85–86, and Sabra, 'Ibn al-Haytham's Revolutionary Project', p. 106.

111. Ibn al-Haytham, *The Optics*, I, p. 203. Many of Owen Jones' aesthetic principles, and especially those that articulate the relationship between colour and form, echo Ibn al-Haytham's postulations. That relationship merits a separate study, which would go beyond the scope of the discussion at hand.

112. Grabar, *The Mediation of Ornament*, p. 135.

113. Fernández-Puertas, *The Alhambra*, p. 356; see also Jean Marc Castera, 'El decorado de la Alhambra: una geometría viva', in José A. González Alcantud and Abdellouahed Akmir (eds), *La Alhambra: Lugar de la memoria y el diálogo* (Granada: Editorial Comares, 2008), pp. 152–63.

114. On the interventions in the repairs of the dadoes in the Alhambra, providing information on the names of the craftsmen, payments for their work and the amount of tiles for specific jobs as documented from 1495 to the nineteenth century, see Díez Jorge, 'Los alicatados del baño de Comares'. Despite the valuable information recorded here, much work remains to be done. For instance, some documents specify

particular spaces where repairs were undertaken, such as 'Sala de Abencerrajes', or 'Sala de Mocárabes', but others do not. Furthermore, as with other media, until the dadoes within a given room have been examined in their entirety, definitive conclusions remain elusive. Even if the dadoes replaced by the Contreras in the nineteenth century can be easily identified by conservators today, more research is needed to determine which areas of dadoes are original; which should be dated to the late fifteenth and early sixteenth century, continuing Nasrid techniques and methods; and which constitute much later alterations.

115. See Rubio Domene, 'La Sala de las Camas', p. 157.
116. Ibid., p. 170.
117. Ibid.
118. Rubio Domene remarked that the black colour serves to outline the decorative composition of the ceramic tile mosaic in the floor and dadoes in the baths in ibid., p. 154.
119. Jones and Goury, *Plans, Elevations, Sections*, I, pl. IX.
120. It remains to be determined with certainty which of the dadoes of ceramic tile mosaics redeployed by Contreras in his renovations are original to the baths, which may have been from the Nasrid period, but not original to this interior, and which are the nineteenth-century reproductions. Given that the pattern with 'propellers' is used in two different spaces, it would appear that even if the panels in the bath come from elsewhere in the Alhambra, they were produced during the Nasrid period. For a summary of the discussion of this issue, see María Elena Díez Jorge, 'Purificación y placer: el agua y las mil y una noches en los baños de Comares', *Cudernos de la Alhambra* 40 (2004), pp. 134–6; and Díez Jorge, 'Los alicatados del baño de Comares'. It has also been proposed that the Seville-type ceramic tiles that once embellished this interior, and which were recorded in Frederick Lewis' images, were executed in *cuerda seca* technique; they were replaced with plasterwork decoration by the Contreras. See Serrano Espinosa, 'The Contreras Family'.
121. Puerta Vílchez, 'La Alhambra y el Generalife', p. 216.
122. García Gómez, *Foco de antigua luz*, pp. 124, 143.
123. Ibn al-Haytham, *The Optics*, I, pp. 171–3.
124. Ibid., p. 187.
125. It is possible that these elements are the result of restorations undertaken in the twentieth century and in this way they were deliberately differentiated from the original tiles according to conservation principles espoused by Torres Balbás.
126. Flores points to a number of Jones' chromolithographs as examples. See Flores, 'Engaging the Mind's Eye', p. 163 and n. 29.
127. Fernández-Puertas noted that during the early period of Nasrid art, which he dates between 1273 and 1302, the plaster panels were carved in situ. Afterwards, plaster panels were made with the aid of a mold. See Fernández-Puertas, *The Alhambra*, p. 92. However, José Antonio Ruiz de la Rosa and Antonio Almagro Gorbea have discovered traces of a geometric grid on plaster panels made with artisans' tools in the small patio, now called the Patio of the Harem, in the Palace of the Lions in the Alhambra, which belongs to the period of Muḥammad V, as well as in a contemporaneous house in Granada, located on Cobertizo de Santa Inés street, No. 4. See José Antonio Ruiz de la Rosa, 'La arquitectura islámica

como forma controlada: Algunos ejemplos en al-Andalus', in Rafael López Guzmán and Mauricio Pastor Muñoz (eds), *Arquitectura en al-Andalus: Documentos para el siglo XXI* (Barcelona: Lunwerg Editores, 1995), p. 44.

128. Ibn al-Haytham, *The Optics*, I, pp. 168–70.
129. Puerta Vílchez asserts that the traces of polychromy in the vaults of the Hall of Two Sisters and of the Hall of the Abencerrajes are original. See Puerta Vílchez, 'La Alhambra y el Generalife', p. 224.
130. Ibn al-Haytham, *The Optics*, I, pp. 171–3.
131. Ibid., I, p. 187.
132. Ibid., I, p. 167.
133. Margaret Livingstone, *Vision and Art: The Biology of Seeing* (New York: Harry N. Abrams, 2002), p. 92.
134. Flores, 'Engaging the Mind's Eye', p. 164; and Calatrava, 'Owen Jones: Diseño islámico', pp. 34–5.
135. Yvonne Dold-Samplonius, 'Calculating Surface Areas and Volumes in Islamic Architecture', in Jan P. Hogendijk and Abdelhamid I. Sabra (eds), *The Enterprise of Science in Islam. New Perspectives* (Cambridge, MA: MIT Press, 2003), pp. 235–65.
136. Dold-Samplonius, 'Calculating Surface Areas', pp. 252–3.
137. Puerta Vílchez, *Leer la Alhambra*, pp. 213–14. Grabar commented on Ibn Zamrak's imagery as an 'external indicator' to the heavenly spheres with constellations, which helps to understand the meaning of the vault. See Grabar, *The Mediation of Ornament*, p. 148, and Grabar, *The Alhambra*, pp. 140–50.
138. The optical effect of this vault is comparable to that of the central medallion in the mosaic floor of the bath at Khirbat al-Mafjar (second/ eighth century, near Jericho, Israel/Jordan), where such 'a dizzying pattern of movement ... required considerable geometric knowl- edge', according to Grabar, *The Mediation of Ornament*, p. 115. In both cases, as the constitutive geometric elements – triangles in the mosaic medallion and *muqarnas* elements in the vault – decrease in size proportionally from the perimeter towards the centre, the dis- tance or illusion of depth is emphasised by variations in the colour of the elements.
139. Cardell-Fernández and Navarrete-Aguilera, 'Pigment and Plasterwork Analyses', p. 171.
140. Ibid.
141. Ibid., p. 172.
142. It has been determined that the artisans used black gypsum and molds to execute the elements for the *muqarnas* vaulted ceilings in the Alhambra. Rubio Domene explains that molded elements would then have been set in place 'during the ceiling assembly process'. See Rubio Domene, 'Mould Techniques Used in Nasrid Plasterwork', p. 537. He also notes that all Nasrid plasterwork, whether carved or molded, and whether executed in black or white gypsum, was always painted with white finish layers.
143. With the rapid advance of imaging techniques and technologies, research in these fields has grown exponentially since the early 1990s. See, for instance, Donald D. Hoffman, *Visual Intelligence: How We Create What We See* (New York: Norton, 2000); John Onians, *Neuroarthistory: From Aristotle and Pliny to Baxandall and Zeki* (New Haven, CT: Yale University Press, 2007); Barbara Maria

Stafford, *Echo Objects* (Chicago: University of Chicago Press, 2007); Barbara Maria Stafford (ed.), *A Field Guide to a New Meta-Field: Bridging the Humanities–Neuroscience Divide* (Chicago: University of Chicago Press, 2011); and Mark Turner (ed.), *The Artful Mind: Cognitive Science and the Riddle of Human Creativity* (Oxford: Oxford University Press, 2006).

144. For an overview, see Phillip J. Ethington, 'Sociovisual Perspective: Vision and the Forms of the Human Past', in Barbara Maria Stafford (ed.), *A Field Guide to a New Meta-Field: Bridging the Humanities–Neuroscience Divide* (Chicago: University of Chicago Press, 2011), pp. 136–41.

145. On functional specialisation of different areas in the brain as related to visual perception pertinent to the study of art, see Margaret S. Livingstone, 'Art, Illusion and the Visual System', *Scientific American* 258(1) (1988): 68–75; Semir Zeki, *A Vision of the Brain* (Oxford: Blackwell, 1993); Semir Zeki and M. Lamb, 'The Neurology of Kinetic Art', *Brain* 117 (1994): 607–36; Semir Zeki, 'Art and the Brain', *Daedalus* 127(2) (1998): 71–103; Semir Zeki, *Inner Vision. An Exploration of Art and the Brain* (Oxford: Oxford University Press, 1999).

146. Zeki, 'Art and the Brain', pp. 75–6.

147. Sabra, 'Ibn al-Haytham's Revolutionary Project', p. 104 (emphasis added).

148. Livingstone, *Vision and Art*, pp. 46–7.

149. Quoted in Cynthia Robinson, *In Praise of Song. The Making of Courtly Culture in al-Andalus and Provence, 1005–1134 AD* (Leiden: Brill, 2002), p. 54.

150. Dodd et al., *The Arts of Intimacy*, p. 56. Lapis lazuli for blue pigment and mercury sulphide (that is, either vermillion or cinnabar) for red pigment have been discovered in the plasterwork of another *taifa* palace in Balaguer (Lerida), thus corroborating the use of these traditional minerals for architectural decoration. See Ramon Solé Urgellés and Carme Alós Trepat, 'Restoration of Islamic Arch Fragments from the Palace of Balaguer (Lérida). Process and Historical Data', *I Congreso Internacional (REMAI)*, Actas, pp. 650–1, available at: http://remai.alhambra-patronato.es/es/content/actas-del-congreso-remai, last accessed 15 December 2013.

151. Livingstone, *Vision and Art*, pp. 36–67.

152. Valérie Gonzalez, *Beauty and Islam. Aesthetics in Islamic Art and Architecture* (London: I. B. Tauris, 2001), p. 85.

153. Bevil R. Conway, Akiyoshi Kitaoka, Arash Yazdanbakhsh, Christopher C. Pack and Margaret S. Livingstone, 'Neural Basis for a Powerful Static Motion Illusion', *Journal of Neuroscience* 25(23) (2005): p. 5652; Donald D. Hoffman, 'The Interaction of Colour and Motion', in Rainer Mausfeld and Dieter Heyer (eds), *Colour Perception: Mind and the Physical World* (Oxford: Oxford University Press, 2003), pp. 361–77.

154. Conway et al., 'Neural Basis for a Powerful Static Motion Illusion', pp. 5651–6.

155. Bice Curiger, *The Expanded Eye: Stalking the Unseen*, exhibition catalogue, Kunsthaus, Zurich, 16 June–3 September 2006 (Ostfildern: Hatje Cantz Verlag, 2006), p. 12. Curiger considered this effect as one of the main features of the works of Op art. For a discussion of the connections between Op art and the use of colour in the Alhambra,

see an early version of this chapter, Olga Bush, '"Designs Always Polychromed or Gilded": The Aesthetics of Color in the Alhambra', in Sheila Blair and Jonathan Bloom (eds), *And Diverse Are Their Hues: Color in Islamic Art and Culture* (New Haven, CT: Yale University Press, 2011), pp. 53–75.

156. Livingstone, *Vision and Art*, pp. 158–61.

157. Mariana Kalaitzidou and Naima Anahnah, 'Universo decorativo en la Alhambra', *El legado andalusí* 27(7) (2006), p. 65.

158. Rubio Domene, *Yeserías de la Alhambra*, p. 213. See also Medina Flórez and García Bueno, 'Técnica pictórica', p. 13; and Cardell-Fernández and Navarrete-Aguilera, 'Pigment and Plasterwork Analyses', p. 172.

159. Rubio Domene, *Yeserías de la Alhambra*, pp. 181–6, 210–14.

160. Cardell-Fernández and Navarrete-Aguilera, 'Pigment and Plasterwork Analyses', p. 173.

161. Fernández-Puertas *The Alhambra*, p. 406.

162. López Pertíñez, *La Carpintería*, p. 85.

163. Bernabé Cabañero Subiza and Valero Herrera Ontañón, 'La techumbre de la ampliación de al-Hakam II de la mezquita aljama de Córdoba. Análisis técnico y estudio formal de su policromía', *Cuadernos de Madinat al-Zahra*, 5 (2004): 391–412.

164. Jones, *Decorative Ornament*, p. 165 (original emphasis).

CHAPTER TWO

Addressing the Beholder: The Work of Poetic Inscriptions

Poetry creates out of ignoble material inventions of transcendental value; and acts in such a manner as to make you believe that alchemy is truthfully capable of performing what is claimed for it, and that the miracle of [the] philosopher's stone is true and credible – save that these operations are in the case of poetry operations which involve man's imagination and understanding rather than the body or the senses.

'Abd al-Qāhir al-Jurjānī (d. 471/1079)[1]

I

Visitors to the Alhambra need not understand Arabic to remark that nearly every architectural member and architectural surface – whether in carved stucco, marble, wood or ceramic tile mosaics – is embellished with inscriptions: well over 3,000 inscriptions in all (Figure 2.1). For their part, scholars have compared the palatial city with an open book, or as Puerta Vílchez has proposed, the Alhambra is 'literally, textual architecture', adding that the inscriptions 'become the very infrastructure of the building'.[2] Inscriptions with votive phrases, verses from the Qur'ān and the dynastic motto abound in the Alhambra, as in other monuments of Islamic architecture. What is distinctive in the Alhambra is the abundant use of poetic epigraphy.

Distinctive but, I hasten to add, not unique, as has sometimes been asserted. Textual sources attest that, as early as the 'Abbasid period, verses in Arabic adorned the palace of al-Ma'mūn b. Hārūn al-Rashīd (d. 218/833) in Baghdad.[3] Centuries later, the practice was found in the Ghaznavid palace of Mas'ūd III at Ghazna, as demonstrated by architectural fragments with verses inscribed in Persian,[4] and further examples of Persian poetic epigraphy at the Seljuq palace of 'Alā' al-Dīn Qayqubād I (r. 616–34/1220–37) known as Qubadabād (or Qayqubādiye) erected west of Konya.[5] The inscription of poetry *in Arabic* crossed over to Christendom at the important interface of the palaces of King Roger II (r. 1130–54) in Palermo and Messina in Norman Sicily.[6] Although no longer standing, the palace of al-Ma'mūn, a ruler of Toledo during the *taifa* period, offers the

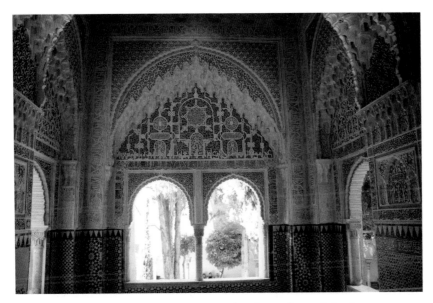

Figure 2.1 *Mirador de Lindaraja, central niche, Palace of the Lions, Alhambra (photograph: Olga Bush)*

earliest known instance of poetic inscriptions on architecture in Muslim Iberia.[7]

Poetic epigraphy played a performative function in palatial settings, whether recited before or after its inscription on the architectural fabric. The Nasrid court poet Ibn Zamrak declared that in his thirty-seven years of service at the court of Muḥammad V, he wrote sixty-six panegyrics or *qaṣāʾid* 'intended for many ... celebrations'.[8] As Matthew Canepa states in his study of the pre-Islamic royal Iranian epigraphy in the built environment, recitations and even royal proclamations not only 'continually enlivened and reinvigorated the significance of inscriptions in the mind of viewers (though not necessarily "readers")', but also represented the 'royal efforts to communicate and fix the cultural understanding of the visual experience of an inscription'.[9]

Within that long tradition, the frequent use of poetic inscriptions in the Alhambra is evidence for the importance of this feature in the aesthetics of the palatial complex. A new consideration is now in order and has been greatly facilitated by Puerta Vílchez' painstaking transcription and architectural contextualisation of all of the inscriptions, whether poetry or prose, throughout the palatial precincts. Not that the poetry has been overlooked, but rather its study has often been limited by an unquestioned presupposition that the poetic inscriptions were intended by the poets who composed them to be understood by the craftsmen who inscribed them, and read by beholders in Nasrid times, as literal descriptions of the rooms in which they appear. I will argue instead that the key to understanding

the work of the poetic inscriptions, less self-evident than this may seem, is to read the poetry as poetry. Poems may well include literal description, but it is crucial to look beyond mimesis to account for the uses of the figurative language that is characteristic of and heightened by poetry.

A remark by the philosopher Paul Crowther will help to set the course of study: 'visual art shows different aspects of phenomeno-logical depth, but does not *speak* them'.[10] On the contrary, in the Alhambra, and more generally in the Islamic tradition of epigraphy on luxury objects no less than on architecture, visual art does just that: inscriptions give a voice to objects and architecture, guiding the experience of the beholder from surface phenomena to deeper mean-ings. All of the various modes of inscription have much to say about the closely interrelated political and religious contexts in which they originally appeared. Poetic inscriptions play a particular role in articulating the aesthetics of visual experience. To recall the terms of Ibn al-Haytham explored in the preceding chapter, poetry speaks for the imagination as the necessary bridge between perception and cognition. Poetic inscriptions do this imaginative work in three basic ways, all to be discussed in detail in this chapter and the next: (1) the poetic tropes focus the gaze on interrelationships – between different visual elements, including elements in different media, or between the seen and the unseen; (2) the self-reflexive aspect of figurative language increases awareness of the imaginative processes that lead towards cognition, among them the very process of giving objects and architecture a voice; and (3) poetic reading demands that beholders pause to dwell on the inscriptions, thereby situating them in architectural space and dramatising the visual encounter.

This study will proceed along two tracks, historical and theo-retical. Highly developed theoretical discussions in the field of medieval Muslim poetics inform the workings of poetic tropes, above all metaphor (studied in this chapter), but also other figures of interrelationship in medieval Arabic *badīʿ* poetry (reserved for the following chapter). One crucial trope is employed frequently enough in the Alhambra to constitute something of a signature of its poetic inscriptions: prosopopoeia, that is, the figure of speech in which a first-person voice is attributed to an inanimate object (e.g., a pyxis, a vase, a building). Since prosopopoeia is not theorised in medieval Muslim poetics, it is necessary to supplement the discussion of its function with references to contemporary literary theory, employ-ing due caution about anachronistic and transcultural applications.

The historical issue arises, once again, as a response to the over-statement of the uniqueness of epigraphy, especially poetic inscrip-tions, in the Alhambra. I have already given brief notice of some of the evidence for related architectural inscriptions, but those material remains are scanty, especially for inscriptions in Arabic in Islamic courts, much less specifically Iberian examples. But, as noted above

in passing, architectural inscriptions participate in a much broader Islamic tradition that includes the practice of inscribing luxury objects, whose history will be outlined in somewhat more detail in the following pages. That inter-medial tradition supports my over-arching methodological proposal that to understand the Alhambra as a living environment requires a consideration of the relationship between architecture and the other arts that would have made for an integrated aesthetic experience. To that end, this chapter focuses on a pair of poetic inscriptions in the architectural setting of the room known today as the Sala de la Barca, but I will also turn to certain inscribed Nasrid luxury objects to illustrate how metaphor and prosopopoeia operate.

2

The Sala de la Barca forms part of the throne-complex of the Palace of Comares, one of the two largest extant Nasrid palaces in the Alhambra (Figures 1.3: 21 and 2.2). It has received insufficient study from scholars, who have devoted their attention to the adjoining and more magnificent reception hall, the Hall of Comares, for which it serves as an anteroom. The original name for this space has been lost. In the one pertinent designation from Nasrid times, the sultan Yūsuf III (r. 810–20/1408–17) refers to it as *bāb al-bayt* or 'door of the house'.[11] The long-standing Castilian name has been supposed to be an alteration of the Arabic word '*baraka*' or 'blessing'. As the preced-ing discussion of colour will have suggested, there have been other, architectural deformations. The original wooden ceiling of the Sala de la Barca in the shape of an inverted boat (*barca*, 'boat' in Spanish, is another possible origin for the modern name of the room), for instance, was destroyed in a fire in 1890, and replaced by a replica in 1965.[12] But to set both the Nasrid design and the current state of the Sala de la Barca in the course of the history of deterioration, deliber-ate destruction and sometimes misguided efforts at preservation and restoration in the Alhambra, it is necessary to view it within the larger context of the Palace of Comares.

No change in the Alhambra has been more far-reaching than the construction of the Palace of Charles V, which impinges directly and deliberately upon the Palace of Comares (Figures I.3 and I.4: nos 31–33). Started in 1533 in the generation immediately following the final defeat of the Nasrids, and abandoned, unfinished, in 1637, the Palace of Charles V is nonetheless the largest standing structure within the Alhambra today, obliterating whatever may have been the pre-existing buildings and streets on its site beneath its enormous, imperial footprint (Figure I.6).[13] It abuts the south side of the Palace of Comares, which, consistent with a well-established typology of pala-tial architecture of al-Andalus, is organised around a large rectangu-lar courtyard, the Court of Comares (north side: 36.60 m × 23.50 m;

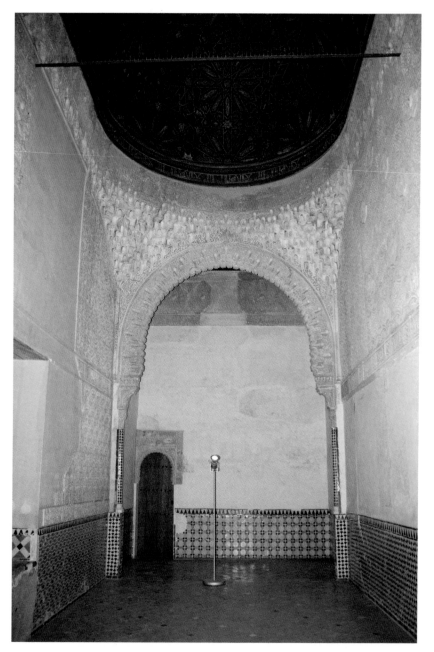

Figure 2.2 *Sala de la Barca, interior, looking west, Palace of Comares, Alhambra (photograph: Olga Bush)*

south side: 22.95 m) (Figure I.3: nos 19–24; Figures 2.3 and 2.4). The courtyard is enclosed on all four sides by adjoining palatial precincts, but on the south side the Palace of Charles V literally lops off Nasrid dependencies.

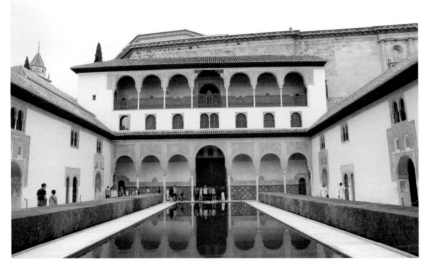

Figure 2.3 *Court of the Myrtles, south portico with the Palace of Charles V abutting it, Palace of Comares, Alhambra (photograph: Olga Bush)*

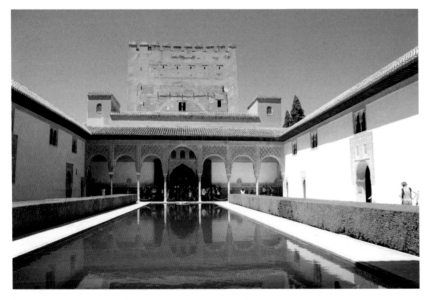

Figure 2.4 *Court of the Myrtles, north portico and the Tower of Comares, Palace of Comares, Alhambra (photograph: Olga Bush)*

In one sense, though one sense only, the loss is relatively modest, for the precincts on the remaining three sides were not affected by the new construction. Charles V's builders respected the design of the patio, framed by a colonnaded portico on both of its short, that is, north and south sides. A long rectangular pool (34 m × 7.1 m) situated on the longitudinal axis of the courtyard and surrounded

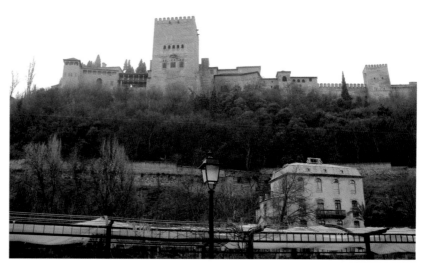

Figure 2.5 *Alhambra, view from the street along the River Darro (Paseo de los Tristes) (photograph: Olga Bush)*

by wide, marble walkways, emphasises further the north–south orientation of the Palace of Comares, and directs the gaze towards the looming volume of the Tower of Comares on the north side. Dominating the two-storey structures that flank the pool to the east and west, this tower, 45 m high, forms part of the curtain wall of the palatial city. Seen from the urban neighbourhoods along the Darro River and the Albayzín hill to the north, the Tower of Comares would have appeared as the most imposing feature of the Alhambra's profile in Nasrid times (Figure 2.5). It remains so today when looking at the Alhambra from below. From the crown of the Albayzín hill, however, it is rather the sheer size of the Palace of Charles V that dominates the palatial city (Figure I.2).

The destruction suffered by the Palace of Comares is devastating in a different sense. Further typological considerations can begin to give the measure of the loss. The Hall of Comares presents the outstanding Nasrid example of the *qubba* type with regard to its dimensions (11.3 m × 11.3 m; 18.2 m high) and elaborate decoration in various materials of vibrant colours: ceramic tiles, carved stucco, marble and wood (Figure 1.3: no. 23; and Figure 2.6). The main feature of its plan are the three tall, deep niches set within the west, north and east walls, which, through their arched double-light windows, open onto splendid vistas of the city and the surrounding landscape. The upper elevation of the interior on the west, north and east sides is fenestrated by five large windows that provide a filtered light through carved marble screens and lead the eye to the soaring wooden *artesonado* cupola.

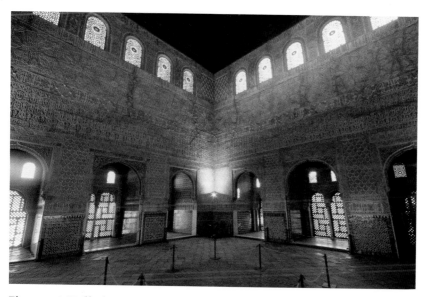

Figure 2.6 *Hall of Comares, interior, Alhambra (photograph: Olga Bush)*

There has long been scholarly consensus that, as the superlative *qubba* in the Alhambra, the Hall of Comares functioned as a reception hall for the highest state occasions. That view is reflected in its popular name, the Hall of the Ambassadors, which the *qubba* acquired in the post-Nasrid period. That interpretation of the function of the hall has been reinforced by the inscription of verses from *sūrah* 67, *al-Mulk* ('Dominion'), which appears on the cupola. The text in itself does not make for definitive evidence, since verses from *sūrah* 67 were often inscribed in the interiors of mausoleums during the medieval period, and, less frequently, in mosques, to various effects.[14] However, in this instance, that Qur'ānic inscription may be read in combination with the seven rows of radiating stars in the decoration of the cupola, which have been understood by scholars as a representation of seven heavenly spheres, to depict Yūsuf I as a divinely-guided ruler.[15] The image is made explicit in the poem inscribed on the central niche of the Hall of Comares, whose final verses state: 'My Lord Yūsuf [I] . . . transformed me into the throne of the kingdom (*kursī al-mulk*).[16] The Qur'ānic and poetic inscriptions, taken together with the elaborately decorated, lofty interior have led to the conclusion that the Hall of Comares would have been a space for royal audiences.

This explanation of the function of the hall reflects back on the Palace of Comares as a whole. At present, the visitor gains access to the Court of Comares through a circuitous route: from the street entrance to the *mishwār* or council chamber, crossing the precinct of the Cuarto Dorado and passing into the court by way of a modest entrance arch at the court's northwest corner (Figure 1.3: no. 12 – street entrance to the *mishwār*). The Christian builders

added an alternative entry through an oblique passageway leading down an inconspicuous, covered flight of stairs that connect the Palace of Charles V to the courtyard in the southwest corner. Neither the one nor the other is consistent with the grandeur and axial organisation of the Palace of Comares and what would have been a fitting court ceremonial, oriented by the architectural typology to proceed from a main entrance at the south end of the palace along the longitudinal axis on one or the other of the marble walkways parallel to the reflecting pool, and culminating in a royal reception in the Hall of Comares. There are no extant forms of documentation on which to base a reconstruction of the south wing of the Palace of Comares. What is certain, however, is that by closing off the south side of the Nasrid palace, the function of the Palace of Comares as the approach to Muslim *dominion* was eliminated, even if much of its beauty was preserved.

All the more reason, then, to attend carefully to the pivotal role of the Sala de la Barca in the construction of ceremonial space in Nasrid court ritual, since all access to the Hall of Comares would have necessarily passed through this space. Situated just inside the portico on the north side of the reflecting pool, it mediates between the exterior, open-air Court of Comares and the highly embellished interior of the Hall of Comares. It is generally accepted that the Palace of Comares was constructed in two phases: the Tower of Comares and its reception hall, initiated by the sultan Yūsuf I, were finished by 755/1354, the date of the sultan's assassination; the Court of Comares with its precincts was completed around 772/1370 under the patronage of his son, Muḥammad V.[17] The Sala de la Barca, the room that links the Tower of Comares with the courtyard, was one of the first rooms to be completed in the expansion of the palace by Muḥammad V (Figure 1.3: no. 21). The inscriptions in the room's interior omit Muḥammad V's *laqab*, or honorific title (al-ghanī bi-llāh or 'He who is content through the help of God'), which he adopted at the end of 769/1367, hence, the room has been dated prior to that year.[18] The original state of the space as conceived under Yūsuf I can no longer be re-established.

Puerta Vílchez emphasises the role of poetry in the overall design of the Palace of Comares when he maps the plan of what he calls its 'poetic axis', relating various spaces along the longitudinal axis of the palace in a coordinated epigraphic programme.[19] Starting from the south end of the Court of Comares, the inscriptions include: (1) two short poems by Ibn Zamrak in the niches of the central arch of the south portico (preserved in his *dīwān* only); (2) short devotional poems, also by Ibn Zamrak, in the doorways leading to lateral dependencies along the east and west sides of the court; (3) selected verses from two long panegyrics composed by Ibn Zamrak, one recited during the 764/1362 *mawlid* in the Alhambra, the other celebrating Muḥammad V's victory in Algeciras in 770/1369, inscribed

on the wall's north portico; (4) two poems by Ibn Zamrak in the entrance arch of the Sala de la Barca, and two additional poems that were inscribed in the room's interior, but have only been preserved in the poet's *dīwān*; (5) two poems by Ibn al-Khaṭīb inscribed in the archway of the Hall of Comares; and (6) the poem composed by either by Ibn al-Jayyāb or Ibn al-Khaṭīb and inscribed within the central niche of the Hall of Comares, previously cited in support of the argument that the large *qubba* served as a throne hall.[20]

It should be noted that the verses in the north portico were repeated in the south portico in the course of nineteenth-century restorations, whereas Ibn Zamrak's *dīwān* indicates that different verses had been selected and inscribed in the south portico.[21] I reserve further consideration of Ibn Zamrak's inscriptions on the north portico in the Court of Comares for the discussion of the celebration of the *mawlid* in the Alhambra in the final chapter. Here, the focus is on the Sala de la Barca as a case study for the analysis of poetic inscriptions in relation to their architectural context, and, ultimately, for what they suggest about the dynamics of court ceremonial.

3

The Sala de la Barca is a long rectangular room that measures 24.05 m × 4.35 m, standing perpendicular to the main, north–south axis of the courtyard.[22] Large lateral alcoves, framed by an arch, terminate the room on its short, west and east walls and could have served as a sitting space (Figure 2.2). Such alcoves present a common feature in the Alhambra precincts and may be found, for instance, in the Hall of Two Sisters in the Palace of the Lions, as well as in the north portico of the Court of Comares itself. The present-day ceiling is a replica, as already noted, and some of the dadoes of ceramic tile mosaics also date to the nineteenth century. Great expanses of the walls have lost their decoration, but the original carved stucco panels have been preserved on the upper walls (Figure 1.10). The remaining decoration suggests that the design of the Sala de la Barca, as we know it today, adhered to the model found in numerous rooms in the Alhambra: walls embellished with dadoes of ceramic tile mosaic in the lower part, and carved stucco decoration, assembled from individual panels, on the upper walls. As in other precincts, the stucco decoration was composed of bands in which a lozenge-based grid filled with vegetal motifs was crowned by a band with radiating stars that formed a geometric interlace. Epigraphy was employed profusely in bands and cartouches, stars and medallions, overlaying floral and geometric forms.

The entrance arch of the Sala de la Barca, like the arches that frame entrances and fenestration in other precincts in the Alhambra, is executed in carved stucco, and its intrados is composed of several rows of *muqarnas* (Figure 2.7). Resting on small, engaged decorative

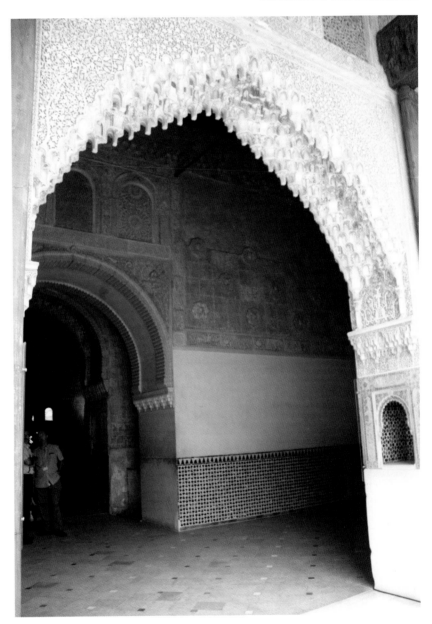

Figure 2.7 *Entrance arch, Sala de la Barca, Palace of Comares, Alhambra (photograph: Olga Bush)*

columns, a row of *muqarnas* at the north and south extremities of the intrados form the arch's distinct, sharply delineated profile. The spandrels of the arch are embellished with delicately carved spiralling arabesques of profuse foliage. The arch's imposts are decorated with several rows of *muqarnas* as well, forming a projecting cornice supported by minute pilasters. Like the intrados, the elements of the

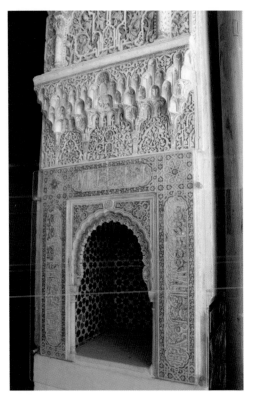 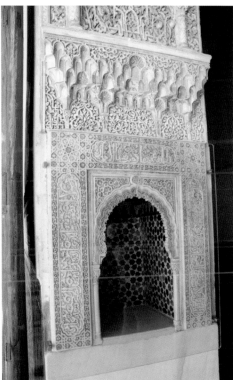

Figure 2.8 (left) *Niche, east side, entrance arch to the Sala de la Barca, Palace of Comares, Alhambra (photograph: Olga Bush)*

Figure 2.9 (right) *Niche, west side, entrance arch to the Sala de la Barca, Palace of Comares, Alhambra (photograph: Olga Bush)*

imposts were carved with foliate forms. Traces of vivid polychromy – red cinnabar, blue lapis lazuli, green and gold leaf – are visible on the individual *muqarnas* and other decorative elements, in keeping with what I have proposed as the generally multi-coloured decoration of the Alhambra in Nasrid times. A small lateral niche, cut into the jamb below the *muqarnas* cornice on either side, completes the entrance arch (Figures 2.8 and 2.9). The niches are framed by a poly-lobed arch that rests on marble columns and, in turn, is surrounded by a rectangular frame or *alfiz* – a decorative device used widely in the architectural decoration of the Alhambra to accentuate windows, doors and niches.[23] The back wall within both niches is embellished with polychromed mosaic of ceramic tiles cut in polygonal shapes and forming a geometric composition.

The rich decoration of the entrance arch visually heightens its significance as a physical threshold between the outdoor space of the courtyard and the interior of the reception hall, across the narrow span of the Sala de la Barca. The graceful, undulating stems with

abundant foliage that expansively cover the arch's spandrels recall vegetation rippling under a light breeze, such as would have been enjoyed in the gardens of the palaces, filling them with colours and perfumed air. And the vivid colours of the pattern of radiating stars in the geometric tile mosaics in the small lateral niches would have recalled the canopy of the star-studded sky above the courtyard just outside and its architectural counterpart in the reception hall, that is, the great *artesonado* ceiling with its seven rows of radiating stars.

The niches are empty today. In this respect, they present a miniature version of all precincts in the present-day palaces – empty rooms, halls and courtyards, completely devoid of furnishings. Yet everything we know about life at medieval Muslim courts, and indeed court life elsewhere and virtually at all times, suggests that the Nasrid Alhambra would have been fully outfitted, right up to the niches, with luxury objects of the decorative arts. The absence of such objects in situ, like the dearth of Nasrid documentary evidence, has diverted scholarly attention from that fundamental premise. The poetic inscriptions speak for that inter-medial experience. The Sala de la Barca is exemplary in this sense, too, in that here is a rare case in which scholars have in fact turned to the poetic inscriptions to answer the question of what was inside the niches, though the approach has been limited to a mimetic reading that calls for expansion.

Before taking up the evidence of that inter-medial aesthetic, I need to set the poetic inscriptions in the broader context of the epigraphy in the Sala de la Barca and the Alhambra at large.[24] The question of legibility immediately arises. Hence, I note that the poetic inscriptions in the entrance arch of the Sala de la Barca and those that once framed large rectangular recesses on the south wall of its interior – only their fragments have been preserved[25] – appear at eye-level, a placement that facilitates reading and one that is consistent with the use of poetic epigraphy in other palatial sites. In the palace of Masʿūd III at Ghazna, the poetic inscriptions were plainly visible at waist level.[26] Most likely the same was true of Ibn Hūd's Aljafería palace in Zaragoza.[27] In the case of the palace of al-Maʾmūn in Toledo, the courtier Ibn al-Khabīr recorded that the poetic inscriptions 'could be read from a large distance'.[28] The other epigraphic modes – votive and formulaic inscriptions, on the one hand, and Qurʾānic inscriptions, on the other – are abundant in the Alhambra, including the Sala de la Barca, and more widely distributed in the visual field of the decoration.[29] But those other inscriptions differ from the poetic inscriptions precisely with regard to the process of reading.

Votive words and formulaic phrases, which are inscribed repeatedly throughout the precincts of the Alhambra, are executed either in Kufic or *naskhi* script, both in this space and elsewhere. Within the immediate area around the lateral niches in the arch of the Sala de la Barca, for instance, the plainly visible votive inscriptions include 'blessing' (*baraka*), '[good] health' (*ʿāfiya*), '[good] fortune' (*al-yumn*),

and a formulaic phrase in praise of Allāh, namely, 'Allāh provides in all adversity' (*Allāh 'dda li-kull shidda*). Some of the inscribed words and phrases are carved, while others are painted, and many of them are repeated on various elements, including the minute *muqarnas*.

The dynastic motto, which is employed profusely in the embellishment of Nasrid arts and architecture, especially in the architectural decoration of the Alhambra, appears twice above the niches in the arch in the Sala de la Barca. The Nasrids adopted the first statement of the *shahādah*, the attestation of faith, as their motto; it reads: '*wa-lā ghālib illā Allāh*' ('There is no conqueror, but God'). While it is not a verse from the Qur'ān, the declaration is linked to the Qur'ānic verses in which the unity of God is revealed and proclaimed: 'There is no god, but I, so worship Me' (21:25) and 'God bears witness that there is no god but He' (3:16).[30] Upon encountering the oft-repeated Nasrid motto in the epigraphy, any Muslim beholder would have recognised it as the first part of the *shahādah* and would have completed it mentally with the second statement, 'Muḥammad is the messenger of God', thereby constantly reaffirming the faith as part of the visual experience. Where Qur'ānic verses were inscribed in the Alhambra, the process would have been the same. Familiar to, or memorised by, the Muslim beholder, the Qur'ānic inscriptions, like the Nasrid motto, would have been *recognised* even before and perhaps instead of being *read*. The very frequency of the repetition of the Nasrid motto in the epigraphy of the Alhambra – sometimes dismissed as mere redundancy – would have favoured the process of recognition above reading.

While acknowledging the conjectural nature of an argument for a particular reception by readers, where no accounts of actual reading experience are available, it is nonetheless possible to contrast the use of votive inscriptions to poetic epigraphy, following a line of thought similar to the preceding discussion of the inscriptions of the dynastic motto and Qur'ānic verses. Jeremy Johns has argued that votive words and phrases like '[good] fortune' (*al-yumn*), 'power' (*al-mulk*) and 'blessing' (*baraka*), among others, which appear in the epigraphy in the royal palaces in Norman Sicily, served to supplement 'official protocol'.[31] He proposes that these inscriptions were abbreviations for longer formulas that were well known and readily understood. For example the inscription 'blessing' would have evoked in the reader the longer, though no less formulaic expression, 'a blessing of God upon its owner'. Whether or not a precise repertoire of longer formulas was the subtext of the votive inscriptions in Norman Sicily, the Alhambra or other medieval courts, John's argument is suggestive.[32] The very brevity of votive inscriptions indicates that they would have been read in an instant and that their full meaning would have been the result of inference or the recall of a familiar phrase already committed to memory; in other words, the meaning was not limited to the reading experience itself.

The reading of poetic inscriptions is necessarily different, since the beholder must linger in order to understand the verses. The Nasrid viziers who composed the poetic epigraphy for the Alhambra – Ibn al-Jayyāb, Ibn al-Khaṭīb and Ibn Zamrak – were held in high esteem as the most distinguished court poets, and their work would have been widely known. Even so, in contrast to the recognition of inscribed Qurʾānic verses, a beholder who encountered a poem inscribed on a wall could not have grasped its meaning at a glance. The key to reading poetic inscriptions is cognition, not recognition. The poems are not remembered, but read, and thus the process of reading is dilated, not deliberately truncated and fleeting. In keeping with the psychological dimensions of Ibn al-Haytham's theory of visual perception, a reading of 'letters of script' or calligraphy requires concentration and con-templation.[33] One might say then that the all but instantaneous move from perception to cognition in the case of Qurʾānic and votive inscriptions is expanded, in the case of poetic epigraphy, by calling attention to and exercising the intermediary stage of imagination.

4

The Sala de la Barca offers itself as an exemplary case of the use of poetic epigraphy for several reasons. First, the two poems that appear there, both composed by Ibn Zamrak, are placed symmetrically within the cartouches of the *alfiz* of the lateral niches on either side (east and west) of the entrance arch. The symmetry in their place-ment extends to their imagery, structure and meaning, giving evi-dence of a coordinated decorative design. Second, the typology of the throne complex of the Palace of Comares – a T-shaped conjunction of a *qubba* and an extended, transverse anteroom – marks the Sala de la Barca as a threshold space. Thresholds articulate movement through architectural space by heightening awareness of boundaries and their crossing, often by indicating, or even obliging, a temporary halt in the movement from one space to another – in this case, from the outdoor courtyard to the interior of the reception hall. Threshold spaces, therefore, are mediators, in Grabar's sense, and poetic epig-raphy, I shall argue, articulates in turn that mediating function. The task ahead, then, is to examine the ways that poetry accomplishes that work of mediation, above all by studying in detail the ways in which poetic figures guide the beholder's experience of architectural space and its decoration.

The two poems, each executed in *naskhi* script, and both appear-ing at eye-level, would have been easily legible to the cultivated Nasrid beholder. They are short enough to quote here in full. The poem that frames the niche on the east side reads:

1 I am beautiful and perfect,
 The throne on which the bride is shown.

2 Look (n-ṭ-r) at my water jug, you will know (ʿ-r-f)
 I affirm the truth (ṣ-d-q) in my speech (q-ā-l).
3 Then consider (ʿ-b-r) my crown,
 and you will see the half moon.
4 Ibn Naṣr is the sun in the kingdom,
 brilliant and beautiful.
5 may he remain in such a high position
 safe from the hour of setting.[34]

And the text of the poem that frames the niche on the west side reads:

1 I am a mihrab for prayer
 that indicates the direction of happiness.
2 You believe (h-s-b) that the water jug is standing in it,
 Enacting the prayer,
3 and each time when it finishes
 it's bound to start over again.
4 With my lord Ibn Naṣr
 Allāh honoured his servants,
5 since he descends from the leader
 of the Khazraj, Saʿd b. ʿUbāda.[35]

In each of Ibn Zamrak's poems, the first verse offers an image of the niche itself, introduced by the formula, 'I am'; the second and third verses characterise the contents of the niche, addressing the beholder directly as *you*; and the two final verses refer to the Nasrid sultan in the third person ('he') in the *fakhr*, that is, the traditional culminating section in which the ruler (or the patron of the poem) is lauded.[36] In the other epigraphic modes (votive, formulaic, Qurʾānic), repetition constitutes an act of reaffirmation or reinforcement; in poetic inscriptions it speaks above all for conscious intention. Where even García Gómez tends to dismiss the poetry in the Alhambra as pedestrian due to its redundancy,[37] one might say rather that poetic elements are repeated from poem to poem to underline the relationship between architectural spaces. It is in this sense that the poetic epigraphy constitutes a kind of infrastructure. When one finds that the images in these poems – water jug, bridal throne and astral bodies – not only mirror one another, but also repeat the imagery in the poems by Ibn Zamrak's predecessor as Nasrid vizier and his poetic mentor, Ibn al-Khaṭīb, inscribed, analogously, on each side of the entrance arch to the Hall of Comares just beyond the Sala de la Barca, one may say that the poetic inscriptions are designed to unify the two spaces. Ibn Zamrak's tribute to Ibn al-Khaṭīb is an extension of the poetic programme of the Hall of Comares, just as Muḥammad V's newly built or renovated Sala de la Barca is an extension of the pre-existing architecture of the throne hall built by his father Yūsuf I.

Puerta Vílchez has determined that there were also poetic inscriptions composed by Ibn Zamrak on recesses in the south wall of the Sala de la Barca, which are now lost, except for some fragmentary remains currently housed in the Museo de la Alhambra.[38] The complete texts of two poems have been preserved in the poet's *dīwān*, and the reference in them to the palace as the seat of the caliphate (*khilāfa*), echoing other compositions by Ibn Zamrak dedicated to Muḥammad V, further corroborates the patronage of the Sala de la Barca.[39] The *fakhr* of the verses inscribed around the niche on the west side of the entrance arch underscores Muḥammad V's genealogy as a descendent of Saʿd b. ʿUbāda, a statement that is often used in epigraphy in the Alhambra to extol the Nasrid rulers. It is well to note, however, that even in the *fakhr*, the poems on the west and east niches go beyond the designation of the patron. Muḥammad V's glorified pedigree as stated literally in the west niche is supplemented in the verses on the east niche as 'the sun in his kingdom'. Commonplace though it may be (borrowed here directly from Ibn al-Khaṭīb's fourth verse on the west niche of the entrance to the Hall of Comares, referring to 'the sun of our Lord Abuʾl-Ḥajjāj'),[40] the expression is still figurative, and the figure is *istiʿāra*, metaphor, the chief trope in medieval Muslim poetics.

ʿAbd al-Qāhir al-Jurjānī (d. 471/1079) offers grounds for evaluating and classifying metaphor with regard to 'its degree of exaggeration and fusion between the referents of metaphor, and its remoteness and strangeness'.[41] In the case at hand, the sun is remote enough from the sultan, but the well-worn expression is not strange enough to give the reader pause.[42] Yet, even in such a modest example of poetic craft, the turn to figurative language raises questions about the approach to the poetic inscriptions in the Alhambra as *waṣf*, usually rendered as 'description', with the implication that *waṣf* meant only the mimetic reproduction of reality.

Originally an independent literary form that was later incorporated into the tripartite form of the *qaṣīda*, *waṣf* is not limited to mimesis. As literary theorist Ibn Rashīq al-Qairawānī (d. c. 458/1065) argued, the purpose of *waṣf* was not only to reflect but to transform: *waṣf* should enable those who *listened* to a poetic recital to *envision* the object described; thus, the literal act of hearing (*sam*) would be transformed into the imaginative act of seeing or vision (*baṣar*).[43] In the case of the *fakhr* section of these poetic inscriptions in the entrance arch of the Sala de la Barca and other poems, the transformation appears in as much as *waṣf* describes in order to praise.[44] Indeed, the term *waṣf* derives from a verb whose first form, *waṣafa*, in addition to meaning 'to describe; to characterise', also signifies 'to praise, laud, extol'.

As early as the ʿAbbasid period, writers such as al-Fārābī (d. 339/950), Ibn Abī ʿAwn (d. 322/933) and al-Jurjānī identified poetry with a

combination of mimesis or imitation (*muḥākāh*) and imagination (*takhyīl*). The image of the water jug that appears in the second verse of the inscriptions on both the eastern and western niches of the Sala de la Barca illustrate the point. A note in Ibn al-Khaṭīb's *dīwān* states that his poems were composed and then 'written in the niches for water' in the royal *qubba* of Yūsuf I (*al-qubba al-sulṭāniyya al-yūsufiyya*), which is to say, the Hall of Comares.[45] That testimony offers strong support for the reading of Ibn Zamrak's references to water jugs in the same way, as literal descriptions of the contents of the niche. However, as with the naming of Ibn Naṣr in the *fakhr* of each poem, the indication of the water jug does not stand as an isolated, self-sufficient image in either poem, but rather forms part of a metaphor that carries meaning beyond mimesis.

The point is not to dispute the inference that the two niches held water vessels. Metaphor neither denies nor replaces literal meaning, but adds to and transforms it. When the poetic inscription claims to 'affirm the truth', as on the east niche of the Sala de la Barca, the poetic truth is more than meets the eye. Or to put the relationship between imitation and imagination in al-Jurjānī's terms, a poet 'affirms something which is not certain at the outset, and makes a claim which cannot be verified, and says something by which he deceives himself and *makes himself see what he sees not*'.[46]

The opening verses of the poem on the west are especially apt for showing the limitations of reading the poetic inscriptions simply as a caption designating the contents of the decoration, since the function of pointing is made explicit there ('that *indicates* the direction of happiness'). As every Muslim beholder would know, whatever the direction of happiness may be, a *mihrab* points to Mecca and, in al-Andalus, should stand in the east. While errors in *qibla* calculations are common in Islamic architecture, the evidence is near at hand that in this case the accurate orientation was well understood. Moving past the niche through the Sala de la Barca towards the Hall of Comares, one finds a small, private oratory situated in a narrow corridor with a literal *mihrab* – on the east wall, of course. So one may well return to the inscriptions on the west niche prepared to entertain the possibility of a metaphoric reading of the sort familiar to the courtier class in Nasrid times, steeped in Arabic poetry.

Following Aristotle closely, medieval Muslim poetics presents metaphor as an alternative route to a higher truth than is attained by means of analogy.[47] In its most complete form, metaphor articulates the analogy as a four-part correlation. For example, in the poem inscribed on the east niche of the Sala de la Barca, the water jug is to the niche as a bride is to her throne. The visual resemblance between a niche and a throne as places with a flat, horizontal surface and a backing upon which a vessel or a person might be 'seated' enables the analogy. The work of understanding requires the further cognitive

step of transferring attributes between the water jug, present to
sense perception, and the bride, present only to the imagination. The
unspoken term that is transferred would be something like 'exalted':
the no doubt luxuriously crafted vessel in the niche is exalted above
other water jugs as a bride is exalted above other women. Al-Jurjānī
coined the term 'form [sūrah] of meaning' to speak of the process
whereby metaphor comes 'to express an intellectual concept by
analogy with a visual object'.[48] He explains: 'Objects are said to be
analogues not because they possess the same quality in differing
measures but because they each bear to some other object a similar
relation. Thus God may be said to bear the same relation to his
personality as man does to his, though the two objects described as
personality differ profoundly.'[49] The luxury ceramic object and the
bride may both be beautiful, but what exalts the vessel above other
vessels are artistic values, whereas the bride is exalted by her virtue.
In like manner, the poet draws on the visual resemblance between
the tilting of the water jug to pour forth water, followed by its return
to an upright position, and the bending of a Muslim in prayer. It
is the reader who will complete the metaphor by surmising that
the water jug and prayer may have the same relation to happiness,
but the happiness in question is of a different kind in each case. By
imaginatively yoking difference in resemblance through metaphor
(and other poetic figures), the poet leads the reader from perception
(both niche and mihrab appear as concave spaces built into a flat
wall) to contemplation: what is meant by happiness? in what would
true happiness consist?

The relationship between figurative language and truth is all the
more explicit in a poetic inscription on a Nasrid object in another
medium: a small ivory pyxis dated to the late seventh/thirteenth
century or first half of the eighth/fourteenth century and pre-
served in the collection of the Cabildo Metropolitano de Zaragoza
(Figure 2.10).[50] Its shape, size, function and inscribed verses are
indicative of its close relation to models made in the royal work-
shops of the Umayyads of Córdoba.[51] The discussion of this object
offers an example of the principle that a more complete understand-
ing of the Alhambra depends upon an integrated, inter-medial
aesthetic. The cylindrical, flat-lidded pyxis, measuring 9.4 cm in
height and 11.5 cm in diameter, is embellished with bands of carved
and open-work decoration with interlace and geometric motifs.
The silver fittings with a lock are decorated in filigree technique
with floral elements and the repeated word al-mulk, 'dominion',
seen often in the decoration of the Nasrid arts and especially in the
Alhambra. The patronage and occasion for the production of this
elaborate luxury object have yet to be determined, but the use of that
formulaic inscription, as previously suggested, implies a fuller state-
ment (e.g., a wish for continuing rule) easily comprehensible to the
beholder/recipient in its original ceremonial context.

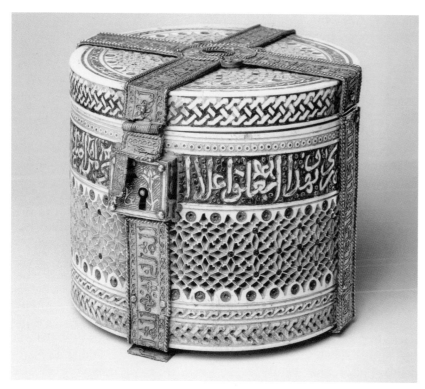

Figure 2.10 *Pyxis, ivory, silver, paint and gold leaf, height 9.4 cm, diameter 11.5 cm, Spain or Egypt, seventh–eighth/thirteenth–fourteenth century. Catedral Basílica del Pilar, Cabildo Metropolitano de Zaragoza, Zaragoza (photograph: courtesy of Catedral Basílica del Pilar, Cabildo Metropolitano de Zaragoza)*

A wide band on the body of the pyxis is inscribed with verses that read:

> Truth (ḥ-q-q) is in me like something stored in a pyxis (ḥ-q-q)
> and they say faithfulness is my share in life.
> Never did I betray this confidence [in me].
> Thus my name soared so I serve only the great.[52]

With no other extant documentation than the verses themselves, the final line now expresses what may well have been an unintended paradox. Despite its soaring nature, the name of the person referred to is not preserved. The identity of the *I* of the poem would have been familiar to at least a small circle, and might well have been made known in a public ceremony, if the luxury object were given as a gift at court. But even were the mystery of 'my name' resolved, the relationship between fidelity and truth would remain: whether giver or receiver, poet, reader or the pyxis itself, the faithful *I* is true by revealing only *that* it conceals, not *what* it conceals. Where *waṣf*

opens secrets and points to contents, metaphor and other poetic figures are containers – the word used for 'pyxis' in the inscription is etymologically related to 'truth' – holding back or covering up as much as they hold forth and reveal.

Responding to a misreading of Ibn al-Haytham's optics that was based on the Western pictorial tradition, and also Western prejudices that reduce 'the coexistence of different modalities of gazing' in Islamic art to 'a monolithic Islamic way of seeing or mindset', Gülru Necipoğlu argues on two fronts.[53] On the one hand, against the mistaken assertion of a thoroughly aniconic tradition, she explains wide-ranging theoretical discussions in the medieval and early modern Islamic world in favour of mimetic representation. On the other hand, she articulates the alternative of a 'contemplative gaze', explicitly grounded in Ibn al-Haytham's work and associated with 'the inner (spiritual) senses that complement the outer (corporeal) sense, thereby testifying to the elevated productive and perceptual capacities of humankind'.[54] Correspondingly, it may be said that the poetic mode of *wasf* tells the truth of the outer senses, whereas poetic figures like metaphor work to give expression to a hidden inner truth *stored* in the objects of sensory perception, but accessible only through the imagination. The deceit or fiction of metaphor at the surface level, then, is a truth of a different order and at a greater depth. Philosopher Paul Ricoeur summarises the issues succinctly when, in contrast to metaphysical conceptions of truth based on equivalence (this *is* that), he writes that 'the metaphorical "is" at once signifies both "is not" and "is like"'.[55]

5

Even a close reading of metaphor does not exhaust the work of poetic figures in the inscriptions on the niches of the entrance arch of the Sala de la Barca. They also insistently employ the trope of prosopopoeia, whose sign is the use of the first-person voice, but more particularly, the attribution of that voice to an inanimate object. The pyxis provides an illuminating contrast. The speaker of the inscribed verses speaks in the first person – 'Truth is in *me*' – but if I am '*like* a pyxis', it is not the pyxis that speaks (the pyxis is not *like* itself, it *is* itself). Rather, the inscriptions work as a quotation of the discourse of the faithful servant, who keeps secrets, and so is well represented by the carved object and also by the simile in the inscribed verses. In the poetic inscriptions in the Sala de la Barca, on the contrary, the *I* that opens the poem – '*I am* beautiful and perfect', '*I am* a mihrab . . .' is the niche itself.

As noted at the outset of the chapter, prosopopoeia, for all that it is characteristic of the poetic practice of the inscriptions in the Alhambra, was not theorised by medieval Muslim literary critics, either in al-Andalus or elsewhere, and its aesthetic function has gone

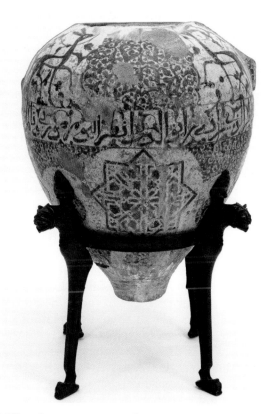

Figure 2.11 *'Alhambra' vase, incomplete, Nasrid period, eighth/fourteenth century, Spain. Freer Gallery of Art, Smithsonian Institution, Washington, DC, F1903.206a–b (photograph: courtesy of the Freer Gallery of Art)*

largely unattended in discussions of Arabic poetry.[56] The way in which this trope works may best be illustrated through the study of an example: for instance, a large, partially preserved Nasrid ceramic vase in the Freer and Sackler Gallery in Washington (Figure 2.11). The choice is also intended, once again, as an example of a different sort, that is, as further evidence of the value of analysis across different media for the understanding of the Alhambra.

Before proceeding to the Freer vase, I offer some brief, general remarks about prosopopoeia. The force of the trope draws upon the first-person voice in two respects. First, *I* is a grammatical shifter, a place-holder for whoever pronounces it, or, as linguist Émile Benveniste succinctly explained: '*I* signifies "the person who is uttering the present instance of the discourse containing *I*."'[57] Second, the use of the 'speaking' *I* always implies a listening *you*, no less a grammatical shifter, whose place may be occupied, for instance, by anyone reading the first-person speech. Given this grammar, and the imaginative attribution of a first-person voice

to an inanimate object by prosopopoeia, wherever the trope is employed in poetic inscriptions, it is as if the object itself – a niche, a wall, a vase – addressed the beholder directly. Prosopopoeia makes for the dramatic, explicit staging of that relationship in an ever-renewed *present* moment when any beholder steps before the inscribed object. Art theorist Jonathan Crary elaborates further as follows: 'the state of being suspended, a looking or listening so rapt that it is an exemption from ordinary conditions, that it becomes a suspended temporality, a hovering out of time . . . It implies the possibility of a fixation, of holding something in wonder or contemplation, in which the attentive subject is both immobile and ungrounded.'[58]

The Freer vase belongs to a group of large lustre vases (ten complete pieces and a number of large fragments) now dispersed in various collections.[59] On account of their stylistic affinities with the architectural decoration of the Alhambra palaces, and the fact that three vases and a group of 129 shards definitely associated with the same objects were actually found or excavated within the Alhambra precincts, they have often been called the 'Alhambra vases'.[60] The archaeological findings establish their use in the palaces, implying royal patronage. The provenance of the vases – whether in the workshops of Granada or Málaga – remains as yet unresolved.[61] On the other hand, their size, between 1.20 m and 1.70 m in height, and their elaborate and costly lustre and cobalt embellishment (or lustre only) leave no doubt that they served a decorative function. Textual evidence between as early as 1465 until the nineteenth century records that visitors to the Alhambra had seen the vases there, confirming that they served as decorative furnishings.[62] When Rafael Contreras made an inventory of the objects in the Alhambra in 1875, only one such vase remained on the site; it is now housed in the Museo de la Alhambra.[63]

Several of the extant vases were inscribed with votive and formulaic epigraphy, such as 'dominion', and 'good fortune and prosperity'. The Freer vase includes a short poetic composition. The collar, neck and wing-like handles seen in other examples are missing, but the tin-glazed earthenware body of the Freer vase, embellished with lustre and cobalt decoration, is preserved and has been dated to the end of the eighth/fourteenth century or the beginning of the ninth/fifteenth century. Despite its pockmarked surface, which is due to the loss of glaze and most of its lustre, the overall decoration gives evidence of its former splendour.

The decorative composition is divided into three bands. In the wide upper band two confronting quadrupeds flank a large central space enclosed by a polylobed frame and filled with delicate spiral tendrils and dense foliate forms. The bodies of the animals bear the votive inscription '[good] health' (*āfiya*) enclosed in a cartouche. In the wide lower band of the vase's body, large, eight-pointed stars

formed by interlace alternate with circular medallions. The stars and medallions stand against the white tin-glaze background, which has a curvilinear outline. The spaces left beyond the outline are filled with irregularly shaped elements, which, like the medallions, are filled in turn with dense arabesques and foliate motifs akin to those in the upper band. The middle or central band is decorated with epigraphy, and, as in the upper band, where sparse tendrils form a foil for the animals, they sparingly fill the spaces between the letters of the text, much as is in the upper band.

The poem inscribed in the band reads:

> O thou onlooker (n-ṭ-r) who art adorned with the splendour of the
> dwelling
> Look (n-ṭ-r) at my shape today and contemplate (a-m-l): thou wilt
> see my excellence
> For I am made of silver and my clothing of blossoms
> My happiness lies in the hands of him who is my owner, under-
> neath the canopy.[64]

Like the pyxis discussed above, this Nasrid vase with its poetic epigraphy participates in a tradition of poetic inscriptions on luxury objects and architecture of very long standing. Despite a claim made by al-Masʿūdī (c. 282/896–345/956), a Baghdad-born historian and geographer, in his *Murūj al-Dhahab* (*Golden Meadows*), that such inscriptions were an ʿAbbasid innovation from the middle of the third/ninth century,[65] the practice was well known in the Mediterranean region since Greco-Roman antiquity.[66] As in many other respects, Byzantium would have provided the link between Hellenistic culture and Islam. One finds such epigraphy as early as the epigram inscribed on the walls of the sixth-century church of the St. Polyeuktos in Byzantine Constantinople.[67]

A comprehensive anthology of epigrams datable to c. 900, based on ancient models and composed by Constantinus Cephalas, *protopapas*, or head priest, of the palace in Constantinople,[68] would appear to be the immediate precursor of one of the principal literary sources on ʿAbbasid cultural innovations, *Kitāb al-Muwashshā* (*The Book of the Brocade*) by the Baghdadi courtier al-Washshāʾ (d. 324/936).[69] The work is primarily a compilation of rules and norms of etiquette for the members of cultured Baghdadi society, the ẓurafāʾ ('the elegants'), with precedents dating back to a section dedicated to epigrams on manners in the *Anthology* by Posidippus of Pella, from the third century BCE. Al-Washshāʾ followed Greek and Latin anthologies, if not Cephalas, providing a collection of Arabic verses and passages of rhymed prose intended for inscription – the first such compilation in the Islamic world.[70]

Al-Washshāʾ's anthology records a great variety of objects and surfaces embellished with verses. The last paragraph of chapter XXXIX

offers a digest of subsequent topics, something of a table of contents
that would have allowed a reader to see a list of objects and locate
corresponding literary excerpts:

> We had gathered in this part elegant poems, pleasant news, chosen
> verses, short, selected poems, curious refrains, graceful phrases
> that can be inscribed on stamp-rings, apples, bottles and cups, the
> borders of tunics and on button loops, in the trimmings of robes
> and sleeves, on caps, on headdresses, on headbands, on pantaloon
> drawstrings, on veils, on handkerchiefs; on cushions, pillows,
> seats, thrones, rooms, divans, platforms or low benches, at the
> front of reception halls, in halls and on daises, on the façades of
> houses and in cupolas, on curtains and doors; on the sandals of
> Sind and short boots; on the forehead, near the hairline and on the
> cheeks with perfume, civet and ambergris; on the insoles of shoes
> and on belts, and on halved grapefruit and apples.[71]

Architecture takes its place in a diverse registry of media for bearing
inscriptions. Poetic epigraphy 'at the front of reception halls, in halls
and on daises, on the façades of houses and in cupolas' shares the
same roots, and is conceived within the same artistic practice, as
inscriptions on other objects. In this regard, too, the Freer vase would
have been at home in the richly inscribed architectural precincts of
the Alhambra.

 As al-Washshā' proceeds, he often provides enough narrative
details to situate the inscribed objects within specific social rela-
tions, usually on the occasion of gift-giving in which an 'Abbasid
caliph or a high court official is a giver or a receiver of a gift, or
between the 'elegants' or between an 'elegant' and his favourite
slave. Indeed, much as the *Kitāb al-Muwashshā* functions as a
guidebook to courtly comportment, the chapters with verses may
well have served as a collection of samples to be emulated to inspire
a gift-giver's poetic talents, if not copied outright by those unable
to compose original verses. Craftsmanship and precious materials
make for luxury goods; poetic inscriptions make the goods into
personal, unique and often intimate gifts by giving them a specific
social addressee.[72] Address is the key to the work that prosopopoeia
does. This trope can be traced back from its prominent use in the
poetic inscriptions of the *Kitāb al-Muwashshā* to Greco-Roman
roots, most notably in the funerary epigraphy of the *Sta viator*
('stop, traveller') type, in which the gravestone speaks for the
dead, enjoining the passer-by to stop and consider the meaning of
mortality.

 One example from the *Kitāb al-Muwashshā* may suffice to attest
to the cultural transactions and shared tastes that constituted
the tradition of poetic epigraphy as it reached the Middle Ages.
Al-Washshā' reports an eye-witness account of a poem inscribed in a

niche within the interior of a hall in al-Ma'mūn b. Hārūn al-Rashīd's palace in Baghdad and he records the verses: 'The Merciful has never created a better scene / Than that of two lovers upon a single bed, / Embracing each other beneath the coverlets of love.'[73] The erotic image appears in the very same terms, including the metaphor of love as a coverlet, in a Hellenistic epigram by Asclepiades of Samos (born c. 320 BCE),[74] and a text identical to that cited by al-Washshā' is inscribed on an ivory casket attributed to the workshops of Norman Sicily and dated by scholars to the first half of the seventh/thirteenth century.[75] The chain linking these precise instances remains to be established, but they nonetheless exemplify the long-standing and widespread contacts by literary transmission, gift exchange and trade in luxury goods by which the practice of poetic inscriptions came to be firmly established at the 'Abbasid court by the first three decades of the fourth/tenth century. This tradition of inscribing objects with verses spread further, both eastward and westward in the medieval Islamic world. Objects inscribed with poetic epigraphy were produced under the patronage of such dynasties as the 'Abbasids, the Umayyads of Spain, the *taifa* rulers of Spain, the Ghaznavids, the Seljuqs, the Ilkhanids and the Mamluks.[76]

The transmission of this tradition of poetic inscriptions to the Nasrids, whether on luxury goods like the Freer vase, or the walls of the Alhambra, has been well established. The Umayyad court in Córdoba was familiar with 'Abbasid cultural developments, above all through the presence of Ziryāb, an eminent Baghdadi cultural figure, along with Baghdadi poets and philologists who were instrumental in disseminating 'Abbasid literary sources and poetic innovations in al-Andalus.[77] The author of the earliest account of Ziryāb, Ibn 'Abd Rabbih (d. 328/940), was a poet at the court of Muḥammad I and then 'Abd al-Raḥmān III in Córdoba.[78] He composed the *'Iqd al-farīd (The Unique Necklace)*, an encyclopaedic work covering topics from government and war, to food and drink, to jokes and anecdotes; in sum, a compendium of 'cultural knowledge about which well-educated people should be acquainted'.[79] Since the matters treated in *The Unique Necklace* concern the customs of the Muslim East, of which Ibn 'Abd Rabbih had only second-hand knowledge,[80] it has been suggested that he drew upon al-Washshā''s *Kitāb al-Muwashshā* for the very concept of such an encyclopaedia, as well as some of the topics.[81]

The impact of 'Abbasid culture and its refinements on al-Andalus was long-lasting, and the influence of the *Kitāb al-Muwashshā* has been demonstrated with respect to such important literary texts as *Tawq al-ḥamāma (The Dove's Neckring)*, authored by Ibn Ḥazm (383–456/994–1064), an Andalusī polymath, in the fifth/eleventh century.[82] More generally, as late as the sixth/twelfth century, the character of the cultured elite of al-Andalus could still be measured in terms by which the 'Abbasid 'elegants' were defined. Ibn Ghālib al-Gharnāṭī (d. 571/1175), a genealogist and biographer from

Granada, provides a lengthy description, or better yet, a psychological portrait of a typical Andalusī by explicit comparison with the ʿAbbasid model: the inhabitants of al-Andalus are known 'for their courtesy, cleanliness and refinement of their customs, their vitality of spirit, subtlety of thinking, height of vision, and generosity of their character, the gentleness of their ideas and nimbleness of their intellect, and penetration of their reflections'.[83] Thus, the tradition of epigraphy dating back at least to al-Washshāʾ leads directly to the cultural environment of the Alhambra and the Freer vase. Boasting about his status as a court poet and of Muḥammad V's preference for his poetic compositions, Ibn Zamrak stated: 'All of the admirable verses and rare praises that are in his [Muḥammad V's] mansions – as much in the palaces and gardens of the Alhambra as in Alixares [al-Dishār] and the Sabīka; the same in cupolas as in niches, tapestries and other places, they are my work.'[84]

The poet who composed the verses inscribed on the Freer vase has not been identified, but in any case, the first-person voice of the poem quickly shifts to the vase itself in an elaborate use of prosopopoeia. If there is some doubt about who is the implicit *I* enunciating the opening invocation, 'O thou onlooker', the uncertainty is dissipated in the reference to 'my shape' in the second verse, and altogether eliminated in the third. There, literal description – silver sulphate is often used in making lustre patina – is expanded as metaphorical re-description in which the excellence of luxury ceramics is likened, not to natural beauty, but to the parallel art of textile craftsmanship: 'my *clothing* of blossoms'. I will consider at length both the workings of what I shall call *textile metaphors* and the inter-medial relationship between textiles and architecture in Chapter 4. What is crucial here is the use of prosopopoeia in the staging of the direct address of an *I* to a *you* as a relationship between a work of art and its beholder (onlooker) in the present moment of the reading of the inscription.

When Paul de Man first reintroduced prosopopoeia as a topic for contemporary literary theory in a deconstructive mode, it was in relation to autobiography and for the purpose of reconceiving the formation of Western modernity and the interconnected creation of the modern Western self.[85] Those concerns have little bearing on the study of the Alhambra and other Nasrid arts. Nevertheless, his rhetorical analysis of the trope is illuminating for the reading of the verses on the Freer vase and the poetic inscriptions in the Alhambra in arguing for 'the superiority of prosopopoeia . . . over antithesis',[86] which would include the opposition of inner and outer that is typical of metaphor. De Man adds, 'In terms of style and diction, prosopopoeia is also the art of delicate transition . . . The gradual transformations occur in such a way that "feelings [that] seem opposite to each other have another and finer connection than that of contrast".'[87]

The fundamental mediation accomplished by prosopopoeia transforms the opposition of subject to object into the finer connection of

what Crowther has called 'ontological reciprocity'.[88] By imparting a fictitious, but nonetheless efficacious and authoritative voice to an otherwise mute object, prosopopoeia grants agency and so subjectivity. Prosopopoeia allows for imagining that *you* and *I*, whatever we are – a member of an ambassadorial entourage, a pyxis, a vase, a wall in the Alhambra, for instance – enter into a relationship in which each is a subject. With respect to poetry, the figure of voice construes that reciprocity as dialogue; as al-Washshā' records, the gift of a poem could lead the recipient to find voice and reply with a poem in turn. The verses on the vase are paradigmatic of poetic inscriptions in representing reciprocal subjectivities in visual terms. The addressee of the poem is not only identified explicitly as an onlooker (n-ṭ-r), but also the voice of the vase enjoins *you*, first of all, to look (n-ṭ-r).

The act of looking initiates a process that might lead through imagination to possession. Even before calling attention to its surface decoration ('made of silver . . . clothing of blossoms'), the vase directs the beholder to gaze at its *shape*. That view is now obscured by the incomplete state of the Freer vase, but it is possible to reconstruct the full form on the basis of the complete objects in the group, like the vase in the Museo de la Alhambra in Granada (Figure 2.12). The missing upper portion of the vessel would have flared up and out from the broken top of the Freer vase. When one looked at the shape, one would have perceived the resemblance to the female body with high hips and slender waist. The erotic undertone of the inscription, culminating in happiness beneath the canopy, depends upon that visual metaphor. The grammar of prosopopoeia, however, gives an ironic twist to erotic fulfilment, since anyone who reads the verses temporarily takes the place of the *you*. In one version of the truth, the beholder knows who is the real owner of the splendid vase; but in another, the owner knows that possession begins already with the first look and so belongs to any beholder.

If the movement from looking to owning seems merely to reinforce the status of the vase as an object of desire, the speaking vase poses an intermediate term that makes for a more delicate transition: 'Look . . . and *contemplate* (a-m-l)'. And it is the contemplative gaze, to recall Necipoğlu's expression based on Ibn al-Haytham, that enables the imagination of a deeper truth, figured as a visual reciprocity. From the point of view of the beholder, the vase is a splendid portable object framed by the transitory *textile architecture* of the canopy (I will return to this hybrid, inter-medial term in Chapter 5). But contemplation turns the beholder's gaze back upon the beholder's own place in the physical and social construction of space. Prosopopoeia allows for the expression of that reverse perspective from the point of view of the vase. From the opening verse, the beholder is also visible and appears *to the vase* as one who is 'adorned with the splendour of the dwelling', that is, framed by the permanent architecture of a hall, a palace, perhaps a precinct in the Alhambra.

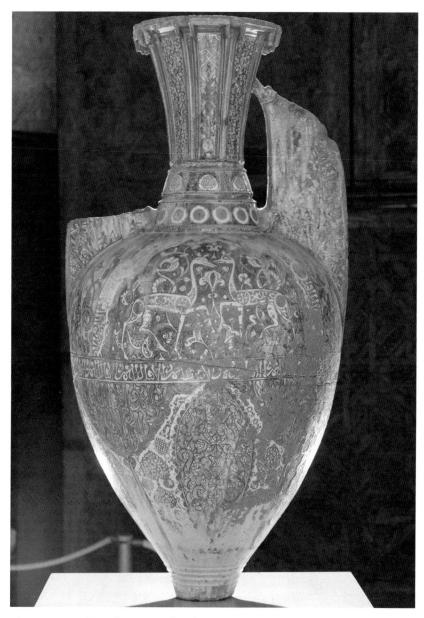

Figure 2.12 *'Alhambra' vase, height 135.2 cm, maximum diameter
68.7 cm, Nasrid period, eighth/fourteenth century, Spain. Museo de la
Alhambra, Granada (R. 290). (photograph: Museo de la Alhambra)*

The vase is both seen and seeing; the beholder both perceiving and
perceived. They share a reciprocal gaze.

In principle, any beholder of any work of art might well take
stock of the activity of viewing and so raise questions of social
location (how did I gain access? what aesthetic traditions guide

my appreciation? and others). Prosopopoeia makes that moment of self-reflexivity explicit by staging it as a dialogue of reciprocal subjects and by addressing the beholder directly to turn from the outward gaze of looking to the inward gaze of contemplating. All poetic figures lead beyond perception by way of the imagination. Prosopopoeia, more specifically, brings a performative aspect to the work of poetic inscription in two senses: doing things with words, namely, creating an animated, reciprocal relationship through the figure of voice that exists only because the poem says so; and staging that relationship as a dramatic and self-conscious encounter enacted in the moment of the reading of the inscription.

6

I now return to the Sala de la Barca to complete the reading of its poetic inscriptions and to offer some more general conclusions about the relationship between poetic texts and architecture in the Alhambra. Beginning with the poem framing the eastern niche, it will now be clear that the opening metaphor relating the niche to a bridal throne by visual resemblance forms part of a larger system governed by prosopopoeia. The self-presentation of the niche ('I am') allows the architecture to address the beholder directly, or more precisely, calls upon any *you* who stands before the arch to engage actively in the role of beholding: 'Look at my water jug, you will know/I affirm the truth in my speech.' The discovery of the truth that the speaking niche affirms, moreover, is initiated, but not limited, to the outer sense. The poetic inscription guides the beholder from perception ('Look') to cognition ('you will know'). The transition is in fact more delicate, moving from *n-ṭ-r*, whose range of connotations includes 'to see, perceive, contemplate, notice', to *ʿ-r-f*, 'to know, perceive, recognise'.

The look that will make the beholder truly see, and so know, is already a contemplative gaze. The work of poetic inscriptions generally is to heighten awareness of that process and so give greater depth to the aesthetic experience. In addition to a mimetic and a contemplative gaze, then, poetic epigraphy articulates a self-reflexive gaze, speaking for the ways in which architecture and objects *wish to be seen*, as well as the ways beholders may see themselves in relation to the works of art they behold. More narrowly, poetic figures, and especially prosopopoeia, open the intermediate space of contemplation by embodying the stage of imagination that Ibn al-Haytham interposed between perception and cognition. In the preceding examination of the uses of colour in the Alhambra, I proposed that Ibn al-Haytham's model of the visual process was activated by the introduction of kinetic elements into the otherwise static presence of the architecture. Poetic inscriptions, and again, the trope of prosopopoeia above all, effect a reversal, arresting the movement of

the beholder through the space of the palatial precincts to allow the work of contemplation to take place.

These broad issues are represented as a poetic crux in the *fakhr* on the east niche in the Sala de la Barca. As has already been remarked, the literal identification of Ibn Naṣr is supplemented by metaphor in the fourth verse, where the sultan is also depicted as 'the sun in the kingdom, / brilliant and beautiful'. But even metaphor will not sustain the wish expressed in the closing benediction: 'may he remain in such a high position / safe from the hour of setting'. However brilliant and beautiful at its zenith, no sun rises without setting. In the more literal terms of the *fakhr* on the western niche, even if the Nasrid tribe had persisted since the days of the Prophet, the very fact of genealogical descent attests that no one leader can remain forever at the height of power. The point would have been especially notable to the beholder in Muḥammad V's reign, well aware that his father Yūsuf I had been assassinated, and that Muḥammad V himself had been forced into exile before returning to rule in the Alhambra. It is not the astral imagery of sun and moon, here and elsewhere on the poetic axis of the Palace of Comares, that speaks for the wish to '*remain* in such a high position', but the *enacting* of that stasis by the beholder in the moment of reading.

Whereas colour introduced a dynamic element into the stability of geometric design, the direct address of the prosopopoeia, conversely, stages that moment of arrest. The first line of an anonymous poem inscribed in the anteroom of the *Qalahurra* of Muḥammad VII in the Alhambra, makes the connection between contemplation and arrest explicit: 'You who enter, stop for God's sake, contemplate (*a-m-l*) . . .'[89] All of the tropes of the poetic inscriptions in the Alhambra mediate between an initial perception of beauty and a more contemplative appreciation of meanings by engaging the imagination of beholders to see what they see not. But in addition, prosopopoeia articulates the construction of social space – if not to say it embodies the spatial turn – by framing aesthetic experience as the arrested movement of ceremonial ritual, especially at the thresholds. If the constant message of the richly decorated architecture of the Alhambra is the power of the sultans, the veneration required in response is manifested when beholders stop in their tracks even more than when they approach as supplicants.

Notes

1. 'Abd al-Qāhir al-Jurjānī, cited in Kamal Abu Deeb, *Al-Jurjānī's Theory of Poetic Imagery* (Warminster: Aris & Phillips, 1979), p. 265.
2. José Miguel Puerta Vílchez, 'Speaking Architecture: Poetry and Aesthetics in the Alhambra Palace', in Mohammad Gharipour and Irvin Cemil Schick (eds), *Calligraphy and Architecture in the Muslim World* (Edinburgh: Edinburgh University Press, 2013), p. 43. All scholarship on

the epigraphy of the Alhambra is indebted to the pioneering research of Emilio García Gómez, especially *Poemas árabes en los muros y fuentes de la Alhambra* (1996), including texts in Arabic and his Spanish translations and interpretation. The new standard in the field is Puerta Vílchez, *Leer la Alhambra* (2010), with reproductions of all epigraphy in Arabic, often with transliterations, and translations into Spanish; photographic images and diagrams, locating each inscription with precision; and illuminating commentary. All quotations of the epigraphy in the Alhambra in this and subsequent chapters will refer to the texts as established by Puerta Vílchez and are cited by reference to *Leer la Alhambra*; the English translations are my own. One other source may be mentioned here, an interactive DVD with a short introduction to the epigraphic classification, extensive photography, as well as schematic drawings of the inscribed surfaces, and the texts of individual inscriptions in Arabic and in Spanish translations: Juan Castilla Brazales, *Corpus epigráfico de la Alhambra* (Patronato de la Alhambra y Generalife, 2007).

3. See, for instance, Ibn Isḥāq ibn Yaḥya al-Wa<u>sh</u>shā' Abu'l-Tayyib Muḥammad, *al-Muwa<u>sh</u>shā al kitāb al-ẓurafā'* (Beirut: Dar Sadir, n.d.). References to the *Kitāb al-Muwa<u>sh</u>shā* will be cited from al-Wa<u>sh</u>shā', *El Libro del Brocado*, ed. and trans. Teresa Garulo (Madrid: Alfaguara, 1990), here, p. 290. There is also a French translation: al-Washshā', *Le Livre de brocart (al-kitāb al-muwashshā) par al-*Washshā', trans. Siham Bouhlal (Paris: Gallimard, 2004).

4. For poetic epigraphy in the palace at Ghazna, see Alessio Bombaci, *The Kufic Inscription in Persian Verses in the Court of the Royal Palace of Mas'ūd III at Ghazni* (Rome: IsMEO, 1966). This was found on slabs in situ in the palace in Ghazna during the 1959–64 excavations conducted by the Italian Archaeological Mission in Afghanistan. Although the inscription was preserved in a fragmentary state, Bombaci was able to interpret verses on the west side of the court sufficiently to report that they were dedicated to Maḥmūd (388–421/998–1030), the founder of the Ghaznavid dynasty, and his son, Mas'ūd III. The rest of the epigraphy survived in isolated phrases and words.

5. Scott Redford, *Landscape and the State in Medieval Anatolia* (Oxford: Archaeopress, 2000), p. 76. Redford points out that further investigations of these fragmentary inscriptions are needed in order to draw conclusions with regard to the text(s) employed on this site.

6. For a comprehensive analysis of the Arabic inscriptions of Norman Sicily, see the works of Jeremy Johns, especially 'The Arabic Inscriptions of the Norman Kings of Sicily. A Reinterpretation', in Maria Andaloro (ed.), *Nobiles Officinae: perle, filigrane e trame di seta dal Palazzo Reale di Palermo* (Palermo: Guiseppe Maimone Editore, 2006), vol. 2, pp. 324–37. For the text of inscriptions in King Roger II's palaces in Palermo and Messina, see catalogue entries by Jeremy Johns and Annliese Nef, 'Twenty Block Fragments with Arabic Inscriptions in Praise of Roger II from the Palace in Messina', in Maria Andaloro (ed.), *Nobiles Officinae: perle, filigrane e trame di seta dal Palazzo Reale di Palermo* (Palermo: Guiseppe Maimone Editore, 2006), vol. 1, pp. 765–70.

7. María Jesús Rubiera Mata, *La arquitectura en la literatura árabe: datos para una estética del placer* (Madrid: Hiperión, 1988), p. 169.

8. Emilio García Goméz, *Cinco poetas musulmanes* (Madrid: Espasa-Calpe, 1959), p. 210.

9. Matthew P. Canepa, 'Inscriptions, Royal Spaces and Iranian Identity: Epigraphic Practices in Persia and the Ancient Iranian World', in Antony Eastmond (ed.), *Viewing Inscriptions in the Late Antique and Medieval World* (Cambridge: Cambridge University Press, 2015), p. 12.

10. Paul Crowther, *Phenomenology of the Visual Arts (even the frame)* (Stanford, CA: Stanford University Press, 2009), p. 5 (original emphasis).

11. Puerta Vílchez, *Leer la Alhambra*, p. 106; Jesús Bermúdez Pareja, 'Crónica de la Alhambra', *Cuadernos de la Alhambra*, 1 (1965): 99–115.

12. Puerta Vílchez, *Leer la Alhambra*, p. 106.

13. For a detailed study of the palace, see Earl Rosenthal, *The Palace of Charles V in Granada* (Princeton, NJ: Princeton University Press, 1985).

14. Erica Cruikshank Dodd and Shereen Khairallah, *The Image of the Word: A Study of Quranic Verses in Islamic Architecture*, 2 vols (Beirut: American University of Beirut, 1981), vol. 2, pp. 136–7. Dodd and Khairallah do not cite examples of inscriptions of verses from *sūrah* 67 in palatial architecture.

15. See Cabanelas Rodríguez, *El techo del Salón de Comares*, pp. 81–90, followed closely on this point by such scholars as Orihuela Uzal, *Casas y palacios*, p. 89. Gonzalez rejects their interpretation of the dome decoration as a cosmological representation of the seven Islamic heavens, which she finds reductive (*Beauty and Islam*, pp. 49–59). She suggests instead that the microcosm defined by the epigraphy and decoration 'prepares [the beholder] to receive the whole spectrum of spiritual, ontological, ethical and political cognitions' (p. 53). An examination of the scholarly debate goes beyond this study; what is immediately pertinent is that neither side contests the function of the Hall of Comares as a throne hall.

16. Puerta Vílchez, *Leer la Alhambra*, pp. 123–5. See also Cabanelas Rodríguez, *El techo del Salón de Comares*.

17. Puerta Vílchez, *Leer la Alhambra*, p. 78; Orihuela Uzal, *Casas y palacios*, pp. 81–102; Fernández-Puertas, *The Alhambra*, pp. 30, 37.

18. Puerta Vílchez, *Leer la Alhambra*, p. 106; see also Orihuela Uzal, *Casas y palacios*, p. 86; Fernández-Puertas, *The Alhambra*, p. 37.

19. For a diagram, see Puerta Vílchez, *Leer la Alhambra*, p. 79.

20. For the location of the poems and their texts, see Puerta Vílchez, *Leer la Alhambra*, pp. 79–126.

21. Ibid., pp. 84–5.

22. Ibid., p. 106.

23. The Spanish term *alfiz* is derived from *al-ifrāz*; the verb *f-r-z* in Form IV means to set apart, to isolate, to separate.

24. See Puerta Vílchez, *Leer la Alhambra*, p. 108.

25. Carved stucco fragments with the verses from two short panegyrics composed by Ibn Zamrak have been preserved in the Museo de la Alhambra. Puerta Vílchez provides complete texts as they have been preserved in Ibn Zamrak's *dīwān* or poetic compilation; see Puerta Vílchez, *Leer la Alhambra*, pp. 110–11.

26. Robert Hillenbrand, *Islamic Architecture. Form, Function, Meaning* (New York: Columbia University Press, 1994), p. 414.

27. Robinson, *In Praise of Song*, p. 243.

28. Ibid., *In Praise of Song*, p. 54, after Rubiera Mata, *La arquitectura en la literatura*, pp. 166–71.

29. For a complete overview of all of the types of inscriptions in the Sala de la Barca, see Puerta Vílchez, *Leer la Alhambra*, pp. 106–13.

30. On the interrelated themes of the two statements of the _shahādah_, see, for instance, Peter Samsel, 'The First Pillar of Islam', _Parabola_ (2007): 42–9.
31. Johns, 'The Arabic Inscriptions of the Norman Kings of Sicily', pp. 327–8. For a complete list of _adʿiya_, see his table II, p. 337.
32. It has been suggested, for instance, that in the palace of Masʿūd III at Ghazna, the votive words preserved on architectural fragments originally formed part of the embellishment of a corridor that led to the courtyard where a dado frieze with an inscribed panegyric decorated its perimeter, and that, taken as a programme, the architectural epigraphy bestowed blessings on the patron and visitors. See Martina Rugiadi, 'Marble from the Palace of Masʿūd III in Ghazni', in Pierfrancesco Callieri and Luca Colliva (eds), _Proceedings of the 19th International Meeting of the European Association of South Asian Archaeology in Ravenna, Italy, July 2007_, BAR International Series 2133: Volume 2, Historic Periods (Oxford: Archaeopress, 2010), pp. 297–306; Martina Rugiadi, 'Carved Marble in Medieval Ghazni: Function and Meaning', _Hadeeth al-Dar_ 34 (2011): 5–11; Sheila S. Blair, _Text and Image in Medieval Persian Art_ (Edinburgh: Edinburgh University Press, 2014), p. 96; Bombaci, _The Kufic Inscription in Persian Verses_.
33. Ibn al-Hay_th_am, _The Optics_, I, pp. 208, 222.
34. For the text of the poem in Arabic, see Appendix. García Gómez erroneously attributed this poem to Ibn al-Jayyāb; see García Gómez, _Poemas árabes_, p. 97. Puerta Vílchez attributed both poems, that is, on the east and west niches, to Ibn Zamrak, since the poem on the west side can be found in this poet's _dīwān_; see Puerta Vílchez, _Leer la Alhambra_, p. 107. For another discussion of these poems, see Darío Cabanelas Rodríguez and Antonio Fernández-Puertas, 'Los poemas de las tacas del arco de acceso a la Sala de la Barca', _Cuadernos de la Alhambra_ 19/20 (1987): 61–152.
35. For the text of the poem in Arabic, see Appendix.
36. On the _fakhr_ as a frequent device in the poetic inscriptions of the Alhambra, see García Gómez, _Poemas árabes_, pp. 42–6; José Miguel Puerta Vílchez, _Los códigos de utopía de la Alhambra de Granada_ (Granada: Diputación de Granada, 1990), pp. 146–51; José Miguel Puerta Vílchez, 'El vocabulario estético de los poemas de la Alhambra', in José Antonio González Alcantud and Antonio Malpica Cuello (eds), _Pensar la Alhambra_ (Barcelona: Anthropos Editorial, 2001), pp. 75–83.
37. García Gómez, _Poemas árabes_, p. 137.
38. Puerta Vílchez, _Leer la Alhambra_, pp. 110–11.
39. Puerta Vílchez reproduces and translates the two poems from Ibn Zamrak's _dīwān_ and remarks on the use of the term _caliph_ in his commentary, a point to which I will return in Chapter 5. See Puerta Vílchez, _Leer la Alhambra_, pp. 110–11.
40. Puerta Vílchez, _Leer la Alhambra_, p. 120.
41. Kamal Abu Deeb, 'Al-Jurjānī's Classification of _Istiʿāra_ with Special Reference to Aristotle's Classification of Metaphor', _Journal of Arabic Literature_ 2 (1971), p. 61; Abu Deeb, _Al-Jurjānī's Theory of Poetic Imagery_, pp. 65–90. Al-Jurjānī is cited here as a characteristic and influential figure in the tradition of Arabic poetics, but since he came from the Muslim East, these references do not comprise an argument that the Nasrid poets of the Alhambra consulted his work in particular. I will

comment further on the transmission of both Arabic poetry and poetics to the Muslim West later in this chapter and also in Chapter 4.

42. On the other hand, reflecting on Aristotle's *Poetics* and *Rhetoric* some two hundred years later than al-Jurjānī, and probably familiar with the latter's writings, Andalusī poet and literary theorist Ḥāzim al-Qarṭajannī (607–83/1211–85) cautions about exaggeration: 'for excess occurs when the poet transgresses all bounds in his description, and by this means goes from the limits of the possible to the impossible and the absurd', urging that 'the descriptions and imitations that are made with restraint and without exaggeration are really truth', quoted in James T. Monroe, *Hispano-Arabic Poetry: A Student Anthology* (Berkeley: University of California Press, 1974), pp. 52–3. For a discussion of al-Qarṭajannī's theory of mimesis and imagination as it pertains to poetry, see Puerta Vílchez, *Historia del pensamiento estético árabe*, pp. 360–406. More generally, on this relationship in medieval Arabic rhetoric, especially poetry, see also Puerta Vílchez, *Historia del pensamiento estético árabe*, pp. 278–359.

43. Akiko Motoyoshi Sumi, *Description in Classical Arabic Poetry: Waṣf, Ekphrasis, and Interarts Theory* (Leiden: Brill, 2004), p. 8. For a concise summary of Ibn Rashīq al-Qairawānī's interpretation of the terms of *badīʿ* poetry, and for the possible sources of dissemination of his work in al-Andalus, see Robinson, *In Praise of Song*, pp. 152–60.

44. Motoyoshi Sumi studies *waṣf* at length in *Description in Classical Arabic Poetry*.

45. Al-Jurjānī quoted in Puerta Vílchez, *Leer la Alhambra*, p. 119.

46. Kamal Abu Deeb, 'Literary Criticism', in Julia Ashtiany, T. M. Johnstone, J. D. Latham, R. B. Serjeant and G. Rex Smith (eds), *ʿAbbasid Belles-Lettres* (Cambridge: Cambridge University Press, 1990), p. 385 (emphasis added).

47. On Ibn al-Haytham's use of the term, *qiyās*, also found in the context of medieval legal thought, to refer to a visual comparison of two objects, see Puerta Vílchez, *Historia del pensamiento estético árabe*, pp. 691–715. Robinson has concentrated attention on the topic of analogy, sharpening the focus on the philosophical tradition underwriting medieval Muslim literary theory; see *In Praise of Song*, pp. 141–72.

48. Abu Deeb, 'Literary Criticism', p. 381.

49. Al-Jurjānī quoted in Abu Deeb, 'Al-Jurjānī's Classification', p. 67. Abu Deeb's detailed account of the workings of *istiʿāra* as delineated by Al-Jurjānī in his *Al-Jurjānī's Theory of Poetic Imagery* has been crucial to the discussion of metaphor in this chapter.

50. While most scholars agree that the pyxis was made in Nasrid al-Andalus, Stefano Carboni questions that attribution. He identified a group of pyxides with similar decoration executed in the open-work technique to which this pyxis belongs. On the basis of one example inscribed with the name of a Mamluk sultan, Carboni suggested that the group of pyxides could have been made in Mamluk Egypt, and that the pyxis under consideration could have been an imitation of Mamluk examples, possibly made elsewhere in medieval Iberia. See Stefano Carboni, 'Cylindrical Ivory Boxes with Open Decoration: Mamluk, Nasrid or Something Else?' *Journal of the David Collection* 2(2) (2005): 214–25.

51. Among this group of Umayyad pyxides, I refer here specifically to the pyxis preserved in the Hispanic Society of America, New York (D752), which is inscribed with a short poem.

52. Juan Zozaya, 'Pyxis', in Jerrilynn D. Dodds (ed.), *Al-Andalus. The Art of Islamic Spain* (New York: Metropolitan Museum of Art, 1992), pp. 266–7. I cite here Zozaya's translation; he also provides a text in Arabic.

53. Necipoğlu, 'The Scrutinizing Gaze', p. 53. Necipoğlu is arguing specifically against the assessment of Ibn al-Haytham in Hans Belting, *Florence and Baghdad: Renaissance Art and Arabic Science*, trans. Deborah Lucas Schneider (Cambridge, MA: Harvard University Press, 2011).

54. Necipoğlu, 'The Scrutinizing Gaze', p. 30.

55. Paul Ricoeur, *The Rule of Metaphor* (Toronto: University of Toronto Press, 1977), p. 7.

56. In the light of that paucity, I have been working on prosopopoeia as a theoretical tool for the study of Islamic art for some time, beginning with: Olga Bush, 'Architecture, Poetic Texts and Textiles in the Alhambra', PhD dissertation, Institute of Fine Arts, New York University, 2006), chs 1 and 2; Olga Bush, '"When My Beholder Ponders": Poetic Epigraphy in the Alhambra', in Linda Komaroff (ed.), *Pearls from Water, Rubies from Stone: Studies in Islamic Art in Honor of Priscilla Soucek*, *Artibus Asiae*, 66(2) (2006): 55–67; and more recently, in relation to contemporary Islamic art in Olga Bush, 'Prosopopeia: Performing the Reciprocal Gaze', introduction, in Olga Bush and Avinoam Shalem (eds), *Gazing Otherwise: Modalities of Seeing*, special issue, *Muqarnas* 32 (2015): 13–19. My most extensive discussion of the theoretical background of the use of prosopopoeia, will appear in Olga Bush, 'Poetic Inscriptions and Gift Exchange in the Medieval Islamicate World', *Gesta* 56(2) (2017): 179–97. The literary history in the following pages also draws on that related research.

57. Émile Benveniste, 'The Nature of Pronouns', in *Problems in General Linguistics*, trans. Mary Elizabeth Meek (Coral Gables, FL: University of Miami Press, 1971), p. 219. For those interested in the technical linguistic aspects of this discussion, see also the closely related essay by Benveniste in the same volume, 'Subjectivity in Language', pp. 223–30.

58. Jonathan Crary, *Suspensions of Perception: Attention, Spectacle, and Modern Culture* (Cambridge, MA: MIT Press, 1999), p. 10.

59. The vase is preserved in the Freer and Sackler Gallery of Art in Washington (F1903.206a). See Balbina Martínez Caviró, 'El arte nazarí y el problema de la loza dorada', in Jesús Bermúdez López (ed.), *Arte islámico en Granada. Propuesta para un museo de la Alhambra. 1 de abril–30 de septiembre de 1995, Palacio de Carlos V – la Alhambra* (Granada: Junta de Andalucía, Consejería de Cultura/Patronato de La Alhambra y Generalife/Comares Editorial, 1995), pp. 157–60.

60. For a study of these vases as a group in the context of the production of luxury ceramics during the Nasrid period, see *Los Jarrones de la Alhambra: Simbología y poder. Granada, capilla y cripta del Palacio de Carlos V, Conjunto Monumental de la Alhambra y Generalife, octubre 2006–marzo 2007* (Granada: Patronato de la Alhambra and Junta de Andalucía, 2006); and Summer S. Kenesson, 'Nasrid Luster Pottery: The Alhambra Vases', *Muqarnas* 9 (1992): 93–115.

61. Heather Ecker attributes them to the Málaga workshops. See Heather Ecker, *Caliphs and Kings. The Art and Influence of Islamic Spain* (Washington, DC: Arthur M. Sackler Gallery, Smithsonian Institution,

2004), p. 141; Heather Ecker, 'Jarrón', in *Los Jarrones de la Alhambra* (Granada: Patronato de la Alhambra and Junta de Andalucía, 2006), p. 166.

62. Eva Moreno León and Paula Sánchez Gómez, 'Fragmentos de jarrón tipo Alhambra', in *Los Jarrones de la Alhambra* (Granada: Patronato de la Alhambra and Junta de Andalucía, 2006), pp. 175–7.

63. Ibid., p. 176.

64. Cited in A. R. Nykl, 'The Inscriptions of the "Freer Vase"', *Ars Orientalis*, 2 (1957): 496–7. For text in Arabic, see Ecker, *Caliphs and Kings*, p. 167.

65. Grabar, *The Mediation of Ornament*, p. 63 and nn. 27–29. Grabar cites al-Mas'ūdī's *Murūj al-Dhahab*, ed. and trans. Barbier de Meynard and Pavet de Courteille (Paris, 1861–1877), vol. 7, pp. 192–4.

66. Amid the vast bibliography on poetic epigraphy in Greek and Latin, the following are especially useful for the broader historical context of 'Abbasid poetic inscriptions: Christopher Jones, 'Epigrams from Hierapolis and Aphrodisias', *Hermes* 125(2) (1997): 203–14; John Ma, 'The Epigraphy of Hellenistic Asia Minor: A Survey of Recent Research (1992–1999)', *American Journal of Archaeology* 104(1) (2000): 95–121; Kathryn Gutzwiller, 'Gender and Inscribed Epigram: Herenia Procula and the Thespian Eros', *Transactions of the American Philological Association* 134(2) (2004): 383–418.

67. An epigram in praise of the noblewoman Anicia Juliana, the patron of the building, was carved on a marble entablature of the nave, in the narthex and in the courtyard of the sixth-century church of St. Polyeuktos in Byzantine Constantinople. Although only forty-one lines were employed in the epigraphy, the complete text of the epigram, seventy-six lines long, was preserved in the *Greek Anthology*. See Liz James, '"And Shall These Mute Stones Speak": Text as Art', in Liz James (ed.), *Art and Text in Byzantine Culture* (Cambridge: Cambridge University Press, 2007), pp. 188–9.

68. Kathryn Gutzwiller, *Poetic Garlands: Hellenistic Epigrams in Context* (Berkeley: University of California Press, 1998), pp. 15–16.

69. See n. 3 and also Wājida Majīd 'Abdullāh al-Aṭraqjī, *al-Mar'a fī adab al-'aṣr al-'Abbāsī* (Baghdad: Dār al-Rashīd, 1981).

70. Gutzwiller, *Poetic Garlands*, pp. 15–16.

71. al-Washshā' (Garulo), pp. 259–60.

72. On objects inscribed with poetry in the context of gift-giving, see Bush, 'Poetic Inscriptions and Gift Exchange'.

73. al-Washshā' (Garulo), p. 290.

74. Asclepiades, who is considered to be the founder of the genre of the erotic epigram in the early Hellenistic period, composed the poem, which reads: 'Sweet for the thirsty an icy drink in summer and sweet for sailors to spot spring's Crown after a storm. But sweeter still when one cloak covers two lovers, and the Cyprian is honoured by both.' This text is quoted in Gutzwiller, *Poetic Garlands*, p. 128.

75. The ivory casket is now housed in the Museo del Duomo in Trento. For an analysis of this casket in the context of a very large group of similar objects, see R. H. Pinder-Wilson and C. N. L. Brooke, 'The Reliquary of St. Petroc and the Ivories of Norman Sicily', *Archaeologia* 104 (1973): 261–306.

76. A comprehensive study of medieval poetic epigraphy in Arabic on objects and architecture in the Islamic world and the paths of its

transmission is badly needed. For some examples and their discussion, see Bush, 'Architecture, Poetic Texts and Textiles'. For the Persianate world, see Bernard O'Kane, *The Appearance of Persian in Islamic Art* (New York: Persian Heritage Foundation, 2009); Blair, *Text and Image*; Abdullah Ghouchani, 'Some 12th Century Iranian Wine Ewers and their Poems', *Bulletin of the Asia Institute* 13 (1999): 141–7; Linda Komaroff, 'Persian Verses of Gold and Silver: The Inscriptions on Timurid Metalwork', in Lisa Golombek and Maria Subtelny (eds), *Timurid Art and Culture: Iran and Central Asia in the Fifteenth Century* (Leiden: Brill, 1992), pp. 144–57; Rugiadi, 'Marble from the Palace of Mas'ūd III'; Rugiadi, 'Carved Marble in Medieval Ghazni'.

77. On the presence of Baghdadi poets in al-Andalus in the fourth/tenth and fifth/eleventh centuries as recorded in literary sources, see Henri Pérès, *Esplendor de al-Andalus. La Poesía andaluza en árabe clásico en el siglo XI: sus aspectos generales, sus principales temas y su valor documental*, trans. Mercedes García-Arenal (Madrid: Hiperión, 1983), pp. 49–62. For a comprehensive overview of the poetry of al-Andalus in the fifth/eleventh century, see Teresa Garulo, *La literatura árabe de al-Andalus durante el siglo XI* (Madrid: Hiperión, 1998).

78. Dwight Reynolds, 'Music', in María Rosa Menocal, Raymond P. Scheindlin and Michael Sells (eds), *The Literature of al-Andalus* (Cambridge: Cambridge University Press, 2000), p. 64.

79. Peter Heath, 'Knowledge', in María Rosa Menocal, Raymond P. Scheindlin and Michael Sells (eds), *The Literature of al-Andalus* (Cambridge: Cambridge University Press, 2000), p. 109.

80. Ibid.

81. Among studies that examine affinities between *Kitāb al-Muwashshā* and the work of Andalusī writers from the late Umayyad and *taifa* periods, such as Ibn Ḥazm and al-Ḥimyarī, see Emilio García Gómez, 'Un precedente y una consecuencia del "Collar de la Paloma"', *Al-Andalus* 16 (1951): 309–30; Robinson, *In Praise of Song*, pp. 72–3, 94–103.

82. García Gómez, 'Un precedente'.

83. Quoted in Pérès, *Esplendor de al-Andalus*, p. 26.

84. Quoted in Rubiera Mata, *La arquitectura en la literatura*, p. 89, following Gárcia Gómez, *Cinco poetas*, pp. 210–11.

85. See Paul de Man, 'Autobiography as De-Facement' and 'Shelley Disfigured' in Paul de Man, *The Rhetoric of Romanticism* (New York: Columbia University Press, 1984), pp. 67–81 and 93–123, respectively; and 'Hypogram and Inscription', in Paul de Man, *The Resistance to Theory* (Minneapolis: University of Minnesota Press, 1986), pp. 27–53.

86. de Man, 'Autobiography', p. 76. For an analysis in which prosopopoeia is differentiated from related figures of speech, such as apostrophe, personification and anthropomorphism, see Barbara Johnson, *Persons and Things* (Cambridge, MA: Harvard University Press, 2008), pp. 17–22.

87. de Man, 'Autobiography', p. 76; de Man is quoting from William Wordsworth's 'Essays upon Epitaphs', which is the foundation of his development of a theory of prosopopoeia. See William Wordsworth, *The Prose Works of William Wordsworth*, ed. W. J. B. Owen and Jane Worthington Smyser (Oxford: Clarendon Press, 1974), vol. 1, pp. 45–96.

88. Crowther, *Phenomenology of the Visual Arts*, p. 3.

89. Puerta Vílchez, *Leer la Alhambra*, p. 317.

CHAPTER THREE

Qalahurra of Yūsuf I:
A Case Study of a Tower-palace

Of this tower, which is grand among the towers,
the Alhambra is proud, like a crown.
Qalahurra on the outside, while it conceals within
a palace that emits a burning light.

Ibn al-Jayyāb[1]

I

In the Alhambra, the voice of the imagination is embodied in the
poetic inscriptions. This chapter will develop that argument by exam-
ining a wider range of tropes cited explicitly in a poem inscribed in a
more elaborate poetic and decorative programme than those found in
the entrance arch of the Sala de la Barca. Discussion of the role that
poetic inscriptions play as a guide to the aesthetic experience of the
architectural spaces in which they appear will now turn to a little-
studied building popularly known today as the *Torre de la Cautiva*
(the Tower of the Captive, a name invented in the post-Nasrid era).
I shall refer to the building by its original name, the *Qalahurra* of
Yūsuf I, indicating at once its patron, Nasrid sultan Yūsuf I, and
its hybrid architectural type, according to a designation attested in
Nasrid times in the poetic epigraphy in the interior of the building.

Qalahurra is related to the Arabic term *qalʻat*, citadel or fortress,
which, in textual sources written in the seventh/thirteenth century,
refers to defensive towers built in the Muslim West.[2] In his compari-
son between the cities of Málaga and Salé, Ibn al-Khaṭīb describes
Málaga's fortified enclosure with its towers, which he calls *qalahur-
rāt* (plural of *qalahurra*), stating that these structures are like small
towns unto themselves.[3] The vizier's description would hardly have
been considered an exaggeration: the towers of *al-qaṣaba* of Málaga
and the *ḥiṣn*, a fortified castle linked to *al-qaṣaba* by a defensive
wall, now known as Gibralfaro, were imposing in their height and
dimensions. Ibn al-Khaṭīb glorified the formidable stronghold and
attributed the beginning of the expansion of an earlier *ḥiṣn* to Yūsuf
I and its further additions to Muḥammad V.[4] Two examples of
qalahurrāt are standing in the Alhambra: the *Qalahurra* of Yūsuf I,

constructed some time before 750/1349,[5] the subject of this chapter; and the *Qalahurra* of Muḥammad VII, built in 795-7/1393-5 under the patronage of Muḥammad VII (r. 794–811/1392–1408), and referred to by that term by the poet Ibn al-Zamrak.[6]

A full study of the history of the *qalahurra* as an architectural type is beyond the scope of this chapter, and, in any case, obstructed by the state of preservation of the remains in various locations and the scant references in historical documents. The fortifications in Málaga, for instance, have suffered considerable destruction and numerous alterations over many centuries, much like the *qalahurra* built by the Marinid sultan Abū l-Ḥasan ʿAlī in the period 734–50/1333–49 in *al-qaṣaba* of Gibraltar.[7] The *qalahurrāt* in the Alhambra are exceptional in that regard, but for that reason only limited remarks are possible on their basis for a widespread architectural type. It is generally accepted that the term *qalahurra* designates a military tower that is distinct for its volume and height; but also, and more importantly, for its spacious rooms providing housing for a military commander, as Torres Balbás proposed for the *qalahurra* of Gibraltar under the Marinids.[8] That combination of defensive function and luxurious, or even royal, residence is also apparent in the *qalahurrāt* in the Alhambra.[9] Hence, scholars regularly refer to the Nasrid *qalahurrāt* by the hybrid term, 'tower-palace'.[10]

The *Qalahurra* of Yūsuf I, which, it appears, the sultan ordered for the Alhambra after seeing the Marinid example of this type of building in Gibraltar, particularly recommends itself for this case study of poetic inscriptions for several reasons.[11] First, there is an extensive programme of poetic epigraphy in the main room of the tower-palace composed by a single author, Ibn al-Jayyāb, for that specific site. Second, one of the poems offers an unambiguous reference to its own poetic devices, providing an explicit, self-referential reflection on the workings of poetry that is unusual for medieval poetic epigraphy in general and for a mid-eighth/fourteenth-century Arabic verse in particular.[12] Finally, the *Qalahurra* of Yūsuf I remains one of the least examined buildings of the Alhambra,[13] so it provides an occasion to see how the study of the poetic epigraphy may open new areas of investigation into architecture and architectural decoration.

2

The *Qalahurra* of Yūsuf I is embedded in the curtain wall of the Alhambra's enclosure (Figures I.3 and I.4: no. 58). The building projects outward as a massive defensive bastion with solid walls, except for a double-light window piercing each of the west, north and east walls high in its elevation. It is flanked by the *Qalahurra* of Muḥammad VII to the east, and the Torre del Cadí to the west, all of them forming part of the defensive system of the Alhambra's *madīna*, which includes these and other towers and gates, and

expanses of the curtain wall linking these structures (Figures 3.1 and 3.2). Seen from the most impressive perspective, which opens from the palace of Generalife overlooking the Sabīka hill on the northeast side, the exterior appearance of the *Qalahurra* of Yūsuf I is

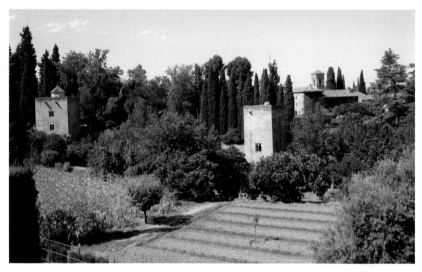

Figure 3.1 *View of the* Qalahurra *of Yūsuf I with the* Qalahurra *of Muḥammad VII to the east (on the left) from the palace of Generalife; dense vegetation obscures the curtain wall from view, Alhambra (photograph: Olga Bush)*

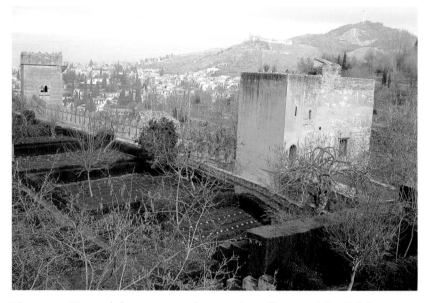

Figure 3.2 *View of the towers in the curtain wall west of the* Qalahurra *of Yūsuf I: Torre de Cadí in the foreground and the Torre de los Picos in the background, Alhambra (photograph: Olga Bush)*

much in keeping with that of other towers in the Alhambra that give it the outward aspect of a fortified city.

The defensive features of the *Qalahurra* of Yūsuf I can be appreciated fully when one approaches it from within the Alhambra's *madīna*, that is, from an area south of the building. It is probable that this area, now laid out as terraced gardens, was originally occupied by buildings. The curtain wall is visible east and west of the tower-palace, with a sentry walk along the top and a vaulted passageway within the wall itself below the ground level of the building (Figures 3.3 and 3.4). The rooftop terrace of the tower-palace is reached by an interior staircase and contributes further to the defence of the Sabīka hill, since it allows unobstructed observation of the terrain on the north, east and west sides, including the pathways that link the escarpments of the Generalife and the Alhambra. This arrangement of walls, passageways and observation posts functions as a communications system, not only among all the defensive structures of the enclosure, but also between them and the *madīna* within.[14]

 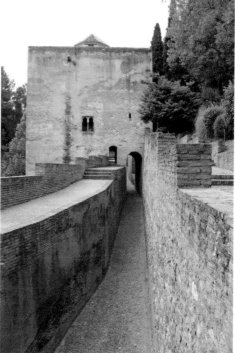

Figure 3.3 (left) Qalahurra *of Yūsuf I, exterior with the curtain wall, looking west from the* Qalahurra *of Muḥammad VII, Alhambra (photograph: Olga Bush)*

Figure 3.4 (right) Qalahurra *of Muḥammad VII, exterior with the curtain wall, looking east from the* Qalahurra *of Yūsuf I, Alhambra (photograph: Olga Bush)*

The *Qalahurra* of Yūsuf I suffered mutilations, especially during the French occupation from 1808 to 1812, during which time the wooden doors and the ceiling in the principal room were destroyed. It appears that the first restoration and conservation works were begun as early as 1814 and they have continued intermittently since then. The present-day wooden ceiling of the *Qalahurra* of Yūsuf I dates to the period between 1878 and 1892, and several panels in the dadoes of ceramic tile, as well as the marble floor, belong to later periods. Aside from those changes, the decoration of the interior of the principal room has generally been preserved in its original state.[15]

The plan of the *Qalahurra* of Yūsuf I is rectangular and measures 15.14 m × 7.5 m (Figure 3.5).[16] The volume of the tower-palace is divided, as it were, into three connected parts: the entrance, with a room above it on both the second and third floors; a small patio,

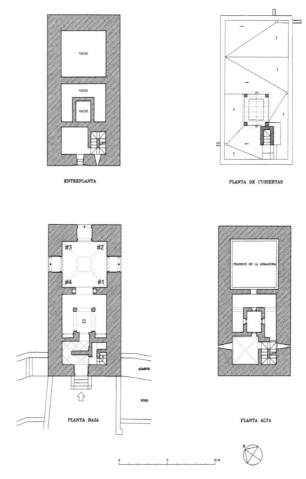

Figure 3.5 Qalahurra *of Yūsuf I, plan, Alhambra (Archivo de la Alhambra) Numbers added to the plan of the ground floor to indicate the location of the inscriptions of Ibn al-Jayyāb's poems.*

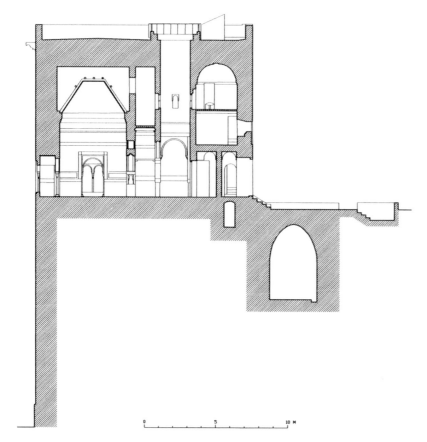

Figure 3.6 Qalahurra *of Yūsuf I, longitudinal section, Alhambra (Archivo de la Alhambra)*

which was originally open to the sky, but is now covered with a glass lantern; and the main room, whose elevation extends nearly the entire height of the building (Figure 3.6). The *bāshūra* or bent entrance corridor, a defensive feature characteristic of Nasrid towers and gates, leads from the entryway, situated on the south side, to the small interior patio, which is square in plan.[17] The pilasters on the entrance side of the patio and the square piers on the opposite side support the structure of the lantern that crowns the patio, serving as its source of light (Figure 3.7).

Similarly, the plan of the later *Qalahurra* of Muḥammad VII is also rectangular, measuring 15 m × 10.4 m (Figure 3.8). The height of the building from the ground level at its entrance on the south side to the platform on the roof is about 9.6 m, or about 1 m lower than the *Qalahurra* of Yūsuf I. The difference in its plan accounts for a difference in its elevation, which gives the *Qalahurra* of Muḥammad VII the appearance of a significantly taller structure (Figure 3.9). Its bent-entrance passageway opens onto a central space that extends

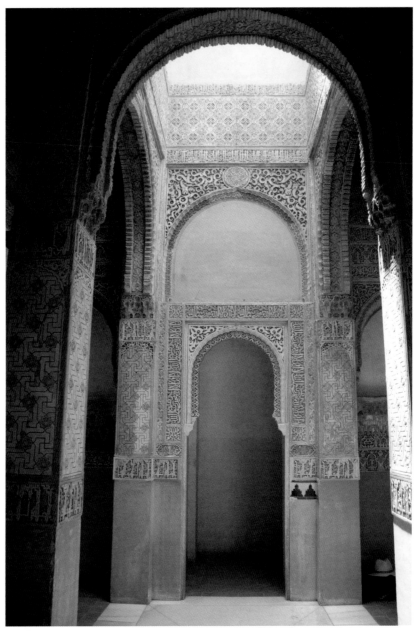

Figure 3.7 Qalahurra *of Yūsuf I, interior patio, Alhambra (photograph: Olga Bush)*

the entire elevation of the building and which was originally crowned with a lantern *muqarnas* vault, recorded in a drawing by Owen Jones. The original vault suffered substantial deterioration and it was replaced by Rafael Contreras and his son by a wooden *artesonado* cupola.[18]

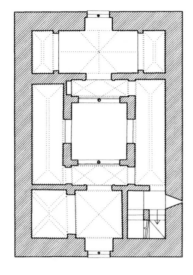

PLANTA ALTA

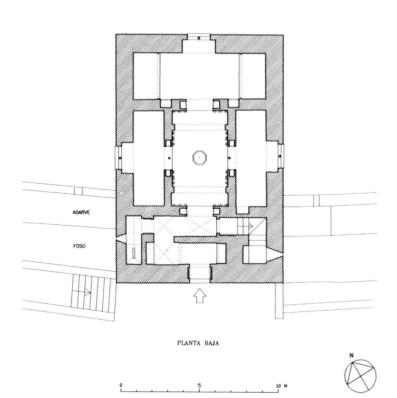

ADARVE

FOSO

PLANTA BAJA

0 5 10 M

N

Figure 3.8 Qalahurra *of Muḥammad VII, plan, Alhambra (Archivo de la Alhambra)*

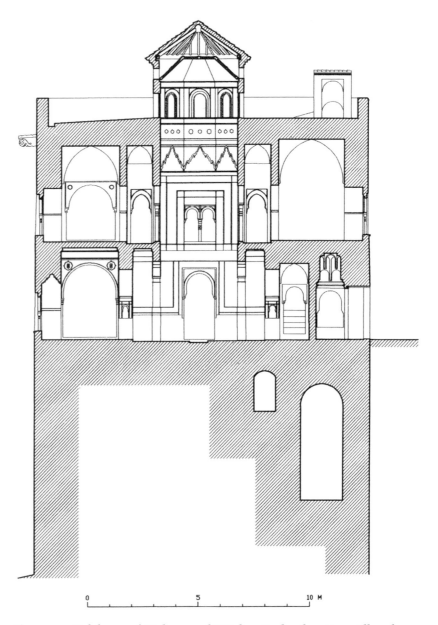

0 5 10 M

Figure 3.9 Qalahurra *of Muḥammad VII, longitudinal section, Alhambra (Archivo de la Alhambra)*

The stucco decoration in the interior patio the *Qalahurra* of Yūsuf I has sustained considerable loss on the piers, but has otherwise been mostly preserved.[19] With regard to epigraphy, it appears that with the exception of the profession of faith, 'There is no god but Allāh, Muḥammad is His Messenger', and one Qur'ānic verse, *sūrah* 6:73, 'His word is the Truth and His is the kingdom', only formulaic

inscriptions seen in other precincts in the Alhambra were employed in the patio.[20] These formulaic dicta were inscribed on the stucco decoration in Kufic and cursive script in bands and cartouches, under crenellated motifs and framed by *muqarnas* arcades. The following inscriptions are typical of the formulae in the patio: 'Everlasting glory and eternal kingdom belong to God' and 'The kingdom and eternity belong to God'.[21]

As in Nasrid times, the present-day visitor to the *Qalahurra* of Yūsuf I proceeds from the interior patio through an archway and finally reaches the principal room, which is typologically a *qubba* (Figures 3.10 and 3.11).[22] Its immediate antecedent is the *qubba*

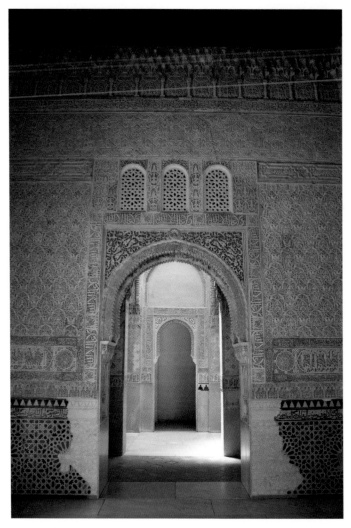

Figure 3.10 Qalahurra *of Yūsuf I, interior of the principal room or* qubba, *south wall, entrance, Alhambra (photograph: Olga Bush)*

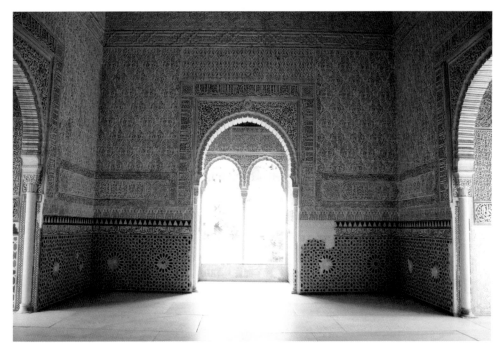

Figure 3.11 Qalahurra *of Yūsuf I, interior of the* qubba, *Alhambra (photograph: Olga Bush)*

of the Hall of Comares, also built under the patronage of Yūsuf I (Figure 2.6). Like its model, the principal room in the *Qalahurra* of Yūsuf I is square in plan with a vaulted ceiling and a central niche cut within its thick walls on three sides; each niche is open to the exterior by a double-light window. Further architectural and decorative features that the *Qalahurra* of Yūsuf I shares with the Hall of Comares will be considered as the analysis develops.

In contrast, when the *Qalahurra* of Muḥammad VII was erected only half a century later, the Hall of Two Sisters and the Hall of the Abencerrajes in the Palace of the Lions were also available as models of the *qubba* type. Similar to those halls in the Palace of the Lions, originally a lantern *muqarnas* vault crowned the square space of the central room in the *Qalahurra* of Muḥammad VII; and, like the spatial disposition of its models, this central room gives access to lateral rooms on both the ground and upper floors. The distribution of space in the *Qalahurra* of Muḥammad VII is especially reminiscent of the Hall of Two Sisters: lateral rooms on the ground floor open onto spectacular views through a deep niche with a double-light window (Figures 1.3 and 3.8). Nevertheless, Orihuela Uzal differentiates the plan of the *Qalahurra* of Muḥammad VII from the earlier examples of the *qubba* in the Palace of the Lions, agreeing with Torres Bálbas' proposal that the central space vaulted with a lantern served as a patio for the rooms organised around it and, at

the same time, as a vaulted room. This plan is akin to what has been termed *qāʿa* in Fatimid residential architecture.[23]

3

As in the precincts of many other buildings of the palatial city, the beholder is arrested at once upon entering the principal room of the *Qalahurra* of Yūsuf I. Striking views open from the windows onto the hill-studded landscape of Granada: to the northeast, the palace of Generalife, surrounded by a cultivated landscape; to the southeast, the eastern end of the Alhambra's fortified escarpment and the snow-capped mountain peaks of the Sierra Nevada; and to the northwest, the Albayzín hill (Figures 3.12, 3.13 and 3.14). Much transformed during the long post-Nasrid period, the view of the Albayzín's many neighbourhoods captivates the beholder even now, but in the Nasrid period the view would have been still more striking. The hill was then dotted with numerous mosques, all easily identified from the Alhambra's Sabīka hill by the projection of their minarets, which would have towered over the numerous large estates of court officials and nobility, with their verdant gardens, enclosed intimate courtyards and reflecting pools.

The interior of the tower-palace was no less overwhelming: as is typical in the Alhambra, every architectural surface – whether stucco, ceramic, wood or marble – is lavishly embellished (Figures 1.11

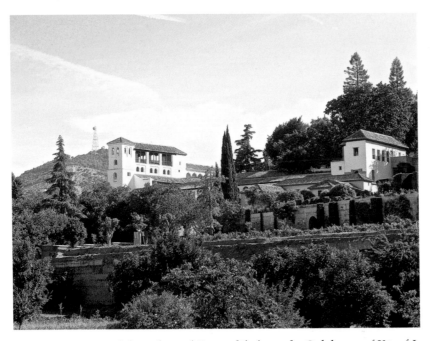

Figure 3.12 *View of the palace of Generalife from the* Qalahurra *of Yūsuf I (photograph: Olga Bush)*

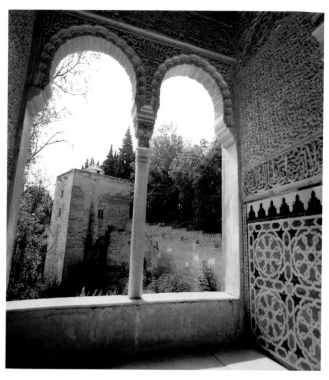

Figure 3.13 Qalahurra *of Yūsuf I, interior of the* qubba, *niche on the east wall with a view of the* Qalahurra *of Muḥammad VII, Alhambra (photograph: Olga Bush)*

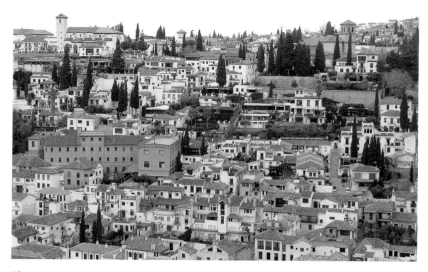

Figure 3.14 *View of the Albayzín from the* Qalahurra *of Yūsuf I, Alhambra (photograph: Olga Bush)*

and 3.11). Complex compositions of distinct geometric forms, schemes of diverse and prolific foliate motifs and numerous epigraphic bands and cartouches are distributed around the perimeter of the room along its elevation. Despite the *qubba*'s relatively modest dimensions – 7.8 m in height and 4.6 m to each side – its intended effect was to astound.[24] But once astonishment yielded to discernment, and looking turned to contemplation, the beholder would have recognised the main organising feature of the decoration: the division of the elevation of the interior into four major horizontal areas, creating a number of divergent decorative bands. The three lower areas, which correspond to the elevation and decoration of the walls, are of equal height, measuring 1.70 m; and the wooden cupola with its frieze is nearly 2.70 m high.

The lowest horizontal area (designated as area no. 1) reaches from the floor to a height of 1.70 m (Figures 1.11 and 3.15). This area combines two materials, ceramic mosaic and plaster, and contains inscriptions, including both poetry and passages from the Qur'ān. With natural light streaming from the double-light openings on three sides of the hall during the day and with candlelight illuminating the interior in the evenings, the inscriptions would have been perfectly legible from either a standing position or a seated position

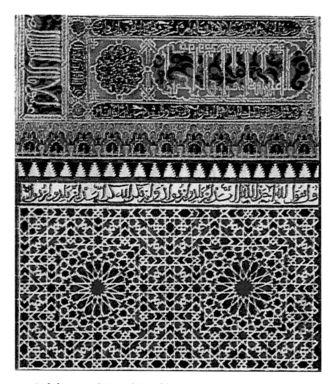

Figure 3.15 Qalahurra *of Yūsuf I,* qubba, *interior decoration, detail, area no. 1, Alhambra (detail after William Harvey, fig. 1.11)*

on the floor, as they remain today. In this area, the lower part of the wall is occupied by dadoes of ceramic tile mosaic and is divided into three bands. The widest band, located at a height of 82 cm from the floor, is filled with a geometric design based on a motif of radiating stars.[25] Above it, there is an epigraphic band, measuring 13 cm in height (95 cm from the floor). In the southeast corner of the room (to the right of the entrance), the band contains an inscription that reads: 'In the Name of God, the Compassionate and Merciful. God's blessing and peace on our lord Muḥammad and on his family'; it is followed by *sūrah* 113, *al-Falaq* ('The Daybreak' or 'The Dawn'), which is a brief invocation, asking God for protection from evil: 'Say: "I seek refuge in the Lord of Daybreak from the mischief of his creation; from the mischief of the night when she spreads her darkness; from the mischief of conjuring witches; from the mischief of the envier, when he envies."'[26] In the southwest corner (to the left of the entrance), inscriptions in this band start with a similar prayer, followed by *sūrah* 112, *al-Ikhlāṣ* ('The Unity' or 'Oneness of God'), a declaration of God's absolute unity: 'Say: "God is One, the Eternal God. He begot none, nor was He begotten. None is equal to Him."' (The Qur'ānic verses inscribed in the ceramic dadoes are only partially preserved.) Crowning the epigraphic band, a similarly narrow band is decorated with a crenellation element. Four different geometric designs can be distinguished in the dadoes: the first two are based on an eight-pointed star, while the third and fourth each has a sixteen-pointed star as the central element. They are distributed around the perimeter of the room in the following manner: the dadoes with the first design are located on the walls of the central niche; those with the second design appear in the lateral niches; the dadoes on the walls between the three niches are embellished with the third design; and the dadoes on the walls between the lateral niches and the entrance are decorated with the fourth design (Figures 3.5, 3.16 and 3.17).[27] Here, in addition to white, green, blue and brown in the polychromed colour scheme of the ceramic tiles, lustre tiles with sulphates of copper and silver appear for the first time in the decoration of the Alhambra (Figure 3.18).[28]

Between the dadoes of ceramic tile mosaic and the main expanse of the wall formed by panels of carved plaster there are two horizontal bands (Figure 3.19). The first of the bands is filled with a *muqarnas* frieze, 18 cm in height, supported by miniscule columns. The next band, measuring 29 cm in height and situated 1.32 m from the floor, contains two large oval cartouches in each corner, eight in all, each cartouche filled with the same verse from the Qur'ān, *sūrah* 12:64, 'God is the best of guardians, the most merciful of the merciful', executed in knotted Kufic.[29] The cartouches are punctuated by polylobed circular medallions filled with dense foliate forms. The combination of the inscriptions and the medallions is evocative of a Qur'ān manuscript, where similar, highly ornate, polychromed

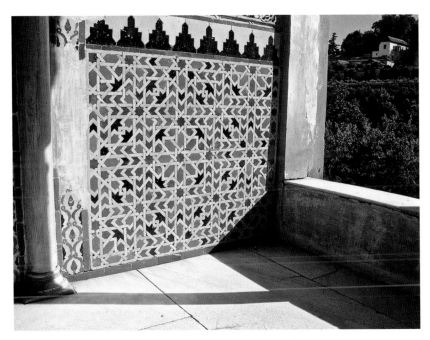

Figure 3.16 Qalahurra *of Yūsuf I,* qubba, *central niche, dadoes of ceramic tile mosaics with an eight-pointed star design, Alhambra (photograph: Olga Bush)*

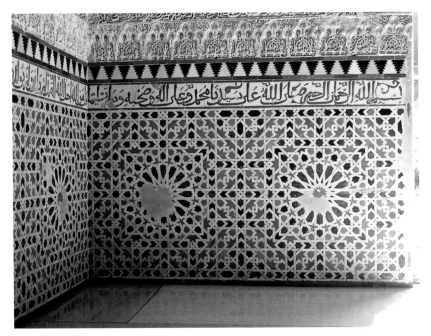

Figure 3.17 Qalahurra *of Yūsuf I,* qubba, *northwest corner, dadoes of ceramic tile mosaics with a sixteen-pointed star design, Alhambra (photograph: Olga Bush)*

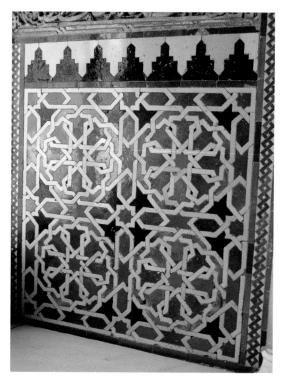

Figure 3.18 Qalahurra *of Yūsuf I,* qubba, *niche on the east wall, dadoes of ceramic tile mosaics with lustre, Alhambra (photograph: Olga Bush)*

and gilded medallions indicate the beginning of *sūrah*s.[30] In each corner of the room, a rectangular frame enclosing the cartouches with Qur'ānic verses is itself inscribed with a poem (Figure 3.20). For instance, in the southeast corner, the poetic text starts on the south wall and continues to the adjoining, east wall; the second poem in the northeast corner starts on the east wall and continues on the north wall, and so forth. This frame with poetic epigraphy measures 9 cm in height; its lower and upper bands are situated 1.23 m and 1.61 m, respectively, from the floor. Hence, the Qur'ānic verses and poems enclosing them are easily accessible from both standing and seated positions. The contrast in scale between the two texts is striking and so is the visual impact of the composition that combines them. The text of the Qur'ānic inscriptions is three times as large as that of the inscribed poems, but it is the poetic epigraphy that visually links the two sides of each corner, as though the verses, serving as a metaphoric L-bracket, provided structural support for the elevation of the building.

The second horizontal area of the elevation is filled with three superimposed rhomboid grids (geometric, floral and epigraphic) (Figures 1.11, 3.19 and 3.21). The employment of a geometric grid

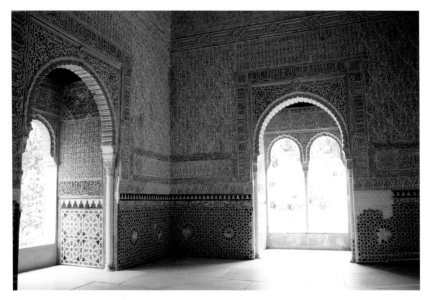

Figure 3.19 Qalahurra *of Yūsuf I,* qubba, *northwest corner, view of Ibn al-Jayyāb's poem, inscribed in the rectangular frame around the large cartouches with the Qur'ānic verses, Alhambra (photograph: Olga Bush)*

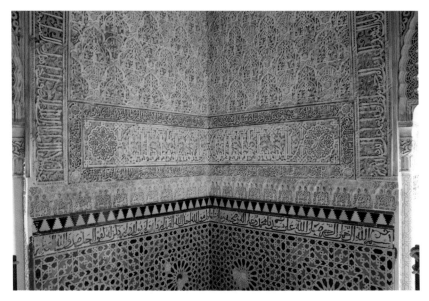

Figure 3.20 *Detail of Figure 3.19: rectangular frame inscribed with a poem surrounding cartouches with the Qur'ānic verses (photograph: Olga Bush)*

overlaid with a grid composed of vegetal elements is not unique to the Alhambra; on the contrary, models abound in Islamic arts and architecture. Examples might be cited from far and wide, but the most proximate would be Nasrid textiles from the late ninth/fifteenth

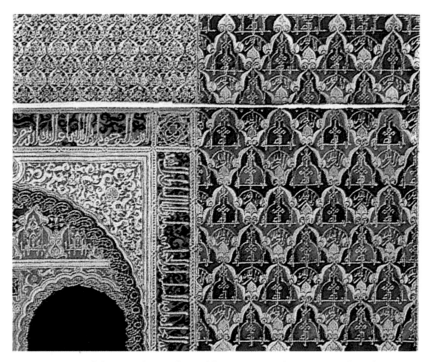

Figure 3.21 Qalahurra *of Yūsuf I*, qubba, *interior, decoration, detail, area no. 2, Alhambra (detail after William Harvey, fig. 1.11)*

century, and they are among the most vivid. The use of grids in these textiles is so prominent that scholars have referred to certain carpets that were similar to them in design, but made elsewhere in Iberia at that time, as the 'lattice-design' group.[31]

Fernández-Puertas reconstructs the general design for this type of stucco decoration found frequently on the walls in the Alhambra, showing that a geometric grid forms the basis for the overlaying of floral and epigraphic grids (Figure 3.22).[32] All floral and epigraphic elements are composed within a unit of the geometric grid, and the units are then repeated along the vertical and/or horizontal axes. The superimposition of three different grids, all placed on the same vertical axis, produces the effect of a pattern densely filled with mixtilinear, floral and epigraphic elements. In the *Qalahurra* of Yūsuf I, the epigraphic grid is formed by letters of Kufic calligraphy (Figure 3.23). The letters *alif* and *lam* are extended to create adjoining intersecting arches at the apex of the grid, while their prolongations are knotted at its base.[33] The Kufic phrase, which reads, 'Dominion [belongs] to God (*al-mulk li-llāh*)', alternates with another inscription placed within the adjoining arch of the same grid and executed in cursive script: 'Glory [belongs] to God (*al-ʿizza li-llāh*)'.[34]

Just as in the first horizontal area, this second level of the decoration extends onto the adjoining walls, creating the effect of

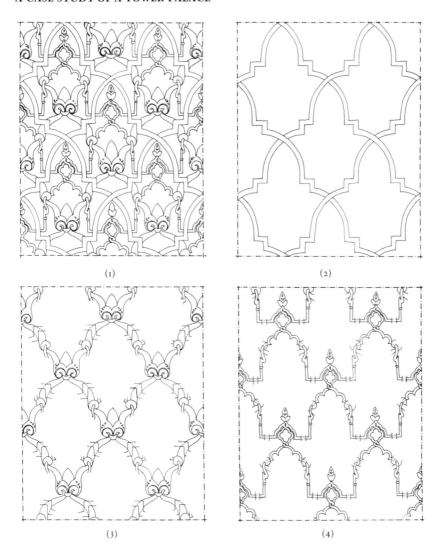

(1)

(2)

(3)

(4)

Figure 3.22 *Schematic construction of the superimposed decorative grids (after Fernández-Puertas, The Alhambra)*

a continuous band around the perimeter of the room. This effect is counterbalanced by the interruptions of the apertures: the entrance arch and the three openings with screens of carved and pierced plaster above it on the south wall and the deep, lintel-crowned niche on the north, west and east walls (Figures 3.10 and 3.11).[35] The single, slender column of the double-light window emphasises the vertical thrust of the apertures. It is reinforced decoratively by the rectangular frame or *alfiz* that articulates the openings of the niches and contains an epigraphic band. The text of the *alfiz* over the niches, repeated twice in each frame, reads: 'Glory to our lord

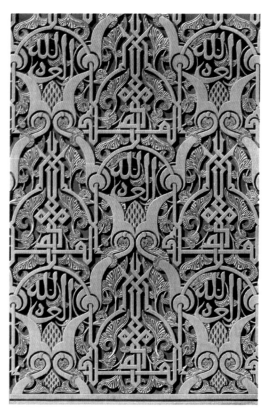

Figure 3.23 Qalahurra *of Yūsuf I,* qubba, *plaster panel in the northeast and northwest corners, Alhambra (drawing by Owen Jones, reproduced in Fernández-Puertas,* The Alhambra*)*

the sultan, the pure one, the *jihād* fighter, the prince of the Muslims Abu'l-Ḥajjāj Yūsuf, son of our lord the sultan and venerated martyr, the deceased Abu'l-Walīd Ismāʿīl, may God favour him with His help (*'azza li-mawlā-nā al-sulṭān al-maʿṣūm al-mujāhid amīr al-muslimīn Abu 'l-Ḥajjāj Yūsuf ibn mawlā-nā al-sulṭān al-shahīd/ al-muqaddas al-marḥūm Abu 'l-Walīd Ismāʿīl ayyada-hu Allāh bi-naṣri-hi)'* (Figure 3.24).[36]

The contrast of vertical and horizontal directions in the decoration is made even more emphatic in the small panels placed directly above the *alfiz* over the niches. These panels constitute an area that mimics, on a diminutive scale, the rhomboid grid that flanks it on either side. Thus, this area further underscores the articulation of the niche and of the double-light window within it – just as the latticed windows do on the south side – and consequently it makes the vertical ascent of the panels with the large rhomboid grid more prominent.

Within each niche, the lateral walls are adorned with epigraphic cartouches that counterbalance the vertical thrust of the decoration and visually echo the epigraphic cartouches in the corners of the

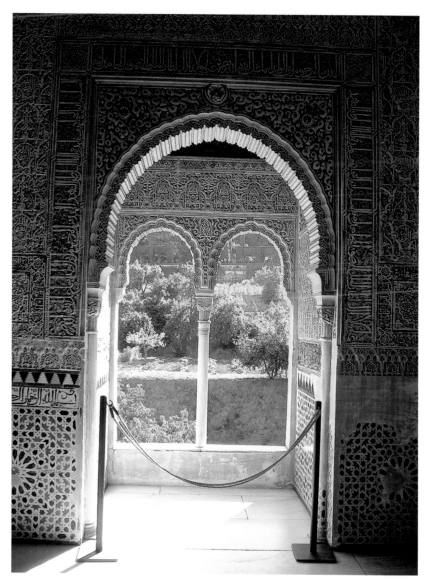

Figure 3.24 Qalahurra *of Yūsuf I, qubba, central niche, Alhambra (photograph: Olga Bush)*

room (Figure 3.25). The inscriptions preserved in the cartouches in all three niches appear immediately above the dadoes of ceramic tile mosaic, at a height of 1.40 m from the floor, and so they are easily legible. The texts of the two cartouches in the central niche read: 'Praise be to God for the favours that one after the other He grants day and night', and 'I hope that just as He gave favours in the past He may also be generous in the future.'[37] These verses have been copied from a longer poem attributed to Ibn al-Jayyāb that is inscribed in

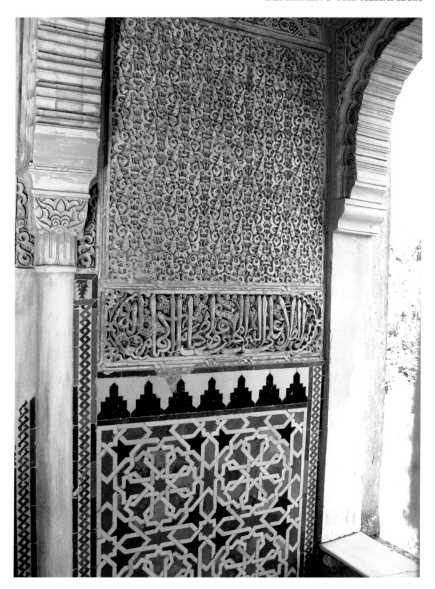

Figure 3.25 Qalahurra *of Yūsuf I*, qubba, *niche on the west wall with an epigraphic cartouche, Alhambra (photograph: Olga Bush)*

the central medallion of an epigraphic band above the openings on the north wall in the Palace of Partal in the Alhambra.[38] The two inscriptions in the cartouches in the east niche read: 'To praise God is delicious nourishment, so devote yourself to doing it repeatedly', and 'Thus may the chosen Prophet, his noble Companions and his family be blessed.'[39] The texts of the cartouches preserved in the west niche are 'I praise God for all of His favour as His glory and majesty deserve' and a repetition of the second text from the east niche.[40]

These poems in these niches seem little more than an expansion of the devotional sentiments expressed in the Qur'ānic and formulaic inscriptions that appear on the walls in main area of the room. Their language is straightforward in comparison with the use of prosopopoeia and other figures of speech discussed above in the poetic inscriptions in the niches of the entrance arch of the Sala de la Barca, and again, as shall be seen presently, in the inscriptions that comprise the main poetic programme in the *Qalahurra* of Yūsuf I. Still, they help to prepare the study of the more extensive poetic inscriptions as a model for the use of space. The distribution of verses between the cartouches in a single niche, and also between the niches, may well appear as a dispersion; but moving from niche to niche and reading all the verses gives a clear sense of a coordinated expression, emphatically condensed in the one reiterated verse cited above: 'Thus may the chosen Prophet, his noble Companions and his family be blessed.' The relation of the verses in the niches to the other kinds of inscriptions in the *qubba* reinforces the sense in which poetry forms part of a coherent epigraphic programme.[41]

Returning to the decoration of the walls in the main area of the *qubba*, the third horizontal area is divided into four bands of various widths (Figures 1.11 and 3.26). The geometry of the first band is an alternation of tiny eight-pointed stars and much larger epigraphic cartouches, whose lateral sides repeat the profile of the tiny stars. A Qur'ānic verse, *sūrah* 16:53, which is repeated in the cartouches reads: 'Whatever blessings you possess come from God (*wa-mā bi-kum min niʿma fa-min Allāh*).'[42] The second and much larger band is fully dominated by eight-pointed stars, the interstices of which are filled with polygonal geometric shapes and further embellished with floral elements. Above it is an epigraphic band in cursive script that contains a phrase that is repeated and that reads, 'Happiness and success are the favours of the Compassionate [God] (*al-saʿd wa'l-tawfīq niʿam al-Rafīq*).'[43] The wide band of a *muqarnas* frieze supported by a colonnade surmounts the epigraphic band.

Finally, the fourth area is the wooden cupola of the *artesonado* ceiling, a timber roof assembled from numerous, small wooden elements and constructed in the shape of an inverted trough, composed of four slanting trapezoidal sides and a flat horizontal panel at the top (Figures 1.11 and 3.27). As mentioned, the original ceiling was destroyed during the Napoleonic occupation of Spain (1808–12). Just prior to that destruction, however, in 1807, Simón de Argote recorded that the *artesonado* ceiling was made of 'wood neatly fitted, with a variety of figures, and four rosettes at the center'.[44] The present-day ceiling is a late nineteenth-century restoration undertaken by Rafael Contreras, whose work has been encountered in the examination of the Sala de las Camas

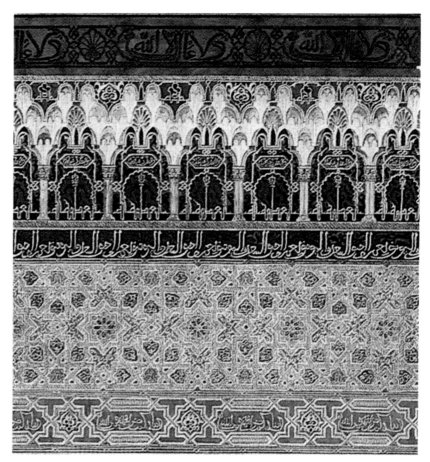

Figure 3.26 Qalahurra *of Yūsuf I, qubba, interior decoration, detail, area no. 3, Alhambra (after William Harvey, fig. 1.11)*

in Chapter 1 (Figure 3.28). As in that precinct, caution is called for here, but Orihuela Uzal has adduced strong supporting evidence in favour of Rafael Contreras' restoration work in this case.[45] Not only did Contreras employ Nasrid methods of *artesonado* construction in the *Qalahurra* of Yūsuf I, but also the design of the restoration corresponds to Argote's description of 1807 and closely follows that of original ceilings preserved elsewhere in the Alhambra, namely, the ceilings in the Partal Palace and the Hall of Comares. The ceiling in the *Qalahurra* resembles the ceiling in the Partal Palace in its size and in the use of clusters of *muqarnas*, whereas its shape – constructed of four main *artesonado* panels – is related to that of the Hall of Comares. The design of all three examples is based on the *lazo* or geometric patterning of radiating stars. In the *Qalahurra* of Yūsuf I an epigraphic band that is carved in wood and contains the Nasrid motto crowns the elevation of the walls and serves as a transition to the cupola.

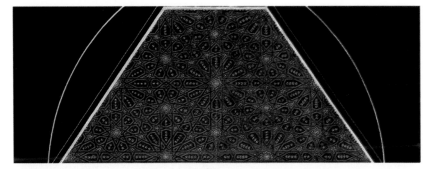

Figure 3.27 Qalahurra *of Yūsuf I, qubba, interior decoration, detail, area no. 4, Alhambra (detail after William Harvey, fig. 1.11)*

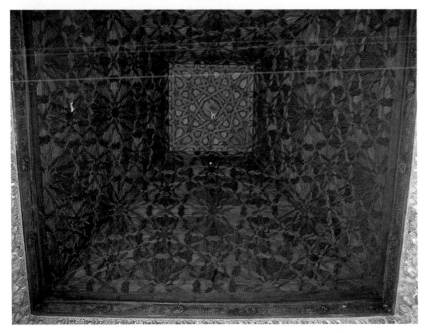

Figure 3.28 Qalahurra *of Yūsuf I, qubba, wooden cupola, Alhambra (photograph: Olga Bush)*

4

From this initial overview of the decoration of the *Qalahurra* of Yūsuf I, it will be clear that several elements are repeated in different horizontal areas. Before exploring the use of epigraphy, which appears in all three horizontal areas of the walls and in the band that serves as a transition into the fourth, I will examine more closely another unifying element, the superimposed grids – foliate, geometric and epigraphic – in the plaster panels, which likewise appear in all three of the horizontal areas of the walls.

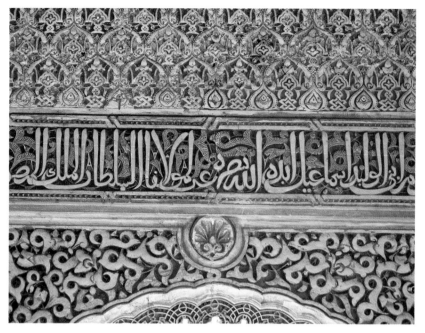

Figure 3.29 Qalahurra *of Yūsuf I*, qubba, *parietal decoration, detail, Alhambra (photograph: Olga Bush)*

The constituent elements of the grids were carved at different depths, varying from 0.5 cm to 4 cm.[46] The several levels of relief in the carving give the panels a three-dimensional texture, whose initial optical effect is that of the intersection of greatly varied decorative forms (Figure 3.29). This texture was enriched by the treatment of the surface of the foliate motifs that fill the grids in different ways: some are left flat or plain, while others are ribbed, dentated, serrated, lenticular or bevelled.[47] In the bands embellished with epigraphy, for instance, several depths of carving can be distinguished: the letters of the inscriptions form the foreground, while the vegetal motifs, carved in lower relief, constitute the middle ground.

The use of coloured pigments contributed further to the texture of the grids. The plaster panels have lost most of their original polychrome painting, here as elsewhere in the Alhambra. Nevertheless, the remains of pigments in many places in the room provide evidence of the rich and vibrant palette that was used in the decoration, and which, as discussed in Chapter 1, served Harvey for his reconstruction of this polychromed interior (Figure 1.11). The juxtaposition of primary colours red, blue and gold (a brilliant and costly substitute for yellow) appears to have predominated in the colour scheme, where the red and blue grounds alternate within the rows of the rhomboid grid. Foliate elements in some compositions were also painted with gold or silver leaf, while in others their serrated edges

were painted either in red or blue in contrast to the ground colour.[48] Contrast is also a key to the use of colours in the epigraphy, as Ibn al-Khaṭīb already recognised in his historical account describing a *qubba* in the Alhambra, in which he related that the poetic epigraphy was executed in letters of 'pure gold' on a ground of lapis lazuli.[49] The traces of pigments show that most of the epigraphy on the walls in the *Qalahurra* of Yūsuf I was painted with gold or silver leaf, or in white with black outlines,[50] executed on a red, blue or turquoise ground.[51] The optical effect of that contrast would have been to render the inscriptions more legible in the thick tangle of the foliate and geometric motifs in the panels.

Legibility was all the more paramount with respect to the poetic inscriptions, which, for that reason, are located just below the eye-level of a standing beholder. It bears repeating that the lower band of the poetic epigraphy here runs at the height of 1.23 m above the floor and the upper band at 1.61 m. The poetic texts, executed in *naskhi* script, are also vocalised, which would have further facilitated their reading. At that height the poetic inscriptions would also be legible to a beholder seated on the floor, although given the dimensions of the room, it would have been necessary to stand and walk around the perimeter to read the whole poetic programme. In this most fundamental sense of bodily motion, the poetic inscriptions would have guided the beholder's experience in an itinerary dictated by the reading of Arabic texts from right to left (counter-clockwise).

The poetic epigraphy is a guide in a further related sense, which, as in the case of the use of colour, establishes an interplay of stasis and dynamism. The poetry in the *Qalahurra* of Yūsuf I does not make use of the figure of prosopopoeia, considered at length in Chapter 2, but the message of 'Look! Contemplate!' dramatised emphatically by that trope is nonetheless implicit. The beholder may move about the room in the course of reading, but to experience the inscriptions as legible texts, it is necessary to pause long enough to read the poetic text. This pause is inherent in the experience of all forms of epigraphy, formulaic and Qur'ānic as well as poetic. Yet, as argued previously, the formulaic expressions are not only short, they are also frequently repeated, and the Qur'ānic verses might well have been memorised. In both of those cases, the inscriptions would have been recognised immediately more than read. To read slowly the longer and less familiar poetic verses would mean at the same time to gaze more steadily at the architectural decoration of which the poetic inscriptions were an integral part.

This is not to deny that the formulaic and Qur'ānic inscriptions in the *Qalahurra* of Yūsuf I were integrated into the decorative design, and that the latter, especially, had a role in guiding the beholder's understanding of the space. The Qur'ānic inscriptions need to be seen against the backdrop of their frequent and familiar use in mosque architecture, especially in the areas of the dome, *mihrab* and

doors.[52] The overarching connotation of Qur'ānic inscriptions in the mosque carries over to their use in the Alhambra. They represent a call to piety at all times, much as the formulaic inscriptions, which usually refer to the ruler, represent a call to fealty. In the context of pious foundations built by the Ottomans, for instance, Murat Sülün states that among other verses, the inscription of *sūrah* 112, 'The Unity' – also present in the Alhambra in both the *Qalahurra* of Yūsuf I and the Hall of Comares – should be understood as the most 'fitting tool' for representing 'the essence of God to the human intellect', and so meets the need 'of constantly recalling and emphasising the oneness of God' in order 'to instil [the names, attributes and commandments of God] in the minds of believers'.[53]

Particular inscriptions, however, are not simply the bearers of a generic religious message, but rather gain additional meanings from their particular surroundings. The inscription of verses from *sūrah* 67, *al-Mulk* ('Dominion') in the Hall of Comares has already been discussed in Chapter 2.

The use of *sūrah* 113 in the Alhambra suggests another case of focused contextualisation. Verses from *sūrah* 113 are not frequently encountered as a choice for epigraphy in Islamic architecture during the medieval period. The *mihrab* area in four mosques in Delhi, which are dated to the period from the ninth–tenth/fifteenth–sixteenth centuries, are among the few examples.[54] In the Alhambra, however, one finds examples of *sūrah* 113 in several places. The *sūrah* embellishes the *alfiz* of the central niche of the Hall of Comares, and also the entrance arch to the same hall, although reduced there to the opening verse.[55] The same *sūrah* is also inscribed in the *Qalahurra* of Yūsuf I in epigraphic bands executed in ceramic tile mosaic in the southeast and southwest corners of the *qubba*, flanking its entrance.[56] Puerta Vílchez emphasises the importance of the apotropaic dimension of *sūrah* 113, that is, a belief in God's power to avert evil,[57] which makes it an apt device for an entryway. The inscriptions of *sūrah* 113 guard the door, as it were, in both the Hall of Comares and the *Qalahurra* of Yūsuf I. That understanding is reinforced in the latter case by another Qur'ānic inscription repeated in the eight large oval cartouches in the *qubba* that were described at the outset of this chapter: 'God is the best of guardians, the most merciful of the merciful' (12:64).

What might otherwise be read as a general invocation of divine protection 'from the mischief of the envier, when he envies' (113:5) takes on a more pointed meaning in these spaces when *sūrah* 113 is read in connection with other inscriptions in the rooms. A poetic inscription cited in Chapter 2 from the central niche of the Hall of Comares, that is, the niche crowned by *sūrah* 113, provides an explicit reference to 'My lord Yūsuf [I]', the reigning sultan, and to the niche itself as 'the throne of the kingdom (*kursī al-mulk*)'.[58] The poetic figure of metonymy (relationships of contiguity) can

substitute container for contents, here, niche for throne, and if read thus, the combination of the poem and the inscription of *sūrah* 67, *al-Mulk* ('Dominion'), on the cupola of the Hall of Comares, supports the proposal that the space functioned as a royal audience hall.[59] That supposition is reinforced by the vast dimensions of the space and its elaborate decoration, as previously discussed, but these features do not yet explain the placement of *sūrah* 113 above the central niche.

One may turn for illumination to the inscription of *sūrah* 113 in the *Qalahurra* of Yūsuf I. Here, the Qur'ānic inscription appears in conjunction with a formulaic inscription on the *alfiz* of the niche on the main axis of the *qubba*. The formulaic text not only refers to Yūsuf I, concluding with the words, 'May God favour him with His help', but speaks of him more particularly as the 'son of our lord the sultan and venerated martyr, the deceased Abu'l-Walīd Ismāʿīl'.[60] Yūsuf I's father was a martyr inasmuch as he was assassinated in 755/1354 by his cousin Muḥammad, the ruler of Algeciras. In itself this inscription, like the reference to Yūsuf I in the poem inscribed in the central niche of the Hall of Comares, fulfils the common function of identifying the royal patron of the building in which it appears and reaffirming his dynastic legitimacy, but it is the redundancy, not the text that seems to call for attention here. To use the same Qur'ānic passage twice in a single room suggests deliberate emphasis on the part of the designers of the decorative programme. Historical context might well explain the special urgency. The reference to the deceased ruler in the formulaic text as a 'venerated martyr' would have evoked the memory of his assassination in the immediately preceding generation. Against that background, the repeated inscription may have heightened the apotropaic sense of *sūrah* 113, the need of divine aid to guard over the reigning sultan.[61]

That same sense is also picked up in the poetic inscriptions, where the poem in the northeast corner (the second poem according to the itinerary organised by the poetic programme, for location see Figure 3.5) also speaks of protection:

It [*qalahurra*] reveals Yūsuf to us, his face
like the sun that a night can never hide.
Because of it we love everything that delights us;
and [with it] we are protected from everything that bewilders us.[62]

More than coincidence, these interrelationships suggest coordination between Qur'ānic, formulaic and poetic inscriptions within a single space and therefore the possibility of reading them together. One might understand that as divine protection is invoked for the sultan (son of the assassinated predecessor), so the sultan, in turn, provides protection for his subjects – though, again, it would be the combination of texts, and not any one of the inscriptions, that

says so. The integrated reading across the generic divisions between the various inscriptions then gives added depth to the extension of the analogy that most concerns the study of the *Qalahurra* of Yūsuf I, that is, the identification of the sultan, as protector, with the architectural structure itself.

The proposal for an integrated reading of the different kinds of inscriptions is strengthened by adapting a general remark by Akiko Motoyoshi Sumi, who speaks of epigraphy as 'commentary' on the 'text' that is the architecture and decoration of the Alhambra.[63] As just seen, the inscriptions may comment on each other in the creation of a coordinated epigraphic programme. Since the inscriptions form part of the decoration, the epigraphy also comments on itself when commenting on the decorative programme in which it appears. This self-reflexive character is especially notable in poetry and will provide a key to the poetic inscriptions in the *Qalahurra* of Yūsuf I in the upcoming section. By making explicit the technical terms of its own forms of expression – above all, the major tropes, or poetic figures of speech – the poetic inscriptions refer the cultivated beholder to a familiar literary practice and a traditional body of thought about it (medieval Muslim poetics) and thereby provide a language in which to conceive of and articulate the meanings of the building and its decoration. It is in this sense that the overwhelming initial perception of decorative abundance is elevated to the level of contemplation through the imaginative work of poetry. It is not, of course, that the architecture depends on the poetic inscriptions, but rather that the poetic inscriptions help to guide beholders to a deeper understanding of the architecture that is before their eyes.

5

In the *Qalahurra* of Yūsuf I, the poems tell the beholder not only that the *qalahurra* speaks, but more precisely, that 'it speaks *badīʿ* poetry' (poem 3.6). Ibn al-Jayyāb, who composed the four poems inscribed here, is still more specific. (For the complete text of these four poems in Arabic and my translation into English, see Appendix.) That sixth verse of poem number 3 inscribed in the northwest corner of the *qubba* continues this unusually explicit self-referential procedure[64] – poetry referring to the workings of poetry – by naming some of the chief tropes in the tradition of *badīʿ* poetry. The references will now seem arcane, but it needs be remembered that the courtly Nasrid beholders were steeped in a culture of poetic recitation. The technical terms for poetic tropes would have been plainly intelligible. The Nasrid beholders would have found in the language of *badīʿ* poetry, and especially in this enumeration of the resources of its poetic tropes, a guide to orient their perception and understanding of the architectural decoration of which the epigraphy formed an integral part.

Before undertaking a sustained explanation of the poetic figures named by Ibn al-Jayyāb, I point to two important omissions from his list. First, he does not include metaphor, even though metaphor was considered the most important trope in medieval Arabic poetics, and Ibn al-Jayyāb himself uses metaphor abundantly throughout the poetic programme inscribed in the *Qalahurra* of Yūsuf I. It may be that he did not refer to metaphor precisely because of its ubiquity; to speak of metaphor would have been tantamount to a general expression for the figurative language of poetry.[65] In fact, the self-referential verse in which the other figures of *badīʿ* poetry are listed enacts the metaphor fundamental to epigraphy, wherein poetry is likened to architectural decoration, as shall be discussed. Second, Ibn al-Jayyāb does not refer explicitly to prosopopoeia, either. Recalling the discussion in Chapter 2, prosopopoeia is not a common term in medieval Arabic poetics, even if it is a frequent and characteristic element in the poetic epigraphy in the Alhambra. Prosopopoeia dramatises what is the general experience of inscriptions, especially poetic inscriptions, with or without the explicit use of the first-person voice for otherwise inanimate objects: the arrest of the viewer, literally a long enough pause in the beholder's movement through architectural space to transform looking into contemplation. The perceptual and cognitive processes of prosopopoeia and metaphor are both implicit as the founding conditions of poetic inscriptions, while the explicit references in Ibn al-Jayyāb's verse turn attention to more particular processes shared with the architecture and its decoration.

I cite here the whole text of the third poem in the sequence followed in the *Qalahurra* of Yūsuf I, whose general import is to guide the Nasrid beholder to experience the architectural decoration of the Alhambra as an *interrelated* ensemble:

1. This monument (*al-maṣnaʿ*) embellishes the Alhambra,
 It is the abode of the peaceful person and of the warrior.
2. *Qalahurra* was set as a palace (*al-qaṣr*)
 So, say: it is a stronghold or gathering place (*majmaʿ*) for happiness.
3. The beauty (*bahāʾ*) of the palace (*al-qaṣr*) is distributed between its four directions (*jihāt*), the sky (*samāʾ*), and the earth (*arḍ*).
4. Marvels of stucco and tiles
 [it] holds, but the carpentry of its ceiling is even more marvellous.
5. In storing (*jumiʿat*) so much treasure (*jamʿ*) it triumphed in going up and in rising to the highest heights.
6. It [Qalahurra] speaks *badīʿ* poetry: paronomasias, antitheses, caesuras, and internal rhyme (*mujannas, muṭabbaq, mughaṣṣan, muraṣṣaʿ*).[66]

7. If Yūsuf is there, his face is a marvel (*abda'*)
 that accumulates (*'ajma'*) all enchantments:
8. The main glory [comes] from K͟hazraj, whose traces
 in the religion are the thunder with light that spreads.

This short poetic text is formally and thematically congruent with
the other poems inscribed in the *Qalahurra* of Yūsuf I.[67] The general
characteristics of all of the poems may thus be enumerated together.
The poems are short, each composed of eight verses divided into
three parts. Each poem begins with a verse that refers to the immedi-
ate architectural setting as either a 'monument' (*al-maṣna'*), as here
in poem 3 and in poem 2, or a *burj*, a generic term for a tower, in
poems 1 and 4. The Alhambra is also named in the opening verses
of all four poems, indicating that the monumental tower in question
and its poetic inscriptions are site-specific. The reader of the poems
is the beholder of the *Qalahurra* of Yūsuf I. Beyond location, the first
verse articulates a relationship between the Alhambra as a whole
and this particular precinct. The Alhambra is 'proud' of it, 'like
[of] a crown' (1.1); it 'embellishes' and 'honours' the Alhambra (3.1
and 4.1). That relationship may even extend more broadly, since it is
said that the building's 'fame spread through every land' (2.1).

The poems then move to a middle section, verses 2–5 in each
case, which develops the initial, generalised reference to the archi-
tecture in a series of detailed descriptive images. The abundant
waṣf (mimetic description) of the carved stucco panels (3.4, 4.3), the
dadoes of the mosaic tiles (1.4, 3.4), the cupola of the *artesonado*
ceiling (2.5, 3.3), and the floor (1.4, 3.3) draws attention to the lavish
embellishment of the *Qalahurra* of Yūsuf I, pointing to the variety
of techniques, materials and designs.

The poems close with a *fak͟hr* (glorification) of the patron, typical
of poetic epigraphy in the Alhambra, as encountered already in the
entrance arch of the Sala de la Barca. The sultan Yūsuf I, under
whose rule this tower-palace was built and its poetic inscriptions
commissioned, is identified explicitly through his dynastic names.
The *fak͟hr* may then be said to summarise the message of the
Alhambra as a whole, which, scholars agree, expresses the glorifica-
tion of the sultans who were its builders. In the Alhambra, that is,
beauty (*bahā'*) represents power.[68]

If the *contents* of that message leap to the eye in the splendour of
the building, the *code* requires further explanation. How, precisely,
does architecture represent its patron? Ibn al-Jayyāb provides an
answer by concentrating the relation between the monumental
tower-palace of the first two sections of each poem and the sultan of
the closing *fak͟hr* into a single transitional verse, the sixth, in each
of the four poems. Here, sultan and building appear together. In the
most straightforward sense, the *Qalahurra* of Yūsuf I is identified as
the sultan's achievement, and so represents him, or his wisdom, as a

creation does its creator: 'A marvellous edifice was made to manifest [itself] by wisdom – that which only the caliph Yūsuf achieved' (4.6). The nature of such manifestation is articulated more acutely by way of metaphors in two of the other poems: 'Dressed in a *ṭirāz* of glory, as in them [walls] appears – the name of Our Lord (*mawlānā*) Abu'l-Ḥajjāj' (1.6); 'It [the tower (*burj*)] reveals Yūsuf to us, his face like the sun that a night can never hide' (2.6). The architectural decoration and, more exactly, the inscriptions identifying the sultan (including these very poems) are like a *ṭirāz*, an epigraphic band, such as might appear on textiles (e.g., on a robe of honour).[69] Alternatively, the ever visible *Qalahurra* of Yūsuf I, rising above the curtain wall, is like a sun that never sets, and in that sense is a proper likeness for the unending glory of Yūsuf I. In sum, these three poems proclaim that the tower is not only the product of the sultan's wisdom, wealth and power, but also that it represents the person of Yūsuf I, indeed, is his metaphorical likeness. The *Qalahurra* of Yūsuf I is the sultan's material achievement and his symbolic representation.

The remaining poem unfolds these figures of speech in still greater detail. Its sixth verse reads: 'It [*Qalahurra*] speaks *badīʿ* poetry: paronomasias, antitheses, caesuras and *murassaʿ* (*mujannas*, *muṭabbaq*, *mughassan* and *murassaʿ*). I emphasise the structural analogy. This crucial verse enumerating the tropes of *badīʿ* poetry stands in the same place (verse 6) and fulfils the function of transition supplied by the sixth verse that associates the building and the sultan in the other three poems. Here, Ibn al-Jayyāb presents poetry itself – or concretely, the four poems inscribed in the *Qalahurra* of Yūsuf I – as a mediator of the metaphorical relationship between architecture and ruler. And, beyond the general analogy that asserts that the tower 'both "is not" and "is like"' the sultan – to recall Ricoeur's definition of metaphor – Ibn al-Jayyāb turns to the devices of the tradition of *badīʿ* poetry to speak for the building and its decoration. Poetry does not so much describe the tower-palace as articulate and exemplify the workings of its design for the beholder. Each of the poetic figures that Ibn al-Jayyāb enumerates, I will now argue, contributes to understanding of the *Qalahurra* of Yūsuf I, so that the beholder may fully grasp the harmony of the parts in the beauty of the whole.

6

Ibn al-Jayyāb's use of the term *badīʿ*, the literal meaning of which is 'the new, creative, beautiful', constitutes an allusion to a particular tradition of classical Arabic poetry. *Badīʿ* poetry fully emerged at the end of the third/ninth century as an innovation at the ʿAbbasid court, exemplified in the works of such poets as Abū Nuwās (d. *c.* 200/815), Abū Tammām (d. 231/845 or 232/846) and Ibn al-Muʿtazz (d. 296/908), among others. The new poetry was examined for the first time by

Ibn al-Muʿtazz in his *Kitāb al-Badīʿ*, a work that became the model for theoretical writing about poetry.[70] He proposed that *badīʿ* poetry was not entirely new, but rather that its innovations depended on a subtle and nuanced use of poetic tropes.[71] Ibn al-Muʿtazz analysed five rhetorical figures of speech employed in *badīʿ* poetry: *istiʿāra* (metaphor), *tajnīs* (paronomasia), *ṭibāq* (antithesis), *radd aʿjāz al-kalām ʿalā ṣudūrih* (internal repetition) and *al-madhhab al-kalāmī* ('dialectical' manner). His analysis suggests that the interrelationship of these five rhetorical elements formed the structure of a *badīʿ* poem, which, in the words of modern literary critic Kamal Abu Deeb can be understood as 'a system within which the elements are not isolated but interrelated.'[72] Abu Deeb further states that 'the basic property of the structure is that it is formed on the level of the code, rather than the message of discourse; it explores relations of opposition and similarity, of oneness and multiplicity, between the linguistic constituents of poetry'.[73] In addition to the complex interrelationship of different linguistic elements in the structure of a poem, the question of what constituted a poem's ultimate beauty occupied poets and literary critics of the period as well, informed primarily by Aristotle's *Rhetoric* and *Poetics*. Thus, according to Ibn Ṭabāṭabā (d. 322/934), the ultimate beauty of a poem depends on *iʿtidāl*, or 'well-formedness and harmony'.[74]

In sum, defined and judged by these criteria, innovative *badīʿ* poetry not only took hold at the ʿAbbasid court, but transformed the medieval poetry of all Muslim lands, including al-Andalus.[75] From the tenth century onward, Andalusī poets composed *badīʿ* poetry.[76] Ibn al-Khaṭīb included poems of the most accomplished practitioners of *badīʿ* poetry – Abū Nuwās, Abuʾl-ʿAtahiya, Ibn al-Rumi and Ibn al-Muʿtazz – in his *al-Siḥr waʾl-shiʿr* (*Enchantment and Poetry*), the poetic anthology that was to serve as 'a guide to good poetry and literary taste'.[77] It has been noted that Ibn al-Khaṭīb's own poetry in traditional genres betrays dependence on the poetic works of Abū Nuwās, Abū Tammām and al-Mutanabbī.[78] In short, his work as compiler and poet attests to the continuity in the understanding and interpretation of the terms of *badīʿ* poetry under the Nasrids. This poetic tradition culminated in the Nasrid period in the work of the court poets Ibn al-Jayyāb and Ibn Zamrak, in addition to Ibn al-Khaṭīb himself, all three of whom composed poems inscribed on the walls of the Alhambra.[79] The examination of Ibn al-Jayyāb's poetic programme in the *Qalahurra* of Yūsuf I serves as further evidence.

In the light of Abu Deeb's explanation, where the code (roughly, structural properties and figurative functions), rather than the message (i.e., the contents), constitutes the aim of poetic composition and the principal touchstone for judgement, García Gómez' dismissal of Ibn al-Jayyāb's four poems in the *Qalahurra* of Yūsuf I as a mere redundant 'variation on a theme' must be contested.[80] This

is necessary not least because, if García Gómez' view were adopted, virtually the whole decoration of the Alhambra, and not only its poetic epigraphy, would have to be judged inferior. Against such a conclusion, two postulations made by Grabar are of special interest. First, with regard to the 'iconographic inscriptions' in the Alhambra, he suggests that they might serve the function of revealing 'an association which is not *a priori* obvious'.[81] Typical of Grabar's work, one finds theoretical richness in his hybrid formulation, 'iconographic inscriptions', which opens a new perspective on the interrelationship of word and image, epigraphy and architecture. Second, I cite Grabar's positive assessment of the 'conservatism' of the Alhambra: 'Even if at times repetitive and obvious, the forms of the Alhambra are perfect in the sense that each of them is developed and used with a full awareness of its possibilities and with visual clarity and logic in spite of their complexity.'[82]

Following the seminal work of Grabar and informed by semiotic theory, Puerta Vílchez, Valérie Gonzalez and D. Fairchild Ruggles in their various ways have read the Alhambra as a text; that is, they take its architectural structures, gardens as well as palaces, and its decoration, to constitute elements in a system of signs designed to communicate a message – a message most often understood, as already noted, to express the power of the sultans who were patrons of the works.[83] Pursuing Puerta Vílchez' line of inquiry, Cynthia Robinson examines the social assemblies at the *taifa* courts that included poetic recitation as a principal element. She raises poetry from an incidental ornament – if one may still speak of ornament as incidental after Grabar[84] – to the level of a major contributor to the construction of a fundamental aesthetic embracing architecture no less than literature.[85] Robinson also highlighted the importance of *badīʿ* poetry for understanding the aesthetic of al-Andalus throughout the *taifa* period, observing, for instance, that al-Badīʿ was the name of one of the palaces of al-Maʾmūn in Toledo, which 'indicates that both [al-Maʾmūn] and his contemporaries conceived of palace and poetics as intimately connected'.[86]

Despite his disparagement of Ibn al-Jayyāb's poems, García Gómez made an attempt to understand the characteristic tropes of *badīʿ* poetry mentioned by the poet in the inscriptions in the *Qalahurra* of Yūsuf I as a guide to the decoration of the principal room. However, his interpretations were based on the assumption of a straightforward mimetic relationship between the poetic tropes and decoration. His readings are correspondingly literal, as though poetry were merely a pointer to what stands self-evidently before the eye. The experience of the beholder during the Nasrid period would, I argue, have been notably different. The poetry does not simply mimic the decoration by literal description, but rather offers a pathway to understanding its complexity by analogy to poetic figures of speech. I now turn to the specific modes enumerated by Ibn al-Jayyāb.

7

Mujannas

The term *mujannas* is common to Ibn al-Muʿtazz and Ibn al-Jayyāb in the form of *tajnīs*, or paronomasia. García Gómez understood the term to mean 'similarity'.[87] The numerous decorative forms employed in the embellishment of this space support his under-standing, since there are certainly similarities between the various features. A closer examination of the term's poetic possibilities, however, suggests a more expansive interpretation. *Tajnīs* is inter-changeable with *jinās*, and both take their name from 'the principle of relationship of kind or *mujanasa*',[88] usually understood as play on words or poetic punning. Although there are several types of *tajnīs*, all of them depend on 'the extent of the identity between the two terms that form the paronomasia'.[89] Julie Meisami specifies the following types: 'they may be two identical words with different meanings, one of which may be a combination of two words; they may contain identical letters, but differ in their vocalisation and dia-critics; they may be only partially identical verging on alliteration; and the two words may be identical except for a reversed sequence of their letters'.[90] The Arabic language 'lends itself especially well to this device', she notes, because the root system (usually three con-sonants) provides countless occasions in which different words and meanings are derived from the same root.[91]

A first and relatively facile example of *tajnīs* may be found in the use of the root *n-ṣ-r*, which is the base of the name of the Nasrids, the dynasty founded by Muḥammad I from the clan of Banū Naṣr (Muḥammad b. Yūsuf b. Naṣr), also known as Banū al-Aḥmar, who ruled in Granada from 634/1237 to 671/1273.[92] As Ibn al-Khaṭīb stated in his *Iḥāta*: 'there are abundant references in many writers to the fact that the Nasrid house descends from Saʿd b. ʿUbāda, lord of the tribe of Khazraj and Companion of the Prophet'[93]; and, as previ-ously seen, Ibn Zamrak's verse around the west niche of the entrance arch of the Sala de la Barca likewise glorifies Muḥammad V through his ancestor Saʿd b. ʿUbāda. In the first poem in the *Qalahurra* of Yūsuf I, Ibn al-Jayyāb invokes the dynastic heritage, and then imme-diately plays upon the root *n-ṣ-r*, which means to help, aid, assist; to render victorious, let triumph; to protect, to save; and the verbal noun *naṣr*, which means help, aid, support; victory; triumph.[94] The poet honours the Nasrid sultan as being from the 'family of Saʿd and of the Banū Naṣr tribe, who helped (*naṣarū*) / and sheltered the one who "ascended the Ladder"', that is, the Prophet in the *miʿrāj* (Muḥammad's Ascent) (1.8). The second poem closes with a similar paronomasia on the Nasrid genealogy: 'May it always – the blood of Naṣr – in triumph (*naṣr*) and happiness (*saʿdin*) – / build whatever it wants wherever it wants' (2.8). Here, however, further puns, or,

perhaps, a double paronomasia, can be detected. The meaning of one of the forms of the verb with the root s-ʿ-d is to help, to assist, to aid,[95] but, at the same time, it is also a paronomasia on Saʿd, the name of the Nasrids' ancestors, and a reference to their assistance in the Prophet's miʿrāj, both of which appeared in the preceding poem (1.8).

Even though Ibn al-Jayyāb dispenses with the paronomasia on n-ṣ-r in the last verses of poem 3, where he refers neither to the Banū Naṣr nor Saʿd, he still makes reference to the Nasrids' dynastic gene-alogy, stating that the sultan's 'main glory [comes] from Khazraj' (3.8). The poet refers to the Khazraj tribe once more, but this time by its other name, Anṣār, by which the tribe is known in the Qurʾān.[96] Thus, in the last verses of the remaining poem (4.8), Yūsuf I's lineage is linked in a paronomasia to 'triumph': 'Because he is the chosen of Anṣār, may his kingdom always / continue to have triumph (naṣr), and may he continue to lead in the religion [of Islam].'

This poetic emphasis on the sultan's genealogy was particularly important with regard to Yūsuf I's dynastic claims, since his father, Ismāʿīl I, was a matrilineal descendant of the founder of the Nasrids – Ismāʿīl I's mother, Fāṭima, was Muḥammad I's granddaughter. Ismāʿīl I took the throne in a revolt against Sultan Naṣr (r. 708–13/1309–14), the last ruler in the direct line of descendants of Muḥammad I. The struggle for power between the two sides of the family, al-dawla al-ghalibiyya (victorious state) and the collateral branch of the Banū al-Aḥmar termed al-dawla al-Ismāʿīliyya (after Ismāʿīl I), predated Ismāʿīl I's reign and continued between the Nasrid princes through the reign of Muḥammad V (755–61/1354–59 and 764–94/1362–91).[97] Consequently, the poet's reiteration of Yūsuf I's genealogy and the Nasrids' dynastic ties to Saʿd, the Companion of the Prophet links Yūsuf I's triumphs to those of the prophetic faith itself.

Those first examples of paronomasia on family names are barely a step beyond literal designation. Perhaps one might note this differ-ence in the poetic inscriptions in the Qalahurra of Yūsuf I, where the paronomasias represent the ways in which the varied expressions of the dynasty's names (Banū Naṣr, Saʿd, Anṣār), on the one hand, and the several usages of n-ṣ-r and s-ʿ-d, on the other, are all traced back to the same historical and verbal roots in the assistance of Yūsuf I's forebears to the Prophet. Or the reverse: through the many tajnīsāt on the family names, a single lexical root yields a multiplicity of artistic expressions.

So even in this relatively simple deployment of the trope, it can already be seen that mujannas provides a term for the fundamen-tal geometrical principle of the architectural design: Fernández-Puertas' thesis, mentioned in Chapter 1, that a single ratio was the architectural root, as it were, of every element of the Alhambra.

Among his many detailed demonstrations based on exacting and comprehensive measurements, Fernández-Puertas offers an analy-sis of the plan of the Qalahurra of Yūsuf I as an illustration of

that design principle. He explains how a plan of a building in the Alhambra might have been drawn in Nasrid times on the basis of a technique known since antiquity:

> If we give the side of a square (whatever its size) the value of unity (= 1), its diagonal will be sq. rt. of 2, as Pythagoras' theorem shows. So if we then take the side of this square (= 1) as the short base of a rectangle, and give its longer side the diagonal of the square, we obtain a proportional sq. rt. of 2 rectangle. This sq. rt. of 2 rectangle, in turn, will have a diagonal with a value of sq. rt. of 3 – as Pythagoras' theorem again confirms. So by repeating the operation, we obtain a sq. rt. of 3 rectangle; and by repeating the operation again we obtain a sq. rt. of 4 rectangle (i.e. a double square), and so on.[98]

Using a string with a peg on one end and a marker on the other, and starting with a square whose diagonal divides it into two isosceles right triangles, a sequence of proportionate rectangles can be drawn in increasing sizes. Alternatively, as Fernández-Puertas also shows, builders could have used geometric instruments in the form of right triangles with angles of varying degrees (e.g., the *escuadra* with angles of 90, 45 and 45 degrees and the *cartabón* with angles of 90, 60 and 30 degrees).[99] He then demonstrates the way in which all the elements of the plan of the *Qalahurra* of Yūsuf I were drawn in proportion both to each other and to the plan as a whole, always building on the same fundamental ratio of the diagonal of a square to its side. In the *Qalahurra* of Yūsuf I, the width of the tower-palace was taken as the basic unit on which all other dimensions rested: the complete length of the plan, the width of the central hall and that of its entrance arch, the width of the deep niches on the three walls, and the width of the small patio within the building's interior (Figure 3.30).[100]

In line with Fernández-Puertas' geometrical thesis, I am proposing a fundamental inter-medial tenet: the many arts that formed part of the architectural ensemble of the Alhambra shared a common principle of relatedness in the coherence of apparently disparate parts (different colours, scales, motifs and media), a principle for which *mujannas* gives a general expression. Therefore, the beholders in Nasrid times, familiar with the traditions of medieval Arabic poetry and poetics, would have found the principles of the architectural design articulated in the tropes to which the poetic inscriptions in the *Qalahurra* of Yūsuf I call their explicit attention.

A second example of *tajnīs* may be cited to illustrate the constructive principle by which a single root proliferates. Words derived from the root *ṣ-n-ʿ* (work, workmanship, design, artistic skill) are used in two different verses of the first poem in Ibn al-Jayyāb's poetic itinerary: *ṣanʿa* (workmanship) (1.3) and *ṣanāʾiʿ* (skilfully made) (1.4); *ṣanʿ* (fabrication) (2.5); and, finally, in both the second poem and

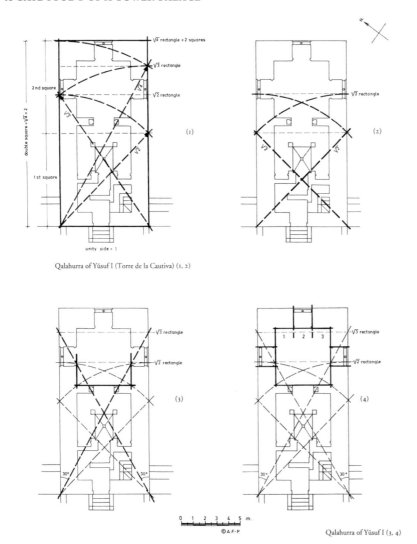

Figure 3.30 Qalahurra *of Yūsuf I, plan, constructed on proportional ratios, Alhambra (after Fernández-Puertas,* The Alhambra*)*

third poem as *maṣnaʿ* (monument; literally, man-made structure, grand structure) (2.1 and 3.1). This, too, is but a small step beyond the first example in that in each individual case the root is used mimetically to refer to the construction and embellishment of the building before the eyes of the beholder. Still, this representation of the *Qalahurra* of Yūsuf I as a whole as an example of *ṣ-n-ʿ* or *artistic skill*, leads to a more detailed consideration of the ways in which the principle of relatedness through a common root appears in the *workmanship* and *design* (still *ṣ-n-ʿ*) of the decorative elements from different horizontal areas, or different bands within an area (Figures 1.11, 3.15, 3.21, 3.26 and 3.27). The eight-pointed stars in

the two consecutive bands of the third area are similar despite the difference in scale, but what is even more important is their relation to other star-motifs elsewhere in the overall decoration of the walls: the eight- and sixteen-pointed stars in the dadoes of ceramic tile mosaics and the twelve-pointed stars in the cupola. The poetic *tajnīs* speaks for a *visual paronomasia* within individual bands (a 'play on visual motifs', as one might say a 'play on words'), whereby the star motif serves as a root out of which the rest of the design radiates. The star explodes into a myriad of small particles helping to give the decoration its sense of overwhelming abundance, and yet, viewed through the lens of *mujannas*, it also helps *to gather* the different bands together in an interrelated composition of the whole elevation that belies the diversity of media, much as the diagonal of the square does for the variety of geometric forms.

It is precisely the function of gathering that is attested by one further and more complex example of *tajnīs* in Ibn al-Jayyāb's poetic inscriptions in the *Qalahurra* of Yūsuf I. The root *j-m-ʿ*, which, in one form, gives the verb 'to collect, to combine, to accumulate, to gather, compose',[101] is used in four places in the third poem of the poetic itinerary in the main area of the *qubba*, including twice in a single verse, giving it considerable salience: *majmaʿ* (assembly) (3.2), in reference to the tower-palace as a place of gathering; *jumiʿat* and *jamʿ* ('storing so much *treasure*'; literally, gathering, collecting or combining in a collection) (3.5), which together also refer to the function of the tower-palace; and finally, *'ajmaʿ* (3.7), in another form of the verb (to gather, to accumulate),[102] in reference to the *abdaʿ*, or overwhelming marvel of the sultan's face, which 'accumulates all enchantments'. Here the paronomasia shows the inter-medial relationship to work reciprocally. *Mujannas* provides a term, and a set of textual examples, for the kind of relatedness through a common root at the base of the decorative programme in the *Qalahurra* of Yūsuf I and elsewhere in the Alhambra; but so, too, that design principle reflects back on poetry. The root *j-m-ʿ* can also mean 'to compose', and so the *tajnīsāt* on that root may also be read as references to poetry, which similarly combines, accumulates and stores up treasures, and, more particularly to Ibn al-Jayyāb's own poetic inscriptions in the *Qalahurra* of Yūsuf I, which, as this very poem claims, collects the tropes of *badīʿ* poetics. Indeed, Ibn al-Jayyāb submits *b-d-ʿ* itself, the root of *badīʿ*, to the technique of *tajnīs*. The root appears throughout the four poems, now referring to the architecture ('marvels [*badāʾiʿu*] of stucco and tiles', 3.4), now to the sultan's face (*abdaʿ*, 3.7); and now to poetry itself, as the mediator between the two ('It [*Qalahurra*] speaks *badīʿ* poetry').

This last paronomasia not only fills out the complexity of the *tajnīs* on the root *j-m-ʿ*, but also speaks more generally for the way that *mujannas*, and, as shall presently be seen, the other tropes of *badīʿ* poetry enumerated by Ibn al-Jayyāb give expression to the

fundamental meaning of the *Qalahurra* of Yūsuf I as an architectural form. The poetry provides some mimetic description of the artistic skills embodied by the tower-palace, of course, but as discussed with regard to *waṣf*, the verses describe in order to praise. In that respect, one might say that the poems are only a means to reach their final cause, which is the *fakhr* section with its *tajnīsāt* on the family names of the sultan, honouring Yūsuf I by designating his distinguished genealogy. And indeed, the root *f-kh-r* is itself subject to paronomasia in the poetic inscriptions: *al-fakhr* (glory) (1.6, 3.8); and *iftakhara* (vying for glory), alongside *al-fakhr* (4.7). But the *tajnīs* on *j-m-ʿ* says more. By using the same lexical root to speak of both the architecture and the sultan's face, the poetic inscriptions articulate what might be called the single root of meaning of this tower-palace and the palatial city at large: the fundamental analogy, that is, the metaphorical relationship, by which architecture may represent the ruler who constructs it. Both the tower-palace and the sultan gather, accumulate and store treasures, though the marvels that they gather may differ profoundly.

Muṭabbaq

Since all of the tropes in the poetic inscriptions represent variations on the same inter-medial root of design principles shared by poetry and architecture, as seen in the case of *mujannas*, it will now be possible to move somewhat more quickly through the other figures enumerated by Ibn al-Jayyāb. Still, as in Fernández-Puertas' demonstrations of the general architectural principle of geometric proportionality, it is as well to work through the inter-medial relations between the tropes of *badīʿ* poetry and the decoration of the *Qalahurra* of Yūsuf I in some detail.

Muṭabbaq (also *ṭibāq*), or antithesis, listed next in the sixth verse of poem 3, is usually glossed as 'antithetical words, ideas, or constructs'.[103] The trope is easily recognisable in the poetic inscriptions in such contradictory combinations as 'single and paired' (1.3). Ibn al-Jayyāb draws upon *ṭibāq* to represent the basic architectural structure opposing ceiling to floor through the antithetical image of 'the sky (*samāʾ*), and the earth (*arḍ*)' (1.3). García Gómez expands discussion when he suggests that *muṭabbaq* should be understood as 'alternation'.[104] Many examples of the alternation of morphological decorative elements can be found within a single horizontal area of the elevation to support his proposition. For instance, the band in which circular and oblong cartouches alternate in the first (i.e., lowest) horizontal area is related to the band with alternating eight-pointed stars and cartouches in the third area (Figures 1.11, 3.15 and 3.26). Not only do the lateral sides of the large cartouches in both bands repeat the profile of the smaller ones, but the large cartouches contain epigraphy, while the smaller ones are filled with floral

elements. Furthermore, the rectilinear cartouches, which alternate
with stars in the third area, are related to the small rectilinear car-
touches filled with inscriptions that are suspended from the *muqar-*
nas frieze in the upper band of the same area. At the same time, the
band above the *muqarnas* frieze in the fourth area, in which oblong
cartouches alternate with circular ones with polylobed contours,
relates back to the band in the first area with alternating cartouches
that are linked by the knotted elements (Figures 1.11, 3.15 and 3.27).

Visual *muṭabbaq* also has the 'potential for organising larger
units';[105] in poetry that can mean establishing the relationship
between segments of a poem, and even between whole poems. In the
architectural decoration of the *Qalahurra* of Yūsuf I, the antitheti-
cal elements serve to organise the initial, overwhelming perception
of the ornamentation as an interrelated set of *alternating* elements
that integrate the horizontal bands into a coherent overall design.
It is in this respect that *muṭabbaq* plays its most significant role in
the inter-medial design as a device for representing the fundamental
analogy between the architecture and the sultan.

Ibn al-Jayyāb uses antithesis at several reprises, even within a
single verse, to depict the basic opposition between the building's
exterior and interior: for instance, '*Qalahurra* on the outside, while
it conceals within a palace (*al-qaṣr*) that emits a burning light' (1.2)
(Figures 3.3 and 3.11). The antitheses of outside–within and con-
ceals–emits may recall the 'poetic truth' of the pyxis that showed its
faithfulness by covering up its contents (or 'storing', *j-m-ʿ*). It may
now be clarified that 'truth' is not so much in the concealed con-
tents, but in the antithetical relationship, that is, in the case of the
Qalahurra of Yūsuf I, the yoking of opposites in a single structure.

Ibn al-Jayyāb introduces the building in the opening words of
the first poem with the most generic of designations: '*al-burj*' (the
tower, not tower-palace) (1.1). Immediately thereafter he divides
that generic term into an antithetical pair: the twin images of *qala-*
hurra and *al-qaṣr*. *Al-burj* is also distinguished from *qalahurra* in
the opening verses of poems 2 and 4, so that the *burj* itself replaces
al-qaṣr to form the *ṭibāq*. Ibn al-Jayyāb provides a further explana-
tion of the dual nature of the building by means of antithesis in those
subsequent poems: '*Qalahurra* was set as a palace (*al-qaṣr*) / So,
say: it is a stronghold, or a gathering place for happiness' (3.2), and
'*Qalahurra* outwardly, on the inside a palace (*al-qaṣr*) / So, say: it is
a stronghold or a dwelling for happy tidings' (4.2).

What is notable in the poetic logic is that antithesis is not a
choice between opposites, but rather a unity in contradiction. The
Qalahurra can be the seat of pleasure and of pacific assembly pre-
cisely because it also projects military strength. The same antith-
esis is transferred from the architecture to express the dual nature
of its royal patron: 'This monument (*al-maṣnaʿ*) ... abode of the
peaceful person and of the warrior' (3.1). This *muṭabbaq* engages

another antithesis that expresses the opposition between Islam and Christianity in the historical context of the Alhambra: 'It has been an honour to the faith that infidel slaves were forced to build it [i.e., the *Qalahurra*]' (1.5). The honour in question is explained by the fact that the 'infidel slaves' would have been Christians, who, it appears, took part in the royal construction projects of the Nasrids in Granada.[106] Here, as elsewhere, the ruler stands for the faith, in that it is both faith and ruler who defend against the infidels: 'we are protected from everything that bewilders us' (2.7). The poetic image of Yūsuf I as protector constructed on the model of the tower-palace is further elaborated in yet another antithesis: 'If the kings compare their glories, / his [i.e., the glory of Yūsuf I], the Qur'ān itself tells us' (4.7). The vainglory of other kings is merely rivalry for earthly power and so circumscribed by history; the true glory of the defender of the faith is sacred and inscribed in the Qur'ān.

Finally, with respect to *muṭabbaq* in the decoration of the Qalahurra of Yūsuf I, in addition to the sense of *ṭibāq* as corresponding or analogous to something,[107] its root, *ṭ-b-q* spans a range of meanings: 'to cover, to make coincident or congruent, to superpose (two figures in geometry); to spread throughout something, to pervade'.[108] One finds analogy in the relation of the star motif in the first, third and fourth areas to the rhomboid grid in the second area, as both elements serve to make geometry explicit in the design (Figures 1.11, 3.15, 3.21, 3.26 and 3.27). All three grids are congruent, since, despite the differences in form, the foliate and epigraphic grids follow the outlines of the geometric one. Indeed, more than congruent, the grids quite literally pervade the panel and, moreover, cover one another. Neither the combination of the three kinds of motifs, nor the overlapping of grids is a novel feature in Islamic architectural decoration. It is striking, however, to find the literal superimposition of grids that form the rhomboid patterning in the second horizontal area (Figure 3.19) put into words for the beholder by the poetic inscriptions at the very site. The trope of *ṭibāq* provides an apt expression for the analogical relationship in the array of decorative grids on the walls, at once the recognition and appreciation of similarities and dissimilarities between the various elements.[109] Conversely, the superimposed grids offer an outstanding visual analogue of the poetic figure of *ṭibāq*. On a larger scale, *muṭabbaq* is evident with regard to the design within any panel, which spreads in horizontal and vertical directions, and for the decorative scheme as a whole, which covers the entire surface of the architectural interior.

Mughaṣṣan

García Gómez reinforced his mimetic bias in his interpretation of *mughaṣṣan* as 'branching'.[110] In his understanding, the term points to the vegetal decoration whose leaves and tendrils sprout and

branch out to fill the space (Figure 3.25).[111] The design, however, does not isolate the foliate motifs. García Gómez' inclination, one might say, is indeed to separate decorative motifs and disambiguate poetic expression, whereas the fundamental resemblance underwriting the relationship between architectural decoration and poetry is their shared ambiguity. Contrary to the isolation of the foliate motifs, the design of the decoration of the walls inserts them in one and the same area (Figures 3.20 and 3.23) with the geometric and epigraphic grids.[112] Certainly, there is branching, in a literal sense, in the foliate grid, but what is wanted is an understanding of the verse enlarged beyond the mimesis that can account for more varied and complex interrelations.

As a poetic term, *mughaṣṣan* refers to the compositional device of caesura, which distributes the syllables of a verse more or less evenly around a central point of metrical balance, thereby dividing the verse into hemistichs. Working like the line breaks at the end of each verse, caesura indicates a logical pause in the performance of a poem and it is 'audible' as a gap between words, the silence in the midst of a verse. In short, caesura divides the structure of a verse into proportional units. As a point of balance between the hemistichs, it highlights the distribution of poetic phrases, amplifying the hemistichs' rhetorical impact. Meisami defines caesura with still greater precision when she notes that such markers in *badīʿ* poetics 'indicate both connections and shifts'.[113] Caesura at once divides a verse metrically and also links its parts syntactically and semantically so as to create a larger unity out of the symmetrical pair of hemistichs.

Ibn al-Jayyāb's reference to caesura as a marker for keeping parts in balance is no less crucial to the analysis of the non-verbal decoration. In both the specific visual and verbal context of the inscribed poems, caesura is the most self-referential of the four tropes enumerated in the third poem in the sequence. It is the most *visible* manner in which poetry talks about poetry in the *Qalahurra* of Yūsuf I, or more generally about the aesthetic experience of the site. First, the band of poetic epigraphy itself makes for a connection and shift, a borderline, as it were, in the overall decorative design (Figure 3.19). In this sense, all of the decorative elements that separate one poetic inscription from another would represent such an interface. But so, too, in the alternation between movement and pause, the beholder would perform the very work of caesura, a stop anticipating a continuation that would embody the process of imaginative contemplation that the rich architecture and decoration of the *Qalahurra* of Yūsuf I require and that the poetic programme articulates.

To summarise, then, to this point: *mujannas*, or paronomasia, was seen to articulate the fundamental principle of inter-medial relations, namely, that a richly varied design grows from a common root (whether the combination of primary colours, the diagonal of a square in geometric proportions or a shared visual motif). *Muṭabbaq*,

though perceptible at several levels of decorative design, is most important as an expression of the architectural relatedness on the largest scale – the opposition of ceiling and floor, for instance, inside and outside, fortification and residence, in a single structure. And *mughaṣṣan*, or caesura, articulates the balanced relationship of movement and pause that has been seen previously — in the interplay of kinetic colour and stabilising geometry and the use of threshold space – as a key to the aesthetic experience of the Alhambra. The final trope in Ibn al-Jayyāb's enumeration will allow some concluding reflections on these various aspects of the inter-medial aesthetic of the Alhambra as it is represented in the poetic epigraphy.

Muraṣṣaʿ

G. Schoeler pointed out that there is no single and consistent meaning of *muraṣṣaʿ* (or *tarṣīʿ*).[114] Meisami has noted, however, following Diyāʾ al-Dīn ibn Athīr (558–637/1163–1239), a literary theorist and critic at the Zangid court in Mosul, that the term derived from an expression related to the jeweller's craft – *tarṣīʿ al-ʿiqd*, or the setting of stones in a necklace in a corresponding or symmetrical manner.[115] If indefinite in origin, then, *tarṣīʿ* is decidedly inter-medial in its common understanding. Thus, García Gómez identified *tarṣīʿ* with 'inlay', recalling that the Arabic word is the etymological root of Spanish *taracea* and Italian *intarsio*, which would then expand the term to include luxury objects in other media.[116]

As a poetic term, *tarṣīʿ* is primarily taken to mean 'the inserting of one part within another',[117] best corresponding to the structure of internal rhyme, that is, the insertion of a rhyme at the close of the first hemistich in the midst of a verse (and so introducing caesura) as a complement to the end rhyme.[118] *Tarṣīʿ* is absent from Ibn al-Muʿtazz' list of the key figures of *badīʿ* poetry, but his reference to internal repetition (*radd aʿjāz al-kalām ʿalā ṣudūrih*) reinforces the reading of *tarṣīʿ* as internal rhyme. Ibn al-Jayyāb's poems inscribed in the *Qalahurra* of Yūsuf I are written in the same metre, but in different end rhymes,[119] and display *tarṣīʿ* in each of their opening verses, where he employs rhyming hemistichs, though he uses only end rhyme thereafter in each text.[120] The popularity of *tarṣīʿ* has been attributed to 'its potential for enhancing both the musicality of the poem and its affective impact on the audience'[121]; which is to say, that it is related to the performative aspect of poetry, to which I will return in Chapter 5 in the context of court ceremonial.

Given the association of *tarṣīʿ* with the craft of jewellery, García Gómez proposed that Ibn al-Jayyāb's use of the term offers a description of the revetments of ceramic tile mosaic in the decoration of the walls,[122] since the technique of tile mosaic is similar to inlay. In a mosaic composition, the fragments, which often contrast in colour or material, are cut to fill a specific space in the design. Yet as

García Gómez himself observed, this mimetic reading (mosaic tile imitating jewellery) is problematic in the context of the *Qalahurra* of Yūsuf I.[123] Ibn al-Jayyāb links the media of stucco and tiles explicitly, 'Marvels of stucco and tiles . . .' (3.4), and the technique of inlay cannot be extended on the same mimetic basis to include the carving of plaster, nor even to the application of pigments to stucco. A more complete understanding of *muraṣṣaʿ* may be gained by observing the many instances in which individual, usually repetitive, decorative motifs are inserted into a larger design, nowhere more evident than in the 'inlay' of floral and epigraphic grids within the framing grid of geometry discussed above.

Reading *muraṣṣaʿ* beyond the specific technique of mosaic decoration also allows one to better recognise that poetry itself is among the decorative media of the *Qalahurra* of Yūsuf I that is inlaid in the decoration (Figure 3.20), that is, an inscribed poem might be likened to a finely faceted precious stone created, by analogy, for its architectural setting. This self-referential quality of poetry allows for a different explanation for Ibn al-Jayyāb's inclusion of *muraṣṣaʿ* in his list of tropes. Examining the theoretical writing on poetry of the ʿAbbasid literary critic and poet Qudāma b. Jafʿar (d. 337/948), Abu Deeb explains that the term *tarṣīʿ* signified 'both morphological and metrical harmony and internal rhyming [that] can occur in single words or in phrases', and that this poetic feature, acting as 'a structural property', belongs to 'the level of organisation and symmetry of a poem'.[124] Recalling, for instance, the way in which Ibn al-Jayyāb's four poems are 'inlaid' at the corners of the room, joining the structures of the walls, as it were, and their decoration in a single, continuous programme, one finds evidence of the use of *tarṣīʿ* as a structural property. The beholder who *pauses* to read must also *continue* the itinerary to gather (*mughaṣṣan*) the full meaning; holding the contrasts between elements in architectural decoration in balanced opposition (*muṭabbaq*) and also, passing from the fortified exterior to the richly adorned interior, the still more basic division of space by architecture; and in so doing, contemplating the inter-medial relationship (*mujannas*) between the poetic inscriptions and the architecture that give depth to the meaning of the *Qalahurra* of Yūsuf I and other palaces as representations of the power of the sultan.

It almost goes without saying that the various elements cited to exemplify the inter-medial relationship between the tropes of *badīʿ* poetry and the architecture of the *Qalahurra* of Yūsuf I and its decoration – the proliferation of motifs based on a shared root; repetition, superimposition, contrasts and symmetries; boundary markers that both separate and connect other elements – are not unique to the Alhambra, much less to this building. Nor did Ibn al-Jayyāb's poems or any other poetic inscriptions in the Alhambra serve as a

blueprint – as though the architect or Master of the Works needed to study poetry before setting about building and decorating. But for the cultivated beholder in Nasrid times, well-attuned to the workings of Arabic poetry, the language of the tropes and their underlying poetics would have been familiar, aesthetic guides. What is characteristic of the Alhambra, then, and especially so in the exemplary case of the *Qalahurra* of Yūsuf I, is that a rich poetic programme was present at the very site of the visual experience to provide a 'commentary' on the architectural 'text'.

Notes

1. These are the opening verses of a poem by Ibn al-Jayyāb that is inscribed in the *Qalahurra* of Yūsuf I. As noted above in the Introduction (n. 12), all citations of the inscriptions in the Alhambra are based on the Arabic texts as published in Puerta Vílchez, *Leer la Alhambra*, and will be referred to by page number in that work, here, p. 309. For the complete Arabic text and my translations of the four poems that make up the main focus of this chapter, including the poem cited in the epigraph, see Appendix.
2. On historical sources with references to *qalahurrāt* in al-Andalus, see María Jesús Viguera [Molins] and Elías Terés, 'Sobre las calahorras', *Al-Qantara* 2 (1981): 265–75; Félix Hernández Giménez, 'La travesía de la Sierra de Guadarrama en el acceso a la raya musulmana del Duero', *Al-Andalus* 38 (1973): 170–87.
3. See Ibn al-Khaṭīb, *Mushāhadāt Lisān al-Dīn ibn al-Khaṭīb fī bilād al-Maghrib wa'l-Andalus*, ed. Aḥmad Mukhtār al-ʿAbbādī (Alexandria: Mūʾassasat Shabāb al-Jāmiʿah, 1983), p. 58.
4. For a discussion of *al-qaṣaba* of Málaga and its *ḥiṣn* in Ibn al-Khaṭīb's texts, see María Isabel Calero Secall and Virgilio Martínez Enamorado, *Málaga, ciudad de al-Andalus* (Málaga: Ágora, 1995), pp. 375–90.
5. Fernández-Puertas, *The Alhambra*, p. 312.
6. For the dating of the *Qalahurra* of Muḥammad VII, see Fernández-Puertas, *The Alhambra*, p. 16. For Ibn al-Zamrak's use of the term *qalahurra* with respect to that tower, see María Jesús Rubiera Mata, 'Ibn Zamrak, su biógrafo Ibn al-Ahmar y los poemas epigráficos de la Alhambra', *Al-Andalus* 42 (1977): 447–51.
7. Leopoldo Torres Balbás, 'Gibraltar, llave y guarda del reino de España', *Al-Andalus* 7 (1942): 168–219, remains a valuable starting point for such a study.
8. Torres Balbás, 'Gibraltar, llave y guarda', pp. 193–7.
9. Fernández-Puertas, *The Alhambra*, pp. 175–6.
10. See, for example, Puerta Vílchez, *Leer la Alhambra*, pp. 299–326, where the section dedicated to the *Qalahurra* of Yūsuf I and the *Qalahurra* of Muḥammad VII is titled, 'Torres-palacios'.
11. María Jesús Rubiera Mata, 'Los poemas epigráficos de Ibn al-Yayyāb en la Alhambra', *Al-Andalus* 35 (1970): 453–73.
12. Fernández-Puertas, *The Alhambra*, p. 312.
13. For the geometrical scheme of the ground plan and a brief discussion of the decoration of the interior, see Fernández-Puertas, *The Alhambra*, pp. 28–9 and 312–14, respectively. Orihuela Uzal reviews the history

of the conservation of the *Qalahurra* of Yūsuf I and offers an analysis of the building in the broader context of Nasrid architecture in *Casas y palacios nazaríes*, pp. 129–36. Basilio Pavón Maldonado's analysis of the dadoes of ceramic tile mosaics that decorate the interior can be found in his *Estudios sobre la Alhambra* (Granada: Patronato de la Alhambra y Generalife, 1977), vol. 2, pp. 21–9. The place of poetic epigraphy within the decorative scheme is discussed in Sophie Makariou, 'Étude d'une scénographie poétique: l'oeuvre d'Ibn al-Jayyâb à la tour de la Captive (Alhambra)', *Studia Islamica* 96 (2003): 95–107; Olga Bush, 'The Writing on the Wall: Reading the Decoration of the Alhambra', *Muqarnas* 26 (2009): 119–47, which forms the basis for this chapter.

14. The place of the *Qalahurra* of Yūsuf I within this system of communication that is shared by all the structures of the outer wall of the Alhambra, the *madīna* and *al-qaṣaba* (the military quarters) alike may be a contributing factor to its relative neglect in the vast bibliography on the Alhambra. The history of the transformation of the Alhambra from a military to a palatial complex has yet to receive the sustained attention it requires. As an architectural type, the *Qalahurra* plays a significant role in that history.

15. For the conservation work that took place in the 1980s, see Fernández-Puertas, *The Alhambra*, p. 312, nn. 4 and 5, and also Orihuela Uzal, *Casas y palacios*, p. 129.

16. Orihuela Uzal, *Casas y palacios*, p. 129. The dimensions of the principal room and the patio are relatively small, which precludes taking photographs that would incorporate the entire interior space. For this reason, I provide many partial images to give as complete a view of the interior as possible.

17. A similar bent entrance is found in the Alhambra, for instance, in the *bāb al-sharī'a* or the Gate of the Esplanade (often misnamed Gate of Justice) and the Puerta de las Armas.

18. Orihuela Uzal, *Casas y palacios*, pp. 137–44.

19. The schematically outlined grid of the decoration indicated on the piers shows the areas where the loss of original decoration occurred, and is a result of the conservation approach in the Alhambra that took hold in the last quarter of the twentieth century.

20. Puerta Vílchez, *Leer la Alhambra*, pp. 301–2.

21. Ibid., pp. 303–5.

22. On the typology of a *qubba*, see Leopoldo Torres Balbás, 'Salas con linterna central en la arquitectura granadina', *Al-Andalus* 24 (1959): 197–220. For a more general introduction to the typology of Nasrid residential architecture, see Orihuela Uzal, *Casas y palacios*, pp. 19–26.

23. Orihuela Uzal, *Casas y palacios*, pp. 137–41.

24. I have measured the lower part of the elevation on site, including the dadoes of the ceramic tile mosaic and the stucco decoration with poetic and Qur'ānic inscriptions. The measurements for the other elements and areas of the interior elevation have been calculated from a scaled section drawing illustrated here as Figure 3.6.

25. On the geometric patterning, which is usually referred to by the Spanish term *lazo*, its construction and variations, see Fernández-Puertas, *The Alhambra*, pp. 94–6 and 332–49.

26. Puerta Vílchez, *Leer la Alhambra*, p. 307.

27. For the distribution of the dadoes in the room and a summary of their affinities with those in other precincts in the Alhambra and other Nasrid constructions, see Pavón Maldonado, *Estudios*, vol. 2, pp. 21–9.

28. Pavón Maldonado, *Estudios*, vol. 2, p. 28.

29. Puerta Vílchez, *Leer la Alhambra*, p. 308.

30. Sabiha Khemir, 'The Arts of the Book', in Jerrilynn D. Dodds (ed.), *Al-Andalus. The Art of Islamic Spain* (New York: Metropolitan Museum of Art, 1992), p. 117.

31. Walter B. Denny, 'Lattice-Design Carpet', in Maryam D. Ekhtiar, Priscilla P. Soucek, Sheila R. Canby and Navina Najat Haidar (eds), *Masterpieces from the Department of Islamic Art in the Metropolitan Museum of Art* (New Haven, CT: Yale University Press, 2011), pp. 84–5. A carpet in the Metropolitan Museum of Art (No. 22.100.124) and a textile fragment in the Cleveland Museum of Art (No. 1939.35), which are related to a number of similar fragments in other collections, may serve as examples.

32. Fernández-Puertas, *The Alhambra*, pp. 96–7.

33. Ibid., pp. 96–7 and 312–15.

34. Puerta Vílchez, *Leer la Alhambra*, p. 306.

35. These screens are a result of restoration work. See Pavón Maldonado, *Estudios*, vol. 2, pp. 21–9. Further research is needed in order to establish whether their present-day design corresponds accurately to the original plasterwork.

36. Puerta Vílchez, *Leer la Alhambra*, p. 313.

37. Ibid., p. 314.

38. Ibid. For the complete text of this short poem in the Palace of the Partal, see ibid., p. 258.

39. Ibid., p. 314.

40. Ibid.

41. María Jesús Rubiera Mata pointed out instances of words in the poetic inscriptions that are the result of erroneous restoration work undertaken over the course of the twentieth century. Her work on Ibn al-Jayyāb's *dīwān* allowed her to reconstruct the original compositions that were inscribed in this building. See María Rubiera Mata, 'Poesía epigráfica en la Alhambra y el Generalife', *Poesía* 12 (1981): 17–76, as well as Rubiera Mata, 'Los poemas epigráficos'.

42. Ibid., p. 306.

43. Ibid., p. 305.

44. Simón de Argote, *Nuevos paseos históricos, artísticos, económico-políticos, por Granada y sus contornos* (Granada, 1807), vol. 3, p. 91, cited in Orihuela Uzal, *Casas y palacios*, p. 136.

45. Ibid.

46. Fernández-Puertas, *The Alhambra*, p. 92.

47. The treatment of the foliate motifs is examined by Fernández-Puertas, *The Alhambra*, pp. 96–104.

48. Fernández-Puertas, *The Alhambra*, pp. 312, 314, 396. For additional references to the original pigments employed in the Alhambra, see the notes to Chapter 1.

49. García Gómez, *Foco de antigua luz*, p. 124.

50. Ibid., p. 128.

51. For these pigments for the ground and more generally on the colours in the epigraphy, see Antonio Fernández-Puertas, 'Calligraphy

in al-Andalus', in Salma Khadra Jayyusi (ed.), *The Legacy of Muslim Spain* (Leiden: Brill, 1992), pp. 639–76.

52. The 'The Throne Verse' (2:255–256) has often been inscribed on cupolas, while the verses of 'Light' (24:35–36) have been used frequently in mihrabs. See, for instance, Dodd and Khairallah, *The Image of the Word* vol. 1, pp. 71–83, and a compilation of examples in Dodd and Khairallah, *The Image of the Word*, vol. 2. See also, Sheila S. Blair, 'Inscribing the Square: The Inscriptions on the Maidān-i Shāh in Iṣfahān', in Mohammad Gharipour and Irvin Cemil Schick (eds), *Calligraphy and Architecture in the Muslim World* (Edinburgh: Edinburgh University Press, 2013), pp. 13–28; Ulrike-Christiane Lintz, 'The Qur'anic Inscriptions of the Minaret of Jām in Afghanistan', in Mohammad Gharipour and Irvin Cemil Schick (eds), *Calligraphy and Architecture in the Muslim World* (Edinburgh: Edinburgh University Press, 2013), pp. 83–102.

53. Murat Sülün, "Qur'anic Verses on Works of Architecture: The Ottoman Case', in Mohammad Gharipour and Irvin Cemil Schick (eds), *Calligraphy and Architecture in the Muslim World* (Edinburgh: Edinburgh University Press, 2013), pp. 163–4.

54. Dodd and Khairallah, *The Image of the Word*, vol. 2, p. 156. Other examples where *sūrah* 113 is found include two ceramic tiles from Iran, dated to 669/1270 and 697/1298, respectively; a tomb in Delhi (894/1489); and a cenotaph in Cairo (533/1139).

55. See Puerta Vílchez, *Leer la Alhambra*, pp. 118, 130, 307.

56. The corresponding epigraphic bands in the northeast and northwest corners of the *qubba* contain an inscription of the closely related *sūrah* 112. See ibid., p. 308.

57. Ibid., p. 130.

58. Ibid., p. 126.

59. Among others, see ibid., pp. 123–6; Cabanelas Rodríguez, *El techo del Salón de Comares*; as well as the discussion above in Chapter 2.

60. See Puerta Vílchez, *Leer la Alhambra*, p. 313.

61. The use of the same *sūrah* as an inscription in both the Hall of Comares and the *Qalahurra* of Yūsuf I offers a suggestive link between them, reinforced by other affinities in their elaborate decoration. One might conjecture that they served parallel functions as a formal and an intimate reception hall, respectively, but more evidence would be needed to sustain the argument.

62. See Appendix. In order to facilitate discussion, I will cite these poems throughout by parenthetical reference to the number of the poem in Figure 3.5 and verse: for example, the above-mentioned verses will be cited as '2.6 and 2.7', that is, poem 2, verses 6 and 7.

63. Motoyoshi Sumi, *Description in Classical Arabic Poetry*, pp. 155–232. Makariou likens the disposition of the epigraphy in the *Qalahurra* to a manuscript and assesses it against the standard of manuscript design: 'the main field is not that of the essential inscription – the poem – and that the layout constitutes rather a sort of testing or deception of that which is given to be read' in 'Étude d'une scénographie poétique', p. 99. In short, the rest of the decoration dominates over the poetic inscriptions, and Makariou takes this to be an upending of the hierarchy expected of a manuscript, in which the poem would be 'essential', and the non-linguistic motifs secondary. There is no reason, however, to expect that inscriptions in an architectural setting would share the same hierarchy.

64. Fernández-Puertas, *The Alhambra*, p. 312.

65. The literature on metaphor is immense, both with regard to medieval sources, rooted in Aristotle, and modern scholarship. For the Arabic and Persian traditions, see the comprehensive treatment in Julie Scott Meisami, *Structure and Meaning in Medieval Arabic and Persian Poetry: Orient Pearls* (London: Routledge/Curzon, 2003), pp. 319–403. Abu Deeb provides a useful introduction, underlining the contributions of the major literary critics of the 'Abbasid period in his 'Literary Criticism'. In addition, Abu Deeb's *Al-Jurjānī's Theory of Poetic Imagery* has been crucial to the formulation of my study. For those interested in the history of literary theory, it will be useful to see Abu Deeb's analysis of the striking similarities between al-Jurjānī's concepts and modern linguistic theories of metaphor as articulated by Ferdinand de Saussure and I. A. Richards in ibid., pp. 24–64. I have also found Ricoeur, *The Rule of Metaphor*, a valuable guide to the literature on metaphor, to which he makes his own important philosophical contributions.

66. The terms that appear in this verse – *mujannas, mutabbaq, mughassan* and *murassa*' – are passive participles of Form II verbs. A detailed discussion of the terms will follow shortly in the analysis of the poems in relation to the architecture and its decoration.

67. The texts are characterised by a linear movement from a general and metaphorical statement to detailed descriptive images. For an extended discussion of poetic structure, see Meisami, *Structure and Meaning*, pp. 55–143.

68. Puerta Vílchez' semiotic analysis of poetic epigraphy in the Alhambra is especially useful in his discussion of other themes associated with a ruler's power, such as victory, distinguished lineage, generosity, temporal and spiritual power, and radiance; see Puerta Vílchez, *Los códigos de utopia*, pp. 104–28. Elsewhere, Puerta Vílchez considers the term *badī*' and the derivatives of its root in conjunction with such aesthetic terms as *husn* and *jamāl* (beauty), and *kamāl* (perfection), within a broader context of poetic imagery in the epigraphy of the Alhambra; he proposes that these terms participate in the construction of a symbolic portrait of the Nasrid ruler as a divinely inspired creator of the architecture and its decoration, and that beauty as a concept has divine origin. See Puerta Vílchez, 'El vocabulario estético', pp. 75–6; and 'Speaking Architecture', pp. 30–2.

69. The relationship between architecture and textiles has been addressed briefly by Puerta Vílchez (see 'Speaking Architecture', pp. 39–41); I will return to it at length in Chapter 4. On inter-medial relations between poetry and other Islamic arts more generally, see Necipoğlu, *The Topkapı Scroll*, pp. 210–15; Yasser Tabbaa, *The Transformation of Islamic Art during the Sunni Revival* (Seattle: University of Washington Press, 2001), pp. 73–102.

70. On the significance of Ibn al-Muʿtazz's *Kitāb al-Badī*' for the tradition of literary criticism on poetry, see S. A. Bonebakker, 'Ibn al-Muʿtazz and *Kitāb al-Badī*'', in Julia Ashtiany, T. M. Johnstone, J. D. Latham, R. B. Serjeant and G. Rex Smith (eds), *'Abbasid Belles-Lettres* (Cambridge: Cambridge University Press, 1990), pp. 388–411.

71. Abu Deeb, 'Literary Criticism'.

72. Ibid., p. 347.

73. Ibid.

74. Cited in ibid., pp. 368–9.

75. For the impact of ʿAbbasid poetry on the poetry of al-Andalus during the Umayyad period, see Salma Khadra Jayyusi, 'Andalusī Poetry: The Golden Period', in Salma Khadra Jayyusi (ed.), *The Legacy of Muslim Spain* (Leiden: Brill, 1992), pp. 317–66.

76. Examples include works by the most distinguished poets from each of the following periods. For the Umayyad period: Ibn Hāniʾ al-Andalusī (*c.* 320–62/932–73), Ibn Darrāj al-Qasṭallī (347–421/958–1030) and the Umayyad prince, al-Sharīf al-Talīq (350–*c.*400/961–*c.* 1009); for the *taifa* period: Ibn ʿAmmār (422–76/1031–83), al-Muʿtamid (432–88/1040–95), the ʿAbbadid ruler of Seville, Ibn Hamdī (447–527/1058–1132) and al-Himyarī (d. 440/1048), who compiled one of the first Andalusian anthologies of poetic and rhymed-prose compositions, titled *al-Badīʿ fī waṣf al-rabīʿ* (*The Most Ingenious Descriptions of Spring*); for the Almoravid and Almohad periods: Ibn Khafāja (450–533/1058–1139), Ibn Quzmān (*c.* 472–555/1078–1160) and al-Ruṣāfī (d. 572/1177). See Monroe, *Hispano-Arabic Poetry*, pp. 3–71; Robinson, *In Praise of Song*, pp. 92–140.

77. Cited in Ibn al-Khaṭīb, *Poesía árabe clásica: Antología titulada 'Libro de la magia y de la poesía'*, ed. and trans. J. M. Continente Ferrer (Madrid: Instituto Hispano-Arabe de Cultura, 1981), p. 40.

78. Alexander Knysh, 'Ibn al-Khaṭīb', in María Rosa Menocal, Raymond P. Scheindlin and Michael Sells (eds), *The Literature of al-Andalus* (Cambridge: Cambridge University Press, 2000), pp. 358–71.

79. For a survey of Nasrid literature, see Celia del Moral, 'La literatura del período nazarí', in Concepción Castillo Castillo (ed.), *Estudios nazaríes* (Granada: Universidad de Granada, 1997), pp. 29–82. More generally, on the cultural production of the Nasrid court – literary, artistic and scientific – see José Miguel Puerta Vílchez, 'La cultura y la creación artística', in Rafael G. Peinado Santaella (ed.), *Historia del Reino de Granada* (Granada: Universidad de Granada–El Legado Andalusi, 2000), vol. 1, pp. 349–413.

80. García Gómez, *Poemas árabes*, p. 137. Puerta Vílchez commented on the disparaging remarks of García Gómez and Rubiera Mata with regard to the poetic merits of Ibn al-Jayyāb's and Ibn Zamrak's poetry in the Alhambra, suggesting that the conventionality of their compositions should be attributed not to the limits of their talents, but rather to the restricted poetic goal that they served in creating a vision of dynastic power. See Puerta Vílchez, *Los códigos de utopia*, pp. 106–7, n. 1.

81. Grabar, *The Alhambra*, p. 101.

82. Ibid., p. 205.

83. Puerta Vílchez has been cited throughout as a cornerstone to this book; of his many relevant studies, the one that pursues a semiotic approach most closely is *Los códigos de utopia*. See also Gonzalez, *Beauty and Islam*; D. Fairchild Ruggles, 'The Eye of Sovereignty: Poetry and Vision in the Alhambra's Lindaraja Mirador', *Gesta* 36(2) (1997): 180–9; as well as Ruggles' important *Gardens, Landscapes, and Vision in the Palaces of Islamic Spain* (University Park, PA: Pennsylvania State University Press, 2000), which takes up a different approach.

84. Grabar, *The Mediation of Ornament*.

85. See Robinson, *In Praise of Song*, as well as Cynthia Robinson, 'Seeing Paradise: Metaphor and Vision in Taifa Palace Architecture', *Gesta* 36(2) (1997): 145–55.

86. Robinson, *In Praise of Song*, p. 189. Robinson also suggestively extends her discussion of the aesthetics of *badīʿ* poetry to other artistic media in her examination of Córdoban ivories of the Umayyad and *fitna* periods. She considers these objects as a visual counterpart of the linguistic artifice of *badīʿ* poetry, noting that their design is 'governed and informed by *badīʿ*'s opaque complexities'; Robinson, *In Praise of Song*, pp. 134–40.

87. García Gómez' understanding of the term is based on the meanings of the verb (root *j-n-s*) in Forms II and III, which respectively correspond to 'to make alike, make similar' and 'to be alike, similar, related'. See García Gómez, *Poemas árabes*, p. 45.

88. On *tajnīs*, its use and some examples, see Meisami, *Structure and Meaning*, pp. 247–53; and Wolfhart P. Heinrichs, 'Tajnīs', in *Encyclopedia of Islam*, New Edition (henceforth *EI2*) (Leiden: Brill, 1954–2002), vol. 10, pp. 67–70.

89. Meisami, *Structure and Meaning*, p. 247.

90. Julie Scott Meisami and Paul Starkey (eds), *Encyclopedia of Arabic Literature* (London and New York: Routledge, 1998), s.v. 'Rhetorical Figures'.

91. Ibid.

92. For a brief overview of Nasrid genealogy, see Antonio Fernández-Puertas, 'The Three Great Sultans of al-Dawla al-Ismāʿīliyya al-Naṣriyya Who Built the Fourteenth-Century Alhambra: Ismāʿīl I, Yūsuf I, Muḥammad V', *Royal Asiatic Society of Great Britain and Ireland* 7(1) (1997): 1–25. Maribel Fierro points out the importance and frequent use of words with the root *n-ṣ-r* in Nasrid poetry, inscriptions and coinage in 'The Anṣārīs, Nāṣir al-Dīn and the Naṣrids in al-Andalus', *Jerusalem Studies in Arabic and Islam* 31 (2006), p. 245.

93. Harvey, *Islamic Spain*, p. 29.

94. In another form, the verb draws on a secondary meaning of the root and denotes 'to make someone Christian', that is, to convert someone to Christianity.

95. Form III of the verb.

96. For a history of the adoption of the *nisba al-Anṣārī* in pre-Nasrid al-Andalus, its meaning in the context of the Qurʾānic use of words based on *n-ṣ-r* root, and, therefore, its ideological implications for the legitimisation of the Nasrid dynasty, see Fierro, 'The Anṣārīs'.

97. See Harvey, *Islamic Spain*, pp. 171–90, and Fernández-Puertas, 'Three Great Sultans'.

98. Fernández-Puertas, *The Alhambra*, pp. 16–18.

99. Ibid., p. 18 and fig. 4.

100. Ibid., pp. 28–30.

101. Form I of the verb.

102. Form V of the verb.

103. Meisami, *Structure and Meaning*, pp. 253–64. For a concise discussion of the term and its use, see also Wolfhart P. Heinrichs, 'Ṭibāq', *EI2*, vol. 10, pp. 450–2.

104. See García Gómez, *Poemas árabes*, p. 45; Fernández-Puertas, *The Alhambra*, p. 314.

105. Meisami, *Structure and Meaning*, pp. 253–64.

106. García Gómez notes that Ibn Zamrak also mentions the captives in a poem located in the Court of the Myrtles. See García Gómez, *Poemas árabes*, p. 96. On the subject of Christian captives at work on the

Nasrid buildings, see Leopoldo Torres Balbás, 'Las mazmorras de la Alhambra', *Al-Andalus* 9 (1944): 198–218.

107. Its meaning in Form II.

108. In Form III, *t-b-q* has the meanings 'to cause to correlate, compare, contrast something with, to correspond to something', which would reinforce the understanding of visual antithesis as a correlated alternation of corresponding forms.

109. See also Lisa Golombek's concept of 'an imperfect symmetry', which she develops in her essay, 'The Function of Decoration in Islamic Architecture', in Margaret B. Ševčenko (ed.), *Theories and Principles of Design in the Architecture of Islamic Societies* (Cambridge, MA: Aga Khan Program for Islamic Architecture, 1988), pp. 35–45.

110. García Gómez' understanding of the term stems from Forms II and IV of its root (*g-ṣ-n*), which have the meaning 'to put forth branches, to branch (tree)'. See García Gómez, *Poemas árabes*, p. 45. Fernández-Puertas follows closely García Gómez' interpretation; see Fernández-Puertas, *The Alhambra*, p. 314.

111. García Gómez, *Poemas árabes*, p. 45. Puerta Vílchez and Fernández-Puertas follow García Gómez' interpretation of the terms with regard to the decoration. See Puerta Vílchez, 'El vocabulario estético', pp. 81–2, Fernández-Puertas, *The Alhambra*, p. 314. In her interpretation of the four terms of *badīʿ* poetics, Robinson too argued that they pertain to the work of mimesis. See Cynthia Robinson, 'Marginal Ornament: Poetics, Mimesis, and Devotion in the Palace of the Lions', *Muqarnas* 25 (2008), pp. 191–5; and my rebuttal in Bush, 'The Writing on the Wall', pp. 119–21.

112. Fernández-Puertas, *The Alhambra*, pp. 96–7.

113. Meisami, *Structure and Meaning*, p. 429.

114. Schoeler indicates several possible relationships covered by this term, including an agreement of word patterns in corresponding parts of the two phrases, which in turn could be partially or completely rhymed, and a metrical equivalence in the first parts of the two phrases. See G. Schoeler, 'Tarṣīʿ', *EI2*, vol. 10, pp. 304–6.

115. Meisami, *Structure and Meaning*, pp. 295–6. In his *Minhāj al-bulaghāʾ wa sirāj al-udabāʾ* (*Method of the Eloquent and Lamp of the Literary*), al-Qarṭajannī mentions that the term *tarṣīʿ* is applicable to the arts of poetry and jewellery alike; cited in Puerta Vílchez, *Historia del pensamiento estético árabe*, pp. 382–3. The term was also used to describe luxury objects studded with precious stones. For examples of such descriptions, see Aḥmad ibn al-Rashīd Ibn al-Zubayr, *Book of Gifts and Rarities = Kitāb al-Hadāyā wa al-tuḥaf*, ed. and trans. Ghāda al-Ḥijjāwī al-Qaddūmī (Cambridge, MA: Harvard University Press, 1996), pp. 177–9, 194–5, 235,238. Michael Roberts has also proposed that the link between the craft of jewellery and poetic composition can be traced to the period of Late Antiquity. He notes that '"the jeweled style" with respect to verse and artistic prose was a commonplace; e.g., verses were deemed "little jewels"', in Michael Roberts, *The Jeweled Style: Poetry and Poetics in Late Antiquity* (Ithaca, NY: Cornell University Press, 1989), p. 53.

116. The term is not to be confused with English 'intaglio', a mode of engraving, though the latter is derived in turn from Italian *intagliare*. For a summary of the definition and use of the term in Arabic and Persian by medieval rhetoricians, see Schoeler, 'Tarṣīʿ'.

117. Schoeler, 'Tarṣī'.
118. Meisami, *Structure and Meaning*, pp. 294–8.
119. The meter is *kāmil*; the rhymes are: (1) ——*ājī*; (2) ——*ashā*; (3) ——'*u*; (4) ——*fu*.
120. See García Gómez, *Poemas árabes*, pp. 137–42.
121. Meisami, *Structure and Meaning*, pp. 294–8.
122. García Gómez, *Poemas árabes*, p. 45.
123. Ibid.
124. Abu Deeb, 'Literary Criticism', p. 371.

CHAPTER FOUR

'Textile Architecture' in the Cuarto Dorado

> I left Sīstān with merchants of fine robes.
> The robe I bore was spun within my heart
> And woven in my soul. A silken robe,
> Composed of words that eloquence designed.
> > Farru<u>kh</u>ī Sīstānī (fourth/eleventh century)[1]

I

The present-day visitor gains access to the courtyard now called the Court of Comares through the *mi<u>sh</u>wār*, or council chamber, and the adjoining space that was originally a small patio (Figures 4.1– 4.3: nos 14 and 14a, respectively; hereafter, 'no.' refers to a space in Figures 4.1–4.3). Between the two, there stands a small precinct built during the reign of Yūsuf I and altered under the patronage of his son and successor, Muḥammad V, whose north–south orientation marks a clear division between the east and west areas of the palatial complex. Known as the Cuarto Dorado (the Golden Room), the very name of the precinct attests to the history of alterations in the Alhambra (no. 15, nos 15a–c; and Figure 4.4). Even before a miniscule patio north of the *mi<u>sh</u>wār* was incorporated into the space of the *mi<u>sh</u>wār* proper in the sixteenth century (no. 14a),[2] the hall on the north side of the Cuarto Dorado (no. 15b) was outfitted with a heavily painted and gilded ceiling, executed in 1499,[3] which gave rise to the modern name of both the hall and the precinct as a whole. The hall is an oblong room with three door-ways that serve as entrances and three windows on the opposite north wall, aligned axially with the doors and with the three-arch arcade of the portico in front. In the light of the absence of alcoves on the short east and west walls of this room, it has been suggested that the Cuarto Dorado might have served as a waiting room for visitors.[4]

Proceeding along the longitudinal axis of the precinct from that hall, one comes to a contiguous portico (no. 15c) followed by a small adjacent patio (no. 15) enclosed on the three remaining sides and paved with marble slabs. The patio includes a small central marble

water basin with a jet. Alterations to the second floor above the hall of the Cuarto Dorado that took place in the post-Nasrid period, as well as to the rooms adjoining the patio on the east and west sides, preclude us from knowing the original elevation and decoration of the precinct, except for the south side where the patio is bounded by an elaborately decorated wall, known as the Façade of Comares (no. 15a).[5] Two spaces beyond the south wall are accessed through twin doorways. Angel C. López López and Antonio Orihuela Uzal have proposed that south of the doorway to the west stood a small room that led to a *qubba* housing the royal treasury (nos 17 and 17a).[6] Later this area was partially destroyed, and it now survives in a greatly altered form.[7] The doorway to the east leads to a small room (no. 16) reserved for guards from which one exits to the east through a passage that changes its axis three times (no. 18), protecting access to the Court of Comares and the Hall of Comares beyond (nos 19 and 23, respectively). This passageway, with its two successive dog-legs, makes the precinct of the Cuarto Dorado a threshold space between the administrative quarters of the *mishwār* and the adjoining area west of it comprising the 'formal quarters' of the Palace of Comares.[8]

The Façade of Comares could not fail to have captured the attention of the Nasrid beholder, as it has that of today's tourists and of modern scholars alike (Figure 4.5). Grabar speaks for the consensus of researchers when he observes that the façade is 'too large, too formal to be a mere passageway, compositionally unbalanced in relationship to the small court which precedes it'.[9] The impression that this elaborately decorated façade was literally out of place has been so glaring that García Gómez proposed that it would have originally served as the principal façade of the Palace of Comares, which would have stood on the south side of the Court of Comares. The Façade of Comares was moved, he contended, to its current place in the patio of the Cuarto Dorado at the time of the erection of the new imperial palace for Charles V, which occasioned the destruction of the south end of the Palace of Comares.[10] This daring hypothesis has been proven to be erroneous by archaeological and historical evidence analysed first by Fernández-Puertas, and then by Darío Cabanelas and Vílchez Vílchez, and has been put to rest.[11] The Façade of Comares stands in its original location, although the patio of the Cuarto Dorado and especially its west and east walls have undergone numerous alterations, starting in the sixteenth century and continuing through to the end of the nineteenth century. Although the observations of nineteenth-century travellers, to which I will return in due course, give clear indication that the precinct was not always as it now stands, the striking, enigmatic effect of the façade must be attributed to the original architectural design and calls for some explanation.

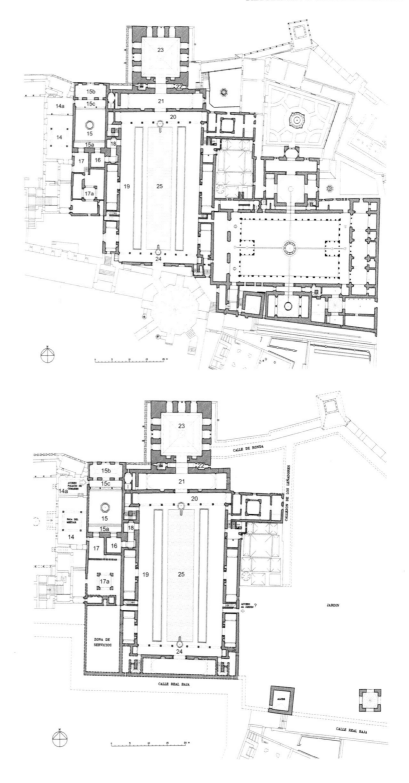

14. *Mishwār*.

14a. Originally, a small patio of the *mishwār*.

15. Patio of the Cuarto Dorado.

15a. Façade of Comares.

15b. Cuarto Dorado.

15c. Portico of the Cuarto Dorado.

16. Vestibule behind the east door of the Façade of Comares.

17. Vestibule behind the west door of the Façade of Comares.

17a. Possibly the treasury.

18. Dog-leg entrance to the Court of Comares.

19. Court of Comares.

20. North portico of the Court of Comares.

21. Sala de la Barca.

22. Oratory.

23. Hall of Comares.

24. South portico of the Court of Comares.

25. Pool.

Figure 4.1 *(facing page, upper)* *Palace of Comares and Palace of the Lions, ground floor, plan, Alhambra (after Orihuela Uzal, Casas y palacios, with added numbering of spaces)*

Figure 4.2 *(facing page, lower)* *Palace of Comares, ground floor, hypothesis of the original plan (after Orihuela Uzal, Casas y palacios, with added numbering of spaces)*

Figure 4.3 *(above)* *Key to Figures 4.1 and 4.2*

Grabar's remark goes beyond description to aesthetic judgement – *too* large, *un*balanced – and like any such judgement, begs a question about the implied standards. One may well suspect that it is once again the post-Nasrid name, designating the wall as a façade, that informs his and others' perspective. The simple fact of being a wall pierced by doorways that fronts on a space under the open sky would seem to support the designation, which is then reinforced, from the point of view of Western art history, by the monumentality of the decoration. The impression is magnified by the current state of the east and west walls of the patio, devoid of decoration and flush with the sides of the south wall, such that its surface is not framed laterally by open space, as would be the case with the façade of a free-standing building. The puzzle for scholars is why a façade so grand in a precinct so small? But to put the matter in this way is to set the discussion strictly in architectural terms. One might pose an alternative question, if not a façade, to what may the south wall be likened? How else might it be contextualised so that its aesthetic principles might be understood, rather than impugned?

Grabar is instructive in a different sense, in that he formulates the main thrust of his observation – again, generally held – in the idiom of proportionality. Whether too large (to be a proper façade) or not,

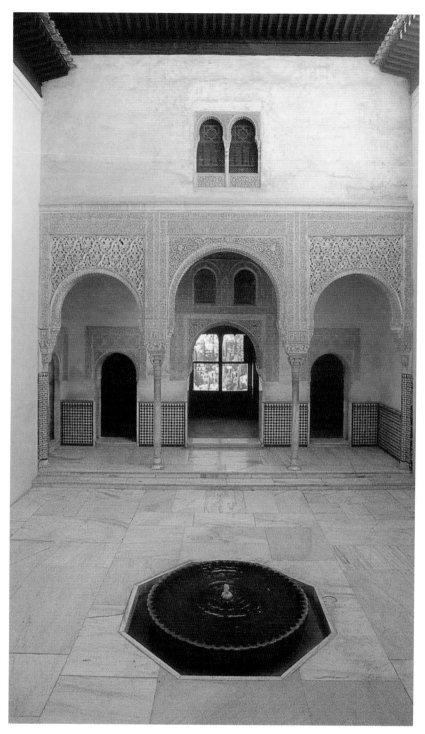

Figure 4.4 *Patio of the Cuarto Dorado precinct with the portico on the north side, Palace of Comares, Alhambra (photograph: Olga Bush)*

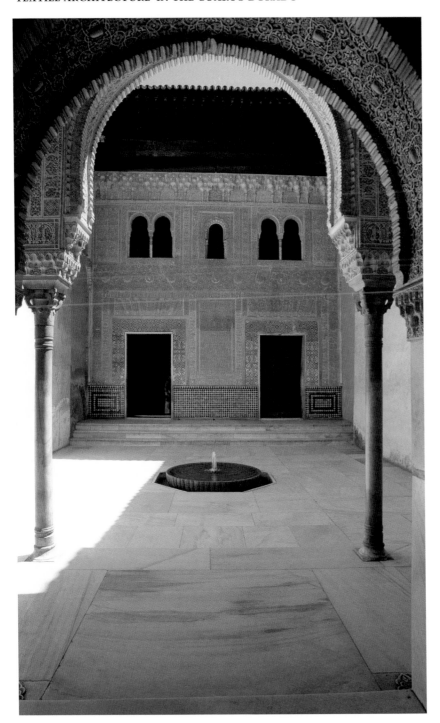

Figure 4.5 *Patio of the Cuarto Dorado precinct with the Façade of Comares on the south side, Palace of Comares, Alhambra (Werner Forman Archive/Bridgeman Images)*

balanced or unbalanced, the remark refers the study of the Cuarto Dorado to optical considerations. The approach to the enigma of the so-called Façade of Comares, then, may be grounded once again in the work of Ibn al-Hay<u>th</u>am. In an analysis of calligraphy, for example, Ibn al-Hay<u>th</u>am asserted that: 'Writing also is not beautiful unless its letters are proportionate in respect of their shapes, magnitudes, positions, and order. And the same is true of all visible objects which are combinations of various parts.'[12] He further explains that the 'completion and perfection [of beauty] is due only to the proportionality and harmony that may obtain between the particular properties'.[13] Andalusī poet and literary theorist Ḥāzim al-Qarṭajannī (607–83/1211–85) makes a similar point for poetry, whose harmony, he believed, was achieved through the proportional relationship of its constituent elements.[14] In these terms, no matter how beautiful the Façade of Comares may be deemed with respect to the elegance and intricacy of its design, its beauty would still be imperfect from the point of view of the beholder in the relatively small space of the adjoining patio due to its disproportionate size. The balance of beauty might have been restored, however, by reinforcing the optical effects of harmony (greater harmony compensating for lesser proportionality). The present chapter will be dedicated primarily to studying that harmony, which might have been achieved not by the architecture alone, but through the coordinated, inter-medial relationship between the architectural decoration and luxury textiles that would have been hung in the space, contributing to an integrated aesthetic experience of the precinct.

To underline the harmonious relations between media is not to set aside the importance of proportionality in the design of architecture and its decoration. Following Fernández-Puertas' analysis of the proportional design of other buildings in the Alhambra, as illustrated with respect to the plan of the *Qalahurra* of Yūsuf I in Chapter 3, it is possible to demonstrate the proportional design of the elevation of the Façade of Comares (Figure 4.6). Taking the width of the door as a basic unit, measured by a length of string (AB), and swinging the string, pegged at point B, one can mark point C on the right upright of the door. Then, unpegging and letting out the string, the builders could stretch its length to connect point A to point C, which corresponds to the hypotenuse (AC) of an isosceles right triangle (ABC) and is equal to the square root of 2 of the original unit (AB), or the width of the door. If the string AC is now pegged at the initial point at the lower left corner (A), and swung to the left upright of the door to mark point D, a triangle DAB is drawn, whose hypotenuse (DB) measures square root of 3. Setting the peg back at the lower right corner (B) and stretching the string again to measure the new hypotenuse (DB), it can be swung to the right upright to mark point E, or the height of the doorway (EB). Continuing the procedure of alternating the point at which one end of the string is pegged (now, point

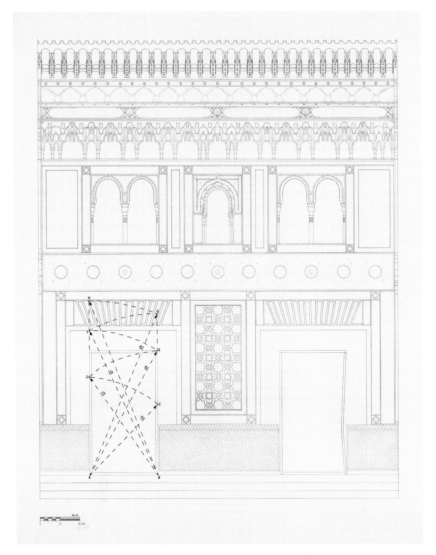

Figure 4.6 *Façade of Comares, Palace of Comares, Alhambra (after drawing by M. López Reche, Archivo de la Alhambra, with added construction of geometric measurements)*

A again) and letting out a greater length to point E, the hypotenuse (EA) of the next triangle ABE will measure the square root of 4 – as Euclidean geometry would have predicted – and that length would mark point F on the vertical line extending the left upright of the door, hence, providing the measurement for the height of the *alfiz* of ceramic tile mosaic that frames the door.[15]

The demonstration may at first appear superfluous, since the square root of 4 is equal to 2, which means the height of the door with its *alfiz* of ceramic tile mosaic simply measures double the

width of the door, a dimension that could have been obtained more easily, where 2 × AB = FA. But further proportions would not have been so self-evident. It turns out that Fernández-Puertas' postulate continues to hold when one measures the ratio between the width of the doorway and its height including the voussoirs (AH = square root of 6).

Harmony proves a more difficult concept to articulate and to demonstrate, since it is based on qualitative rather than quantitative factors. Grabar includes such matters in his judgement when he finds the Façade of Comares 'too formal'. Here, too, the judgement is susceptible to revision insofar as Grabar is implicitly comparing the highly decorated south wall with the plain walls on the east and west as they stand today. The partial continuation of the original decoration in the upper registers of the south wall onto the east wall suggests that the adjoining walls were also decorated in Nasrid times, in which case the south wall may not have appeared too formal, but rather in harmony with the rest of the patio. This discrepancy cannot be resolved, since the original state of the east and west walls remains unknown. But the larger issue raised by Ibn al-Haytham still pertains. In addition to questions of proportion, the aesthetic experience of the architectural space would have engaged questions of harmony.

Poetry will have a role to play once again in articulating intermedial relations. A characteristic figure in medieval Arabic and Persian poetry – what I shall call *textile metaphors* – likens poetry itself to textiles, as in the seventh/thirteenth-century Persian treatise on prosody by Shams-i Qays al-Rāzī (active 601–28/1204–30), where he stated: 'a poet in versifying discourse is like a master weaver who weaves precious stuffs and works various images into them – graceful branches and leaves, precisely drawn sketches'.[16] The metaphorical relationship between poetry and textiles became a convention in medieval al-Andalus too, as attested in the work of al-Qartajannī, for instance, who explained that expression, content, composition and style should come together in a poem's 'beautiful brocade' (*ḥusn dībāj*).[17] The inter-medial analogy embodied in textile metaphors would have helped to prepare the beholder to find a metaphorical likeness between architecture and textiles as well.

Effective metaphors depend on the understanding of their literal reference, and so the discussion here begins with some study of the history of luxury textiles and the close examination of some extant Nasrid examples. Implicit throughout and explicit at times is the premise stated already in the introduction: the empty architectural spaces of the Alhambra of today are entirely misleading; they would have been fully and richly furnished in Nasrid times. Luxury textiles would have made up a large part of that furnishing; or, in Lisa Golombek's cogent terms, the Alhambra would have formed part of the 'draped universe of Islam'.[18] In her recent comprehensive study

of luxury textiles from Islamic lands, Louise W. Mackie furthers Golombek's proposition. Studying court dress, robes of honour and furnishings in court settings across the Muslim world, Mackie argues for an overarching 'textile aesthetic' in the Islamic arts.[19]

Some sense of that universe, especially in the medieval period, may be gathered from numerous textual sources. For example, Abu'-l Faraj al-Iṣfahānī (284–356/897–967), who was born in Isfahan, but lived in many cities in the Muslim world, including Baghdad and Aleppo, described textile furnishings and spaces in which they were used as settings for stories and anecdotes in his *Kitāb al-Aghānī* (*Book of Songs*).[20] Many of the same terms for textile furnishings that appear in this compilation are also used in the fourth–seventh/tenth–thirteenth-century texts among the Geniza documents, originally stored in the Ben Ezra Synagogue of old Cairo (Fustāt), which often include detailed descriptions of cloth and even its monetary value.[21] Several examples of bridal trousseaus in the Geniza documents will suffice to make the point. The furnishings for a *majlis*, a sitting room or reception hall of a middle-class home, included the *martabah*, a sofa that consisted of one or several sections; it was made with a low platform in wood, brick or mortar, with a filled mattress for comfort and elevation, which was covered with precious fabrics, often of silk brocade. A variety of cushions and bolsters placed on top of the sofa provided further comfort. Frequently a *misnad*, or support, a textile with filling, was used as a back. In addition to a *martabah*, side divans covered with costly fabrics were employed as well. Carpets and mattresses of varying heights covered the floor. In the sitting room of a wealthy house there was also often a seat, called *majlis*, which was sometimes made of Tabarī brocade – one of the most costly textiles at the time – indicating special status; sometimes it had a back as well.[22] Other furnishings, such as one-piece mattresses, called *firāsh*, often made of expensive Iberian or Sicilian silks, and *maṭraḥ*, both used for sleeping, could be brought into a sitting room for day-time use.[23] Different cushions, bolsters and pillows enhanced comfort as well as providing additional seating. One may extrapolate from this documentary evidence from prosperous households of medieval Cairo to imagine the textile furnishings of the precincts in the Alhambra, for which no such documentation or archaeological evidence is available. A chief feature of those textile furnishings is their portability. One need not conjecture that textiles were permanently affixed to architecture to propose that textile furnishings could have been brought nonetheless into a precinct on particular occasions, especially those linked to a court ceremonial. Not only would the textiles have further enriched the permanent decoration of a precinct, but also, and more importantly, they would have altered the beholder's experience of the space defined by its architectural plan and elevation.

2

The paucity of documentary information not only touches upon the place of textiles in the Alhambra, but it extends more generally to textile production in the Nasrid kingdom. Medieval historians, such as al-Ḥimyarī, al-Maqqarī and al-Dimashqī, mention Almería and Málaga as important Andalusī textile centres, recounting that the silk cloaks (al-ḥulal al-mawshīya) made there were known for 'marvellous pictures (ṣūra) . . . with the names of the Caliphs and others (inscribed) upon them',[24] and Ibn Ḥawqal noted that the products of the royal workshops of al-Andalus were exported to Egypt, Khurasan and elsewhere by the end of the fourth/tenth century.[25] Royal control of commerce in raw silk, silk cloth and silks embellished with gold and silver threads during the Nasrid and post-Nasrid periods has been attested for Granada,[26] where the much restored royal silk market, al-qayṣariyya (adapted as alcaicería in Spanish) still stands in the city below the Sabīka hill and the Alhambra.[27] It has yet to be determined if there was a royal textile workshop within the palatial city itself.

María Judith Feliciano obviates the documentary problem to some extent by referring textile production in medieval Iberia to the context in which many cultural expressions of the Muslim courts were appropriated and adapted by Christian rulers.[28] Arts, literature and even customs and rituals crossed the porous borders of the Iberian Peninsula through commerce, booty, ambassadorial gifts, and contacts with itinerant craftsmen, poets, scientists and others journeying in search of knowledge and employment.[29] Feliciano prefers to speak of 'Andalusī textiles', rather than associate objects with particular Muslim dynasties (e.g., the Nasrids) or even to distinguish between Muslim and Christian textile production, where documentary sources are scarce and dating is in doubt.[30] The point is well taken and may be extended. Much of what remains of Andalusī textiles, nearly all of silk, have either been preserved only as fragments or have survived precisely because they have been refashioned for use by Christian patrons into garments – attire for royal family and nobility, Church vestments for the clergy, burial shrouds, pillows and coffin covers – as well as furnishings for the Church, such as altar cloths and mantles for sacred sculpture.[31] The trajectory of the extant textiles thus bears witness to the political history of the Iberian Peninsula, indeed, it is almost an allegorical representation of that history: an Islamic luxury object cut to pieces and dispersed, only to reappear, if at all, converted for Church service.

In what follows, I shall concentrate attention on textiles whose attribution to the Nasrids appears to be secure. Where matters are less certain, one may well look to other Muslim courts for insight. For example, the administration of the royal mint (sikka) is as little documented as the ṭirāz (royal textile workshop) under the Nasrids,

though both would have been involved in the production of brocade, a textile made of silk and gold or silver wrapped threads. The close connection is attested at the ʿAbbasid court of al-Maʾmūn b. Hārūn al-Rashīd, where the highest-ranking court official, his vizier, Jaʿfar al-Barmakī, oversaw both the *sikka* and the *ṭirāz*.[32] Historians writing about the Fatimid dynasty, which ruled from its capital in Cairo between the fourth/tenth century and sixth/twelfth century, have also recorded a close link between the two institutions, noting not only that the gold-wrapped thread for *ṭirāz* textiles was produced under the supervision of the mint, but also that the *sikka* and the *ṭirāz* alike produced goods – cloth and coins – upon which the caliph's name was inscribed.[33]

Similarly, in the absence of accounts of the function of luxury textiles in Nasrid court ceremonials, one may turn to Aḥmad ibn al-Rashīd Ibn al-Zubayr, the fifth/eleventh-century author of the *Kitāb al-Hadāyā wa al-Tuḥaf* (*Book of Gifts and Rarities*), to infer something of the value and diversity of such objects among the Nasrids. The author records the following inventory of 'Stores for Upholstery and Furnishings' at the Fatimid court in Cairo:

> In the furnishings treasury (*khizānat al-farsh*) were found four thousand bundles of Khusruwani cloth [woven] with gold [thread]. Each bundle (*rizmah*) contained a complete set of furnishings (*farsh*) for a sitting hall (*majlis*) with its carpets, wall hangings (*taʿālīq*), and the rest of its furnishings [all] woven (*mansūjah*) from the same yarn (*fī khayṭ wāḥid*).[34]

I will return to the implications of the reference to *complete sets of furnishings*, and focus here on the sheer abundance and the use of gold thread (i.e., for brocade), which gives a sense of the wealth invested in textiles.

The *Kitāb al-Hadāyā* gives another noteworthy account of the deployment of textiles in the construction of ceremonial space in the course of the reception of Byzantine ambassadors at the court of the ʿAbbasid caliph al-Muqtadir (r. 295–320/908–32) in 304/917. The envoys were initially brought to the Public Hall (Dār al-ʿĀmmah), where they were seated in the portico, and then, en route to al-Muqtadir's audience hall, they were ushered through the numerous passageways, vestibules, enclosures, courtyards and other precincts of no less than fourteen palaces. The anonymous author states that these passageways and courtyards were embellished with no less than 38,000 draperies (*sutūr*), in addition to 22,000 floor furnishings of carpets and runners (*nikhākh*), which left the envoys 'bewildered and confused', even before arriving at the audience hall, 'tired and breathless'.[35] The author hastened to clarify that the textiles were brought from the royal furnishings treasury especially for the occasion and were additional to the customary furnishings of

private rooms and sitting halls.[36] Whether or not the numbers are to be taken at face value, the keynote is clearly abundance, and one is to understand that the textiles are intended as a display of the ruler's wealth and power.

The characterisation of the psychological (and even physical) impact is of the greatest interest in this account as a preliminary response to the question of disproportion. It is not a by-product, but the intent of the display to leave the beholder 'bewildered and confused'. Understanding, or what Ibn al-Haytham refers to as cognition, is by no means the beginning of the experience of the beholder, where the object at hand is 'too large' or otherwise too abundant. Where the initial stage of perception is so overwhelming, the move towards cognition is confused; a guide is needed to enhance the imagination as a bridge to understanding.

Poetry could and did perform that bridging. A *qaṣīda* composed by Ibn al-Khaṭīb dedicated to the Hafsid sultan Abū Ḥammū Mūsā II (r. 760–91/1359–89) offers a case in point that at once brings discussion to the Nasrid sphere and sets the production of Andalusī textiles in its broader trans-Mediterranean context. The poem was recited by a Nasrid envoy on the occasion of the Nasrid embassy to the Hafsids on behalf of Muḥammad V in 776/1374,[37] in keeping with the ceremonial practice, common throughout the medieval Islamic world, of enhancing the quality and prestige of gifts with accompanying verses, performed or inscribed.[38] In the course of his panegyric, the value of poetry itself – one of the gifts – is extolled by likening it to luxury textiles in the following textile metaphor: 'This poetry is [like] the textiles of Yemen, the older they are, the more one is attached to them and the more one seeks them out.'[39] Gifts incite counter-gifts, and the success of the embassy depends on their perceived value. The Nasrid emissary refers simultaneously to the poet's verses, the textiles and other gifts of Muḥammad V, and, ultimately, through them all, to Muḥammad V himself, when he recites: 'Their renown is great, wherever one finds them in distant lands, their qualities stand forth and their designs become all the finer.'[40]

Such textile metaphors are inscribed on the walls of the Alhambra, providing a direct link to architecture. Ibn al-Khaṭīb himself contributed the following verse, inscribed in the niche on the west side of the entrance arch to the Hall of Ambassadors, 'My *dībāj* skilful fingers embroidered (*raqamat*)'; and Ibn Zamrak wrote these verses as part of an extended poem inscribed in the Hall of Two Sisters: 'With what vestments of brocade (*ḥula min washī*) you honoured it! / They make one forget the textiles of Yemen'[41] (Figures 1.19 and 4.7). Much as in the *Qalahurra* of Yūsuf I, the poem is inscribed in a band of stucco decoration around the perimeter of the room above the dadoes of ceramic tile mosaics. Situated slightly below eye level, the verses occupy alternating elongated and circular cartouches and are plainly legible. Here the textile metaphor speaks

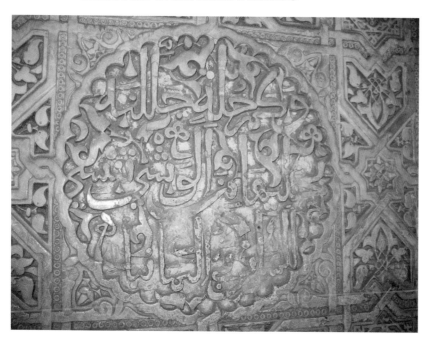

Figure 4.7 *Roundel with Ibn Zamrak's verses, north wall, interior, Hall of Two Sisters, Palace of the Lions, Alhambra (photograph: Olga Bush)*

of its own unsurpassed beauty: the *muqarnas* vault, the arches, the polished marble, and the carved stucco decoration that covers the walls and extends to the *muqarnas* squinches and arches that fill the transition zone and carry upward the octagonal vault above. The analogy to *dībāj* is meant to describe and praise the architectural decoration – each medium is related to beauty in the same way, even if the beauty of the two media is different, to recall the discussion of metaphor in Chapter 3 – but at the same time the verses extol the value of textiles as an art and so reinforce the textile aesthetic of the Nasrid court.

García Gómez understands both Ibn al-Khaṭīb's *dībāj* and Ibn Zamrak's *washī* as references to brocade,[42] but there is much ambiguity concerning nomenclature in Arabic for textiles in general and for Andalusī textiles in particular. Some pre-Nasrid textual sources preserve medieval designations for luxury silks made in al-Andalus, but the precise meaning and specific characteristics associated with terms such as *ibrīsam*, *khazz*, *qazz*, *ḥarīr*, *siqlāṭūn* and *fākhrir*, compiled by R. B. Serjeant, have been lost.[43] Of these terms, only one, *siqlāṭūn* (derived from Latin and thence from Greek), has carried over as a loan word in Castilian as *ciclatón*, defined either as a medieval garment in the form of a tunic or the silk and gold cloth from which such garments were fashioned. Serjeant states that *dībāj* appears as well in early Castilian texts as *dibeth*. The situation is complicated further by additional terms that refer to one, but

not all, of the particular features of a given silk-cloth type. Hence, _shiqqa_ is used for a silk with a _ṭirāz_ (i.e., a band with inscriptions), and _sutūr mukallala_ for silk curtains with vertical bands. As for the term _washī_ as used in medieval texts, it refers to richly coloured textiles, with or without gold thread, sometimes to brocades, and also to striped or variegated cloth.[44] In any case, none of these Arabic terms have been firmly attached to extant Andalusī textiles. Germán Navarro Espinach has culled an additional fifteen terms for silk textiles from various textual sources written in Castile and León in the period between 1190 and 1340.[45] But once again, valuable as that lexicon may be, none of the extant medieval silk textiles of Andalusī manufacture used by the Christian elite has been identified by these terms in medieval texts.

Ibn al-Khaṭīb's use of the root _r-q-m_ in his verse inscription points to a still more fundamental ambiguity, or rather lexical richness, at the heart of textile metaphors. Both García Gómez and Puerta Vílchez interpret _raqamat_ in the inscription in the entrance arch to the Hall of Ambassadors as a reference to embroidery; Arabic _r-q-m_ is the etymological root of Spanish _recamar_, to embroider.[46] But the same Arabic root has a primary meaning of 'to write, to dot a book', and drawing upon that sense, María Jesús Rubiera Mata translates _raqūmun_ as 'inscriptions' when it appears in the last of Ibn al-Jayyāb's poems inscribed in the _Qalahurra_ of Yūsuf I: 'Its walls – in them there are _raqūmun_ that disarm the most eloquent' (poem 4, verse 3).[47] Yet another meaning of the root is 'to stripe a textile' and also 'to weave something in long strips'.[48] In sum, the root _r-q-m_ refers simultaneously to writing and putting stripes on a cloth, such that writing on silk, embroidery and striped silk may be designated as _raqama, raqamāt, raqm_, respectively, and a _ṭirāz_, in the sense of a band with inscriptions, can also be called _marqūm_.[49] When Ibn al-Khaṭīb titles his historical work _Raqm al-ḥulal fī nazm al-duwal_ (_The Ornamentation of the Garments: On the Organisation of the States_),[50] he begins with a _tajnīs_ or play on words that invokes both a textual and a textile meaning for _raqm_. His textile metaphor establishes a further analogy in which the ornamentation of a textile is to the organisation of the state as the writing of poetry is to the writing of history. Hence, the reading of Ibn al-Khaṭīb's title suggests that the worthiness and might of the state lies in its organisation, just as the value of a garment lies in its ornamentation. Textile metaphors rely not only on the crossover terminology that unites textiles and poetry – in Greek and Latin as much as Persian and Arabic[51] – but also on the analogy between ornamentation and organisation.

3

The relationship between ornamentation, especially when understood in more inclusive terms as 'markings' (_r-q-m_), and organisation,

seen as a modular structure of alternating units, is exemplified in the closely interrelated terms *muwashshaḥ*, a designation recorded in textual sources where it is applied to a certain kind of striped or 'figured' Andalusī silk textile, and *muwashshaḥ*, an innovative form of Andalusī poetry.[52] The textile sense of the term has been met in the title of al-Washshā''s *Kitāb al-Muwashshā*, discussed in Chapter 2; the term was also used in several instances in contemporary 'Abbasid texts in connection with sumptuous robes made of striped textiles from Yemen.[53] Ibn al-Jayyāb's poetic inscriptions in the *Qalahurra* of Yūsuf I may be cited as testimony of the literary meaning. In the fourth and final poem in the itinerary there (the southwest corner), following the verse noted above for its use of *raqūmun*, one reads in reference to the decoration that is the 'the markings' of the walls of the *qubba*: 'They surprise; and each part equals another part in proportion [and/or prestige] (*nisba*), and so it is a *muwashshaḥ* and a literary work (*muṣannaf*).'[54] By connecting *muwashshaḥ* to *muṣannaf*, the immediate context would tend to cast the former as a kind of literary work. The proportional relationship between them would then be of a specific form to a general type or, in poetic terms, a synecdoche, the part that can stand for the whole. The initial aesthetic experience of the architecture and its decoration is surprise, which only begins to resolve itself as the beholder organises perception by means of the comparison with poetry, enabling a judgement of quantity (*nisba* as proportion) and quality (*nisba* as prestige). But the literary context is incomplete. Following so closely after *raqūmun*, with its notable overlap of textile and textual meanings, the poem keeps the further relationship between both architecture and poetry, on the one hand, and textiles with both of these, on the other, before the beholder's eye.

Muwashshaḥ in its textile sense seems to have its etymological source in *wishāḥ*, a girdle or sash woven and embroidered in alternating colours.[55] It appears that the *wishāḥ* was worn on the body either between the shoulder and flanks or around the waist, and in either case lent itself to erotic connotations. For instance, in a poem written by al-Muʿtamid (432–87/1040–95), the 'Abbadid ruler of Seville during the *taifa* period, the poet wishes to kiss the part of his beloved's body between the *wishāḥ* and the necklace,[56] while in verses by another poet, the lover's arms form the *wishāḥ* around his beloved's waist.[57] Al-Muʿtamid's court poet Ibn 'Ammār (422–76/1031–84) identified the ruler's beloved wife I'timād as 'the one who has a *wishāḥ*', which extends the erotic implications to a sign of distinction among the ruler's wives and concubines.[58] And, indeed, as early as an account of Khusrau's defeat at al-Madā'in (Ctesiphon), there is mention of the booty taken by the Muslims to 'Umar that suggests that Khusrau's sashes (*awshiḥatahū*) could have been used as royal insignia.[59]

While one looks in vain for a full *wishāḥ* among extant Andalusī textiles, it had been recorded as an article of female attire by an Andalusī author in the eighth/fourteenth century.[60] Such sashes, embellished with stripes of various colours and precious stones, may be found in the sculptural and pictorial depictions of female patrons and saints in the fifteenth- and sixteenth-century art of Spain, attesting well to Feliciano's point concerning the trans-Iberian context.[61] One such statue is of particular significance. The polychromed wooden effigy executed by Felipe Vigarny (c. 1475–1542) of Queen Isabel I of Castile (1451–1504) that stands in the Royal Chapel adjoining the Cathedral of Granada (both buildings constructed by the Christian Monarchs on the foundations of the demolished congregational Great Mosque of Granada), shows the queen attired in a splendid gown girdled by a striped sash, an Andalusī textile (Figure 4.8). According to textual sources, the striped Andalusī sash appears to have been a particular favourite of the queen and her entourage, who had some 105 at their disposal.[62] The inventory of Gonzalo de Baeza detailing daily expenditures by Isabel I lists countless textile items. The enumeration for 13 August 1489, which included purchases of black velvet, *grana*, *paño*, black and purple damask, and black and purple *londres* – all for specified items of clothing – is typical not only for the quantity and variety of textiles, but also for the clear evidence of commercial and cultural contacts with the textile centres of al-Andalus.[63] In fact, this document begins with a reference to a payment for 'certain cloth and silks that her Majesty commanded to give to Abraham de Mora, messenger from the King of Granada, in order for him to dress himself and two other Moors'.[64] The sculpture gives visual confirmation of the court documents penned by Baeza and of the abiding presence of Islamic art on the very monument of its obliteration.

The stripes on Isabel I's *wishāḥ* further identify the sash as an Andalusī textile of the *muwashshaḥ* type. The direction of stripes on the girdle demonstrate that the sash would have been cut from a cloth whose width would have corresponded to that of the loom. Following early medieval historians, al-Maqqarī mentions that '*muwashshaḥ* robes' (*ḥulal muwashshaḥ*) were made in the important Andalusī textile centres of Almería and Málaga. He underscores that the cloaks of this type were 'precious', their prices 'run into thousands', and that both cities exported these robes to Muslim and Christian lands.[65] Specific reference was made to a chasuble of 'striped Granada cloth' in an inventory dating to 1339 and preserved in the Cathedral of Siguenza, in Spain,[66] though the garment itself is lost, and no other extant textiles have ever been attached to that designation – Isabel I's sculpted sash notwithstanding. As a textile term, *muwashshaḥ* has remained an empty category, and as a result, the *markings* that might have characterised this 'figured' cloth, as Serjeant puts it, have yet to be established.

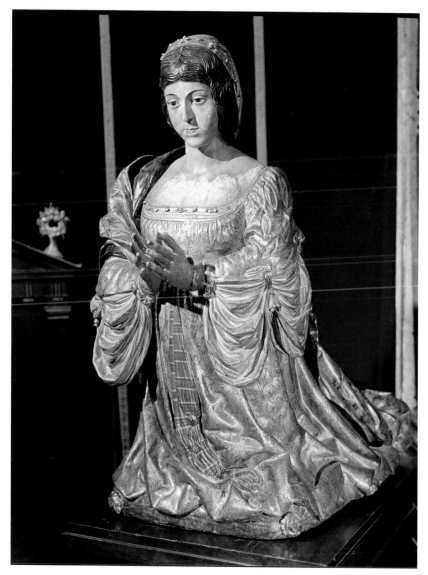

Figure 4.8 *Effigy of Isabel I of Castile in Prayer, 1520–2, polychromed wood, Felipe Vigarny. Capilla Real, Cathedral of Granada, Granada (Capilla Real, Granada, Spain/Bridgeman Images)*

Al-Maqqarī had noted that the Andalusī *ḥulal muwashshaḥ* were often inscribed with a *ṭirāz*,[67] but the relationship between the textiles and inscribed verses dates back at least to the *Kitāb al-Muwashshā*. Al-Washshāʾ gives examples of verses inscribed in a *ṭirāz* of gold thread on a *wishāḥ*, such as: 'I love him just as much whether he does (me) right or wrong, for him I condemn my heart to whatever he asks of me, even when the pleasure of finding him happy does not overtake me, even if the days of his anger do not pass.'[68] The

popularity of sashes inscribed with poetic inscriptions endured well beyond the Reconquista of al-Andalus, both in Iberia and elsewhere. There are, for example, many silk sashes or girdles embellished with both gold-wrapped thread and short amorous expressions made in Spain during the eighteenth and nineteenth centuries,[69] including simple inscriptions in Spanish, such as: 'Constant shall remain my love', and longer, rhymed verses, such as: 'Of your beautiful garden – I am a jealous gardener'.[70]

It is against this background that the term *muwashshaḥ* emerged as the name for a new form of poetry that originated in medieval al-Andalus in the fifth/eleventh century.[71] The themes of the *muwashshaḥāt* (pl. of *muwashshaḥ*) poems are generally love (*ghazal*), panegyric (*madīḥ*) and wine (*khamr*), often combined in a single poem.[72] It is the theme of love or a lover's lament that constitutes the literary link between the *muwashshaḥāt* poems and the poetic inscriptions on *wushuḥ* (pl. of *wishāḥ*). This Andalusī genre is distinguished from the *qaṣīda* in its strophic structure and use of polyrhyme, as well as in its performance – sung, not recited.

The strophic *organisation* of the *muwashshaḥ* calls for further comment. *Muwashshaḥāt* were composed of five strophes or *aghṣān* (sing. *guṣn* or 'branch'), and the rhyme within each strophe is uniform, but changes from one strophe to another. The strophes alternate with a set of isolated, single verses or *asmāṭ* (sing. *simṭ* or 'strands for stringing pearls'), which differ in their contents, but are unified by a common rhyme.[73] Metaphorically speaking, the strophes are the pearls joined together by the strands of isolated verses, forming a distinctive, alternating profile:

[a] (single verse)
BBB (strophe)
a
CCC
a
DDD
a
EEE
a
FFF
a[74]

There may or may not be a *simṭ* preceding the first strophe, but there is always a strand visible after the final strophe, where it is called the *kharja*, and it is the key to the new poetic form, in fact, its generative element. As Ibn Sanā' al-Mulk (550–608/1155–1211) declared in *Dār al-ṭirāz fī 'amal al-muwashshaḥāt* ('The House of the *ṭirāz* in the craft of the *muwashshaḥāt*'), his treatise on the *muwashshaḥ* written after the Andalusī poetic form had travelled east: 'The

kharja is the spice of the _muwashshah_, its salt and sugar, its musk and amber. It is the close of the _muwashshah_; it must, therefore, be beautiful; it is its seal; nay, it is the beginning, although it is at the end. What I mean by saying it is the beginning is that the composition of the poem must begin with it.'[75]

The _kharja_ may be written in classical Arabic, as is obligatory for the rest of the _muwashshah_, but it may also be composed in vernacular Romance, or even in a mixture of vernacular Romance and Arabic.[76] The bilingual code switching is further heightened by a gender distinction. María Rosa Menocal points out that the formal poetic language and the formal code of the preceding single verses or 'strands' and strophes 'embody the equally formal courtly laments of a male speaker', whereas the _kharja_ 'set off by its use of a much more casual code, is often spoken by a woman who does not use traditional formal expressions to convey her sentiments'.[77] Menocal argues nevertheless for the unity of this hybrid poetic genre.[78] The wide range of discontinuities (language, gender and voice) and continuities (rhyme and rhythmic patterns) are conjoined in the _muwashshah_ in the service of expressing the same sentiment – the lament of unrequited love. Menocal further highlights that the _muwashshah_ is a poem 'talking about itself and about literature and language at least as much as it is about its external subject'.[79] I would add that by dividing the voice between the poetic speakers of _muwashshah_ and _kharja_, the genre is also talking _to_ itself, staging an inner conversation. The balance of continuity and discontinuity, the dialogic voicing and the self-reflexivity of the form make the _muwashshah_ a model for a theory of inter-medial study. More concretely, consideration of the organisation of _muwashshahāt_, that is, the poems, can reorient the study of _muwashshah_ textiles.

4

'Striped cloth' is too narrow a descriptor to convey a full understanding of the _markings_ of the _muwashshah_ textiles, which should rather be considered as an organisation of alternating, proportional bands, relating to each other through a balance of similarity and difference, or in short, harmoniously. The category is by no means empty. The first type is exemplified by a silk fragment sewn from two smaller pieces, preserved in the collection of the Textile Museum in Washington (TM 84.29) (Figure 4.9). Measuring 75 cm × 138 cm in its current state,[80] it is the largest textile in a group of silk fragments of identical decorative design that have been preserved in other collections.[81] Scholars generally agree on the date and place of manufacture of the textile, attributing it to late eighth/fourteenth- or early ninth/fifteenth-century Nasrid al-Andalus.[82] As with many other examples of luxury textiles made during the Nasrid period, the Textile Museum fragment is woven using the lampas technique,[83]

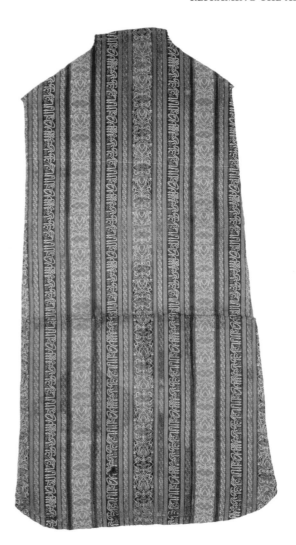

Figure 4.9 *Textile fragment, late eighth–ninth /fourteenth–fifteenth century. Textile Museum, Washington, DC (TM 84.29) (photograph: Textile Museum, Washington, DC)*

which is characterised by a double structure that consists of a ground – satin, in this case – and a pattern.[84]

The width and structure of any given textile was determined by the type of loom employed in its fabrication, and it is known that different types of vertical and horizontal looms were employed during the Nasrid period.[85] The striped design of the Textile Museum fragment is such that it would appear to have been woven horizontally on the loom, as can be readily appreciated, for instance, in the epigraphic bands. A horizontal orientation would make the inscription more legible. The width of the cloth made it possible to turn the textile

vertically, allowing for its new purpose.[86] The asymmetrical inter-
ruption of the design at the edges of its current state gives evidence
of that alteration, and in its present shape, the Textile Museum
fragment appears to have been cut for re-use as a garment, perhaps
a chasuble[87]; two other large fragments belonging to the same group
were cut to form part of a different ecclesiastical vestment, a stole.[88]
In its original horizontal orientation, the Textile Museum fragment
and the others in its group would be a type deemed by medieval
sources as best used for furnishing: _khazz raqm_,[89] usually under-
stood as striped silk. However, the textual sense of _raqm_ is sugges-
tive for the role of inscriptions in further specifying the textile type.
Al-Washshā' records numerous examples in the _Kitāb al-Muwashshā_
of furnishings – wall and bed curtains, carpets, cushions and pillows
inscribed in gold and silver brocade with 'short, selected poems,
curious refrains, graceful phrases'[90] – that stand as distant precursors
to this _muwashshah_ type of Andalusī textiles. In the Nasrid period,
Ibn al-Jayyāb's _dīwān_ indicates that he composed poems for inscrip-
tion on luxury textiles – no longer extant – to be made in the royal
ṭirāz, one of which was intended explicitly for a curtain.[91]

The decorative composition of the Textile Museum fragment
consists of two alternating bands embellished with epigraphy and
foliate motifs, and a narrow border of geometric interlace between
the two main bands. The vibrant red and green colours serve as a
foil for epigraphy and foliate elements woven in white thread. The
epigraphic bands, which are substantially narrower than the foliate
ones, are executed in _naskhī_ script, and in this unique example,
the fragment is large enough to preserve a poetic text in its entirety:
'I am for pleasure. Welcome. For pleasure am I. And he who beholds
me sees joy and delight.'[92] The implied erotic content would have
been wholly out of keeping with the re-use of the textile as a Church
vestment – what would the faithful have said, if they could have
read the poem? But in its original use as a furnishing, the poetic
inscription is much like the _kharja_ part of a literary _muwashshah_,
both in its easy-going frankness and the direct address, and so would
have been acceptable, especially in the private setting of a home.
Moreover, the shifting subjectivity of the prosopopoeia gives voice
to the furnishing – and those in contact with it – in offering sensual
pleasure, while at the same time bidding welcome to the aesthetic
delights of the arts of poetry and textiles.

A second type of _muwashshah_ textile 'of more than average
width' may be identified by adducing an example from the col-
lection of the Museo Diocesano-Catedralicio in Burgos: a large
silk garment (87 cm × 140 cm) sewn from several fragments of
cloth into a pluvial (Figure 4.10).[93] The vestment was made for the
Constables of Castile, don Pedro Fernández de Velasco and doña
Mencía de Mendoza and is preserved in their chapel in the cathedral
of Burgos.[94] Its silk cloth has been attributed to the same Nasrid

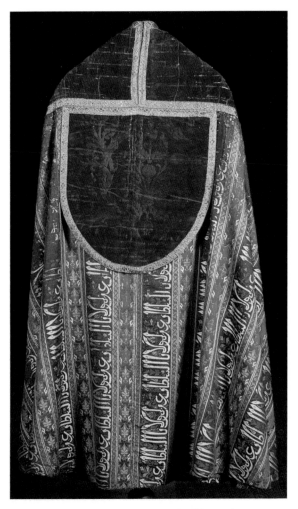

Figure 4.10 *Pluvial, eighth–ninth/fourteenth–fifteenth century. Museo Diocesano-Catedralicio, Burgos (photograph: Edilesa, Burgos, Spain)*

production and to the same period (late eighth/fourteenth or early ninth/fifteenth century) as the Textile Museum fragment on the basis of the Andalusī *thuluth* script of its epigraphic bands.[95] Similar fragments are found in many museum collections,[96] hence the Burgos textile, too, stands for a type.

Like the Textile Museum fragment, the Burgos textile is woven in the lampas technique in a weft-faced tabby pattern on a satin ground, with silk used for warp and weft.[97] The cloth was woven horizontally on the loom,[98] an orientation that would have rendered the inscription more legible: *'izz li-mawlānā al-sulṭan'* ('Glory to Our Lord the Sultan'), a phrase repeated as often as four times per band and also found frequently in the architectural decoration of the Alhambra. The cloth was sufficiently wide to allow it to be reoriented vertically,

and once again, in its use as a Church vestment, the legibility of the inscription was no longer at issue.

The epigraphic or *ṭirāz* band alternates with another band nearly half its width, embellished with a horizontally-oriented pattern that consists of a rhomboid grid formed by tendrils executed in yellow thread, and filled with foliate elements in yellow, white, green and blue colours on a red ground. The two bands are separated by another, narrower band or border of red and yellow interlace on a green ground. Not merely striped, then, but more like the structure of strophes and single verses in the poetic *muwashshaḥāt*, the Burgos textile is organised in alternating bands of different, but proportional measurements and diverse motifs unified by the recurring inscription, as though by a monorhyme single verse or 'strand'. The elongated cursive script in white silk stands out in contrast to the dark blue ground of the *ṭirāz* band, with the spaces between the letters filled with foliate motifs in red and yellow. The optical effect of the juxtaposed vibrant colours emphasises further the figure–ground relationship in the design and the double-weave technique in the material structure of the lampas. This textured effect – to the eye and to the touch alike – is similar to that produced by the superimposed geometric, floral and epigraphic grids in the stucco decoration of the walls exemplified in the *Qalahurra* of Yūsuf I and employed more generally in the architectural decoration in the Alhambra. As the walls surprise, and yet are enriched through their imaginative likening to poetry and textiles, the *muwashshaḥ* textiles, too, surprise, but enter into lively and harmonious conversation with poetry and architecture.

5

A third and last type of *muwashshaḥ* textiles provides a key to the understanding of the enigmatic Façade of Comares in the Cuarto Dorado and precinct as a whole. The type is represented by two large silk textiles, one preserved in the collection of the Metropolitan Museum of Art in New York (MMA 29.22) and attributed to Nasrid production of the second half of the eighth /fourteenth century; the other in the Hispanic Society of America, New York (No. H921), of later and more uncertain date (Figures 4.11 and 4.12). (I will refer to them hereafter as the Met textile and the Hispanic Society textile, respectively.) Each has the general characteristics of the textile *muwashshaḥ*: Andalusī production, alternating bands of diverse decorative motifs, including inscriptions, and designed for furnishings, not garments. This last point was only implied in the case of the Burgos pluvial and the Textile Museum fragment from their current state in the form of church vestments; but the Met textile and the Hispanic Society textile give clear evidence of the original dimensions: 102 cm × 36.3 cm and 237.5 cm × 152.3 cm, respectively.[99]

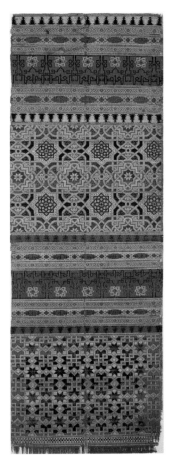

Figure 4.11 *Textile fragment, second half of the eighth/fourteenth century. Metropolitan Museum of Art, New York (MMA 29.22) (photograph: courtesy of Metropolitan Museum of Art, New York)*

Since the Hispanic Society textile preserves chequerboard headings and warp ends or fringes on its short sides, as well as both of its selvages on the long, vertical sides (the Met Textile has only one), its original width on the loom is definitive; it is often called a panel or hanging by scholars.[100]

The two *muwashshah* textiles share important similarities in colour, composition and decorative vocabulary, and so may be seen to form part of a generic type. I will concentrate on the Met textile, whose design Cristina Partearroyo declares to be 'one of the most frequently employed and subsequently most widely distributed [of the Andalusī production]'.[101] It has stronger visual affinities to the Façade of Comares than does the Hispanic Society textile. Other scholars have noted the evidence of a textile aesthetic in the general resemblance between stucco decoration in the Alhambra and Andalusī textiles, although a detailed comparison is still wanting.[102]

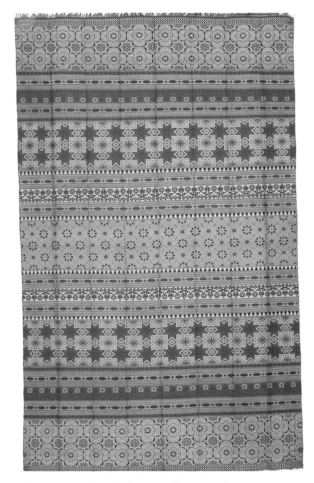

Figure 4.12 *Textile panel, eighth–ninth/fourteenth–fifteenth century. Hispanic Society of America, New York (No. H921) (photograph: courtesy of Hispanic Society of America, New York)*

Mackie goes as far as to assert in her discussion of Nasrid silks and their affinities with architectural decoration that: 'The primacy of the textile aesthetic in the Alhambra [decoration] has no known parallel.'[103] But the careful inventory of similar decorative motifs in both media is only a first, though necessary, step leading from *textile metaphors* to *textile architecture* – that is, in this case, from the visual harmony between the decoration of the Façade of Comares and a *muwashshaḥ* of the Met textile type to a recognition of architectural forms enacting textile functions in the Façade of Comares as well as textile furnishings performing architectural functions in the court ceremonial of the Cuarto Dorado precinct.

This analysis requires a prefatory caveat. No textiles have ever been discovered in situ in the Alhambra, nor are there any documents that link extant textiles to particular precincts. The material

evidence is scant, but intriguing. The remains of silk threads have been discovered on nails in the *mishwār* oratory and in the lateral room that flanks the Hall of Two Sisters on the east side, both of which are interiors with profuse architectural decoration.[104] In consequence, the supposition of some scholars that large-scale textiles would have been used as wall hangings only in spaces where the main wall expanse remained plain – such as the rooms on the upper floor of the Palace of Comares and Palace of the Lions – must be rejected.[105] Textiles were not only a supplement where decorative elements were lacking in the architecture, they could also be present along with the rich decoration of the walls. As the poetic inscriptions in the *Qalahurra* of Yūsuf I suggest, the crucial issue is Ibn al-Jayyāb's *mujannas*, that is, the *relatedness* of the media.

The absence of nails and silk threads in other precincts, including the Cuarto Dorado, is not definitive proof that textile furnishings were not used in those spaces. Ropes were also used to hang textiles from permanent architectural members (columns, for instance), and the rugs and other textile furnishings that would have been moved in and out of architectural spaces, according to their use on different occasions, would have left no permanent trace. The construction of ceremonial space through a combination of permanent architecture and transient textiles is a singularly important aspect of the Alhambra in Nasrid times to be examined at length in the final chapter.

The discussion that follows here is not intended as a proof that the Met textile, or others in its group, were used in the Cuarto Dorado – though this seems likely enough. Rather, its stylistic affinities to the Façade of Comares are presented as an illustration of harmony in the beholders' experience of the *complete and perfect beauty* – in Ibn al-Haytham's terms – of the Cuarto Dorado and indeed all spaces in the Alhambra. To reiterate, then, the purpose is, first, to establish detailed links between the Façade of Comares and the Met textile (as an heuristic, rather than an historical example). The second step in the discussion moves from the harmonious visual relationship between textiles and architectural decoration to the argument for the textile function of a principal feature of the Façade of Comares. Finally, that approach will be reversed in a conjecture about the use of furnishings like the Met textile to perform architectural functions in the Cuarto Dorado.

The examination begins with a closer look at the south wall of the Cuarto Dorado, or Façade of Comares, with its decoration in carved stucco and wood, and dadoes of ceramic tile mosaic (Figure 4.13). A preliminary sketch, to be revisited in detail, will help to situate the evidence of deterioration and restoration that Fernández-Puertas was able to establish, largely on the basis of nineteenth-century prints, including those by British artists John Frederick Lewis (1833–34), Owen Jones (1842) and I. Taylor (1853), in addition to late nineteenth- early twentieth-century photographs.[106] The overall

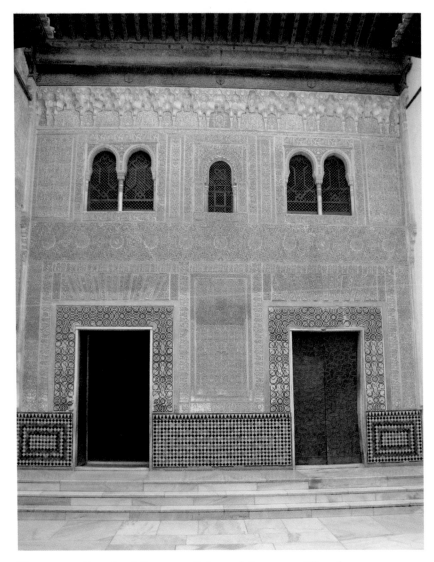

Figure 4.13 *Façade of Comares, Palace of Comares, Alhambra (photograph: Olga Bush)*

decorative schema, characteristic of wall elevations throughout the Alhambra, presents a grid within which rectangular shapes are arranged vertically and horizontally (Figure 4.14; hereafter, 'no.' refers to an element in Figure 4.14). A wide band of decoration (no. 14) running the width of the entire façade marks the division of the elevation into two storeys, with two doorways on the first floor and arcaded double-light windows directly above them. A smaller central window on the second floor, together with the carved stucco panel below it (no. 1), mark the vertical axis of the symmetrical composition of the façade.

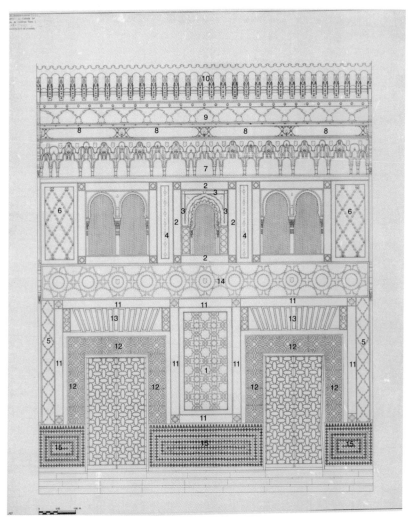

Figure 4.14 *Façade of Comares, Palace of Comares, Alhambra (after drawing by M. López Reche, Archivo de la Alhambra, with added numbers for decorative areas)*

Lewis' print shows the damaged and altered areas most clearly (Figure 4.15). On the upper part of the façade, balconies replaced the two double-light windows and the original plasterwork framing the perimeter of these openings was lost. The lower part also suffered heavy damage: approximately two-thirds of the carved plasterwork between the two doorways was lost, leaving a wall of exposed bricks, and the ceramic tile revetments that originally formed an *alfiz* around both doorways were largely lost as well. The dadoes of the ceramic tile mosaic disappeared altogether. Finally, the original door on the east side of the façade had been filled in with bricks. Another print by Lewis records the damage to the plasterwork in the area to

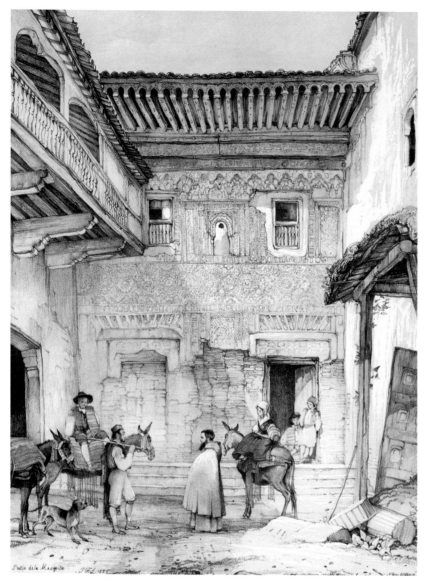

Figure 4.15 *Façade of Comares, Palace of Comares, Alhambra, John Frederick Lewis, lithograph, 1835 (private collection, Stapleton Collection/ Bridgeman Images)*

the left of the east side balcony, where an opening was cut in the wall to provide access to a wooden gallery on the upper floor of the patio (Figure 4.16). Both of Lewis' prints demonstrate that the rest of the carved plasterwork in the upper part of the façade remained intact, including the area around the central window.

The consolidation and restoration of the plasterwork and the dadoes of ceramic tiles was begun by Rafael Contreras no later than

Figure 4.16 *Cuarto Dorado precinct, Alhambra, John Frederick Lewis, drawing, 1833–4, Victoria and Albert Museum, London (photograph: courtesy of Victoria and Albert Museum, London)*

1875 and was completed by his son, Mariano Contreras by 1892.[107] A photograph of the façade taken by J. Laurent some time before 1875 records the initial stage of the restoration work. By then the bricks had been removed from the doorway on the east, and the walls both between and flanking the two doorways had been plastered (Figure 4.17). The photograph also shows that a much larger expanse of the central panel of carved stucco between the doorways had been preserved than appeared in Lewis' print.

Fernández-Puertas has determined that the following elements of the upper part of the elevation are the result of restoration work: segments of the epigraphic band that forms a frame around the perimeter of the two double-light windows; areas in the long rectangular panel of carved plaster flanking the double-light window on the east; and, most likely, an area of the *muqarnas* cornice above this panel. The original plasterwork and the *alfiz* of ceramic tiles around both doorways were preserved to a level slightly below the doors' lintel, and when the Contreras replicated the design for the missing, vertical portions of the frame, they did so in stucco, making visible the distinction between restoration and original.[108] They also covered the remaining expanses of the lower walls with simple dadoes of square ceramic tiles rotated 45 degrees to create an overall rhomboid pattern.[109]

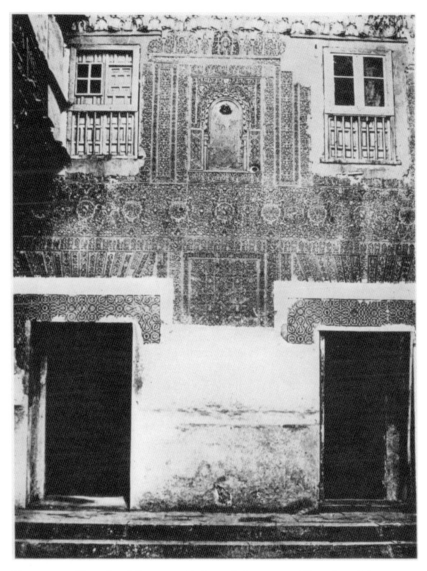

Figure 4.17 *Façade of Comares, Palace of Comares, Alhambra, J. Laurent, photograph before 1875 (photograph: Archivo de la Alhambra)*

With a clearer view of the original stylistic features of the Façade of Comares in mind, it is now possible to pursue an analysis in conjunction with *muwashshah* textiles, such as the Met textile. The reading of the architectural decoration as a textile metaphor proceeds from the fundamental feature of all *muwashshah* types, namely, the overall organisation of the decorative composition into a pattern of alternating bands (Figure 4.14). Starting with the first storey, band one includes the doors, each framed by its own wide *alfiz* of ceramic tile mosaic with interlace (no. 12), and the central panel

of carved stucco (no. 1) between them. A common *alfiz* (no. 11), in which Kufic inscriptions in carved stucco repeat the Nasrid motto, surmounts and surrounds the elements of the first storey, forming a coherent unit. The extensions of the elongated letters *lam* and *alif* in the inscription join to minute polylobed arches above and form an arcade, while the voussoirs of the lintel above the doors (no. 13), carved with foliate motifs, visually extend the height of the doorways. The lower part of the wall is embellished with the dadoes of ceramic tile mosaics (no. 15) made by the Contreras.

The second area is the narrow, central band (no. 14) that indicates the division of the elevation into two storeys. It is decorated with large polylobed medallions filled with radiating stars and foliate elements, three of which (including the one in the middle) contain the Nasrid shield.

The third band corresponds to the elevation of the upper storey. The central window is located on the central vertical axis and is aligned with the central stucco panel below. It is flanked by narrow panels (no. 4) filled with foliate motifs, followed by two double-light windows, flanked in turn by larger rectangular panels (no. 6) decorated with foliate elements and set within a lozenge grid that extends from the windows to the walls adjoining the façade.

The fourth, uppermost band is embellished with the *muqarnas* cornice (no. 7) above the windows supported by a minute colonnade. The arcade-like space between the columns is filled with the Nasrid motto, executed in Kufic script and repeated throughout this space. The cornice is then crowned by a band with elongated cartouches in carved wood with a poetic inscription (no. 8), a band with an arcade formed by foliations (no. 9), and a series of richly carved corbels (no. 10) that support the projecting eave.

The elements of the elevation are unified by proportional relations, as has already been demonstrated. The proportionality extends to smaller decorative elements as well. For example, the rhomboid grids in the lateral panels in the first and third horizontal bands (nos 5 and 6) are proportionally scaled, where the ratio of the heights of their units (the individual lozenge shapes) is equal to the ratio of their widths. But it is not proportionality alone that unifies the design. Rather, harmonious relationships also prevail between decorative elements in different bands. The shared form of the rhomboid grids filled with arabesques in these panels is as important to the unifying impact of the design as the proportional relation between them. The similar placement of each panel at the sides of their respective horizontal bands adds to that harmony by framing the elevation on the two floors. Again, the *muqarnas*-like profile of the arcade in the *alfiz* of the lower elevation (no. 11) echoes the projecting *muqarnas* cornice (no. 7) above the second storey, a congruity further strengthened by the use of Kufic inscriptions in both of these elements.

The size of the Met textile, the delicacy of the thin weave of the silk and the fine state of preservation together suggest that it would have served as a curtain or wall hanging (Figure 4.11). In that vertical orientation, scholars concur in reading the bands of the textile from top to bottom as they appear in the figure, on the basis of what is already an implicit (sometimes explicit) comparison with architectural decoration in the Alhambra. The alternation of dominant and subordinate bands in the Met textile, distinguished by the scale of the decorative elements and the colours employed, offers a striking visual resemblance to the predominance of bands one and three of the Façade of Comares, which stand out for the openings of doors and windows.

The first and third areas of the Met textile, then, are almost identical in design, being composed of a series of bands of merlons, interlace, and the repeated inscription *al-ghibṭa* (beatitude), and cartouches filled with *naskhi* inscriptions that read *al-yumn wa'l-iqbāl* (happiness and prosperity). It is the particularities of the Kufic script that have been the main basis for dating the textile to the second half of the eighth/fourteenth century, during the reign of Muḥammad V.[110]

The second and fourth bands are related by their use of geometric motifs, but distinctive in their initial optical effects. In the second band, yellow interlace forms large quatrefoils with a small white eight-pointed star at their centres. These quatrefoils are arranged in staggered rows with large eight-pointed stars with a dotted white border; the star, in turn, has three other stars inscribed within it, progressively decreasing in size. The geometric design in the fourth band is formed by yellow interlace as well, accentuated by the contrast of black eight-pointed stars inscribed within the large white eight-pointed stars. The narrow band below it presents a chequered pattern in black and white.

On closer scrutiny, the Met textile proves to be deceptive in the apparent disjuncture between its two visually more prominent bands. As seen in the discussion of the dadoes of ceramic tile mosaic in Chapter 1, differences in the use of colour deliberately mask similarities in the geometric design. The geometric pattern of bands two and four are both based on the same figure, known as the *lazo* of 8, which is 'a pattern based on an octagonal grid or radiating from an eight-pointed star'; in this case, the design is generated by an eight-pointed star.[111] The *lazo* of 8 and the large scale of the quatrefoils are made easily discernible in the decoration of the upper band, thanks to the luminous yellow of the interlace, especially as contrasted against the surrounding darker areas of red, green and black, or the light areas in white. In the lower band, the central, white eight-pointed element is on much the same scale as the central, dark eight-pointed elements in the upper band, but the relation of the colours make that main, generating element more difficult to perceive.

The characteristic decorative elements of bands two and four and the differences between them have prompted Partearroyo to remark upon the general resemblance between that the upper area and stucco panels in the Alhambra, on the one hand, and the lower area and dadoes of ceramic tile mosaic, on the other.[112] Both points of resemblance may be reinforced by the more specific comparison with the Façade of Comares. In the case of band four of the Met textile and band one of the Façade of Comares, it needs be recalled that the existing state of the dadoes of ceramic tile mosaic is a nineteenth-century restoration. Nevertheless, the features of band four in the Met textile share elements with the dadoes of ceramic tile mosaic as reconstructed by the Contreras and found elsewhere in the Alhambra: the placement in the lowest, horizontal band of the composition, the exclusion of vegetal motifs, the small scale of the salient elements and the reduction in the number of colours. The relation of the Met textile to the stucco carving on the Façade of Comares is more firmly grounded in extant original elements and more precise. To recall Grabar, geometry is a mode of perception, and it would enable a beholder to recognise the relation between the two media and heighten awareness of other supporting forms of congruence.[113] The staggered rows of quatrefoils and eight-pointed stars in the second band of the Met textile present a design very similar in its geometric composition to that of the central carved stucco panel between the doors (Figure 4.18). The chief difference between them lies in a greater variety of foliate motifs that fill the various geometric shapes of the carved stucco panel. Since the design in both media is based on the same geometric composition (made to be clearly visible), all elements within it are proportionate to each other: namely, the quatrefoils both in the textile and on the stucco panel are twice as large as the stars. The relationship between the scale in the design of the stucco panel to that of the second band of the textile corresponds to 3.5:1, that is to say, that the pattern on the whole and all of its geometric elements in the stucco panel are 3.5 times larger than the corresponding elements in this band on the textile. Once again, these resemblances do not prove that the Met textile was designed for use in the Cuarto Dorado, but attest to the ways in which textiles could be produced and perceived in proportionate and harmonious relationship to the architectural decoration in the spaces in which they appeared. All this, incidentally, increases the likelihood that the Met textile or another *muwashshah* textile in its group was in fact deployed in that space. The historical issue cannot be resolved, but the theoretical point is nonetheless strengthened. The impression of disproportion of the Façade of Comares in relation to the patio of the Cuarto Dorado would have been countered and compensated by the harmony that united the architecture and textiles with similar decorative vocabulary and proportionate designs.

Figure 4.18 *Façade of Comares, detail, central panel of carved stucco, Palace of Comares, Alhambra (photograph: Olga Bush)*

The complete absence of the original colours on the stucco panels of the Façade of Comares greatly diminishes the perception of relatedness to the Met textile or other extant *muwashshah* textiles, of course, but, originally, the polychromy there was surely as brilliant as elsewhere in the architectural decoration of the Alhambra. Colour would have been applied to optimise visual effects, whether to emphasise congruence or, as in the Met textile, to mask the perception of similarities, thereby demanding a more sustained contemplation to discover relatedness. As may be recalled, al-Haytham emphasised that the 'painted designs and decorations of a wall [*nuqūsh wa tazayīn*]' require concentration and contemplation, the crucial faculties in the cognitive process.[114]

If, as may well be supposed, colour was used on the Façade of Comares, as in the *Qalahurra* of Yūsuf I, such that gold was

used for the motifs on the surface of the plane to reflect light and stand out against the darker colours of the elements carved at greater depth and other background areas, then the architectural decoration would have corresponded all the more closely to the Met textile.

The various points of affinity between *muwashshah* textiles and architectural decoration in their shared decorative vocabulary, the proportional and harmonious interrelationships between alternating bands, and almost certainly the use of colour, point to an integrated aesthetic in the Cuarto Dorado and elsewhere in the Alhambra. Generally speaking, in comparison with Western medieval architecture or that of other periods and places, Nasrid buildings are characterised by structures in which the tectonic order is reduced to the elevation of walls and varied, often complex vaulting. Consequently, the decoration of architectural surfaces, especially the stucco panels and the dadoes of ceramic tile mosaics affixed to walls, is largely independent of the underlying weight-bearing and decorative architectural members. With the minimal recessions and projections of carved elements in stucco panels typical of the walls of the Alhambra, the sculptural effect of the decoration of the Façade of Comares is negligible when seen from a short distance. At closer range, however, it appears as a finely-textured surface, and would have seemed even more so with its original colour intact. From a greater distance, this large expanse displays virtually no relief. The flat, highly coloured wall would have greatly resembled a wall hanging; the links between textiles and textile-like architectural surfaces would have been patent.

6

Textile metaphors visible in the resemblance between textiles and architectural decoration point further to a crossover in the functions of these two media. The central panel of carved stucco between the twin doors of the Façade of Comares is a case in point. Its function as textile architecture depends upon the larger context of the Cuarto Dorado as a ceremonial space, which requires a reading of the epigraphic programme on the façade. Characteristically for the Alhambra, the programme includes repetitions of the Nasrid motto, Qur'ānic, votive and formulaic inscriptions in medallions and stars, cartouches and bands, and overlaying geometric and floral forms, and also a poem composed by Ibn Zamrak and inscribed on a wooden frieze just below the eaves.[115]

If the monumentality of the Façade of Comares in its small precinct has been a puzzle, the unusual architectural feature of the twin doors has been an enigma within the enigma. Scholars have resolved the issue through an interpretation of the inscriptions. The poem, along with other textual sources, has provided a key to the dating.

Ibn Zamrak names Muḥammad V as the reigning sultan and gives his *laqab*, or honorific title, *al-ghanī bi-llāh* (He who is content through the help of God), which the sultan took only after his military campaigns of Jaén, Úbeda and Baeza from September to November of 769/1367.[116] Ibn al-Khaṭīb records in the *Ihāta* that a long *qaṣīda* by Ibn Zamrak referring to Muḥammad V's victory in Algeciras in 771/1369 was recited during the celebration of the *mawlid* in the Alhambra after '[Muḥammad V] finished the famous works on his doorway'.[117] Some verses from the *qaṣīda* are inscribed in the north and south galleries of the Court of Comares. Drawing on this information and other historical facts, such as Muḥammad V's attack on the town of Osuna three days before the *mawlid* of 771/1369 and Ibn al-Khaṭīb's escape to Morocco in 774/1372, Fernández-Puertas concludes that the inauguration of the Façade of Comares took place during the *mawlid* of 772/1370.[118] The Façade of the Comares would have been built between 769/1367 and 772/1370 – a dating that has been generally accepted.

The elucidation of the Façade's function has derived primarily from the 'Throne verse' (Qur'ān 2:255), inscribed over the central single-light window of the second storey, which concludes: 'His Throne comprises the heavens and the earth; preserving them oppresses Him not; He is All-high, the All-glorious' (Figure 4.19). As with the inscriptions of verses from *sūrah* 67, *al-Mulk* ('Dominion') in the cupola of the Hall of Comares, generally seen as corroboration of its function as a royal audience hall, James Dickie and Fernández-Puertas have taken the inscription of the 'Throne verse' on the Façade of Comares as evidence that the sultan held public audiences in the patio of the Cuarto Dorado.[119] Much as has been discussed with respect to *sūrah* 67, inscriptions of the 'Throne verse' are a commonplace in Islamic architecture dating back to the epigraphy in the Great Mosque of Damascus (87/705) and continuing to be employed throughout the Muslim world up to the fourteenth/twentieth century in mosques, mausoleums, madrasas, city gates and cenotaphs. Yet among the more than one hundred and fifty examples compiled by Erica Cruikshank Dodd and Shereen Khairallah, the 'Throne verse' appears only twice in palaces, both in Cairo and dated 901/1496 and 1028/1619, respectively.[120] Given the rarity of the use of the 'Throne verse' in palatial settings, its inscription here in the Cuarto Dorado is noteworthy, as Dickie and Fernández-Puertas have argued. They further support their proposal that the throne stood in the patio of the Cuarto Dorado (at least on specific occasions) by pointing to the raised platform immediately preceding the façade that is reached by three steps from the marble pavement of the patio, in addition to the magnificence of the Façade of Comares itself.

These scholars' interpretation is reinforced by the presence of Ibn Zamrak's poem in the cartouches of the wooden frieze, which

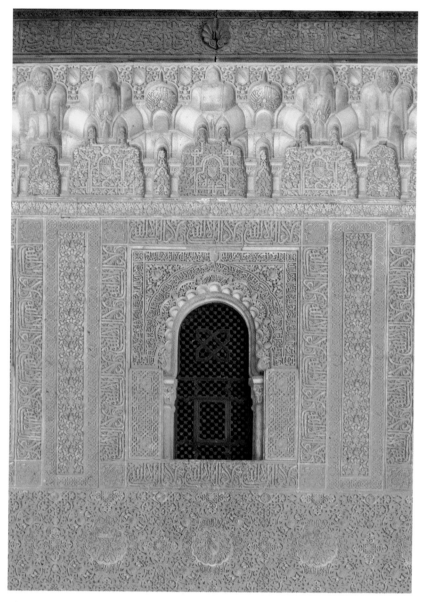

Figure 4.19 *Façade of Comares, detail, central window, Palace of Comares, Alhambra (photograph: Olga Bush)*

commemorates a new dawn for the Nasrids with Muḥammad V's return to the throne in 1362, and his successful military campaigns in Jaén, Úbeda, Baeza and Algeciras:[121]

> My position is that of a crown (*tāj*) and my door (*bāb*) is a
> bifurcation (*mafriq*);
> *Al-Maghrib* (the West) thinks that in me is *al-Mashriq* (the East).

He who is content through the help of God (al-ghanī bi-llāh)
 commanded me to open the entry
To the victory that already had been announced.
And I expect its apparition [to give it an entrance],
Like the horizon that introduces the dawn.
May God embellish his works
Like the beauty of his bearing and his character.[122]

In its position under the eaves 9.2 m above the ground, and in car-
touches 1.86 cm long, Ibn Zamrak's poem would have been illegible
to the Nasrid beholder and it remains so today. The wooden frieze,
now altogether devoid of colour, would have been painted originally
with the background in red, floral motifs in gold leaf and epigraphy
in white.[123] The illegibility would have been somewhat ameliorated
when the original polychromy was intact, since, as seen in the
Qalahurra of Yūsuf I, colour could be used to accentuate epigraphy.
Nonetheless, here is a case quite unlike the uses of poetic inscrip-
tions studied in previous chapters, where the texts of the poems on
the niches of the Sala de la Barca and on the walls of the Qalahurra of
Yūsuf I appeared at eye-level or slightly below and so could be easily
read. Ibn Zamrak's poem under the eaves of the Façade of Comares
can hardly be said to have had a direct impact on the experience of
the beholder, as argued in the other cases. The underlying question
addressed there still obtains nonetheless: why particular inscriptions
in particular places?

 The inscription of verses from sūrah 67 in a wooden frieze
just below the cupola around the perimeter of the Hall of
Comares sheds some light on the issue of legibility. The
present state of preservation makes it impossible to read the text
from the floor, but even when the original white pigment applied
to the calligraphy helped to highlight the letters, it is unlikely that,
at a height of some 12 m, the text would have been legible to the
Nasrid beholder. It may have been common knowledge that it
was a passage from sūrah 67 that adorned the wooden frieze;
and in that case, cultivated Muslim beholders would have rec-
ognised the contents of the text, even if they could not read
it. Whether or not beholders were aware of the contents of the
inscriptions high above their heads, scholars have generally agreed
that the reference in the text to the superimposition of the seven
heavens is intentionally correlated to the architectural decoration
of the cupola of the Hall of Comares with its seven rows of radiat-
ing stars.[124] In sum, even in this case where the beholder could
not read the Qurʾānic text, the selection of this particular passage
and its inscription in this particular place not only form a con-
scious part of the coherent design, but also provide a commentary
or interpretive pathway to the understanding of the architectural
decoration.

Since Ibn Zamrak's poem inscribed on the Façade of Comares is an example of prosopopoeia, the function of address, if no less virtual, is inherent in the text. It needs be emphasised that the poem refers to Muḥammad V *in the third-person* by way of his newly-won *laqab*; it speaks about the sultan, who is clearly the crown of his realm, but not in his voice. The speaking *I* is the wall on which the poem is inscribed. García Gómez must have understood Ibn Zamrak's poem in that way when he translated *mafriq* into Spanish as *'frente'* (forehead, brow): 'I am a crown on the brow of my door',[125] where the *I* likening itself to a crown is the highest band of the elevation. While agreeing with García Gómez' translation, Puerta Vílchez points out that the literal meaning of *mafriq* is 'bifurcation'.[126] Darío Cabanelas Rodríguez and Fernández-Puertas suggest that literal meaning of *mafriq* as a mimetic description of the two doorways below.[127] Yet, as seen in the use of prosopopoeia in the poetic inscriptions in the Sala de la Barca and the tropes of *badīʿ* poetry in the *Qalahurra* of Yūsuf I, mimetic representation may contribute to, but does not exhaust, the interpretive possibilities opened by poetic inscriptions. So, reiterating that in the case of the Façade of Comares, Ibn Zamrak's poetic inscriptions speak for the design, one might look to another bifurcation explicit in the verses: the antithesis or *muṭabbaq* enunciated as the rivalry between *al-Maghrib* and *al-Mashriq*, Muslim West and Muslim East, dating back to the Umayyad caliphate in Córdoba in the fourth/tenth century.[128] Speaking for itself, the façade claims to settle the matter inasmuch as those in the West can find 'in me', that is, in the resplendent architectural decoration, the best of what was once available only in the East.

Prosopopoeia tends to incorporate other tropes, like antithesis, in a complex figure of speech that bridges oppositions. In that sense, as it has been argued above, prosopopoeia is the threshold trope, and here in the Façade of Comares, as in the Sala de la Barca, it is also the trope of thresholds and, it may be added, doorways. The architectural analogue of the poetic bridging of the prosopopoeia is the ingenious arrangement of the *alfiz*. Viewed in isolation, either door might be said to have its own wide *alfiz* of ceramic tile mosaic decorated with interlace and bearing the repeated Nasrid motto in Kufic script (Figure 4.14, no. 12), as would be the more common design, whereby a door, standing alone, is given special emphasis in the decoration of an elevation. But here in the Cuarto Dorado, the unusual structure of the twin doors called for an unusual artistic solution: the *alfiz* (Figure 4.14, no. 11) over each doorway extends downward and frames the central panel of carved stucco. What may appear as an opposition between the opening to the east and the opening to the west on the south wall is mediated subtly by the double *alfiz* to become a unified entryway – the door, *bāb*, of the poetic inscription is in the singular.

To put this otherwise, the bifurcated entry that may startle initially serves rather as an elaborate frame for the *in-between* space, which is the equivalent of an architectural caesura, or *mughaṣṣan*, in the language of *badīʿ* poetics in the Qalahurra of Yūsuf I. The prominence of this in-between space, and of the carved stucco panel that occupies it, is heightened by a peculiarity in the design. In his discussions of the proportional relations in the composition of the Façade of Comares, Fernández-Puertas suggested that the location of the doors on the plane of the wall was dictated by the dimensions of the central stucco panel (Figures 4.13, 4.14 no. 1, and 4.18), rather than the reverse, as might have been expected.[129] The poetic inscriptions, then, may help to articulate what the design of the façade represents to the beholder at eye-level. It is the stucco panel that generates the geometric design of the largest band of the decorative composition of the Façade of Comares. And it is precisely there, against the *backdrop* of that architectural caesura, that, according to Dickie and Fernández-Puertas, the throne was placed for royal audiences in the Cuarto Dorado.

Even if the hypothesis is accepted that the Cuarto Dorado was a site of royal receptions of some sort, it would remain possible that the sultan was not enthroned in front of the façade, but that he sat instead behind the single window on the central axis on the second floor. Such a 'window of appearance' is familiar since Roman times and common in the Islamic world, and, in fact, forms part of the court ceremony in a different precinct of the Alhambra to be studied in detail in the next chapter. The small size of the patio in the Cuarto Dorado would seem to speak against that conjecture, however, since the 'window of appearance' is usually a feature of a ceremonial setting in which the ruler appears before a multitude.

An inter-medial approach offers another line of inquiry and the proposal of a different kind of evidence. In the light of the compositional and decorative correlations between the Façade of Comares and Nasrid textiles, when taken as a backdrop to the throne, the central stucco panel may be seen to take up a function commonly assigned to textiles when they are used as a 'cloth of honour'.

That textile function is widely attested in European medieval and Renaissance depictions of both the Virgin Mary and enthroned kings. Among many examples, *Madonna and Child Enthroned* (*Rucellai Madonna*), a tempera-on-panel painting by Duccio di Buoninsegna (active 1278–1318), commissioned in 1285 for the new Church of Santa Maria Novella in Florence, the 'cloth of honour' is depicted as a sumptuous textile of vibrant colours with a pseudo-Kufic *ṭirāz* border (Figures 4.20 and 4.21). The painting is of special interest in that the all-over pattern of stars and quatrefoils suggests that an Andalusī textile had served as a model. Many such luxury textiles, silks especially, were imported extensively from al-Andalus to Italy in the thirteenth century.[130]

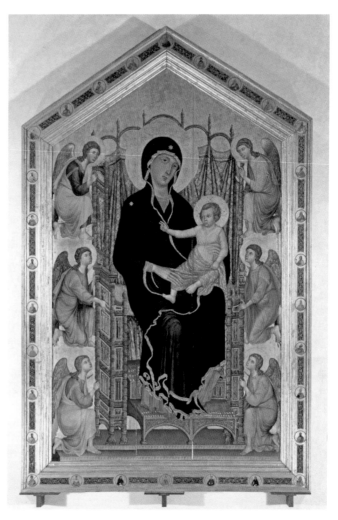

Figure 4.20 *Duccio di Buoninsegna,* Madonna and Child Enthroned (Rucellai Madonna), *tempera-on-panel, commissioned in 1285 for the new Church of Santa Maria Novella in Florence (Galleria degli Uffizi, Florence/Bridgeman Images)*

Visual parallels in the arts of the Muslim West are wanting, but the high value of textiles in the Islamic world is certain, and there is much textual evidence documenting the related representation of honour (or prestige, *nisba*) through textiles in the tradition of the bestowal of <u>kh</u>il'a, or the robe of honour. When Farru<u>kh</u>ī Sīstānī made use of a textile metaphor in the verses cited at the start of this chapter, likening his poetry to a silken robe 'spun within my heart/And woven in my soul', historical sources indicate that he composed this text as part of his larger work to be presented to the Amīr of Cha<u>gh</u>anian, in Khurasan, in the hope of gaining a position as a court poet.[131] So when he extends the metaphor to say

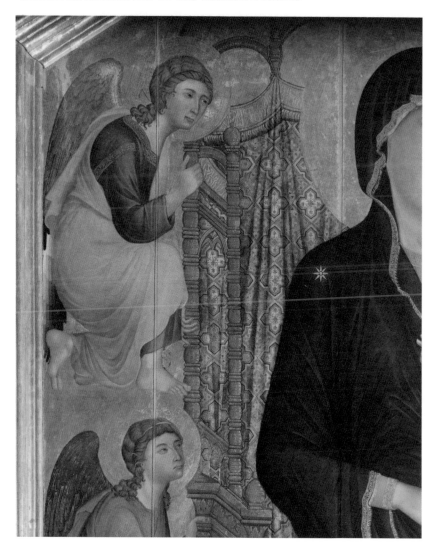

Figure 4.21 *Detail, Duccio di Buoninsegna,* Madonna and Child Enthroned (Rucellai Madonna)*, tempera-on-panel, commissioned in 1285 for the new Church of Santa Maria Novella, Florence (Galleria degli Uffizi, Florence/ Bridgeman Images)*

that 'Your hand and heart gave this [robe] its shape and colour and design. / And at its head you wrote the praises of / Abu Muzaffar, Shah of Chaghanian,'[132] then he refers at once to his poem and to a *khil'a* bearing the ruler's *ṭirāz*. The poet's metaphorical textile is to be exchanged, he hopes, for the literal robe of honour. Visual evidence of the granting of honour or the related use of the cloth of honour is lacking in the Muslim West, but as Duccio's *Madonna and Child Enthroned* and later Italian and Spanish paintings also show, Andalusī textiles were not used simply for adornment,

but could serve to distinguish a space of special prestige within a ritual setting, such as the place of a throne. Since the Western painterly tradition yields plentiful evidence for the status and meaning of Islamic textiles at European courts, these depictions may also serve for a better understanding of the use of these textiles in architectural spaces in the Islamic world. As the account of the Byzantine envoy to the 'Abbasid court cited earlier makes clear, European envoys to medieval Muslim and Byzantine courts brought back gifts of luxury textiles with testimonies about their function in ceremonial settings. The availability of these textiles and the first-hand knowledge of their use and potential significations aided in shaping the palatial and ceremonial spaces of European courts. Western depictions of Andalusī textiles, therefore, provide supplementary visual evidence of the arrangements and function of textiles at the Nasrid court, such as the use of a 'cloth of honour' as a backdrop to a throne. That pictorial evidence supports the suggestion that the central stucco panel in the Façade of Comares is a case of an architectural element taking on a textile function.

The crossover between media may be articulated by reference to the term ṣadr, literally 'front' or 'front part', in such expressions as ṣadr al-dār ('the one who occupies the highest position in the house') and makānat al-ṣadr ('first place, precedence, priority'), and so a word commonly used to refer to a leader or commander. Shelomo Dov Goitein's studies of the Geniza documents attest clearly to both an architectural and a textile meaning of the term. He cites texts in which ṣadr indicates a wall opposite the main entrance of a room, constituting 'its most prestigious side'.[133] On the other hand, among the various documents detailing textile furnishings,[134] he finds a description of a trousseau of a wealthy bride, dated to 511/1117, that lists eight Bahnasī curtains and another single Wasiṭī curtain, which is designated as a ṣadr.[135] Goitein observes with regard to the Wasiṭī curtain that ṣadr should be understood not simply as a single piece, but rather as a central piece, intended for the embellishment of the wall opposite the entrance of the hall or hung as a divider in front of it.[136] In other documents, a ṣadr curtain is listed together with its 'sidepieces', forming an ensemble of textiles,[137] most likely intended for use in a sitting hall (majlis). Goitein also likened the textile ṣadr in Muslim settings to the 'cloth of honour'.[138] Consequently, much like ṭirāz, raqm and muwashshah, the term ṣadr may serve as a switch-point between media, in this case, architecture and textiles.[139]

The central stucco panel of the south wall of the patio of the Cuarto Dorado (Figures 4.13 and 4.18) is a ṣadr in its twofold meaning. It is an element of the architectural decoration made to look like a luxury textile in itself within an overall design that makes the wall as a whole into a visual metaphor for muwashshah

textiles. And it is designed to function like a textile, an architectural cloth of honour that provides a visual backdrop to distinguish the part of the wall opposite the entryway of the petitioners seeking audience with the sultan.

7

I close this study of the Cuarto Dorado with a further proposal – only a conjecture, in the absence of documentary or archaeological evidence, and yet a logical extension of the links between textiles and architecture. The theoretical premise remains that the value attached to proportionality – long since established by Fernández-Puertas – would have been linked to harmony, according Ibn al-Haytham's optics, in the design of architectural space in the Alhambra.

Both proportionality and harmony have been noted in the design of a single textile, like the Burgos pluvial or the Met textile. The same elements would have governed the interrelationship between and deployment of complete sets of furnishings, such as mentioned in the *Kitāb al-Hadāyā* and the Geniza documents.[140] There is evidence of immense loom lengths for medieval Muslim textile production: Ja'far ibn 'Ali al-Dimashqī comments that silk cloth with gold brocade, that is, *dībāj*, was most suitable for the manufacture of furnishings, especially wall hangings, at the length of 200 *shibr* or 42 m.[141] Assuming that there was a certain uniformity of weave, colour and even design in a single loom length of cloth, that manufacturing capacity would have facilitated the creation of highly coherent, if not identical, ensembles. Numerous textile fragments, identical or nearly identical to the Met textile in dimensions as well as design, have been preserved in various collections.[142] There are many fragments either identical or similar in design to the Hispanic Society textile, but considerably smaller, as well.[143] It is likely that examples in both groups of textiles were made for complete sets of furnishings, possibly cut from the same cloth. The affinities between the Met and Hispanic Society textiles are strong with regard to composition, colours and decorative motifs. They share the interlace of quatrefoils and stars, cartouches with *naskhi* epigraphy, knotted Kufic epigraphy (both types containing the same inscriptions), merlons in alternating colours, and, finally, a band with interlace and large eight-pointed stars. If examples from both groups of textiles were used in the same space, they would have constituted a coherent set, too. Thus, even when not cut, literally, from the same cloth, sets of furnishings would have been *perfect* – still in Ibn al-Haytham's sense – if they exhibited proportional and harmonious designs. Such perfect sets of furnishings would have been on hand in the Nasrid Alhambra, including the Cuarto Dorado.

A further step in this line of thinking would be to propose that the resemblances between the design of textiles and architectural decoration, such as *muwashshah* textiles of the Met textile type and the design of the south wall of the Cuarto Dorado, were more than a metaphor. Textiles in harmony with each other, and also in harmony with the decoration of the walls, could have been brought into the Cuarto Dorado, particularly for court ceremonies like the audience before the sultan, seated on his throne against his architectural version of a cloth of honour. Departing from that further conjecture, I offer a hypothetical reconstruction: not only were there architectural elements that functioned like textiles, but also large-scale textiles would have had architectural functions, controlling movement and sight lines in the Cuarto Dorado.

The conjecture may be set within the context of a firmly established understanding of another, minor puzzle in the architecture of the south wall of the patio. The secondary axes of symmetry running through the centre of each of the twin doorways were displaced by some 7.5 cm further from the central vertical axis of the wall.[144] Far from an error in design, the displacement was a correction of an error of sight, such as already described by Vitruvius in his *De Architectura*, by which the doorways would have appeared as flattened, owing precisely to the apparent disproportion of the decoration of the Façade of Comares with respect to the length of the patio.[145]

A second error of sight, described by Ibn al-Haytham but heretofore undetected by scholars, would have impinged upon the ceremonial protocol in the Cuarto Dorado, were it to have appeared unfurnished, as it is today, on the occasion of royal audiences. I refer to the blurry distortions of peripheral vision.[146] The main entrance to the patio, facing its architectural *ṣadr*, would have been on the central axis of the patio. Petitioners would have made their approach to the throne by leaving the central doorway of the hall on the north side, the Cuarto Dorado proper, which, as noted, probably served as a waiting room,[147] and then passing under the central arch of the portico. The only way for petitioners to gain access to that hall would have been through the small patio that once stood north of the *mishwār* – not through the *mishwār* proper, as visitors do today[148] – entering the Cuarto Dorado precinct by stepping directly under the arcade of the portico from a door on the west side (Figure 4.22). (Petitioners would not have used either of the twin doors in the south wall, since that would have meant either entering from the treasury or past the guards, and, in any event, passing behind the back of the enthroned sultan!) On that itinerary, also followed by today's tourists, the *ṣadr*, throne and sultan would all have been visible, obliquely and with the attendant distortions of the corresponding error of sight, from the moment the petitioners stepped into the first

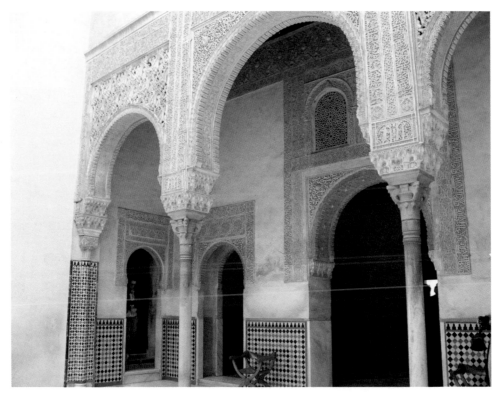

Figure 4.22 *Patio of the Cuarto Dorado precinct, north side, with the entrance on the west end from the patio of the* mi<u>sh</u>wār, *Palace of Comares, Alhambra (photograph: Olga Bush)*

lateral bay of the portico, nearest the *mi<u>sh</u>wār*. Neither optics nor court protocol would have allowed for petitioners to have such an initial view – distorting and so diminishing, just where ceremonial sets out to establish and represent power through forms of visual exaltation.

Where the permanent architecture of columns and bays would have created an error of sight interfering with the ceremonial approach to the throne, the transitory architecture of textiles in the form of large curtains might well have been employed to control sight lines and direct the movement of the petitioners. It seems likely that curtains would have been hung between the columns of the portico, as seen already in the mosaics of Sant' Apollinare Nuovo in Ravenna (500–25). Visual evidence from the nearby court of Alfonso X of Castile and León (r. 1252–84) illustrates a related arrangement, with the king enthroned within an arcaded portico embellished with sumptuous curtains (Figure 4.23).[149] Similarly, in his *Rusūm dār al-<u>kh</u>ilāfa* (*The Rules and Regulations of the Abbasid Court*), Hilāl al-Ṣābi' (359–448/969–1056) gives an account of a court audience in a courtyard where al-Ṭā'i'(r. 363–81/974–91),

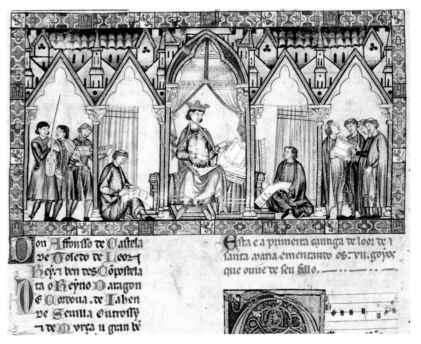

Figure 4.23 *King Alfonso X,* Cantigas de Santa María, *El Códice Rico, fol. 5r, vellum, 1275–1300, Biblioteca Monasterio del Escorial, Madrid (Biblioteca Monasterio del Escorial, Madrid, Spain/Bridgeman Images)*

the enthroned caliph, was seated behind a curtain hung 'on the middle columns' and the 'ropes were connected to all the columns in the courtyard' in order 'to prevent commotion, inconvenience, mingling, and overcrowding, and to enable the caliph to see and recognise from afar whoever is admitted. This contributes to the dignity of the audience and makes it more awe-inspiring.'[150] Dating back at least to the time of the Umayyads of Syria, who employed a 'master of the curtain' (ṣāḥib al-sitr) at court, the use of curtains as a spatial and ceremonial device that concealed the ruler from the beholder's gaze has persisted into the modern period.[151] A photograph of an audience held by the Qajar ruler, Nāsir al-Dīn Shāh (1846–96) at Gulistan Palace in Tehran, shows an enormous curtain opened over the portico to reveal the throne, and so gives much later evidence of the combination of textiles and architectural elements recorded by Hilāl al-Ṣābi' (Figure 4.24).

If the hypothesis of the Façade of Comares as a backdrop for the throne in royal audiences is admitted, then the precinct of the Cuarto Dorado might well be inserted into that long historical trajectory, not only as a site where architectural decoration resembles textiles and textiles join architectural decoration in the creation of a harmonious space, but also where architectural decoration took on textile functions and textiles functioned like architecture. In both of

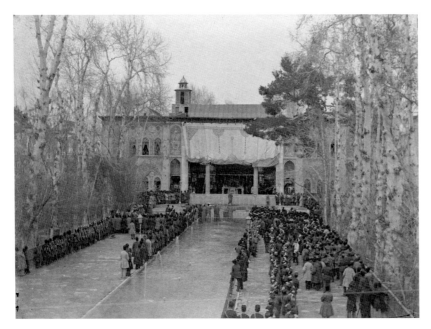

Figure 4.24 *Audience by Nāsir al-Dīn Shāh at Gulistan Palace Complex, Tehran, Iran, late nineteenth century (Myron Bement Smith Collection: Antoin Sevruguin Photographs. Freer Gallery of Art and Arthur M. Sackler Gallery Archives. Smithsonian Institution, Washington, DC. Gift of Katherine Dennis Smith, 1973–1985, FSA A.4 2.12.GN.51.04)*

these latter senses, a new, hybrid inter-medial term may be in order: *textile architecture*.

Notes

1. Quoted in Jerome W. Clinton, 'Image and Metaphor: Textiles in Persian Poetry', in Carol Bier (ed.), *Woven from the Soul, Spun from the Heart. Textile Arts of Safavid and Qajar Iran (16th–19th Centuries)* (Washington: The Textile Museum, 1987), p. 8.
2. The patio was incorporated into the *mishwār*, as seen in the plan made around 1530 by Pedro Machuca. See Antonio Fernández-Puertas, *La fachada del Palacio de Comares* (Granada: Patronato de la Alhambra, 1980), p. 11; Angel C. López López and Antonio Orihuela Uzal, 'Una nueva interpretación del texto de Ibn al-Jaṭīb sobre la Alhambra en 1362', *Cuadernos de la Alhambra*, 26 (1990), p. 144.
3. Bermúdez Pareja, 'Crónica de la Alhambra'; Puerta Vílchez, *Leer la Alhambra*, p. 64.
4. Orihuela Uzal, *Casas y palacios*, p. 86.
5. On the work of the Contreras in this precinct, especially on the court-yard, see Orihuela Uzal, 'La conservación de alicatados', pp. 137–41.
6. On the basis of the findings of their archaeological excavations in the large area that precedes the *mishwār* and their reading anew of a historical text, López López and Orihuela Uzal have proposed new

hypotheses with regard to important issues in the historiography of the Alhambra. However, their plan of the Alhambra as they believe it would have appeared in 764/1362 erroneously includes the Façade of Comares, which was erected eight years later. See López López and Orihuela Uzal, 'Una nueva interpretación del texto de Ibn al-Jaṭīb', pp. 124–5.

7. Ibid., pp. 120–5.
8. Fernández-Puertas, *La fachada*, pp. 16–18.
9. Grabar, *The Alhambra*, p. 57.
10. García Gómez' proposition was based solely on the examination of historical documents written in the 1530s when work was already well underway on the palace built for Charles V. See García Gómez, *Foco de antigua luz*, pp. 177–210.
11. The principal discussion of the Cuarto Dorado precinct is Fernández-Puertas, *La fachada*. In addition, see Carlos Vílchez Vílchez, 'Sobre la supuesta fachada meridional del Palacio de Comares', *Cuadernos de Arte de la Universidad de Granada* 22 (1986): 9–21; and also the following studies by Darío Cabanelas Rodríguez: 'Fachada de Comares y la llamada "Puerta de la Casa Real" en la Alhambra', *Cuadernos de la Alhambra* 27 (1991): 103–18; 'Dos tesis aparentemente innovadoras en la historia de la Alhambra', *Boletín de la Real Academia de Bellas Artes de Granada* 2 (1991): 37–48; 'Cronología de edificaciones de Muhammad V en la Alhambra', in *Realidad y símbolo de Granada* (Bilbao: Banco Bilbao Vizcaya, 1992), pp. 189–202.
12. Ibn al-Haytham, *The Optics*, I, p. 205.
13. Ibid. On Ibn al-Haytham's concepts of harmony (*i'tilāf*) and proportional relations (*tanāsub*), see Puerta Vílchez, *Historia del pensamiento estético árabe*, pp. 707–11.
14. See ibid., pp. 401–6.
15. The demonstration is hampered by the fact that Fernández-Puertas did not publish the measurements of the Façade of Comares, and he points out that there is a slight variance between the measurements of the width of the two doors in the drawing to scale by M. López Reche that he published (reproduced here as Figure 4.6).
16. Quoted in Clinton, 'Image and Metaphor', p. 10.
17. See Puerta Vílchez, *Historia del pensamiento estético árabe*, pp. 391–2.
18. See Lisa Golombek, 'The Draped Universe of Islam', in Priscilla P. Soucek (ed.), *Content and Context of Visual Art in the Islamic World* (University Park, PA: Pennsylvania State University Press, 1988), pp. 25–50. For an overview of Islamic textiles, see Patricia Baker, *Islamic Textiles* (London: British Museum Press, 1995).
19. Louise W. Mackie, *Symbols of Power: Luxury Textiles from Islamic Lands, 7th–21st Century* (Cleveland, OH: Cleveland Museum of Art, 2015), pp. 18–34, as well as relevant discussions in chapters dedicated to particular chronological periods and dynasties. In her use of the expression 'textile aesthetic', Mackie follows Fernández-Puertas, *The Alhambra*, pp. 89–90; Purificación Marinetto Sánchez, 'El uso de tejido y su decoración en los palacios de la Alhambra', in Amparo López Redondo and Purificación Marinetto Sánchez (eds), *A la luz de la seda. Catálogo de la colección de tejidos nazaríes del Museo Lázaro Galdiano y el Museo de la Alhambra* (Madrid and Granada: Museo Lázaro Galdiano, Museo de la Alhambra and TF Editores, 2012), pp. 25–30.

20. For a sustained analysis of the furnishings mentioned in *Kitāb al-Aghānī*, including textiles and their terminology, see Elisa Mesa Fernández, *El lenguaje de la indumentaria. Tejidos y vestiduras en el* Kitāb al-Aghānī *de Abu al-Faraj al-Iṣfahānī* (Madrid: Concejo Superior de Investigaciones Científicas, 2008), pp. 143–88. See also the comprehensive work of R. B. Serjeant, *Islamic Textiles. Materials for a History up to the Mongol Conquest* (Beirut: Librairie du Liban, 1972).

21. Shelomo Dov Goitein, *A Mediterranean Society: The Jewish Communities of the Arab World as Portrayed in the Documents of the Cairo Geniza, vol. 4: Daily Life* (Berkeley: University of California Press, 1983), pp. 105–50, 297–309, 328–31. See also, Yedida K. Stillman, 'Textiles and Patterns Come to Life through the Cairo Geniza', in Muḥammad ʿAbbās Muḥammad Salīm (ed.), *Islamische Textilkunst des Mittelalters: Aktuelle Probleme* (Riggisberg: Abegg-Stiftung, 1997), pp. 35–54.

22. Stillman indicates that nearly half of the silk furnishings listed in the bridal trousseau lists were made of Tabarī silk, which was heavy and so suitable for furnishings, in 'Textiles and Patterns', p. 41.

23. Goitein, *A Mediterranean Society*, vol. 4, pp. 107–10; Stillman, 'Textiles and Patterns', p. 41.

24. Al-Maqqarī, *Analectes sur l'histoire et la littérature des arabes en Espagne*, ed. R. Dozy and others (Leiden, 1855–61), vol. 2, p. 148, and vol. 1, p. 95, cited in Serjeant, *Islamic Textiles*, pp. 169, 172.

25. For historical sources on textile production in al-Andalus, see Serjeant, *Islamic Textiles*, pp. 165–76, esp. pp. 165, 172.

26. For an examination of historical documents that pertain to silk markets under royal control in Granada, Málaga and Almería and their administration during the Nasrid and post-Nasrid periods, see, for instance, Leopoldo Torres Balbás, 'Alcaicerías', *Al-Andalus* 14 (1949): 431–41; José Enrique López de Coca Castañer, 'La seda en el reino de Granada (siglos XV y XVI)', in *España y Portugal en las rutas de la seda* (Barcelona: Universidad de Barcelona, 1996), pp. 33–57. Among studies on the silk market in Granada, see Manuel Garzón Pareja, 'Una dependencia de la Alhambra: la alcaicería', *Cuadernos de la Alhambra* 8 (1972): 65–76; Esther Galera Mendoza and Rafael López Guzmán, *Arquitectura, mercado y ciudad: Granada a mediados del siglo XVI* (Granada: Universidad de Granada, 2003), pp. 73–88.

27. Restorations directed by José Contreras took place after the silk market was severely damaged in a fire on 20 July 1843.

28. See María Judith Feliciano, 'Muslim Shrouds for Christian Kings? A Reassessment of Andalusi Textiles in Thirteenth-Century Castilian Life and Ritual', in Cynthia Robinson and Leyla Rouhi (eds), *Under the Influence: Questioning the Comparative in Medieval Castile* (Leiden: Brill, 2005), pp. 101–32.

29. See, for instance, Dodds et al., *The Arts of Intimacy*.

30. Feliciano, 'Muslim Shrouds'. Feliciano's proposition appears to be independently seconded by Spanish scholars. Many textiles are attributed to Andalusī manufacture in the catalogue that accompanied an exhibition of medieval textiles from the Monasterio de las Huelgas (Burgos): *Vestiduras ricas. El Monasterio de las Huelgas y su época 1170–1340, del 15 de marzo al 19 de junio de 2005, Palacio Real de Madrid* (Madrid: Patrimonio Nacional, 2005).

31. For numerous examples of such re-use of textiles made during the pre-Nasrid and Nasrid periods, see Florence Lewis May, *Silk Textiles of Spain* (New York: Hispanic Society of America, 1957); Feliciano, 'Muslim Shrouds'; and *Vestiduras ricas*.

32. Yedida K. Stillman and Paula Sanders, 'Ṭirāz', *EI2*, vol. 10, pp. 534–8.

33. Ibid.

34. Ibn al-Zubayr, *Book of Gifts and Rarities*, p. 237. In her notes to this passage al-Qaddūmī highlights that the phrase *fī khayṭ wāḥid* (literally, 'of the same yarn') can be understood as 'a uniform set of furnishings from the same fabric', see pp. 396–7.

35. Ibid., pp. 150–3.

36. Ibid., p. 151.

37. The mission was recorded by the historian of the Hafsid dynasty Abū Zakariya' Yaḥyā Ibn Khaldūn (d. 781/1379). See *Histoire des Beni Abd el-Wad rois de Tlemcen jusqu'au règne d'Abou Hammou Mousa II par Abou Zakarya Yahia Ibn Khaldoun*, ed. and trans. Alfred Bel (Algiers: Imprimerie Orientale Pierre Fontana, 1903), vol. 1, p. 370.

38. On inscribed poetry and poetic recitations in the context of gift exchange, see Bush, 'Poetic Inscriptions and Gift Exchange'.

39. These verses are taken from a *qaṣīda* in Ibn Khaldūn, *Histoire des Beni Abd el-Wad*, vol. 1, p. 370.

40. Ibid.

41. Puerta Vílchez, *Leer la Alhambra*, pp. 120, 231–4.

42. García Gómez, *Poemas árabes*, p. 45.

43. Serjeant, *Islamic Textiles*, pp. 165–76.

44. In all but one of the examples found in Ibn al-Zubayr, *Book of Gifts and Rarities*, al-Qaddūmī interprets the term as richly coloured cloth, and once as a richly coloured cloth with gold embroidery. Serjeant cites numerous textual sources that refer to this term in *Islamic Textiles*, indices, pp. 262–3. He prefers to translate it generally as a 'figured silk', and, with regard to the textile production of Yemen, as 'variegated' and/or embroidered silk, but he does not give a more precise definition.

45. Germán Navarro Espinach, 'El comercio de telas entre Oriente y Occidente (1190–1340)', in *Vestiduras ricas*, pp. 89–106.

46. García Gómez, *Poemas árabes*, p. 45; Puerta Vílchez, *Leer la Alhambra*, p. 120.

47. María Jesús Rubiera Mata, *Ibn al-Yayyāb. El otro poeta de la Alhambra* (Granada: Patronato de la Alhambra y Generalife, 1994), p. 114. For the complete text of this poem in Arabic and my translation into English, see Appendix.

48. Ibn al-Zubayr, *Book of Gifts and Rarities*, p. 374, n. 4.

49. The alternative meanings, such as 'striped' or 'inscribed', of the adjective or adjectival phrase based on this root, were noted by Serjeant with regard to a description of an early Umayyad carpet as '*firāsh marqūm maṭmum*', early Umayyad silks (*khazz raqm*) and the textiles of al-Andalus. See Serjeant, *Islamic Textiles*, pp. 65, 67, 168, 172, respectively. Edward William Lane noted that *raqm* is related to a striped cloth or garment termed '*washi*'. See Edward William Lane, *Arabic–English Lexicon* (London: Williams & Norgate, 2003), pt. 3, pp. 1138–9.

50. Knysh, 'Ibn al-Khaṭīb', p. 370, n. 7. Among recent studies on Ibn al-Khaṭīb's literary oeuvre, see Celia del Moral and Fernando Velázquez

Bazanta (eds), *Ibn al-Jaṭīb y su tiempo* (Granada: Universidad de Granada, 2012).

51. English *text* derives from Latin *textus*, from *texere*, to weave, related to Greek *tekhne*, 'art, skill, craft, method, system'. Persian *ṭaraz*, 'adornment' or 'embellishment', and in its corresponding verb form meaning both 'to weave' and 'to compose poetry', cross into Arabic as a loan word, *ṭirāz*. Arabic *ṭaraza*, whose meanings in its Form II include 'to embroider' and 'to embellish a story', can mean both to compose poetry and to weave. The original meaning of *ṭirāz*, 'embroidery' or 'decorative work', in the early centuries of Islam was later extended to include a robe of honour, embellished with a *ṭirāz*, and thence by metonymy, to the ruler's workshop where such fabrics and garments were produced. See Stillman and Sanders, 'Ṭirāz', p. 534. Nasser Rabat has proposed that, in reference to inscriptions on architecture, the term *ṭirāz* was borrowed from textiles, and that the use of this term in the context of architecture should be dated to the Fatimid period, sometime between the fourth /tenth and sixth/twelfth century. See Nasser Rabat, ,'Ṭirāz, 3', *EI2* (Leiden: Brill), vol. 10, p. 538. Meisami has noted, however, that this term was used already in a poem by 'Unṣurī (d. after 422/1031–32) describing the fifth/eleventh-century Ghaznavid palace and its epigraphy. 'Unṣurī compares the *ṭirāz* on the walls with the *ṭirāz* of the kings' robes. This early example of such a use of the term in Persian poetry, she argues, was not likely to have been a borrowing from the Fatimids. See Julie Scott Meisami, 'Palaces and Paradises: Palace Description in Medieval Persian Poetry', in Oleg Grabar and Cynthia Robinson (eds), *Islamic Art and Literature* (Princeton, NJ: Markus Wiener, 2001), p. 27 and n. 22.

52. My preliminary ideas about conceptual and aesthetic links between this Andalusī poetic genre and several types of Andalusī luxury textiles appeared in Olga Bush, 'A Poem is a Robe and a Castle: Inscribing Verses on Textiles and Architecture in the Alhambra', in *Textiles as Cultural Expressions: Proceedings of the 11th Biennial Symposium of the Textile Society of America*, Honolulu, Hawai'i, 2008, available at: http://digitalcommons.unl.edu.

53. Serjeant, *Islamic Textiles*, pp. 14, 126, 212. Mesa Fernández notes that the term is also mentioned in one account in the *Kitāb al-Aghānī*; see *El lenguaje de la indumentaria*, pp. 125–6.

54. See Appendix.

55. Tova Rosen, 'The Muwashshah', in María Rosa Menocal, Raymond P. Scheindlin and Michael Sells (eds), *The Literature of al-Andalus* (Cambridge: Cambridge University Press, 2000), pp. 165–89.

56. Pérès, *Esplendor de Al-Andalus*, p. 404. The observation that the term appears in eleventh-century poetry was made by Joaquina Albarracín de Martínez, *Vestido y adorno de la mujer musulmana de Yebala (Marruecos)* (Madrid: Consejo Superior de Investigaciones Científicas, 1964), p. 57.

57. Pérès, *Esplendor de Al-Andalus*, p. 405.

58. Ibid., p. 404.

59. See Ibn al-Zubayr, *Book of Gifts and Rarities*, p. 170.

60. Along with other garments of female dress, the term *al-wishāḥ*, as a belt encrusted with pearls, appears in a dictionary, titled *Lisān al-'arab*, by Ibn Manẓur (d. 711/1311); see Mona R. Bastawi, 'Vestidos femeninos en el *Lisān al-'arab* de Ibn Manẓur', in Manuela Marín (ed.),

Tejer y vestir de la Antigüedad al Islam (Madrid: Consejo Superior de Investigaciones Científicas, 2001), p. 251.

61. For the depiction of women's dress during this period, see the examples in *Vestiduras ricas* and also Ruth Matilda Anderson, *Hispanic Costume 1480–1530* (New York: Hispanic Society, 1979), pp. 218–21.

62. Ibid.

63. Gonzalo de Baeza, *Cuentas de Gonzalo de Baeza, tesorero de Isabel la Católica*, ed. Antonio de la Torre and E. A. de la Torre, vol. 1: 1477–1491 (Madrid: Consejo Superior de Investigaciones Científicas, 1957), p. 268.

64. Ibid.

65. Serjeant, *Islamic Textiles*, pp. 169, 172. For further references to these cities as centres of textile production in medieval textual sources, see Susana Calvo, 'El arte de los reinos taifas: tradición y ruptura', *Anales de Historia del Arte*, Volumen Extraordinario 2 (2011), p. 86 and n. 54.

66. May, *Silk Textiles*, p. 192.

67. Serjeant, *Islamic Textiles*, p. 169.

68. al-Washshāʾ (Garulo), pp. 269–70.

69. For examples of eighteenth- and nineteenth-century sashes inscribed with verses in Spanish and French, see *La Seda en la indumentaria, siglos XVI–XIX, Colección Rocamora, Exposición, Colegio del Arte Mayor de la Seda 23 septiembre–23 octubre* (Barcelona: Palacio de Comillas, 1959), catalogue numbers 215–16, 569–89, pls XXXIX and LVII. The sashes formed part of the Rocamora collection at the time of their exhibition and publication. For inscribed sashes outside of Iberia, see Deborah L. Krohn, 'Belt or Girdle with a Woven Love Poem', in Andrea Bayer (ed.), *Art and Love in Renaissance Italy* (New York: Metropolitan Museum of Art, 2008), pp. 128–9; Narta Ajmar-Wollheim, '"The Spirit is Ready, but the Flesh is Tired": Erotic Objects and Marriage in Early Modern Italy', in Sara F. Matthews-Grieco (ed.), *Erotic Cultures of Renaissance Italy* (Farnham: Ashgate, 2010), pp. 141–69.

70. *La Seda en la indumentaria*, p. 92. The complexity increases in several of the nineteenth-century sashes, where a hemistich appears on both obverse and reverse sides. See *La Seda en la indumentaria*, pl. LVII.

71. For concise, but illuminating introductions to this much studied genre, see María Rosa Menocal, 'The Newest "Discovery": the *Muwashshahāt*', in María Rosa Menocal, *The Arabic Role in Medieval Literary History: A Forgotten Heritage* (Philadelphia, PA: University of Pennsylvania Press, 1987), pp. 71–114; Rosen, 'The Muwashshah'. For more sustained discussions, see Alan Jones and Richard Hitchcock (eds), *Studies on the Muwashshahāt and the Kharja* (Ithaca, NY: Ithaca Press Reading for the Board of the Faculty of Oriental Studies, Oxford University, 1991); Otto Zwartjes, *Love Songs from al-Andalus: History, Structure and Meaning of the Kharja* (Leiden: Brill, 1997). For a discussion of the relationship of this genre to Provencal poetry, see Robinson, *In Praise of Song*, pp. 273–300.

72. Rosen, 'The Muwashshah', p. 169.

73. Ibid., p. 167.

74. For the basic rhyme scheme, see Zwartjes, *Love Songs*, pp. 28–9.

75. Cited in G. J. H. Van Gelder, *Beyond the Line. Classical Arabic Literary Critics on the Coherence and Unity of the Poem* (Leiden: Brill, 1982),

p. 144. In explaining his title, Ibn Sanā' al-Mulk also suggests a close relationship between the *ṭirāz* workshop and the *Dīwān al-Inshā'* or a royal *scriptorium*: 'No other title I found more comprehensive, perfect, beautiful and adequate, nor more appropriate for the idea, than *Dār al-ṭirāz*. In the *ṭirāz* they make, in effect, the multi-coloured cloth of silk, and those with gold, in the fashion of antique [cloth] and the modern ones, the precious and the rare ones, and this book has to be like the *ṭirāz*, or, at least, the house contiguous [to that of the *ṭirāz*]. So I wrote this expression as the title of this book, as an insignia and as an incitement'; cited in Emilio García Gómez, 'Estudio del "Dār aṭ-ṭirāz", preceptiva egipcia de la muwashshaḥ', *Al-Andalus* 27 (1962), pp. 62–3.

76. For an example with a bilingual *kharja*, see Zwartjes, *Love Songs*, pp. 28–9.

77. Menocal, 'The Newest "Discovery"', p. 99.

78. In keeping with Menocal's arguments, Rosen's considerations of the linguistic hybridity of the *muwashshah*, its use in secular and religious settings, and its popular-vernacular features led her to the interesting observation that this poetic form 'exemplifies a pluralistic cultural politics that allowed for difference and plurality, clashes and juxtapositions' ('The Muwashshah', p. 166). Jewish poets of medieval al-Andalus also composed *muwashshaḥāt* in Hebrew, borrowing directly from Arabic poetics. For an example by Yehuda Halevi with a hybrid *kharja*, see Peter Cole (ed. and trans.), *The Dream of the Poem: Hebrew Poetry from Muslim and Christian Spain, 950–1492* (Princeton, NJ: Princeton University Press, 2007), p. 147 and 441n.

79. Menocal, 'The Newest "Discovery"', pp. 100–1.

80. The examination of this fragment shows that all its sides and edges are cut, precluding any determination of its original dimensions. I am grateful to Sumru Belger Krody, Senior Curator at the George Washington University Museum and the Textile Museum, who provided me with the museum's records of the object's report.

81. These fragments are found in many collections, among them: the Textile Museum, Washington, DC (TM 84.6); Musée des Arts Décoratifs, Paris (inv. 14627); Victoria and Albert Museum, London (acc. no. 821–1894). The fragment from the Victoria and Albert Museum was published in Cyril Bunt, *Hispano-Moorish Fabrics* (Leigh-on-Sea: F. Lewis, 1966), fig. 24. Two fragments in the David Collection in Copenhagen (2/1989), which are sewn together into one piece measuring 36 cm × 53 cm, were published in Sheila S. Blair and Jonathan Bloom, *Cosmophilia: Islamic Art from the David Collection, Copenhagen* (Boston, MA: Charles S. and Isabella V. McMullen Museum of Art, Boston College, 2006), p. 189.

82. Textile Museum object report. See Cristina Partearroyo [Lacaba], 'Los tejidos nazaríes', in Jesús Bermúdez López (ed.), *Arte islámico en Granada. Propuesta para un Museo de la Alhambra, 1 de abril–30 de septiembre de 1995, Palacio de Carlos V, la Alhambra* (Granada: Junta de Andalucía, Consejería de Cultura/Patronato de La Alhambra y Generalife/Comares Editorial, 1995), pp. 117–31.

83. Textile Museum object report.

84. According to the Centre International d'Étude des Textiles Anciens, the definition of 'lampas' is as follows: 'Term used exclusively for figured textiles in which a pattern, composed of weft floats bound

by a binding warp, is added to a ground fabric formed by a main warp and a main weft. The ground may be tabby, twill, satin, damask ... etc. The weft threads forming the pattern may be main, pattern, or brocading wefts; they float at the face as required by pattern, and are bound by the ends of the binding warp in a binding ordinarily tabby or twill and which is supplementary to the ground weave.' This definition is cited in John Becker, *Pattern and Loom. A Practical Study of the Development of Weaving Techniques in China, Western Asia and Europe* (Copenhagen: Rhodos International, 1987), p. 146.

85. See Partearroyo [Lacaba], 'Los tejidos nazaríes'.

86. For the discussion of the re-use of Andalusī luxury textiles by the Church and the court as burial shrouds, see Feliciano, 'Muslim Shrouds'. May's research brought to light many church inventories and other historical documents, and her discussion of particular textile examples remains valuable; see May, *Silk Textiles*. Annabelle Simon-Cahn has interpreted the cosmological motifs on the cloth woven in Almería in the twelfth century and later refashioned into the Chasuble of St. Thomas Becket, and she proposed that it could have originally served as a tent cloth or a canopy. See Annabelle Simon-Cahn, 'The Fermo Chasuble of St. Thomas Becket', *Muqarnas* 10 (1993): 1–5. Andalusī textiles of large dimensions produced in the sixth–seventh/twelfth–thirteenth centuries, which may have originally served as furnishings but were later re-used as church vestments and burial shrouds, can be found in major museums. See, for instance, a coffin cover of María de Almenar, made of silk and gold brocade during the Almohad period, *c.* 600/1200, and measuring 225 cm × 175 cm, as discussed in Concha Herrero Carretero, 'Coffin Cover of María de Almenar', in Jerrilynn D. Dodds (ed.), *Al-Andalus. The Art of Islamic Spain* (New York: Metropolitan Museum of Art, 1992), pp. 324–5.

87. I wish to thank Louise W. Mackie, Curator of Textiles and Islamic Art at the Cleveland Museum of Art, for communicating this information to me.

88. I am grateful to Cristina Partearroyo [Lacaba] of the Instituto Valencia Don Juan in Madrid for bringing these fragments to my attention and proposing that their shape indicates their re-use as parts of a stole. A stole is an ecclesiastical vestment consisting of a long band, usually made of silk, that is worn around the neck by priests and bishops.

89. Al-Jāḥiz, *Al-Tabaṣṣur bi al-Tijārah*, cited in Ibn al-Zubayr, *Book of Gifts and Rarities*, p. 374, n. 4.

90. Al-Washshā' (Garulo), pp. 259–60.

91. For texts, see Rubiera Mata, *Ibn al-Yayyāb*, pp. 118–19. See also Rubiera Mata, *La arquitectura en la literatura árabe*, p. 89; Gárcia Gómez, *Cinco poetas*, pp. 210–11.

92. Carry Welch, *Calligraphy in the Arts of the Muslim World* (Austin: University of Texas Press, 1979), p. 73.

93. May remarked on the width in *Silk Textiles*, p. 193, and she also observed that several of these fragments were re-used in chasubles: one housed in the City Art Museum in St. Louis, and another in the Church of San Sebastián at Antequera, province of Málaga in Spain.

94. Manuel Valdez Fernández, 'Clientes y promotores en la asimilación de modelos andalusíes en la edad media', *El legado de al-Andalus.*

El arte andalusi en los reinos de León y Castilla durante la Edad Media. Simposio Internacional (Valladolid: Fundación del Patrimonio Histórico de Castilla y León, 2007), pp. 19–42.

95. Cristina Partearroyo [Lacaba], 'Pluvial', in Jerrilynn D. Dodds (ed.), *Al-Andalus. The Art of Islamic Spain* (New York: Metropolitan Museum of Art, 1992), p. 336. See also Dorothy Shepherd, 'The Hispano-Islamic Textiles in the Cooper Union Collection', *Chronicle of the Museum for the Arts of Decoration of the Cooper Union* 1(10) (1943): p. 392; May, *Silk Textiles*, pp. 193–4.

96. Several fragments in this group are housed in the Cooper Hewitt Museum, New York; Victoria and Albert Museum, London, No. 1105–1900; Museo Nazionale del Bargello, Florence, inv. No. 141; and the Instituto Valencia de Don Juan, Madrid. A number of other fragments, similar to the one discussed above, but with a difference in the proportions of the cursive script and some floral elements, could be designated as a subgroup. For an example, see a fragment in the Metropolitan Museum of Art, New York (acc. No. 18.31), published in Olga Bush, 'Textile Fragment [cat. No. 48]', Maryam D. Ekhtiar, Priscilla P. Soucek, Sheila R. Canby and Navina Najat Haidar (eds), *Masterpieces from the Department of Islamic Art in the Metropolitan Museum of Art* (New Haven, CT: Yale University Press, 2011), pp. 81–2. For other fragments in this subgroup and collections in which they are housed see Arié, *L'Espagne musulmane*, pl. XI; Isabelle Errera, *Catalogue d'étoffes anciennes at modernes* (Brussels: Musées Royaux des Arts Décoratifs de Bruxelles, 1927), No. 77; May, *Silk Textiles*, fig. 126.

97. It is not the purpose of this study to investigate weaving techniques used in the production of luxury silks during the Nasrid period. The information pertaining to the structure of the textile in question is surmised from the analysis of an identical fragment in the Victoria and Albert Museum (No. 1105–1900), published in *The Arts of Islam Hayward Gallery 8 April–4 July 1976* (London: Arts Council of Great Britain, 1976), p. 81. For technical analysis of Andalusī textiles, see the essays in *Tejidos hispanomusulmanes*, special volume, *Bienes Culturales, Revista del Instituto del Patrimonio Histórico Espanõl* 5 (2005).

98. Partearroyo [Lacaba], 'Pluvial', p. 336.

99. For the Met textile, see, for instance, May, *Silk Textiles*, pp. 169, 199; Cristina Partearroyo [Lacaba], 'Textile Fragment', in Jerrilynn D. Dodds (ed.), *Al-Andalus. The Art of Islamic Spain* (New York: Metropolitan Museum of Art, 1992), p. 335; Cristina Partearroyo [Lacaba], 'Seda nazarí', in *Ibn Jaldun. El Mediterráneo en el siglo XIV. Auge y declive de los imperios. Exposición en el Real Alcázar de Sevilla, mayo–septiembre 2006*, exhibition catalogue (Fundación José Manuel Lara and Fundación El Legado Andalusí, 2006), pp. 160–1; Olga Bush, 'Textile Fragment [cat. No. 49]', in Maryam D. Ekhtiar, Priscilla P. Soucek, Sheila R. Canby and Navina Najat Haidar (eds), *Masterpieces from the Department of Islamic Art in the Metropolitan Museum of Art* (New Haven, CT: Yale University Press, 2011), pp. 82–3. The Hispanic Society textile has been considered in such publications as Mitchell A. Codding, Mencia Figueroa Villota, John O'Neil and Patrick Lenagham (eds), *The Hispanic Society of America. Tesoros* (New York: Hispanic

Society of America, 2000), pp. 145–6; Florence Lewis May, 'Textiles', in *The Hispanic Society of America. Handbook* (New York, 1938), p. 278; May, *Silk Textiles*, pp. 193–201; Adèle Coulin Weibel, *Two Thousand Years of Textiles: The Figured Textiles of Europe and the Near East* (New York: Hacker Art Books, 1952), No. 90; Ecker, *Caliphs and* Kings, pp. 47–9, 139. This textile has been dated by scholars from as early as the beginning of the ninth/fifteenth century to as late as the eleventh/seventeenth century, and, consequently, its place of manufacture has been ascribed to both al-Andalus and Morocco.

100. Mackie, *Symbols of Power*, p. 198.
101. Partearroyo [Lacaba], 'Textile Fragment', p. 335.
102. For the identification of some of the decorative motifs shared by textiles and the decoration of the Alhambra, see May, *Silk Textiles*, pp. 118–70. Similar identifications made in other studies include: Shepherd, 'The Hispano-Islamic Textiles', p. 389; Antonio Fernández-Puertas, 'Un paño decorativo de la Torre de las Damas', *Cuadernos de la Alhambra* 9 (1973): 37–52; Anne E. Wardwell, 'A Fifteenth-Century Silk Curtain from Muslim Spain', *Bulletin of the Cleveland Museum of Art* 70(2) (1983): 58–72; Partearroyo [Lacaba], 'Los tejidos nazaríes'; Partearroyo [Lacaba], 'Textile Fragment'.
103. Mackie, *Symbols of Power*, p. 197.
104. Fernández-Puertas, *The Alhambra*, p. 90.
105. Ibid., p. 104; Partearroyo [Lacaba], 'Los tejidos nazaríes', p. 126.
106. Fernández-Puertas, *La fachada*, pp. 34–41, and pls I–XIIIa, XXIVa, XXIVb and XXVa. See also Bermúdez Pareja, 'Crónica de la Alhambra', pp. 99–105 and pls X–XIV.
107. See Fernández-Puertas, *La fachada*, pp. 34–41; Serrano Espinosa, 'The Contreras Family'.
108. Fernández-Puertas, *La fachada*, pp. 34–41.
109. Orihuela Uzal, 'La conservación de alicatados', p. 140.
110. Partearroyo [Lacaba] cites Fernández-Puertas' dating in her 'Textile Fragment'.
111. For a brief overview of the *lazo* of 8 pattern, see Fernández-Puertas, *The Alhambra*, pp. 94–6; for the geometric construction of the pattern and a variety of decorative schemes based on it, see pp. 332–49. For the discussion of the construction of the *lazo* ('knot') patterns in the Muslim East, for which tools were employed similar to those used in al-Andalus, see Necipoğlu, *The Topkapı Scroll*, pp. 91–110.
112. Partearroyo [Lacaba], 'Textile Fragment'.
113. Grabar, *The Mediation of Ornament*.
114. Ibn al-Haytham, *The Optics*, I, p. 208.
115. For the text and locations of all inscriptions on the Façade of Comares, see Puerta Vílchez, *Leer la Alhambra*, pp. 69–75.
116. Ibn al-Khaṭib, *al-Iḥāṭa fī akhbār gharnāṭa* (Cairo, 1901), vol. 1, p. 37, cited in Fernández-Puertas, *La fachada*, p. 26. n. 3. Fernández-Puertas indicated that between 761/1359 and 764/1362 Muḥammad V was referred to as *al-Maklūʿ* ('the Dethroned'). See Fernández-Puertas, *The Alhambra*, p. 253.
117. Ibn al-Khaṭib, *al-Iḥāṭa*, vol. 2, p. 230, cited and discussed in Fernández-Puertas, *La fachada*, p. 27.
118. Fernández-Puertas, *La fachada*, pp. 26–30.

119. James Dickie, 'The Palaces of the Alhambra', in Jerrilynn D. Dodds (ed.), *Al-Andalus. The Art of Islamic Spain* (New York: Metropolitan Museum of Art, 1992), p. 136; Fernández-Puertas, *La fachada*, p. 16.

120. Dodd and Khairallah, *The Image of the Word*, vol. 2, pp. 9–19.

121. For the complete Arabic text of this brief poem, see Appendix. For the various translations into Spanish and analysis, see Puerta Vílchez, *Leer la Alhambra*, pp. 70–1; Darío Cabanelas Rodríguez and Antonio Fernández-Puertas, 'Inscripciones poéticas del Partal y de la Fachada de Comares', *Cuadernos de la Alhambra* 10–11 (1974/5): 159–64; García Gómez, *Poemas árabes*, pp. 73–4, 91–2; A. R. Nykl, 'Inscripciones árabes de la Alhambra y del Generalife', *Al-Andalus* 4 (1936–39), p. 178.

122. In my translation here, I follow closely the reading of Cabanelas Rodríguez and Fernández-Puertas, 'Inscripciones poéticas', p. 161. As elsewhere, my intention here is to provide a literal rendering of the poem.

123. Puerta Vílchez, *Leer la Alhambra*, p. 71.

124. See, for example, Cabanelas Rodríguez, *El techo del Salón de Comares*, pp. 81–90.

125. García Gómez, *Poemas árabes*, p. 92. García Gómez underlines his interpretation of the word *mafriq* as 'brow' in his commentary, pp. 73–4.

126. Puerta Vílchez, *Leer la Alhambra*, p. 71. On the term *mafriq* in the context of the Alhambra, see also Emilio Lafuente Alcántara, *Inscripciones árabes de Granada* (Granada: Universidad de Granada, 2000), pp. 154–5; Antonio Almagro Cárdenas, *Estudio sobre las inscripciones árabes de Granada* (Granada, 1879), p. 23; Nykl, 'Inscripciones árabes', p. 178.

127. Cabanelas Rodríguez and Fernández-Puertas, 'Inscripciones poéticas', pp. 159–64.

128. Puerta Vílchez, *Leer la Alhambra*, p. 71.

129. Fernández-Puertas, *La fachada*, p. 34.

130. For a discussion of Islamic textiles in European painting, see, for instance, Rosamund E. Mack, *Bazaar to Piazza, Islamic Trade and Italian Art, 1300–1600* (Berkeley: University of California Press, 2002). Mack emphasises the significance of this particular work for Italian *trecento* painting, due to its commission for the new and important church in Florence and for the size of the painted panel (178 in. × 114 in.); see ibid., pp. 56–8.

131. Quoted in Clinton, 'Image and Metaphor', p. 8.

132. Ibid., p. 8.

133. Goitein, *A Mediterranean Society*, vol. 4, p. 107.

134. Ibid., pp. 328–31.

135. Ibid., p. 120.

136. Ibid.

137. Ibid.

138. Ibid., p. 107.

139. To add to the inter-medial possibilities, *ṣadr* can also refer to the first hemistich of a verse in Arabic poetry.

140. See n. 31 above and Goitein, *A Mediterranean Society*, vol. 4, p. 120.

141. Serjeant, *Islamic Textiles*, p. 201.

142. This group includes the Textile Museum, Washington, 84.11 (102 cm × 38 cm); Museo Lázaro Galdiano, Madrid, 1694 (103.5 cm × 41 cm);

Museo Arqueológico Nacional, Madrid, 65.434 (103.5 cm × 41 cm); and the Detroit Institute of Arts, 43.34 (101 cm × 20 cm). See, respectively, Louise W. Mackie, 'Increase the Prestige: Islamic Textiles', *Arts of Asia* 26(1) (1996), p. 85; Amparo López Redondo, *Los Reyes Católicos y Granada* (Granada, 2004), p. 287; María Teresa Sánchez Trujillano, 'Catálogo de los tejidos medievales del M. A. N. II', *Boletín del M. A. N.* 4 (1986), pp. 102, 109; Weibel, *Two Thousand Years of Textiles*, No. 91. Many smaller fragments comprise an extensive group as well, including the following: Museo Arqueológico Nacional, Madrid, Nos 65.421 and 65.422; Kunstgewerbe Museum, Berlin, No. 62.105; the Textile Museum, Washington, No. 84.21; Cooper Hewitt Museum, New York, No. 1902-1-303.

143. This group includes: Cooper Hewitt Museum, New York, No. 1902-1-304 (63.5 cm × 35 cm); Musée Cluny, Paris, No. 12350 (132.5 cm × 103.0 cm); Museo Nazionale del Bargello, Florence, No. 90 (87.5 × 33 cm); and the Textile Museum, Washington, No. 84.1 (69 cm × 60 cm). See, for instance, May, *Silk Textiles*, fig. 41; Jean-Paul Roux (ed.), *L'Islam dans les collections nationales. 2 mai–22 août, 1977*, exhibition catalogue (Paris: Réunion des Musées Nationaux, 1977), No. 110; Bunt, *Hispano-Moorish Fabrics*, fig. 39; Stefano Carboni and Carlo Maria Suriano (eds), *La seta islamica: temi ed influenze culturali* (Florence: Museo Nazionale de Bargello, 1999), p. 20; Shepherd, 'The Hispano-Islamic Textiles', pp. 392–3; Weibel, *Two Thousand Years of Textiles*, pl. 37, No. 131. Weibel noted that in the example in the Textile Museum, Washington (No. 84.1), a metal compound is contained in the fragment, which makes it differ from the others made entirely of silk thread. On the other hand, some of the fragments are identical. The Bargello fragment, for example, has been matched with two fragments in other collections: one in the Museo d'Artes Decoratives, Barcelona, the other in Abegg Stiftung, Riggisberg. See Carboni and Suriano, *La seta islamica*, p. 71.

144. Pérez Gómez et al., 'La búsqueda y materialización de la belleza', pp. 411–16.

145. Vitruvius, *De Architectura*, as discussed in ibid.

146. Ibn al-Haytham, *The Optics*, I, pp. 269–70, 296–7. Livingstone corroborates Ibn al-Haytham's optical theory on this point. She explains that the central vision with its high acuity is employed in the analysis of detailed objects and surfaces, while the peripheral vision with its low acuity is used by human eyes to organise the visual field, identify large areas or objects, and direct our central vision to the next object to be scrutinised in the overall visual field. In her analysis of several paintings, she demonstrates that when the central vision is scrutinising a particular area of a painting, there will be a 'loss of precise spatial information' through the peripheral vision that perceives other areas. See Livingstone, *Vision and Art*, pp. 68–83.

147. Orihuela Uzal, *Casas y palacios nazaríes*, p. 84.

148. This approach to the Cuarto Dorado was first proposed by Orihuela Uzal, *Casas y palacios nazaríes*, plan 12, pp. 85–6.

149. Goitein cites other examples of manuscript paintings in which a figural composition is framed within an arcade embellished with curtains, including 'The Wedding Banquet' in the manuscript of the *Maqāmāt* (*The Assemblies*) of al-Ḥarīrī in the Hermitage Museum, St. Petersburg (MS S. 23, p. 205), Baghdad (Iraq), c. 622–31/1225–35;

and 'Preparing Medicine from Honey' in the *De Materia Medica* of Dioscorides, Baghdad (Iraq), 621/1224, in the Metropolitan Museum of Art, New York (acc. No. 57.51.21). See Goitein, *A Mediterranean Society*, vol. 4, p. 381, n. 70.

150. Hilāl al-Ṣābi', *Rusūm dār al-khilāfa* (*The Rules and Regulations of the Abbasid Court*), trans. Elie A. Salem (Beirut: American University of Beirut, 1977), pp. 64–6.

151. Paula Sanders, '*Marāsim*', *EI2*, vol. 6, p. 519. A similar office will be discussed in the following chapter.

CHAPTER FIVE

Integrating Aesthetic and Politics: The *Mawlid* Celebration in the Alhambra

Until you rose to that station among ranks
That makes the noble and the princely mighty
in the domed tent of dominion whose ropes and pole
Are the [Berber] tribes of Ṣanhājah and Zanātah.
 Ibn Darrāj al-Qasṭalī (347–421/958–1030)[1]

I

The great exception to the absence of documentation of the life at the Nasrid court is Ibn al-Khaṭīb's description of the *mawlid al-nabī* (hereafter, *mawlid*), that is, the celebration of the birth of the Prophet Muḥammad, which took place in the Alhambra on 12 Rabīʿ II 764 (30 December 1362). Ibn al-Khaṭīb, a vizier, court poet and participant in the celebration, included the account of the *mawlid* in the third part of his *Nufāḍat al-jirāb fī ʿulālat al-igtirāb (Dust from the Bottom of the Traveller's Knapsack: A Consolation in Exile).*[2]

Ibn al-Khaṭīb emphasises many elements of the celebration: the sultan's reception; recitations of Qurʾānic passages, invocations, blessings and homilies; the *dhikr* of the Ṣūfī brotherhoods; the recitation of *mawlidiyyāt*, or poems composed especially for the occasion of the *mawlid*, including his own; and the pleasures of the abundant banquet. He writes about the groups of guests in attendance, the decoration of the spaces where the activities of the week-long celebration took place, and their furnishings and illumination. One learns of an ingenious automaton, a clock that regulated the time of the activities and delivered the texts of poems at the striking of the hours, as well as the censers and candles, the perfume sprinkler and the many kinds of vessels in which the food was served, and other details contributing to the kinaesthetic and multi-sensory experience. In sum, he delivers a fascinating testimony.

As a loyal, high-ranking official of the court, it is not Ibn al-Khaṭīb's purpose to provide an objective report, but rather to extol the proceedings and his ruler, Muḥammad V. His text is more impressionistic than systematic, leaving out of account some basic information, perhaps because he assumed that his original readership would have

been familiar with the setting and ceremonial practices on the occasion of the *mawlid* in the Alhambra, or others like it. Those caveats aside, from the time that García Gómez disseminated Ibn al-Khatīb's description of the *mawlid*, the text has been recognised as a rich historical resource, and it has received significant scholarly attention, inviting various approaches and different emphases.[3] The main angle of study, beginning with García Gómez, has focused on identifying the precise location within the Alhambra to which Ibn al-Khatīb referred when he wrote of new and renovated 'sumptuous constructions'[4] that were undertaken by Muhammad V for the *mawlid* celebration. García Gómez' hypothesis that the newly built *mishwār* or council chamber and a *bahw al-nasr* or 'Pavilion of Victory' mentioned in the text would have been the Hall of Two Sisters in the Palace of the Lions and a tower, now called the Peinador de la Reina, respectively, has been overturned by archaeological findings.[5] On the basis of excavations in the large area that served as the administrative zone of the court, López López and Orihuela Uzal have argued convincingly that the 'new constructions' mentioned by Ibn al-Khatīb were existing, but renovated spaces: a reception hall, now known as the *mishwār*; and immediately adjacent to the west of the hall, a courtyard with the *bahw al-nasr* on its north side, known today as the Patio of Machuca and the Tower of Machuca, respectively (Figures 5.1 and 5.2: nos 1, 9 and 11; and Figures 5.3 and 5.4).[6] Of the original structures in the courtyard, only the Tower of Machuca and the portico on the north side remain standing today. A green hedge of myrtle, cut to form an arcade, now outlines what would have been carved stucco arcades supported by marble columns on the west and south side of the courtyard. The current plantings in the administrative area obscure its original plan. The tower was embedded in the curtain wall, overlooking the Darro River and facing the populous medieval neighbourhood of the Albayzín on the opposite hill. The curtain wall had been separated from the courtyard by the moat of the sentry walk, but the moat was filled during the renovations for the *mawlid*, so that the tower was incorporated directly into the courtyard that now extended to the north. The administrative zone also includes a second, contiguous courtyard to the west of the first, and linked to it by stairs located on the main, east–west axis of the administrative area. Only remains of the walls of the original buildings are visible today in this courtyard (Figures 5.1 and 5.2: nos 15–20; and Figures 5.3 and 5.4). This courtyard was not renovated for the *mawlid*, according to López López and Orihuela Uzal, but nonetheless it formed part of the ceremonial setting. They have also argued that the present-day *mishwār* was the site of the audience hall where the sultan was enthroned in Ibn al-Khatīb's account, and was thus the principal architectural space of the *mawlid* celebration (Figure 5.5).

Scholars have widely accepted López López' and Orihuela Uzal's conclusions, which have proved to be of great value in determining

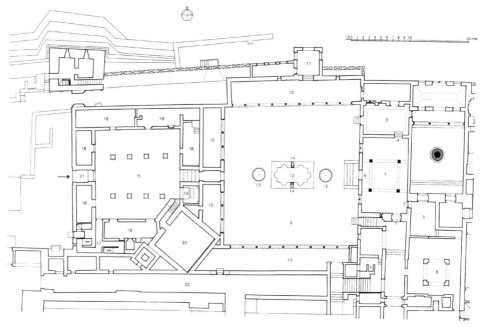

1. *Mishwār* with its cupola over the throne.

2. Access to the vestibule behind the west door of the Facade of Comares.

3. Vestibule behind the west door of the Facade of Comares.

4. Access to the small patio north of the *mishwār*.

5. Small patio north of the *mishwār*.

6. Main entrance to the *mishwār*.

7. Entrance to the *mishwār* from a small patio that links the hall with the street (Calle Real Baja).

8. Royal treasury.

9. Principal courtyard of the *mishwār* (today Patio de Machuca).

10. Porticoes of the courtyard of the *mishwār*.

11. *Bahw al-naṣr* (today Tower of Machuca).

12. Central pool.

13. Marble water basins.

14. Water fountains.

15. Second courtyard of the *mishwār*, which gives access to the administrative area from the esplanade.

16. Ablutions fountain.

17. Latrines.

18. Chambers of the court secretaries and administration.

19. Hall of the Royal Chancery.

20. Old mosque.

21. Gate that gives access to the administrative area from the esplanade.

22. Street of the *madīna* (Calle Real Baja).

Figure 5.1 (upper) *Administrative area and the precinct of the Cuarto Dorado, Alhambra. Reconstruction of the plan as it would have appeared in 764/1362 (after Angel C. López López and Antonio Orihuela Uzal)*

Figure 5.2 (lower) *Key to Figure 5.1*

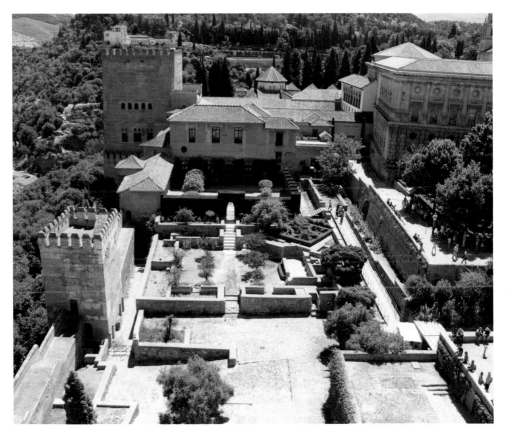

Figure 5.3 *Administrative area of the Nasrid palaces: the two courtyards, the* bahw al-naṣr *and the* mishwār, *view from* al-qaṣaba, looking east, Alhambra (photograph: Olga Bush)

the chronology of various buildings in the Alhambra, as well as for the purposes of conservation and restoration. Their proposal that the *mishwār* was originally built during the reign of Ismāʿīl I has been confirmed by Fernández-Puertas' analysis of the fabric of the south wall of the hall.[7] His analysis differs on one point, however. Fernández-Puertas maintains that the present-day entry on the south side of the *mishwār* was the entrance that Muḥammad V renovated for the *mawlid* and that it was used during the *mawlid* reception (Figures 5.1 and 5.2: no. 7; and Figure 5.6).[8] López López and Orihuela Uzal assert that there was an entry to the *mishwār* on the west side of the hall. Aligned on the east–west axis with a small pool, which has been preserved, and with the gates of the two preceding administrative courtyards, this doorway – made into a window in the post-Nasrid alterations of the *mishwār* – served as the principal entry in the *mawlid* ceremony (Figures 5.1 and 5.2: no. 6; and Figures 5.3, 5.4 and 5.7). They support their view by citing the similarity

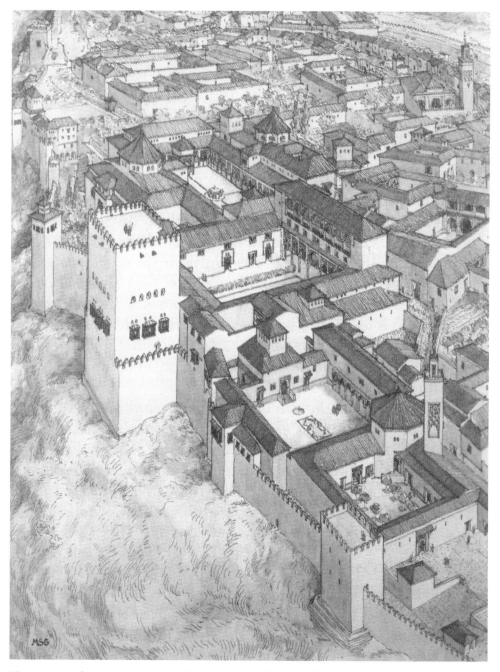

Figure 5.4 *Administrative area of the Nasrid palaces, Alhambra. Reconstruction (after Juan Castilla Brazales and Antonio Orihuela Uzal,* En busca de la Granada andalusí, *p. 353)*

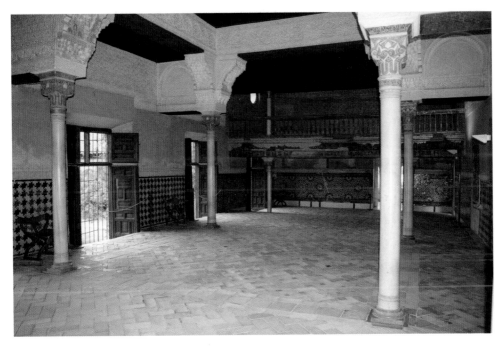

Figure 5.5 Mi<u>sh</u>wār, *interior, Alhambra (photograph: Olga Bush)*

in typology between the administrative area in the Alhambra and that of the royal palace with its *mi<u>sh</u>wār* in Fez.[9] The two views are not mutually contradictory, since it is possible that there were two different entrances: the one on the west side that predates the *mawlid* and the other, on the south side, renovated for the celebration. In that case, the entrances would have served two different functions, which are left unmentioned by Ibn al-<u>Kh</u>aṭīb. I will return to the discrepancy and examine the entrance of Fernández-Puertas' hypothesis, but, in general, I follow López López and Orihuela Uzal. I, too, will present much comparative material, for even where such an important document is available, its lacunae evoke questions for which the ceremonies of other medieval Muslim courts, especially *mawlid* celebrations, provide rich interpretative suggestions. This method will reinforce López López' and Orihuela Uzal's reconstruction of the predominant spatial orientation of the *mawlid* ceremony in the Alhambra, which exploited the east–west axis connecting the *mi<u>sh</u>wār* to the two courtyards and, beyond, to the open area that Ibn al-<u>Kh</u>aṭīb called the esplanade (*wasṭ*) in his account. There, according to Fernández-Puertas, a royal tent, described in detail by Ibn al-<u>Kh</u>aṭīb, was erected for the *mawlid*; it will be a major point of interest in the present chapter.

To begin, it is important to note that Ibn al-<u>Kh</u>aṭīb's text is, above all, the description of an *occasion*, rather than a structure. Hence, the present discussion departs from architectural history in a strict

Figure 5.6 Mi<u>sh</u>wār, *entry on the south side, Alhambra (photograph: Olga Bush)*

Figure 5.7 Mi<u>sh</u>wār, *exterior west wall, Alhambra (photograph: Olga Bush)*

sense along the theoretical path that has been called the spatial turn, focusing on the movement of bodies through built space that finds a reciprocal relationship in which architecture is 'a product of social practice', and, equally, 'society and its practices [. . . are] formed through architecture'.[10] The main question here concerns the relation between the ephemeral activities of the ceremony and the lasting architectural setting within which it occurred: how are multiple artistic and ritual practices deployed to make the architecture of the Alhambra that long pre-existed and long survived the *mawlid* of 764/1362 stand apart for the purposes of that particular occasion. Still more broadly, the question centres on the relationship between the permanent and the transitory, the static, built environment that informs ceremonial practices and the dynamic practices that transform architectural space. Without claiming to exhaust the possible approaches to Ibn al-<u>Kh</u>aṭīb's rich text, one may tackle these issues by studying the interplay between textiles and architecture as discussed in the previous chapter. The chief focus here is the use of the royal tent, followed by the role of the poetry recited at the *mawlid*. This should help to articulate the underlying aesthetic issues and ideological underpinnings of the celebration.[11]

2

The *mawlid* as described by Ibn al-<u>Kh</u>aṭīb is a performance or, to use Miquel Barceló's terms, a 'staging of power'.[12] In the Muslim court of

the Nasrids, the ultimate power was understood to reside in God, and thus the *mawlid* in the Alhambra is a religious celebration in honour of the Prophet. At the same time, the elaborate design and lavish expense of the celebration represented the power of the ruler. The exaltation of Muḥammad V's power is neither a separate nor a lesser dimension of the *mawlid*, but rather the political face of religious devotion. Marion Holmes Katz emphasises that interrelationship in her discussion of the conceptualisation of the *mawlid* by Muslim jurists when she explains that in a widely circulated text written in the eighth/fourteenth century by Ibn Jābir al-Andalusī (d. 780/1377), for instance, it is not only the donations of food and money to the needy during the *mawlid*, but the feasting itself, and indeed all of the ruler's expenditures for sumptuous display, that were considered acts of piety.[13] Cynthia Robinson and Amalia Zomeño demonstrate the importance of the mystic element brought to the *mawlid* in the Alhambra by the Ṣūfī brotherhoods in attendance, not only through the _dhikr_, but also in the poetic imagery of the *mawlidiyyāt*, especially images of light that would have related directly to the participants' experience of the stunning candlelight illumination described by Ibn al-Khaṭīb.[14] Moreover, their discussion corroborates James A. O. C. Brown's findings on the role of the Ṣūfī brotherhoods in the history of the *mawlid* celebration. Studying the *mawālid* (plural of *mawlid*) at the Marinid court in Fez, which was closely associated with the Nasrid kingdom, Brown relates that the celebration was 'a useful occasion for the distribution of patronage and an indication of favour at court',[15] affirming the hierarchical structure of the ruler's power. That observation supports his wider assertion that 'promotion of the *mawlid* cannot be seen narrowly in relation to the development of a "populist" religious policy focusing on sharīfism and Sufism', but rather that the celebration was 'a symbol of the Marinids' attempts to gain the support of the *'ulamā'* [the people of knowledge] and defend legal authority, and to co-opt as wide a spectrum as possible of different groups into support of their rule'.[16] For the Nasrids, too, the *mawlid* in the Alhambra was the occasion both to garner broad political allegiance and to articulate the social hierarchy of the court. Ibn al-Khaṭīb's text not only speaks for the integration of inter-medial aesthetics in the beholder's experience of the Alhambra in Nasrid times, but also for the integration of aesthetics and politics.

The first step in this approach to the ceremonial in the Alhambra will be to specify the occasion by outlining two historical contexts: the tradition of the celebration of the *mawlid al-nabī* as it extended from Fatimid Egypt to the Muslim West; and also the political situation in which Muḥammad V sought to construct his power through court ceremonial.

Originally a Shī'ite festival of the Fatimid dynasty (r. 297–566/ 910–1171), the *mawlid* was first celebrated in the fifth/eleventh century.[17] There were two eyewitness accounts of the earliest

mawlid court ceremonies, by Ibn al-Ma'mūn (d. 588/1192), whose father was a vizier to the Fatimid caliph al-Āmir *c.* 515/1121; and Ibn al-Ṭuwayr (525–617/1130–1220), a secretary at the Fatimid court.[18] The manuscripts have not been preserved, but their descriptions were transmitted in the later writings of historians and court secretaries of the Bahri Mamluks (r. 658–791/1260–1389) and Circassian Mamluks (r. 791–923/1389–1517), such as Ibn 'Abd al-Ẓāhir (620–92/1223–92), al-Qalqashandī (756–821/1355–1418) and al-Maqrīzī (766–845/1364–1442). Hence, there is clear evidence that the Mamluks were familiar with Fatimid *mawlid* ceremonial.

Ibn al-Ma'mūn's description of the *mawlid* at the Fatimid court in 517/1123 is brief, focusing on the generous alms distributed by the caliph. Ibn al-Ṭuwayr records a later, undated *mawlid* celebration, offering valuable details concerning the temporal and spatial sequence of phases of the ceremony, and indicating several locations. The author begins with a description of a reception at which 300 dishes of sugar confections and sweetmeats were distributed to elite social groups and individuals: court dignitaries (*arbāb al-rusūm*), court functionaries (*arbāb al-rutab*), the chief judge (*qāḍī al-quḍāt*), the head of religious propagation (*dā'ī al-du'āt*), readers of the Qur'ān, preachers, teachers working in mosques (*jawāmi'*), and caretakers of mausoleums (*qawāma*). After the distribution of the dishes, all those present at the reception rode to the al-Azhar mosque for the recitation of the Qur'ān, and then they rode on to the square between the two palaces (*bayn al-qaṣrayn*). They dismounted before entering the square where a multitude of the caliph's subjects had gathered for his appearance. The ruler was seated in a *manẓara* (covered balcony) that stood in an area of the square covered with yellow sand. The highest court official after the vizier, the master of the door (*ṣāḥib al-bāb*), who was in charge of protocol, gave a sign to the court dignitaries and officials to approach the *manẓara*. They proceeded on foot along a path cleanly swept and sprinkled with water. Then the caliph's chamberlain (*ṣāḥib al-uns*) opened the window of the balcony through which the ruler's head could be seen – the 'window of appearance' mentioned in the previous chapter – and the chamberlain greeted the dignitaries in the caliph's name. After the recitation of the Qur'ān, the preachers of the Mosque of al-Ḥākim, the Mosque of al-Azhar and al-Aqmar Mosque preached, and prayer (*dū'ā'*) for the caliph was offered. The chamberlain then saluted the crowd through the open window of the balcony, the windows were closed and the crowds left the square. Ibn al-Ṭuwayr ends his description by stating that the celebration of five other *mawālid* – those of 'Alī, Fāṭima, Ḥasan, Ḥusayn, the most important ancestors of the Fatimids, and that of the reigning caliph – 'occurred according to the same pattern, without any additions or omissions'.[19]

Nico J. G. Kaptein has observed that many elements of the Fatimid *mawlid* ceremony, such as the Qur'ān recitation and preaching, the

offering of largesse to the guests, the appearance of the caliph, the prayer for the ruler, and the greeting of subjects by the chamberlain on the caliph's behalf, are features held in common with court ceremonies celebrated for other Fatimid festivals.[20] Furthermore, the multiple stages of the ceremony; the distinction between the settings and gestures directed at the court elite, and the spaces and actions aimed at the public at large; and the linking of all stages by a procession, were also part and parcel of other Fatimid ceremonies. Given that Ibn al-Ṭuwayr does not specify the location where the court reception for the elite took place during the *mawlid*, nor does he provide a description of the site, a comparison with other Fatimid ceremonies may be adduced to clarify the *mawlid* celebration.

The detailed accounts of the ceremonies of the opening of the Nile canal in Cairo recorded by Nāsir-i Khusrau, a Persian traveller, for the early Fatimid period (438–39/1047) and, for the later period, by the same authors who recounted the *mawlid*, Ibn al-Maʾmūn and Ibn al-Ṭuwayr (in 516/1122, 517/1123 and 518/1124, respectively), provide illuminating comparative material.[21]

The intricate ceremony was articulated through a complex spatial design of several settings linked together by a procession. Nāsir-i Khusrau's account records that part of the ceremony intended for the public, which he witnessed on the grounds alongside the canal. He states: 'a large pavilion of Byzantine brocade spun with gold and set with gems, large enough for a hundred horsemen to stand in its shade, is elaborately assembled at the head of the canal for the sultan. In front of this canopy are set up a striped tent and another large pavilion.'[22] After the caliph and his enormous entourage arrived at the head of the canal, the caliph remained in the royal tent, concealed from his subjects until the moment when he would have to break the dam with his spear, releasing the waters. The life-giving force of the river may have come from heaven, but irrigation came from the canal, a royal property, so the ceremony was not only a celebration, but also a performance of the caliph's power.

In the later period, Ibn al-Maʾmūn and Ibn al-Ṭuwayr describe a ceremony for the opening of the canal involving three successive stages. It began with the enthroned caliph surrounded by high-ranking courtiers in the *majlis* (reception hall) of the Eastern Palace. Setting out from there, a procession, including over 8,000 troops, moved through the city, presenting rich pageantry to the eyes of the populace. For this occasion, as had been the case in the ceremony witnessed by Nāsir-i Khusrau, the houses, gates and shops of the city were adorned with luxurious textiles. So even the public space was transformed into a ceremonial space by the temporary deployment of textiles serving as architectural decoration.

The procession then arrived at an open space on the west side of the canal, where royal tents were erected. According to Ibn al-Maʾmūn's description, the largest of the royal tents was a

remarkable construction, consisting of a large main hall (*al-qāʿa al-kubra*), four vestibules (*dahālīz*) and four other, smaller halls (*qāʿa*), although in 516/1122 only the main hall and the four vestibules were raised because the cumbersome task of erecting the whole textile structure had previously caused many injuries and even deaths. The tent appears to have been a construction of lofty proportions, for the height of the centre pole of the main hall reached roughly 23 m (50 cubits). The throne, set in the centre of the hall, was covered with a luxurious silk, the pole was wrapped in multi-coloured brocade, and wall hangings and carpets completed the decoration of the space. It appears that other royal tents and pavilions were also raised on the site.[23]

Here the procession paused. The caliph exchanged greetings with his vizier, 'the officers of the stirrup' and the various groups of the entourage, who dismounted in the order of their rank, kissed the ground, regrouped and followed the vizier, who was now at the head of the procession. The caliph himself then dismounted onto the throne in the main hall of the large royal tent in the presence of court officials of high rank. The Qurʾān was recited and poets paid their homage, after which the caliph mounted his horse again and headed for the next and last setting of the ceremony, the *manẓarat al-sakkara*, the royal pavilion. Like the large royal tent, this pavilion was decorated with wall hangings and Andalusī carpets.

Just as at the initial reception at the palace, and parallel to the *manẓara* in the Fatimid celebration of the *mawlid*, the caliph was seated by an open window in the *manẓarat al-sakkara*. There he could see the labourers who demolished the dam and opened the canal upon the vizier's order, and at the same time, he could be seen by his subjects. The recitation of the Qurʾān continued, and after the water had filled the canal, royal boats were launched, adorned in gold, silver and luxurious curtains, which were multi-coloured and inscribed. Following the boat launch, the caliph withdrew into a chamber (*maqṣūra*) in the *manẓarat al-sakkara*, where a court banquet took place. The ceremony concluded with a recessional return to the palace.

The more detailed record of the ceremony for the opening of the Nile canal makes it possible to supplement the accounts of the Fatimid *mawlid* and to anticipate key elements in the construction of court ceremonial that will remain relevant to the tradition that reaches the Nasrids at the Alhambra. Most fundamentally, multiple spaces require movement, and the Fatimid ceremonies are a combination of assemblies and processions, stasis and dynamism. The distinction between open and closed spaces enables the marking of a clear social hierarchy – ranging from the participation of the common people on the streets to the most restricted court elite – as a matter of visibility. Who is permitted to see what and when? A mediating point is nevertheless reserved within the dichotomous design,

a site that is at once the most withdrawn from the public and yet open to the public view. This use of threshold spaces and temporary constructions (the belvedere, covered balcony and pavilion) indicates the important role played by textiles, from street furnishings and the decoration of boats to enormous royal tents, in the visual construction of a ceremonial within an environment otherwise defined by the permanent architecture of cityscape and palaces.

Celebrated first by the Shīʿite dynasty, the *mawlid* became a prominent Sunni festival in the seventh/thirteenth century. Textual sources attest to its celebrations in Irbil (southeast of Mosul) and its spread to Cairo under the Mamluks and further to the Muslim West with its growing popularisation by the Ṣūfī orders.[24] For instance, the *mawlid* celebrated in 604/1207–8 under the ruler of the local Begteginid dynasty, Muẓaffar al-Dīn Kökbürī, a brother-in-law of the Ayyubid ruler Ṣalāḥ al-Dīn (r. 564–89/1169–93), was recorded by a historian and native of Irbil, Ibn Khallikān (d. 681/1282). It is the first Sunni *mawlid* documented in detail, taking place more than a century and a half after the *mawlid* at the Fatimid court in 517/1123 described by Ibn al-Maʾmūn.[25]

As in the Fatimid festivals, the *mawlid* in Irbil was staged at several main settings, including the ruler's citadel – a permanent structure – and twenty-four five-storey wooden pavilions and a wooden tower, all erected on the city streets especially for the celebration. Although the wooden pavilions were the property of the ruler and of selected court officials, they were used to house visitors, musicians and shadow-players who performed for the court and the populace. Here, the ruler stopped to be entertained every night of the celebration prior to the night of the Prophet's birth, before heading to a Ṣūfī convent, where he slept. On the night of the the Prophet's birth, the ceremony was initiated in the citadel with a prayer and religious music, and then progressed in a candle-lit procession, passing the wooden pavilions to the Ṣūfī convent. The next morning the ruler participated in the ceremony from the window of the wooden tower, erected near the Ṣūfī convent and overlooking the grounds where multitudes of his subjects were assembled. Seated in this tower, the ruler observed his court and populace through the window, listened to the liturgy that included recitations from the Qurʾān and the delivery of sermons, while he also observed the military parade of his army through another set of windows. A banquet followed, served to the ruler in the tower and to the populace in the hippodrome, and the ceremonies concluded with the bestowing of robes of honour.[26]

Although the semi-permanent wooden constructions take the role of the tents and pavilions in Fatimid Cairo, the Sunni *mawlid* ceremonial in Irbil displays the main elements noted in the earlier Shīʿite celebrations. Here, too, one finds multiple spaces linked by processions and occupied by diverse constituencies in the social hierarchy, including the populace at large, the Ṣūfī brotherhood, the

army and high court officials. And, once again, the combination of
open and closed spaces, durable architecture and more ephemeral
structures construct that hierarchy in visual fashion, mediated, as in
Cairo, by a special site of both isolation and display, now in a tower,
from which the ruler sees his subjects and is seen by them.

The scope of those observations could be widened consider-
ably through comparative study of court ceremonial throughout
the medieval Muslim world and the Christian East and West, in
which processions are paramount.[27] It is possible to outline two
fundamental types, defined, as in the several ceremonies already
discussed, according to the restriction or opening of sight lines and
the division between the participants who are stationary and those
who move through ceremonial space.[28] In the first type, exemplified
by a royal entry into a city, known as *adventus* in the Christian
West and familiar from textual sources in the late antique, medieval
and Renaissance periods, the ruler is the dynamic figure, moving
from place to place before stationary subjects and exposed to their
view.[29] The *adventus* has many historical parallels in the Muslim
world.[30] Such processions through public space make a propagan-
distic, popular appeal, seeking the broadest possible political cohe-
sion. In the second, reception-type, the mobile element is made up
of a limited number of subjects and/or foreign ambassadors, who
approach a static figure of power, usually enthroned in an architec-
tural space that controls the sight lines of all those who participate
in the prescribed activities, while closing off entirely the direct view
of the figure of power to those who do not form part of the proces-
sion. The purpose of this type of procession is to construct a social
hierarchy performed spatially: the nearer one is to the (often literal)
seat of power, the higher one's rank, which is also to say, one of the
privileges of high social status is a better view. The approach to the
throne in the Cuarto Dorado, examined in the previous chapter, is
an example of a reception-type procession; hence, the importance of
considering the control of sight lines there. Relative social status is
constructed through the procession, ranging from the crowd's fleet-
ing glance of the passing ruler in the first type to the frontal, steady
gaze effected in the second. In both types, the highest power is also
constructed as a matter of visibility, since the ruler sees all. The
celebrations of the early *mawlid* and the opening of the Nile canal
also demonstrate that the two types could be combined so that a
complex ceremonial could aim at both a broadly inclusive political
consolidation and a strictly controlled social hierarchy.

3

As the *mawlid* celebration expanded westward across the Maghrib,
eventually reaching the Nasrid Alhambra, the history of court
ceremonial came to intersect with the political history in which

Muḥammad V was embroiled. As early as the mid-seventh/thirteenth century, a treatise on the *mawlid al-nabī* was begun in Ceuta by Abu'l-ʿAbbās al-ʿAzafī (d. 633/1236) and finished and disseminated by his son, Abu'l-Qāsim al-ʿAzafī (609–77/1211–79), the founder of the local, ʿAzafid, dynasty.[31] The *mawlid* became an official court celebration in Morocco under the Marinids in 690/1291 and a century later, under the Hafsids in Ifriqiya during the reign of the sultan Abū Fāris ʿAbd al-ʿAzīz (r. 797–838/1394–1434).[32] Annual *mawlid* ceremonies under the Wadids at their court in Tlemcen were recorded between 760/1359 and 769/1368 by Yaḥyā ibn Khaldūn, a vizier to Abū Ḥammū Mūsā II (r. 760–90/1359–89) and brother of the famed historian ʿAbd al-Raḥmān ibn Khaldūn (732–808/1332–1406).[33] There were also accounts describing the *mawlid* ceremonial at the court of Aḥmad al-Manṣūr (r. 986–1012/1578–1603), the ruler of the Saʿdī dynasty in Morocco, as late as the end of the tenth/turn of the seventeenth century.[34]

In addition to the use of textiles and the staging of processions considered at length above, many elements of the early *mawlid* celebrations at Irbil and in Cairo, where the Mamluks followed well-established Fatimid court ceremonial, had become traditions. One finds throughout North Africa such now familiar features as readings from the Qurʾān and recitations of homilies and of *mawlidiyyāt* poems in the presence of the enthroned ruler and his large court; sunset prayer followed by a banquet lasting throughout the night with candlelight illumination and the *dhikr* of the Ṣūfī orders, all in an extended ceremony that took place over many days.[35] Ṣūfī circles disseminated the celebration of the *mawlid* across the Strait of Gibraltar in al-Andalus from the second half of the seventh/thirteenth century,[36] and at least six of the earliest examples of a formal genre of canonical *mawlid* texts that emerged in that period have been attributed to Andalusī scholars.[37] These traditional ceremonial elements would all reappear in Ibn al-Khaṭīb's description of the *mawlid* in the Alhambra.

A review of the documentary evidence attesting to the establishment and spread of these traditions in the Maghrib suggests a certain correspondence with political events. Although the religious purpose of commemorating the Prophet's birth makes the *mawlid* an annual celebration, the accounts are irregular and, overall, sparse. It would appear that *mawālid* were only considered noteworthy enough to be documented when they occurred in times of special political importance. A few examples will suffice to illustrate the connection. *Mawlid* celebrations were recorded when they occurred in conjunction with major military victories, such as that of Abū Yūsuf Yaʿqūb's capture of Miknāsa in 643/1245 from the Almohad caliph, al-Saʿīd, before he became the first Marinid sultan in 656/1258 (he reigned until 685/1286);[38] and in preparation for important battles, like the attack on Algeciras in 741/1341 by the

Marinid sultan Abu'l-Ḥasan ʿAlī.[39] The *mawlid* was also associated with the proclamation of a new ruler. Abu'l-Qāsim al-ʿAzafī (r. 647–77/1250–59) celebrated the first official *mawlid* in Ceuta in 648/1250, only six months after he took the throne; and the Marinid sultan Abū Yūsuf Yaʿqūb named his son, Abū Yaʿqūb Yūsuf, to succeed him during the *mawlid* celebration in 671/1272.[40] Caution must be exercised with regard to sources, since documents may well be lost from times when *mawālid* did not coincide with matters of great political moment. Yet the testimony of Yaḥyā ibn Khaldūn is telling in this regard. When Abū Ḥammū Mūsā II took Tlemcen from the Marinids on 1 Rabīʿ I 760/31 January 1359 and founded the new Wadid dynasty, Yaḥyā ibn Khaldūn provided a detailed account of the *mawlid* celebrated a few days later.[41] In other years, he simply indicated that the celebration was 'like the others', or 'as usual'.[42]

Since the religious significance of the birth of the Prophet would not have fluctuated, other factors must have determined when a *mawlid* celebration should be recorded; and those factors were political. As the historian Ibn Marzūq (711–81/1311–79) shows for the Marinid reign during the second half of the eighth/fourteenth century, for instance, the celebration of the *mawlid* was instrumental in the legitimation of a ruler's power, serving at once to garner and project social and political cohesion and, hence, stability within his domain.[43] Or, as Katz declares in her history of the *mawlid*: 'Ultimately, the special status of the Prophet's birth date depended on a general belief that auspicious events occurred at auspicious times.'[44]

The *mawlid* celebration in the Alhambra of 764/1362 fits perfectly into the pattern connecting an auspicious religious time to an auspicious political event, as well as into the history of complex relations between al-Andalus and the Maghrib that brought more than models of religious ceremonies from North Africa to the Iberian Peninsula. Over the course of eight centuries the rise and fall of polities in al-Andalus were inextricably linked to Muslim rule in the Maghrib. During the last two centuries of the Nasrid period, the relationship with the Marinids was of special importance, as both dynasties, no less than the Christian kingdoms of Castile and Aragon, vied for control of the Strait of Gibraltar.[45] The political situation, including the relations between the Marinids and the Nasrids, oscillated between bellicose confrontations and mutually benefiting alliances, as sovereignty over coastal areas and major cities on both sides of the Mediterranean shifted through military conquest, territorial exchange or gifts from one ruler to another in recognition of aid in military campaigns.

Of most immediate importance for the political context of the *mawlid* celebration in the Alhambra is a series of events that began in the reign of Muḥammad V's father, Yūsuf I. Some time after 751/1350, while in alliance with Pedro I, king of Castile and

León (r. 1350–69), Yūsuf I antagonised the Marinid sultan Abū
ʿInān Fāris (r. 749–59/1348–58) by giving refuge in Granada to the
sultan's brothers, Abū Faḍl and Abū Sālim, potential pretenders
to the throne in Fez.[46] Muḥammad V, too, supported Pedro I in a
war against Pedro IV of Aragon in 760/1358, which was also the
year of the death of Abū ʿInān Fāris and the ascension of Abū Sālim
(r. 760–62/1359–61).[47] The following year, 760/1359, Muḥammad V
was dethroned in Granada by Ismāʿīl II (r. 760–1/1359–60), his
paternal half-brother, who was executed shortly afterwards by
Muḥammad VI (r. 761–2/1360–2), Ismāʿīl II's brother-in-law and the
real instigator of the coup.[48] It was Abū Sālim, the former refugee
in Granada and by then the ruling Marinid sultan, who now offered
asylum at his court to Muḥammad V, his family and courtiers. Ibn
al-Khaṭīb was among those who followed the sultan into exile. After
three years in exile at the Marinid court, this intricate and violent
story reaches its conclusion in 764/1362, when Muḥammad V
left Fez, gained victory over Muḥammad VI's troops in Ronda and
Casares with Pedro I's support, and returned victorious to Granada.
Pedro I promptly delivered the head of the usurper, whom he
had executed in Seville, to the reinstated sultan.[49] Nine months
later, Muḥammad V celebrated the *mawlid* in the Alhambra, an
auspicious time in the religious calendar to mark the auspicious
inauguration of his second reign.

There had been *mawālid* in Nasrid Granada previously. Historical
sources document celebrations hosted by prominent Ṣūfī figures
in their lodges, and they would have an important, continuing role
in the celebration of the *mawlid* until the end of the Nasrid period
and even beyond, among the Moriscos, after the Christian conquest
of Granada in 1492.[50] Poetic texts attest to celebrations at court, if
not concrete evidence of ceremonies in the Alhambra. Ibn al-Jayyāb
composed a panegyric or *qaṣīda sulṭāniyya*, preserved in his *dīwān*,
for a *mawlid* celebrated when Yūsuf I, not yet sixteen years of age,
was invested as the successor to the Nasrid throne in 733/1333.[51] It
has been suggested that two of the eight *mawlidiyyāt* included in
Ibn al-Khaṭīb's *dīwān* were composed for the celebrations that took
place in 734/1334 and in 736/1336 under Yūsuf I.[52] The absence of
accounts for the *mawālid* of 734/1334 and 736/1336, however, is
more easily explained by their having been ceremonies 'as usual'.
It is, then, only the *mawlid* celebration of 764/1362, marking the
politically significant event of Muḥammad V's successful battle to
re-take the Nasrid throne, for which a detailed account was made
part of the historical record. Muḥammad V and his court would
have recognised their victory as having been granted by God, hence,
the ceremony was tied to the calendar of religious observance; but it
was also a ceremony with the clear political purpose of legitimisa-
tion: both a pitch for social cohesion in support of the sultan, and the
construction of the social hierarchy of his reconstituted reign.

4

It is within the ceremonial tradition stretching from Fatimid Cairo and Begteginid Irbil across the Maghrib to al-Andalus up to the Nasrid period, and at the conspicuous political moment of his triumphant return to power, that Muḥammad V staged the celebration of the *mawlid* in the Alhambra, and that his vizier and companion-in-exile Ibn al-Khaṭīb recorded it in his eyewitness account. Ibn al-Khaṭīb relates that the guests were gathered in the two administrative courtyards, where countless candles were placed in crystal and copper candleholders around a pool (located in the courtyard renovated for the *mawlid* that stood immediately adjacent to the *mishwār*). The wax candles burned like 'a forest of lights, dazzling with its marvellous vision . . .' according to the author, who added that they 'caused astonishment and suspended thought'.[53] This emphasis on the illumination corresponds to the *mawālid* celebrated among the Marinids and elsewhere – and one needs to recall that both Muḥammad V and Ibn al-Khaṭīb were personally familiar with the *mawlid* celebration at the Marinid court during their exile.

Another characteristic feature of the tradition of *mawlid* celebrations – if anything, more ubiquitous and less remarked than the dazzling candle-lit illumination – was the display of luxury textiles. Ibn al-Khaṭīb is especially attentive to the furnishing of the *mishwār*:

> The entire floor of the High Qubba [*mishwār*] was covered with precious coverings (*farsh*), on which the royal throne (*arīka*) with coverings of splendour was elevated, in whose whiteness the signs of majesty and uniqueness appeared to be impressed. The floor of [other dependencies] of the *mishwār*, all of it, was covered with clean mats (*ḥuṣur*) and leather cushions (*anṭaʿ*). Marvellous (*bidāʾ*), fine (*laṭīf*) curtains (*astār*) were suspended from its walls.[54]

The description is reminiscent of the time when the *mishwār* and its courtyard were profusely embellished with textiles for *mawālid* at the court of the sultan Abū Ḥammū Mūsā II at Tlemcen, in 760/1359, 761/1360 and 769/1368, as recorded by Yaḥyā ibn Khaldūn.[55] The tradition would continue at the *mawlid* ceremony at the Saʿdīan court of Aḥmad al-Manṣūr, where, at the end of a candle-lit procession to the royal palace in Marrakesh, called al-Badīʿ: 'Silk carpets were spread out and pads lined up, covering the paving. [The rooms] were adorned with hanging veils, curtains and canopies all encrusted with gold. It was on each arch, every dome and all seats. The walls around were covered with hanging silk material outlined with patterns resembling flowers in a parterre.'[56] Al-Tamaghrūtī, who was Aḥmad al-Manṣūr's ambassador to the Ottoman court, and thus familiar with such splendour, spoke of al-Badīʿ as an 'amazing

palace'.[57] And, as noted, Ibn al-Khaṭīb begins his account by refer-
ring to the ceremonial precinct of the *mawlid* celebration in the
Alhambra as a 'sumptuous construction'. So it can hardly be that
luxury textiles in these and other *mawālid* were necessary to make
up for a deficit in architectural decoration. Indeed, Ibn al-Khaṭīb
draws attention to the craftsmanship in the *mishwār*'s decoration,
describing its walls embellished with tiles, epigraphy in gold and
lapis lazuli, and other designs, the hall's doors, as well as the marble
columns supporting its cupola (Figure 5.5).[58]

It is not the beauty of the textiles alone, therefore, that is the key
to their meaning – the walls they covered were already beautiful. But
while the walls would endure and represent the would-be permanence
of power, the portability of textiles lent itself to stagecraft. This role
for textiles, including the 'festive garb' of even the lower ranks in
attendance, who 'showed off their beautiful tunics',[59] is all the more
striking in the case of the *mawlid* in the Alhambra, since much of
the architecture of its setting was either built or renovated for the
celebration. It seems that ephemeral textile architecture was still
required to convey the sense of a ceremonial *occasion*. Ibn al-Khaṭīb's
repeated references to astonishment may serve as a gloss of the under-
lying aesthetic; for, as Ibn al-Haytham had suggested in his optics,
the process that leads to cognition begins with a perception strong
enough to stir the imagination, and in this respect, the ephemeral has
an advantage over the habitual, no matter how beautiful.

'Abd al-Raḥmān ibn Khaldūn remarked condescendingly that the
mawlid celebration in the Alhambra was 'an imitation of what the
rulers of the Maghrib do'.[60] Nevertheless, the very consistency of
the model, including the astonishing illumination and the abundant
luxury textiles, points towards another feature in the development
of the tradition that has attracted little attention, not only from
modern scholars, but from Ibn al-Khaṭīb himself. The simple fact of
multiple spaces in the ceremony implies movement to and through
the Alhambra. Ibn al-Khaṭīb generally omits description of that
movement, but he is explicit at one crucial point, when Muḥammad
V appeared on a throne set against the east wall of the *mishwār*. At
that moment, 'entrance was granted to the people, according to their
ranks', which is to say, that guests were then permitted to *proceed*
from the open space of the courtyard into the sultan's immediate
presence within the enclosed space of the audience hall.[61]

Having made their approach to the enthroned sultan, the par-
ticipants offered him greetings and received his greetings in return.
Then, after all had joined in prayer, they were ushered to their seats,
'in accordance with protocol'.[62] The ranks of the guests, carefully
identified by Ibn al-Khaṭīb, were distinguished according to their
relative proximity to the ruler: the tribal chieftains, the descend-
ants of the Prophet (*shurafā'*), the Nasrids' relatives and the people
of knowledge (*'ulamā'*) were given seats contiguous to the throne.

Next in order were seated the Ṣūfīs and ascetics (al-ṣūfiyaa wa-l-fuqarā'), members of foreign mystical brotherhoods and Christians who had come for the ceremony; and, finally, merchants, including travellers from the East and from North Africa, as well as notables from Granada, all occupying the space opposite and at a greater distance from the throne and closer to the hall's entrance on the west side.[63] The specification of the hierarchical seating order following the approach to the throne suggests a corresponding organisation of the procession of the second type outlined above, namely, an orderly movement of subjects towards a stationary ruler.

However thinly sketched by Ibn al-Khaṭīb, the procession that culminated in the reception by the enthroned sultan is central to the understanding of the *mawlid*, and, more generally, helps to open the analysis of the Alhambra to a spatial turn. Thinking of the agency of moving bodies giving meaning to the architecture that guides them, I offer two conjectures for a fuller understanding of Nasrid ceremonial space.

The first conjecture concerns a group of four large-scale Andalusī silk textiles dating to the eighth/fifteenth century, or late Nasrid period. The group includes two examples of two-panel curtains housed in the Cleveland Museum of Art (1982.16) and the Museum of Islamic Art in Doha, Qatar, and the two single-panel curtains preserved in the collections of the Metropolitan Museum of Art (52.20.14) and the Cooper Hewitt Museum (1902-1-962) (Figures 5.8 and 5.9), respectively. The overall decorative composition of all four examples and their colours – predominantly red for the ground and yellow for the design, with details in green, blue and white – are very similar. One major difference lies in the decoration of the main rectangular fields. In the Cleveland and Qatar textiles, the large, central rectangles are occupied by a polylobed medallion filled with foliations that radiate from an eight-pointed star in the centre. The medallion is framed by cartouches with the phrase, 'Dominion belongs to God alone'. In the analogous area of the single-panel examples, on the other hand, the decorative scheme is generated by the *lazo* of 8 pattern, in which the eight-pointed stars are clearly articulated, relating these two to the group of textiles exemplified by the Met textile (MMA 29.22) and the curtain in the Hispanic Society considered in the preceding chapter.[64] More generally, the affinities of the decorative motifs of all four of the large-scale textiles to the architectural decoration of the Alhambra have led scholars to believe that they originated in Granada.[65] But as in the case of MMA 29.22 textile and the curtain in the Hispanic Society, none of these four has been identified with a particular space in the Alhambra by either documentary or archaeological evidence, nor has a function been assigned to them in any context, including the *mawlid* ceremonial.

I would focus on the physical dimensions of the four textiles in the group, which measure as follows: the Cleveland textile, 4.38 × 2.72 m;

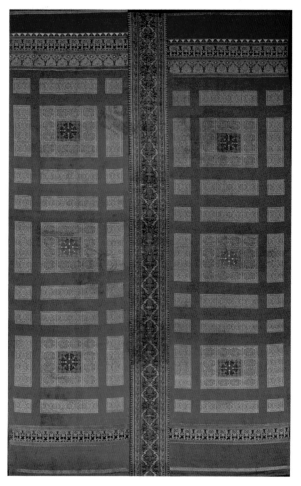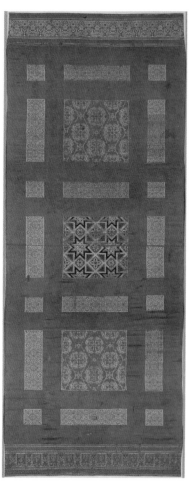

Figure 5.8 (left) *Curtain, silk, 4.38 × 2.72 m, Nasrid period, eighth/fourteenth century. The Cleveland Museum of Art (1982.16), Cleveland (photograph courtesy of the Cleveland Museum of Art)*

Figure 5.9 (right) *Curtain, silk, 3.05 × 1.21 m, Nasrid period, eighth/fourteenth century. The Metropolitan Museum of Art (52.20.14), New York (photograph courtesy of the Metropolitan Museum of Art)*

Qatar, 3.85 × 2.68 m; the single panel in the Metropolitan Museum of Art with both selvages preserved (indicating its original width on the loom), 3.05 × 1.21 m; and the Cooper Hewitt, 2.66 × 1.07 m. Their size and their delicate silk material preclude their use as coverings (whether for cushions and bolsters or floors), which leads to the conclusion that they were originally used as hangings. There is no need to make an uncorroborated claim that any of these four would have been among the 'marvellous, fine curtains . . . suspended from [the] walls' of the *mishwār* during the *mawlid* celebration; but they still offer extant evidence of a type of textile that would have served

an architectural function on that occasion – that is, textile architecture: static, but ephemeral.

Recollecting that the participants in the ceremonial arrived in that draped space in a procession supports a further elaboration of that conjecture. The dimensions of the Cleveland textile (4.38 × 2.72 m) are comparable to those of the wooden doors to the Hall of Two Sisters, measuring 4.72 m in height and 2.92 m in total width, which are among the few remaining original doors from the whole palatial complex (Figure 5.10).[66] Textiles like the double-panel silk in the Cleveland Museum would have been large enough to be hung as curtains in the doorways of the Alhambra. The supposition of a functional relationship between architectural elements (here, the doors) and textiles is strengthened by a certain visual affinity between them, such as that discussed in the case of the Façade of Comares in the previous chapter. Not only were the doors in the Alhambra originally polychromed – traces of pigment are especially well preserved on the doors to the Hall of Two Sisters[67] – and thus much like textiles in colour, but one also finds a distinct harmony in decorative composition. Visual harmony is neither exact replication nor measurable proportion, but rather a kind of coordination of forms such as one finds between the vertical division of the surface in the doors of the Hall of Two Sisters into squares framed by polygonal shapes and with an eight-pointed star in the centre, and the rectangular fields of the single-panel Metropolitan Museum and Cooper Hewitt textiles with their eight-pointed stars. Like wall hangings that harmonise with the decoration of the walls that they sometimes covered, curtains in doorways would have alluded to the doors for which they were substitutes in certain ceremonies. Whether or not this was the case for the main entrance of the *mishwār* on either the west side (according to López López and Orihuela Uzal) or the south side (according to Fernández-Puertas) on the occasion of the *mawlid*, the procession that led into that space points to the need, in that ceremony or other receptions in the Alhambra, to control both visual and physical access.

In the previous chapter, I raised this issue in the context of the approach to the throne in the Cuarto Dorado, and how that might have been regulated by textile architecture. The possibility that hangings like the Cleveland textile might have served as curtains over doorways can be substantiated by comparative material. As early as a court reception given in 376/986 by the Buyid prince Ṣamṣām al-Dawla (r. 373–88/983–98) in honour of visiting Byzantine dignitaries, Hilāl al-Ṣābi' recorded that in the profusely decorated royal residence, 'The elegant brocade was hung at the doors of all its rooms, courtyards, passageways and corridors.'[68] Fatimid court protocol included an office of the *ṣāḥib al-majlis* or *ṣāḥib al-sitr* ('master of the audience hall' or 'master of the curtain'), who was in charge of lifting and lowering the curtain in

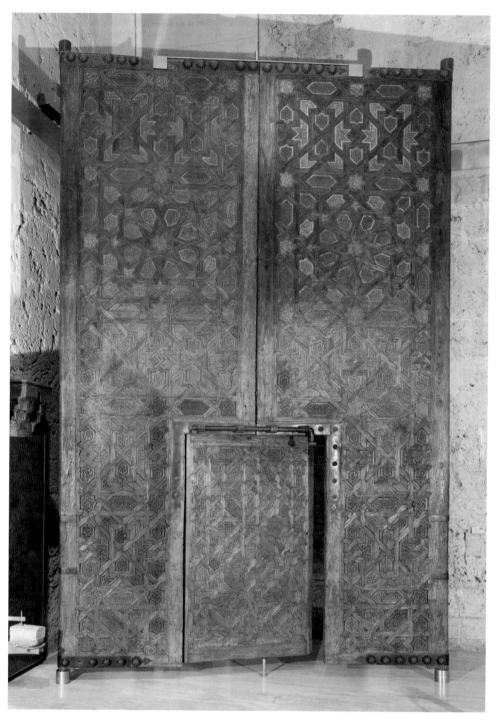

Figure 5.10 *Doors, Hall of Two Sisters, wood, 4.72 × 2.92 m, Nasrid period, eighth/ fourteenth century. Museo de la Alhambra (R. 10230_2), Granada (photograph: Museo de la Alhambra, Granada)*

the entryway.[69] The Mamluks, who followed many of the court rituals of the Fatimids, also instituted the office of curtain holder (*bardadārīya*) in their court.[70] In al-Andalus, the historian 'Īsā ibn Aḥmad al-Rāzī described the reception held by the Córdoban caliph al-Ḥakam II in the *qaṣr* of Córdoba in 360/971, in which the vizier and courtiers twice kissed a luxurious curtain hung on the doors of the audience hall before entering and presenting themselves before the enthroned ruler.[71] And years earlier, the ambassador of the Saxon king Otto I to the court of 'Abd al-Raḥmān III in Madīnat al-Zahrā' in 345/956, reported that the exterior of the doors to the audience hall was decorated with 'precious cloth and tapestries', and that the entire interior was 'completely covered with sumptuous textiles' in such a way that 'that they deceived the sight in distinguishing the walls from the floor'[72] – as though to transform the whole building into the textile architecture of a tent. In sum, precedents and parallels abound for the use of large-scale textiles in doorways in the Alhambra. These would have served to impose a pause in processions approaching the enthroned ruler, temporarily disrupting sight lines, the better to instil astonishment when this transitory textile was removed.

5

The use of poetic inscriptions to speak for the balance of dynamism and stasis in the threshold space of the Sala de la Barca in the implied, but undocumented, reception and procession leading to the Hall of Comares has been discussed. Supported by Ibn al-Khaṭīb's testimony of a procession in the *mawlid*, I now propose a second conjecture concerning thresholds. The construction or confirmation of social hierarchy, part of the consolidation of political power accomplished by ceremonial processions, suggests that the outer limit of ceremonial is precisely the site where a mass of subjects is re-assembled as a gathering ordered by rank. Ibn al-Khaṭīb describes a pressing throng in the courtyard before participants were 'granted entrance' to the *mishwār*, which represents their eagerness to gain access to the seat of power. The plan of the administrative area and the space of the *mishwār*, along with the dignity of the ceremony itself, suggest that the diverse groups of attendees would have been organised 'according to their rank' prior to approaching the enthroned sultan. Where, then, would the visual construction of the social hierarchy have begun?

There is evidence that the celebration of other canonical religious feasts during the reign of Yūsuf I – the *'īd al-fiṭr* (the Festival of Breaking the Fast, which marks the end of Ramadan) and the *'īd al-aḍḥā* (the Festival of the Sacrifice) – included performing musicians and dancers on the streets of Granada.[73] Ibn al-Khaṭīb makes no reference to the city beyond the Alhambra in his description of the

mawlid, but he does state that the notables of Granada were among those who entered the *mishwār* – and he himself had his villa in the Albayzín. They must have proceeded up the Sabīka hill to do so. Might they have assembled already according to their ranks in the city for a public display? The ceremonial model transmitted from the earliest celebrations of the *mawlid* combined the reception-type of procession with the *adventus*-type that staged power in open, often urban space. Consideration of the procession that led into the reception in the *mishwār* raises questions rarely addressed about the relationship between the city of Granada and the Alhambra. The questions point to a largely overlooked spatial crux in Ibn al-Khatīb's description and carry my conjectures back to the solid evidence of his testimony.

A procession from Granada to the Alhambra in the time of Muḥammad V, whether during the *mawlid* – if there was such a procession – or in any other court ceremony, such as the arrival of a foreign embassy, would have entered the palatial city by one of two approaches.[74] Both passed through monumental gates in the defensive curtain wall on the escarpment's west side. The *bāb al-silaḥ*, or so-called Puerta de las Armas, built during the reign of Ismā'īl I on the north side of the *qasaba* or fortress of the Alhambra, provided access on the northwest side of the enclosure (Figure 5.11). Jesús Bermúdez López suggests that during the Nasrid period a path to the west of the gate that links the Puerta de las Armas to the centre of Granada was used by city residents to reach the administrative area in order to address court officials about issues like taxation (Figures I.3: no. 13).[75] The other approach to the administrative area was from the southwesterly direction, entering the south side of the Alhambra enclosure through the *bāb al-sharī'a*, or the Gate of the Esplanade (misnamed Gate of Justice in the post-Nasrid period), built by Yūsuf I in 749/1348 (Figures I.3 and I.4: no. 22; and Figures 5.12 and 5.13), and continuing through the so-called Royal Gate, which is no longer standing.[76] In that case, the procession would have first traversed the *bāb al-khandaq* (Gate of the Ravine) that was embedded in the defensive wall connecting the original *al-qasaba* on the Sabīka hill with the pre-Nasrid defensive *hisn* or bastion, *al-Mawrūr*, now known as the Torres Bermejas, situated on the Mawrūr hill across a ravine (Figures I.3 and I.4: no. 3).[77] The Puerta de las Granadas (Gate of the Pomegranates), a triumphal arch erected by Charles V's architect Pedro Machuca in 1536, now stands at the site (Figures I.3 and I.4: no. 2; and Figure 5.14).[78] Since it is known that Charles V had gates constructed for his triumphal entries into Innsbruck, Schwaz and Tyrol in 1530, and Nuremberg in 1541,[79] the typological evidence suggests an imperial procession under Christian rule passing through the Puerta de las Granadas, which at least supports the feasibility of an *adventus*-type procession to the Alhambra along that southern route in Nasrid times.

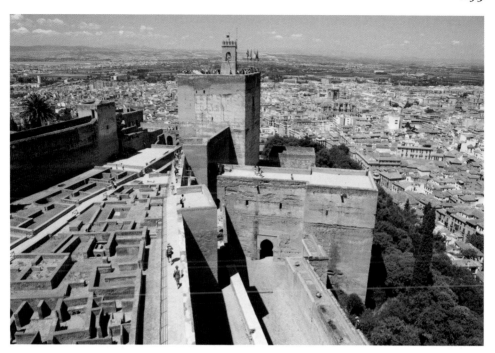

Figure 5.11 Al-qaṣaba *and the interior façade of the Puerta de las Armas, Alhambra (photograph: Olga Bush)*

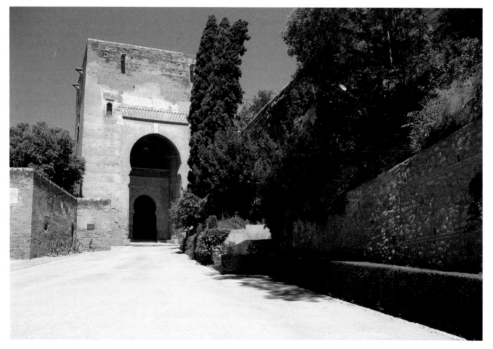

Figure 5.12 Bāb al-sharī'a, *exterior façade, Alhambra (photograph: Olga Bush)*

Figure 5.13 Bāb al-sharīʿa, *interior façade and street leading to the esplanade,* Alhambra *(photograph: Olga Bush)*

Figure 5.14 *Puerta de las Granadas, 1536, architect Pedro Machuca, Granada (photograph: Olga Bush)*

What can be said with certainty is that both paths – one through the Puerta de las Armas and the other the through the *bāb al-sharīʿa* – would lead processions to the Alhambra to the same open space, or esplanade, within the walls: the *wasṭ* of Ibn al-<u>Kh</u>aṭīb's account, now called the Plaza de los Aljibes, after water cisterns built there in 1494 (Figure 5.15). At the same time, the esplanade is also a terminal point for the two major arteries running east–west within the palatial city, now known as the Calle Real Alta and the Calle Real Baja.[80] The Camino de Ronda, or lower sentry walk, between the inner and outer walls of the enclosure, gives access to the esplanade on the north side as well. The esplanade, then, was a threshold for movement into and out of the administrative area, and it may also have served as a gathering place for prayers in the open air.[81]

The esplanade is a liminal space in another sense, too. Located between the royal *madīna* of the Alhambra to the east and *al-qaṣaba* to the west, it is a spatial link between the political power of the sultan and the military power that sustained – or threatened – him (Figures I.3 and I.4: no. 17; and Figures 5.15 and 5.16). For even if Muḥammad V had regained the throne through force of arms, it had been the Marinid family of the Banū Abi'l-ʿUlā, military chiefs

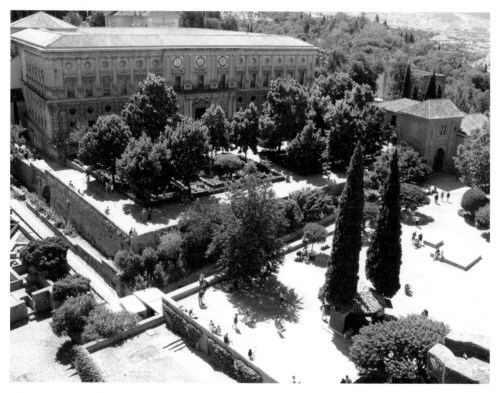

Figure 5.15 *Esplanade with the Palace of Charles V and Puerta del Vino to the east in the background, Alhambra (photograph: Olga Bush)*

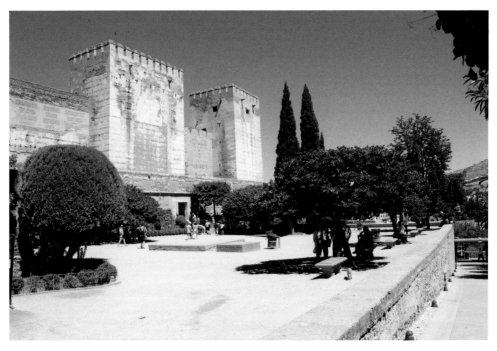

Figure 5.16 *Esplanade with the towers of* al-qaṣaba *to the west, Alhambra (photograph:* Olga Bush)

of an elite contingent of Berber troops serving the Nasrids, who had instigated the assassinations of Ismāʿīl I, and later his sons and heirs to the throne, Muḥammad IV (r. 725–33/1325–33) and Yūsuf I, in 733/1333 and 755/1354, respectively.[82] The Banū Abiʾl-ʿUlā remained in charge of the Berber contingent in Granada and the other key Nasrid cities of Málaga, Guadix and Ronda at the time of Muḥammad V's return to power. Only in 773/1373, a decade after the celebration of the *mawlid* in the Alhambra, did the sultan feel secure enough to remove them and take charge of those elite troops himself.[83]

It was on the *waṣṭ*, this open court or esplanade, just beneath the tall defensive tower of the *qaṣaba*, known today as the Torre de Homenaje, that Muḥammad V erected the royal tent for the *mawlid* celebration of 764/1362.[84] So the elite troops above in the *qaṣaba* had a front-row seat for the staging of power, and what they saw on display before them was a war trophy, as it were: the Nasrid dynastic tent recaptured in Muḥammad V's victorious return to the Alhambra, and, therefore, an overt visual claim to legitimacy.

Royal tents were among the most prominent and prized royal insignia throughout the medieval and early modern periods, whether made for a ruler, taken as booty in military campaigns, or exchanged as gifts to seal a political alliance or an economic treaty.[85] For

instance, ʿAbd al-Raḥmān ibn K̲h̲aldūn records that in 738/1338, in a mutual attempt to mend their relations, as well as to negotiate the control of the Strait of Gibraltar, the Mamluks and the Marinids made such an exchange of gifts, including large and ornate ceremonial tents (*madārib*, *masākin*), one of which was made of silk with poles of gilded silver inlaid with ebony and ivory. When the gifts were received at the Mamluk court, the tents were pitched and over three hundred additional textiles and other luxury goods from the Marinids were displayed within.[86] The Mamluks reciprocated with counter-gifts; among them, a silk pavilion (*ṣiwān*), square in plan, and two tents, made a special impression on Ibn K̲h̲aldūn. One tent made of silk and linen consisted of many structures – residential quarters and a kitchen, ceremonial *īwāns*, a mosque with a *miḥrab* and a minaret, towers for the guards and one for the sultan, from which he could view parades. A second, circular tent with a conical roof was attached to the first and served as a courtyard that could accommodate 500 horsemen. The Mamluk sultan sent along skilled craftsmen to erect what seemed like nothing less than a tensile palace. Ibn K̲h̲aldūn reports that it remained in people's memory for a long time, adding that when the embassy to Fez stopped along the way in Tunis, the tent complex was exhibited there for the Hafsid sultan.

There are ample textual sources for the use of such treasured, highly symbolic tents by early medieval Muslim dynasties, supplemented by manuscript paintings for later dynasties, including the Ilkhanids, Timurids, Safavids, Ottomans and Mughals.[87] Within al-Andalus, there are accounts from Umayyad Córdoba referring to royal pavilions and tents in the reigns of ʿAbd al-Raḥmān III (r. 299–350/912–61) and his son al-Ḥakam II (r. 350–65/961–76), employing varied terms yet to be clearly identified with respect to types, sizes and shapes.[88] Of particular interest for the *mawlid* ceremony in the Alhambra is ʿĪsā al-Rāzī's reference to a large open space in the Córdoba of al-Ḥakam II as *faḥṣ al-surādiq*, esplanade of the pavilion.[89] Janina M. Safran relates that in 360/971, Jaʿfar ibn ʿAlī, a former Fatimid governor of the city of Masīla, and his entourage were accommodated on that esplanade in fully-furnished tents before his entry into Córdoba in a ceremony of submission to the Umayyad caliph.[90]

Ibn al-K̲h̲aṭīb describes the Nasrid's 'famous tent' (*k̲h̲ibāʾ al-s̲h̲ahīr*), as one of the most impressive elements in the *mawlid* ceremonial.[91] The author mentions that the celebrated tent 'was known by its employment for various occasions by the previous rulers of the dynasty'.[92] It was of lofty proportions, raised by experts with formidable engineering skills, and was ample enough to accommodate 'a great mobilised army'.[93] The central upright or pole, 'unique in its beautiful form' and of great height, was extended even further by another pole surmounting it.[94] The panels for the tent, brought

by numerous beasts of burden and assembled with the aid of iron rings, were elaborately decorated with embroidery in the most vivid colours. Such was the embroidered foliage, the author says, that 'the most beautiful gardens transformed into brocade by rains' would pale in comparison.[95]

Unfortunately, Ibn al-Khaṭīb does not relate which ceremonial activities took place within the tent, but he does provide vivid details of its interior. He especially admired the long, narrow strips of cloth (ta'ābīn) that were rolled up and attached to posts; unrolled, they could reach the mattresses and leather cushions spread on the floor, some embroidered with silk and silver brocade. He points out that these strips also covered the slits in the walls of the tent that enabled air to circulate. When the wind blew into the pavilion, the strips would flutter in the air like 'potent dragons' (see Qur'ān, 7:106), further embellishing and animating the embroidered foliage of the panels.[96] The description of the ta'ābīn recalls verses that al-Mutanabbī, a poet whom Ibn al-Khaṭīb greatly esteemed, had dedicated to the princely pavilion of Sayf al-Dawla (r. 333–56/945–67), Hamdanid ruler of Aleppo and northern Syria, which he had seen on a visit to Antioch in 336/948. But where al-Mutanabbī likened the textile ornaments moving in the wind to running steeds and lions springing upon their prey,[97] Ibn al-Khaṭīb's Qur'ānic reference alludes to the story of Moses' staff transformed into a serpent as a sign to the Pharaoh that he is God's Messenger. The same note is extended in the conclusion of the passage, when Ibn al-Khaṭīb speaks of the tent as 'an instruction for the eyes' that will prove to be an 'enduring sign to challenge the passing of time', thereby emphasising the visual perception at the basis of revelation in the Qur'ānic passage: 'It is God who alternates the night and the day: verily in these things is an instructive example for those who have vision' (Qur'ān, 24:44).[98]

For Ibn al-Khaṭīb, a royal tent, very much like Moses' serpent, was a visual sign of legitimacy grounded in the Qur'ān. He draws upon the sūrah titled 'The Calamity' (Qur'ān, 56:30), when he speaks of the 'extended shade' of the tent on the esplanade as a traditional metaphor for the protection of the faithful.[99] Not only were Muslim rulers considered 'the Shadow of God on earth',[100] but, even more directly, during the first centuries of Islam, theologians held that the Umayyad caliphs were 'the tent pegs of our religion' and God's rope to mankind.[101] Suzanne Pinckney Stetkevych further observes that by the early fifth/eleventh century, the metaphor of dominion as a tent was a familiar poetic trope in the panegyrics composed for Muslim rulers.[102] She offers the following example, cited at the head of this chapter, from a qaṣīda written by Ibn Darrāj al-Qasṭalī in 403/1013 at another conjunction of auspicious time and event, the 'īd al-adḥā and the restoration of the Umayyad caliphate in Córdoba

by Sulaymān ibn al-Ḥakam ibn Sulaymān, a great-grandson of ʿAbd al-Raḥmān III:

> The days bear witness to you that you are their *ʿīd*:
> for you the desolate one yearned, to you the faraway returned
> . . .
> Until you rose to that station among ranks
> That makes the noble and the princely mighty
> in the domed tent of dominion whose ropes and pole
> Are the [Berber] tribes of Ṣanhājah and Zanātah.[103]

I will return shortly to poetic imagery and conventions as they were performed in the *mawlid* in the Alhambra.

As a sign of dominion, the tent on the esplanade may also be taken as an outer boundary of visual access to the ceremony (Figure 5.3). The roof of the tent was 'a magnificent crown', stretched high and wide, and it was topped with a finial (*jāmūr*) whose beauty and proportions surpassed that of the finials of famous mosques, according to Ibn al-Khaṭīb.[104] At that height, the tent would have been visible to the inhabitants of the neighbourhoods on the hills north and northeast of the Sabīka hill, including those of the Albayzín (Figure 5.17), at least during the days between the nightly celebrations. Thus, the broader populace, barred from visual access to the ceremonial taking place within the enclosed spaces (including the

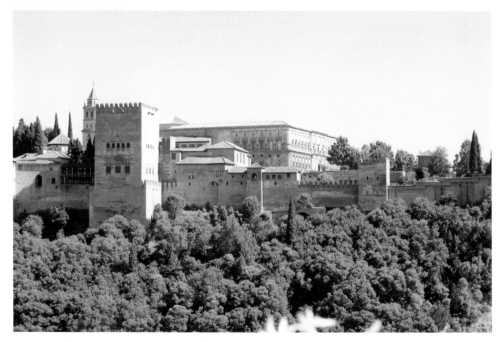

Figure 5.17 *Alhambra, seen from the Albayzín (photograph: Olga Bush)*

activities in the tent), would have seen this textile crown from the distance corresponding to their modest rank. As the esplanade was a doorway to the ceremony, the tent, aligned with the east–west axis connecting the *mishwār* and its two adjacent courtyards, was like a large-scale textile hung on that door.

The need to include the people in the visual regime of the ceremony, while still affirming the social hierarchy that limited their visual access to power, was met in a different way by the *bahw al-naṣr*, an architectural structure left largely unexamined in the context of the *mawlid*. Of its functions, Ibn al-Khaṭīb says only, 'In this pavilion the Sultan was found on the day of the event.'[105] García Gómez identified the unnamed sultan as Ismāʿīl II and took the passage as a reference to his assassination.[106] Since his spatial and concomitant historical contextualisation of Ibn al-Khaṭīb's account are in error, one may set aside this reading. I propose the more straightforward understanding that Ibn al-Khaṭīb here refers to Muḥammad V and to the occasion of the *mawlid* itself. In accordance, his only remark about the tower would indicate that the sultan occupied a place there at some unidentified moment during the unfolding of the ceremony. A typological comparison clarifies this.

The tower forms part of the curtain wall on the north side of the courtyard adjoining the *mishwār* (Figures 5.1 and 5.2: no. 11; and Figures 5.17 and 5.18). It was built during the reign of Yūsuf I, and,

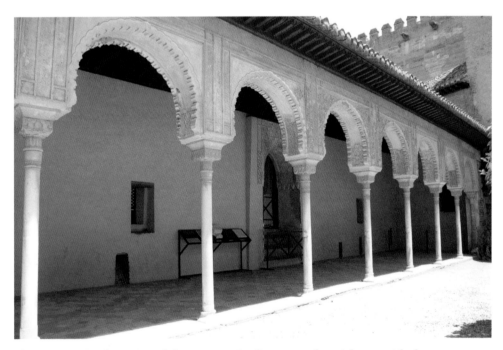

Figure 5.18 *North portico of the courtyard adjacent to the* mishwār *with the entry to the* bahw al-naṣr, *administrative area, Alhambra (photograph: Olga Bush)*

Figure 5.19 Bahw al-naṣr, *interior, administrative area, Alhambra (photograph: Olga Bush)*

as mentioned earlier, it was renovated under Muḥammad V for the *mawlid*. The tower is square in plan with two connecting, lateral corridors running along the curtain wall. The corridor on the west side links the tower's interior to another structure of the curtain wall, while the corridor on the east side links it to the small oratory of the *mishwār*.[107] The tower looks out over the River Darro and the neighbourhoods in its vicinity and across to the Albayzín through arched openings on three sides of the interior that were formerly enclosed with wooden lattice-work (Figure 5.19). Ibn al-Khaṭīb emphasises that 'this place is distinguished by the merits of its visibility and its well-favoured singularity'.[108] The tower also opens and is opened to clear sight lines.

One might recall the instances of the Fatimid caliph seated at the open window of the *manẓarat al-sakkara* in the related ceremony of the opening of the Nile canal, and the Begteginid ruler seated in the open window of the wooden tower in the celebration of the *mawlid* in Irbil. To these may be added the use of a *shubbāk*, a grilled window, or even a loggia,[109] in the context of Mamluk ceremonial. The renovated *bahw al-naṣr* may have had the same function in the *mawlid* in the Alhambra. Having arrived there from the *mishwār* through the oratory and the connecting corridor, the sultan would take his place in the tower for the sake of seeing and being seen by his subjects, much as in the temporary wooden towers

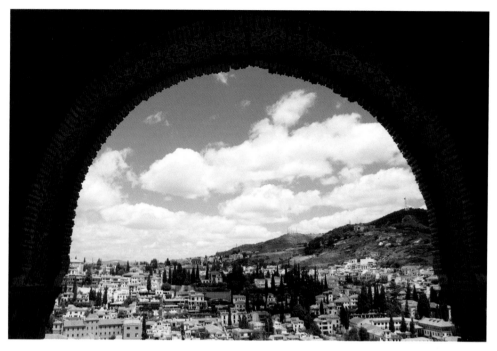

Figure 5.20 *View onto the city from the interior of the* bahw al-naṣr, *administrative area, Alhambra (photograph: Olga Bush)*

of Fatimid ceremonial and the other threshold spaces that developed in the tradition of the *mawlid*. Clearly visible from the privileged position of the guests gathered in courtyard of the *mishwār*, the sultan could look out at them in turn. At the same time, like the ruler at the *mawlid* in Irbil observing the populace from the window of the wooden tower constructed for the ceremony, Muḥammad V could also cast his gaze beyond the curtain wall of the Alhambra to the city and his subjects (Figure 5.20). Although from their point of view, he would be veiled behind the lattices, his presence in the tower would have sufficed as a source of blessings to his subjects. As in the case of the royal tent, then, the *bahw al-naṣr* would have been a visual sign for the population otherwise excluded from the *mawlid*, granting them indirect, visual access to the display of power – if not entry to the more immediate, enclosed spaces of the celebration (Figure 5.21).

6

The presence of the temporary royal tent standing amid the permanent architecture of the Alhambra is a fact to be reckoned with. The combination is consistent with the long tradition of *mawlid* celebrations, with the most notable parallel being found among the Mamluks some few decades later. At the court of al-Ẓāhir Barqūq

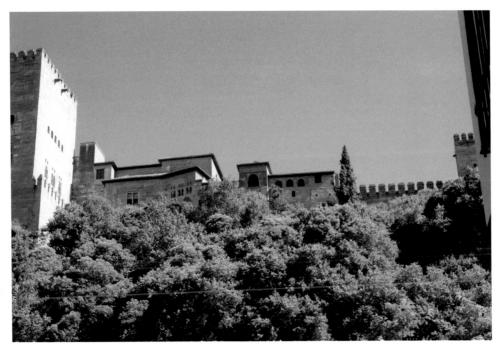

Figure 5.21 Bahw al-naṣr *(in the centre), as seen from the Albayzín from the embankment of the River Darro, Granada (photograph: Olga Bush)*

(r. 784–801/1382–99), the founder of the dynasty of Circassian Mamluks, the annual celebration of the *mawlid* included the main traditional elements: recitations of the Qur'ān followed by sermons; the distribution of money to religious dignitaries; gatherings of the members of the Ṣūfī orders; a banquet; and a gigantic royal tent in which the sultan was enthroned. Under al-Ẓāhir Barqūq, the royal tent was erected *within* the citadel in Cairo, on the open ground between the palaces.[110] The issue, therefore, is not the novelty of the ceremony in the Alhambra, but the meaning of the spatial design. It has been a fundamental argument of this book that in the highly cultivated literary society of the Nasrid court, poetry was a chief means of articulating the implied aesthetic foundations of the Alhambra and its ideological messages, thereby guiding the experience of the beholder from perception through imagination to cognition – to invoke the psychological dimension of Ibn al-Haytham's *Book of Optics* that has informed this whole study. This closing section, then, will examine some of the poetry recited at the banquet during the *mawlid* of 764/1362, and a single extant poetic inscription on the doors of the renovated *mishwār*. For at the *mawlid*, too, the rich sensory satisfactions – gustatory and olfactory as well as visual – that the participants experienced were only an initial, perceptual starting point in a process that led them to grasp the full meaning of the occasion. The relationship between

transience and permanence is a key to that understanding, whose most prominent visual emblem is the relationship of the royal tent to the standing architecture; but it is the poetry that gives that emblem voice.

García Gómez dismissed the poetry recited at the *mawlid* as little more than 'rhetorical exercises' with minimal poetic merit.[111] Here, as elsewhere, his critical judgement was based on an unexamined theory of poetry as mimesis that fitted his overall approach. He hoped to find literary imitations of the buildings that would help him to determine, for instance, the particular architectural spaces in which the various ceremonial activities took place. The employment of conventional poetic topoi make the descriptive elements of the poems, both those recited in the *mawlid* and those inscribed on the walls of the various precincts of the Alhambra, too generic to serve his purposes. It did not help his textual analysis, of course, that he was also looking for mimetic representations in all the wrong places: the *mawlid* did not take place, as García Gómez thought, in the precincts of the Palace of the Lions and neither the images in the poetry nor the prose of Ibn al-Khaṭīb's account could be expected to correspond to those precincts.

To cite but one example from Ibn al-Khaṭīb's 'Poems of the Hours' where it is self-evident that a literal meaning cannot be intended, one may look to the following praise of Muḥammad V: 'To the Muslim year you add a new celebration.'[112] All present would have been aware of the long tradition of *mawlid* celebrations outlined above, including, of course, Ibn al-Khaṭīb himself and the sultan whom he addresses, since they had witnessed the corresponding Marinid court ceremonies during their exile. The figurative language of poetry does not reproduce reality, but transforms it. The trope in force in this verse is hyperbole – usually understood as exaggeration, often with comic effect, but here more like exaltation – which gives the characteristic panegyric tone to the poetry of the *mawlid*. The particular hyperbolic claim – that an old ritual is new and, therefore, that Muḥammad V was an innovator and the *mawlid* celebration in the Alhambra a point of origin – is also characteristic of the ceremony and its poetic articulation.

Recourse to the theoretical frame of Nora's concept of *lieux de mémoire*, or sites of memory, will help to illuminate the point.[113] Nora outlines an antagonistic relationship between memory and history, the former being spontaneous and unself-conscious, collective and geared towards continuity, and the latter self-willed and organised as a series of ruptures. Memory supports social cohesion by preserving the continuity of tradition. History takes over when social cohesion breaks down, fracturing traditional collective memories. The *lieux de mémoire* mediate between memory and history. They are the *places* where memory persists in a historical age: 'Memory attaches itself to sites, whereas history attaches itself

to events.'[114] As a 'mixed, hybrid, mutant' formation,[115] the *lieux de mémoire* are those sites at which historical events are transformed into collective memories. As an occasion that is at once a traditional, religious celebration and a historical marker of a political moment, the *mawlid* in the Alhambra is such a hybrid. Furthermore, the *mawlid-in-the-Alhambra* (not the Alhambra itself nor the *mawlid* itself) constitutes a *lieu de mémoire*. The spatial hybrid or mixed architectural form of tent-and-palace, joined as one by the procession, could be seen as an emblem of that site of memory.

It may be that all events – historical turning points, large and small – are memorable to someone, by definition, but not all events enter collective memory. For Nora, the crucial question is what would make certain events memorable and their commemoration traditional. His answer touches directly upon Ibn al-Khaṭīb's hyperbole:

> As for 'great events', only two types are especially pertinent, and not in any way as a function of their 'greatness'. On the one hand, there are those minuscule events, barely remarked at the time, on which posterity retrospectively confers the greatness of origins, the solemnity of inaugural ruptures. On the other hand, there are those non-events that are immediately charged with heavy symbolic meaning and that, at the moment of their occurrence, seem like anticipated commemorations of themselves . . .[116]

The birth of the Prophet, barely remarked at the time, but later seen as an inaugural moment for the formation of Islam, would be an example of the first type. The commemoration of the birth of the Prophet at the Alhambra is a *non-event* (in contrast to the military victories that changed the political situation in Granada). The ceremonial of the *mawlid*, including the poetry that proclaims the celebration to be new, anticipates a future in which the historical event of Muḥammad V's return to the Nasrid throne will appear to have been an inauguration that has taken its place in the memory of the people.

The traditional celebration of the *mawlid* may have been a collective and ahistorical continuation in which the participants are no less followers of the Prophet than his original Companions. The transformation of the 764/1362 *mawlid* from a spontaneous memory to a site of memory required the self-conscious articulation of the poetry on the occasion. The further step from a site of memory into history is subsequently taken when Ibn al-Khaṭīb writes his prose account.

Ibn al-Khaṭīb makes clear that poetic recitation formed an integral part of the banquets during the *mawlid*, if not to say their main dish. He contributed a *mawlidiyya*, a *qaṣīda* and eleven 'Poems of the Hours', to use García Gómez' commonly accepted designation,

all composed expressly for the *mawlid*. He also recorded the names of twenty-three other poets whose *qaṣāʾid* were recited, and he included eighteen of the compositions in his account, among them those by ʿAbd al-Raḥmān ibn Khaldūn and Ibn Zamrak.[117] A *musmiʿ* was employed, that is, a professional singer, who recited verses 'with perfection' and elicited 'emotions'.[118] The engagement of a *musmiʿ* was a common practice,[119] but the fact that on this occasion he was a native of Mosul particularly enhanced the prestige of the performance.

It lies beyond the scope of the present study to provide a comprehensive literary examination of such a large body of poetry, especially since it is not my purpose in this book to assess the texts as an independent artistic medium.[120] The discussion here will concentrate almost exclusively on Ibn al-Khaṭīb's 'Poems of the Hours', and on the way that his figurative language creates a *lieu de mémoire* as a hybrid site of the temporary and the permanent, visualised in the conjunction of tent and palace. Key questions include: what does the occasion of the *mawlid* in the Alhambra inaugurate? What is enduring in what is new? The answers lie in Ibn al-Khaṭīb's integration of aesthetics and politics.

The 'Poems of the Hours' had a noteworthy mode of delivery at the *mawlid*. Festivities began in the evening and ended at dawn. Each night the celebration was punctuated by the announcement of the hours by the sound of a small stone falling on the plate of an automated clock, at which moment a piece of paper with a poem written on it was retrieved from a niche on the clock, and the poem was recited.[121] Each poem announced the hour in its first verse, and thus functioned as a verbal counterpart to the mechanism of the clock, setting the rhythm and order in the unfolding of the ceremonial for each night and, in more than one sense, 'telling' the time.

Clock automata had a long history in the medieval Muslim courts of the Mediterranean, including al-Andalus, and were a widespread phenomenon by the eighth/fourteenth century.[122] Yaḥyā ibn Khaldūn included a description of the mechanism of a chronometer used in the *mawālid* at the Wadid court in Tlemcen in 760/1359 and 761/1360, for instance, as well as the texts of the 'Poems of the Hours' recited there.[123] Yet even if in this regard the Nasrid *mawlid* ceremony was 'as usual', the rock-and-plate chronometer in the Alhambra, made of wood with richly polychromed decoration and measuring approximately 1.65 m in height, was a significant visual ornament in itself.[124] Ibn al-Khaṭīb expresses his praise for the device in a textile metaphor, declaring that the clock was 'a *ṭirāz* band on the vestment of a splendid banquet'.[125] As discussed previously, a *ṭirāz* is a band inscribed, sometimes with poetry, whether on architecture, textiles or other luxury objects. Ibn al-Khaṭīb's canny metaphor, therefore, not only resonates with the abundant use of textile decoration at the *mawlid* and to the pleasures of the meal, but also

alludes to the poems that appeared in the niches of the clock – a condensed summary of the multi-sensory and inter-medial experience integrated by the aesthetics of the ceremonial.

Ibn al-Khaṭīb relates that his own 'Poems of the Hours' were delivered from the clock and recited on the first night of the celebration. If not *qaṣāʾid*, that is, in the form of the panegyric ode proper in Arabic poetry that glorifies the ruler through praise for his military exploits, religious adherence, patronage of the arts, personal virtues or all of the above, the 'Poems of the Hours' are nonetheless panegyric in tone.[126] Composed as a coherent poetic programme for the night, they are replete with praise of the ruler expressed in a series of conventional images associated with royalty (e.g., 'proud lion').[127] As argued throughout this book, disparagement of poetic tropes for lack of originality ('rhetorical exercises') is an anachronistic application of the canons of Western modernity, in fact, the same mentality that Nora presents as historical consciousness. Ibn al-Khaṭīb's poetic topoi seek and produce precisely the opposite effect: they represent Muḥammad V within the recognisable literary tradition. Indeed, in the face of the palpable political change wrought by Muḥammad V's defeat of his rival and return to power, the purpose of the panegyric poems in the ceremony – *and of the* mawlid *ceremonial as a whole –* was to reassert the claims of collective memory, beyond the unstable rises and falls of history, while at the same time, acknowledging the historical event.

Stetkevych captures the memory-work of panegyric poetry in general when she speaks of its 'archetypal and mythopoetic' mode as 'a vehicle or means of transforming or commemorating [an] event so that it becomes permanently valid and validating'.[128] That transformation is figurative – in the historical world, nothing is literally permanent – and achieved not in spite of, but precisely through the unchanging quality of conventional images. Finbarr Barry Flood has shown that the employment of the clock automata at the medieval Muslim courts 'reveals something of the conceptual and ideological links between medieval monarchy, cosmology, and horology'.[129] Ibn al-Khaṭīb's 'Poems of the Hours' give voice to those links through traditional astral imagery. In the tenth poem, for instance, he praises Muḥammad V with these connected metaphors: 'full moon by the caliphate's halo/ radiant sun by the glory's orbit'.[130] The heavenly bodies endure, and so do their corresponding poetic tropes; what is new, however, is the figurative transformation of the sultan into a caliph, the *khalīfa* who 'shored up the kingdom', in the words of the fourth poem.[131]

Hyperbole is at work once again in the use of the caliphal title. At most, in political terms, the *mawlid* legitimised Muḥammad V's rule over the small kingdom of Granada, very much diminished from al-Andalus of the Córdoban caliphate. No one present at the *mawlid* would have recognised Muḥammad V as the head of the Muslim

'umma, or worldwide community, but neither would they have been surprised by what had come to be a Nasrid tradition. Rubiera Mata has proposed that the caliphal title had first been employed among the Nasrids by Ismā'īl I (r. 713–25/1314–25), who founded *al-dawla al-Ismā'īliyya al-Naṣriyya*, the second Nasrid dynasty, by wresting the throne from Sultan Naṣr (r. 708–13/1309–14), the last ruler in the direct line of descendants of Muḥammad I, the founder of the first Nasrid dynasty.[132] Needing to legitimise his sovereignty, Ismā'īl I not only adopted the caliphal title, but also a supporting genealogy that made him a descendant of Sa'd b. 'Ubāda, lord of the tribe of Khazraj and one of the Companions of the Prophet (*Anṣār*), who was appointed by his fellow Companions to the caliphacy after the Prophet's death in 9/632 – an appointment that was thwarted.[133] Fierro has pointed to a conflation of the term *Anṣār* in its use as a tribal designation and in its broader understanding as a 'religious *nisba* or appellation' as helpers of God and the Prophet that enabled the Nasrids to augment their standing by way of their claim to descent from the Khazraj tribe.[134] Bárbara Boloix-Gallardo develops that argument further when she states that an examination of historical texts gives 'strong reason to doubt the authenticity of [the Nasrids'] far-fetched family origin'.[135] Three Nasrid viziers and court poets articulated the legitimising genealogy and extended to their rulers the related caliphal title: Ibn al-Jayyāb, who served under Ismā'īl I and later his heirs, Yūsuf I and then Muḥammad V; Ibn al-Khaṭīb, his pupil and successor in the chancery; and, finally, Ibn Zamrak, Ibn al-Khaṭīb's pupil. But in the light of the research of Fierro, Rubiera Mata and Boloix-Gallardo, the writing of the Nasrid genealogy in historical and poetic texts 'appears to be a calculated strategy of fabricated legitimacy'.[136]

One of the earliest expressions of that strategy was a poem composed by Ibn al-Jayyāb and inscribed in Ismā'īl I's palace of *Generalife*, in which the ruler is referred to as a caliph.[137] Rubiera Mata argues that in the case of Yūsuf I, the caliphal claim was initially limited to restricted settings.[138] She observes, for instance, that the site of Yūsuf I's public receptions, the Hall of Comares, is called the *kursī al-mulk* or the throne of the *kingdom* (i.e., not caliphate) in the inscriptions over its central niche. In contrast, Yūsuf I is called caliph in a poetic inscription by Ibn al-Jayyāb in his private tower-palace, the *Qalahurra* of Yūsuf I, examined in Chapter 3. However, she also cites two instances that addressed a wider audience. In the first, Ibn al-Khaṭīb proclaimed Muḥammad V as the successor to the Nasrid throne, referring to Yūsuf I as caliph, and to his heir as an *amīr*. In the tradition of al-Andalus as established by the Umayyads of Córdoba, Rubiera Mata notes, an *amīr* could take a caliphal title after impressive military victories in defence of Islam. The second instance of a more public expression of Yūsuf I's caliphal aspirations was a poetic inscription for a curtain that Rubiera Mata believes was intended to be employed in the Hall of Comares, and

therefore presented to beholders beyond the limited numbers that would have entered the *Qalahurra* of Yūsuf I. The curtain speaks for itself in the first-person voice of prosopopoeia, proclaiming: 'I am a curtain [or veil, *ḥijāb*] that falls over the *imām* that is the shade that extends over men . . .'[139] Rubiera Mata includes the example in her study of the use of the caliphal title, because the religious office of the *imām* is associated with the caliph. In this verse, as in the examples considered earlier, the metaphor linking the ruler and his subjects by means of textiles – a curtain or a tent – highlights the Qur'ānic image of the extended shade.

Both the title of *imām* and the tent metaphor also appear in a poetic inscription that has been preserved in the architectural decoration of the *mishwār* in the Alhambra. The following verses by an unidentified poet appear on the wooden frieze over the door in the south wall, which Fernández-Puertas considered to be the entrance renovated specifically for the *mawlid* celebration of 764/1362 (Figure 5.22):

> Oh mansion of the exalted kingdom
> that harbours an astonishing architectural form.
> You were opened for resounding victory
> And for the beauty of art and of the skilled artist.
> Work of the *imām* Muḥammad.
> May the shadow of God extend over all.[140]

Figure 5.22 *Wooden frieze with an epigraphic poem,* mishwār, *exterior, Alhambra (photograph: Olga Bush)*

The use of the poem as an inscription on an architectural element relates the now familiar Qur'ānic image of the concluding verse to the hall on which it appears. The *mishwār*, and by extension, the Alhambra as a whole, fulfils the sheltering function of God's shade, supporting Muḥammad V's claim to the religious role of *imām*.

The question of whether that doorway in the south wall was the main entry to the *mishwār*, renovated for that purpose for the *mawlid*, as Fernández-Puertas maintains, has an important bearing on Rubiera Mata's argument. If the procession of the varied ranks of his subjects approached the enthroned ruler through a door in the west wall, as López López and Orihuela Uzal argue, then the doorway with its frieze on the south wall would have been subsidiary. In that case, the inscription would have been reserved for a more restricted audience, at least during the *mawlid*. One way or the other, once inside the hall, the participants would have encountered another poem, composed by Ibn al-Khaṭīb. The poem was inscribed in a stucco band above the dadoes of the ceramic tile mosaics and so would have been perfectly legible for all those seated on the cushions on the floor. The inscription disappeared during post-Nasrid alterations of the *mishwār*, but the text of the poem has been preserved in Ibn al-Khaṭīb's *dīwān*.[141] It is panegyric in nature, enumerating Muḥammad V's virtues and his military victories, without going to the extent of enunciating caliphal aspirations, whether under the title of *khalīfa* or *imām*. Instead, the poetry speaks for the architectural space as the most vivid embodiment of the ruler's highest ambitions. The trope of prosopopoeia enables the architecture to make its own claims:

> It is as if, of all the royal buildings,
> I were the eye and my lord the pupil of it.[142]

The ideological message was fully monumentalised only some years later, after historical events appeared to confirm the announcement of a new and more expansive Nasrid era. Following Muḥammad V's military campaigns in Jaén, Úbeda and Baeza from September to November 769/1367, Ibn Zamrak uses the *laqab*, or honorific title *al-ghanī bi-llāh* in the poetic inscription on the Façade of Comares, as has been seen in the preceding chapter. The title of caliph, moreover, is given a more public and permanent expression in his verses inscribed on the entrance arch of the Sala de la Barca, and in the Mirador de Lindaraja and on the Fountain of the Lindaraja, both in the Palace of the Lions, in which the Alhambra figures as *kursī al-khilāfa* or throne of the caliphate.[143]

The related inscriptions in the north gallery of the Patio of Comares tell a further story. Here the epigraphy contains verses from a *qaṣīda* composed by Ibn Zamrak for the *mawlid* of 764/1362 and other verses drawn from his *qaṣīda* dedicated to Muḥammad V's victory in Algeciras in 771/1369.[144] Neither of the poetic excerpts

refers to the sultan as a caliph. According to Ibn al-Khaṭīb's *Iḥāṭa*, the later *qaṣīda* was also recited during a *mawlid* celebration in the Alhambra that took place after '[Muḥammad V] finished the famous works on his doorway'[145] – presumably referring to the Façade of Comares, which was inaugurated in 772/1370. There is no other record of that second *mawlid* celebration in the Alhambra, but Ibn al-Khaṭīb's remark gives evidence that while the subsequent inscriptions in the Patio of Comares mark two different historical *events*, they are joined in recollecting the same ceremonial tradition. Thus, the *occasion* of the *mawlid* celebration of 764/1362 had indeed proved to be an anticipated commemoration of itself.

Muḥammad V's second reign was long, but his claims to the caliphacy proved a poetic exaggeration that foundered on the rock of history. In Nora's conception, history is always in the ascendancy at *lieux de mémoire*, which are the sites of a rear-guard action by memory to assert a note of continuity in a world that already conceives of itself as the result of change. Ibn al-Khaṭīb spins a slender thread in the first of the 'Poems of the Hours' when he links Muḥammad V to the beginnings of Islam by dint of being a namesake of the Prophet:

> Ibn Naṣr, name you carry of the Prophet!
> For you God predestined glory.
> If you have engaged in combat, the victory
> of God sets itself in motion.
> With the brilliance of the Truth souls remove their veils (*ḥijāb*)
> and disrobe.[146]

The poet reinforces the sense of continuity in the collective memory of those present by laying the genealogical claim connecting Muḥammad V to the Khazraj and the *Anṣār* in the eighth poem.[147] As has already been seen, this claim was a deliberate fabrication. The purpose of the poetry, however, is not history, but the creation of a *lieu de mémoire*, a site of continuity that makes the present a participant in an unchanging past. The purpose is met still more fundamentally by Ibn al-Khaṭīb's representation of the theme of military victory as an act of divine providence throughout the 'Poems of the Hours', casting the historical events of Muḥammad V's rise, fall and rise again as a revelation of divine light and purpose.[148]

Yet, if Muḥammad V is a 'beacon of Truth' in the eyes of his panegyrist in the ninth 'Poem of the Hours', the candles that illuminated the procession and banquet were not eternal flames: rather, 'The wax poured forth tears.'[149] The temporal unfolding of the ceremony itself, including the recitation of the 'Poems of the Hours', speaks for passing time. In the hybrid formulation of the *lieu de mémoire*, that mournful note is a consistent counterpoint to the praise of Muḥammad V.

Whereas the ruler extends his shade, like a tent, gathering his subjects in a religious and political unity, the power of time is

represented in Ibn al-Khaṭīb's second poem of 'Poems of the Hours' as separation: 'Time always separates those united.'[150] As the cycle of hours in the nightly celebration proceeds towards dawn, a leave-taking is in the offing. The literal separation threatens a final defeat of figurative language and with it, a final victory for history and change over memory and continuity. The poet would offer that lesson to his ruler, whom he addresses directly in his own voice – as *I* speaking to *you* – in most of the 'Poems of the Hours'. Who better to teach the lesson of the fall into history than Time itself? In two of the poems, Ibn al-Khaṭīb employs the trope of prosopopoeia, placing the first-person voice in the mouth of Time, who knows that the political world is where 'pacts are broken that were thought to be firm'.[151] But in the memory site of the *mawlid* ceremonial, figurative language can still speak for unending allegiance, and the trope of prosopopoeia can still enact the unity of relationship. Thus, Ibn al-Khaṭīb concludes his 'Poems of the Hours' by referring once again to Muḥammad V as *imām* in the eleventh and final poem,[152] and his prose account declares the achievement of that political cohesion by stating that at the moment of departing all those present spoke 'in one voice'.[153] They all agreed that in all of its multi-sensory elements, the ceremony had been unprecedented and that 'the like would never be seen again, nor surpassed'.[154] And yet it would be remembered. Under the sultan's aggrandised political power, the meaning of the *mawlid* transformed the ephemeral historical event into an enduring collective memory site.

Conclusion

The olfactory and gustatory delights recorded in Ibn al-Khaṭīb's account in abundance remain to be explored, not to mention much more poetry and many other details of architectural decoration, religious observance and ceremonial practice. Further studies are needed. My purpose here has been to bring together the various approaches developed in the preceding chapters in a study that integrates the political and aesthetic dimensions of this single documented occasion in the Alhambra, as they were conceived and practised in the inter-medial design of the *mawlid*. For the many, diverse and valuable approaches to the subject have all too often given us a disaggregated ceremonial; and, more broadly, studies of the Alhambra have been fragmented into disciplinary divisions, whereas the experience of those who moved through and paused in its precincts in Nasrid times must have been whole. Architecture was decorated with and even conceived as textiles; textiles could serve architectural purposes; and poetry spoke for the integrated aesthetics in a figurative language that guided the beholder by way of the imagination through the trajectory from an initial, some-times overwhelming perception to a new understanding of the built

environment as a political construct. Attention to a wider scope of materials and modes shows that the evidence is richer than we have often believed for recognising the Alhambra as a living environment in Nasrid times and, indeed, for our own, where it continues to be a site at the intersection of historical knowledge and contested collective memories.

Notes

1. Suzanne Pinckney Stetkevych, *The Poetics of Islamic Legitimacy. Myth, Gender, and Ceremony in the Classical Arabic Ode* (Bloomington: Indiana University Press, 2002), p. 274.

2. Fernández-Puertas clarifies that three manuscripts of *Nufāḍat*, part III have been preserved: a complete manuscript in the General Library of Rabat (n. 256K) and two incomplete manuscripts, one in the Royal Library of Rabat (n. 6.593) and the other in the library of the University of Leiden. See Antonio Fernández-Puertas, 'El *Mawlid* de 764/1362 de la Alhambra según el manuscrito de Leiden y la *Nufāda III* editada', in Celia del Moral and Fernando Velázquez Bazanta (eds), *Ibn al-Jaṭīb y su tiempo* (Granada: Universidad de Granada, 2012), pp. 161–203. He also provides a translation of the Leiden manuscript and a valuable glossary of Arabic terms for architecture and furnishings that appear in the text. For an edition and study of the complete Rabat manuscript, see Saʿadiyyah Fāghiyyah (ed.), *Lisān al-Dīn Ibn al-Khaṭīb, Nufāḍat al-jirāb fī ʿulālat al-igtirāb* (Casablanca, Maṭbaʾa al-Najāḥ al-Jadīda, 1989).

3. García Gómez published his edition of the Arabic text, based on the incomplete Leiden manuscript, along with his own translation into Spanish and his analysis in *Foco de antigua luz*. I follow recent scholarship in referring throughout to Ibn al-Khaṭīb's text in García Gómez' *Foco de antigua luz*; see, for example, Cynthia Robinson and Amalia Zomeño, 'On Muḥammad V, Ibn al-Khaṭīb and Sufism', in Amira K. Bennison (ed.), *The Articulation of Power in Medieval Iberia and the Maghrib* (Oxford: Oxford University Press, 2014), pp. 153–74. Henceforth, I cite Ibn al-Khaṭīb's *Nufāḍa III* according to the page numbers of the Arabic text and García Gómez' Spanish translation in *Foco de antigua luz*.

4. Ibn al-Khaṭīb, *Nufāḍa III* in García Gómez, *Foco de antigua luz*, Arabic text, p. 123; Spanish translation, p. 142.

5. García Gómez, *Foco de antigua luz*, pp. 58–81. His related proposal – likewise now generally rejected – that the Façade of Comares was originally located at the south entrance to the Patio of Comares and then moved to its present position as the south wall of the Cuarto Dorado, was discussed above in Chapter 4. The point of departure for modern, archaeologically informed study of the Alhambra is the work of Torres Balbás. See Chapter 1, n. 9.

6. López López and Orihuela Uzal, 'Una nueva interpretación del texto de Ibn al-Jaṭīb'. To avoid confusion, I note that López López and Orihuela Uzal include the Façade of Comares on their plan (not identified by a number), but it was not erected until at least 1367, which is to say, well after the celebration of the *mawlid* in the Alhambra under discussion here.

7. Antonio Fernández-Puertas, 'El Arte', in María Jesús Viguera Molins (ed.), *Historia de España Menéndez Pidal, vol. 8: 4, El reino nazarí de Granada (1232–1492). Sociedad, vida y cultura* (Madrid: Espasa-Calpe, 2000), plan, 199; discussion, pp. 237–42. Fernández-Puertas' excavations in the northern sector of the *mishwār*, which was originally a small patio (Figure 5.1: no. 5), have also contributed much to the understanding of the administrative area. See Antonio Fernández-Puertas, 'Memoria de la excavación realizada en el sector N. del mexuar del Palacio de Comares', *Cuadernos de la Alhambra* 18 (1982): 231–8.

8. Fernández-Puertas, 'El Arte'.

9. Despite its date, López López and Orihuela Uzal consider valid the description by Domingo Badía (also known as Alí Bey) of the administrative area and *mishwār* in the royal palace in Fez; he visited Fez in 1803. See Domingo Badía (Alí Bey), *Viajes por Marruecos*, ed. Salvador Barberá (Madrid: Editora Nacional, 1984), p. 207.

10. Joseph Maran, 'Architecture, Power and Social Practice – An Introduction', in Joseph Maran, Carsten Juwig, Hermann Schwengel and Ulrich Thaler (eds), *Constructing Power. Architecture, Ideology and Social Practice* (Berlin: LIT Verlag, 2009), p. 10, as well as the bibliographical references on the spatial turn in the Introduction, n. 9, above.

11. I will address specific studies in the course of the chapter, but take a moment here to correct a misapprehension of my own previous work. In an essay bringing valuable attention to the role of the Ṣūfī brotherhoods in the *mawlid* of 764/1362 and more particularly, the ways in which the celebration sought to reinforce their place within the political tensions at the Nasrid court, Cynthia Robinson and Amalia Zomeño discuss the poetic recitations from that point of view. They make reference to my 2006 doctoral dissertation, affirming my emphasis on textiles and my understanding of the role of the tower in the *mawlid*; on the other hand, they take issue with what they see as the 'secularising undertone' of my analysis, an approach 'that has plagued scholarship concerned with the Alhambra since its very earliest days' ('On Muḥammad V', p. 168). I will address that point briefly at the outset of the next section of this chapter, attentive to their alternative approach, while retaining my own focus. But they also assert that '[Bush] rejects Ibn al-Khaṭīb's "Poems of the Hours" – verses which were actually composed for and recited on the occasion in question – as compositions of little importance, full of "commonplaces" and "clichés" . . .' ('On Muḥammad V', p. 169). I did make note of the use of poetic topoi, much as Robinson and Zomeño themselves do when they recognise that 'The majority of the motifs, tropes, metaphors and comparisons employed by poets charged with composing verse in honor of Muḥammad V's *mawlid* celebration, of course, have a long tradition . . . in Arabic poetry' ('On Muḥammad V', p. 170) – and Ibn al-Khaṭīb was among those poets. More importantly, however, in claiming that I reject the importance of Ibn al-Khaṭīb's 'Poems of the Hours' (in fact, discussed at length in the dissertation, see Bush, 'Architecture, Poetic Texts and Textiles', pp. 367–77), or that of any poetry associated with the Alhambra, is to mistakenly attribute to me the attitude that I cite – in order to dispute – in the prior approach of García Gómez: 'I note that García

Gómez thought that the majority of the poems were little more than "rhetorical exercises" written for the occasion with minimal poetic merit [see García Gómez, *Foco de antigua luz*, p. 108] . . . Here, too, *I would contest García Gómez*, not in terms of aesthetic quality – an issue proper to the field of literary criticism – but rather in asserting that the poetic production at the *mawlid* alerts the reader to aspects of the social function of the architectural space' (Bush, 'Architecture, Poetic Texts and Textiles', pp. 369–70, emphasis added). My dissertation as a whole, much of my subsequently published work and the preceding chapters of this book all stand as a correction to Robinson's and Zomeño's surprising misapprehension. On the other hand, Fernández-Puertas decided to omit all examples of the poems recited at the *mawlid* from his recent translation of *Nufāḍat*, part III; his focus lies elsewhere.

12. Miquel Barceló, 'El Califa patente: el ceremonial omeya de Córdoba o la escenificación del poder', in Antonio Vallejo Triano (ed.), *El Salón de 'Abd al-Raḥmān III* (Córdoba: Imprenta San Pablo, 1995), pp. 153–76; Barceló's subtitle, 'la escenificación del poder', is precisely the 'staging of power'.

13. Muḥammad ibn Jābir al-Andalusī, *Kitāb mawlid rasūl allāh*, MS. Istanbul, Süleimaniye, No. 344, 14a–15a, cited in Marion Holmes Katz, *The Birth of the Prophet Muḥammad. Devotional Piety in Sunni Islam* (London: Routledge, 2007), pp. 74–5.

14. Robinson and Zomeño, 'On Muḥammad V', p. 168.

15. James A. O. C. Brown, '"Azafid Ceuta, *Mawlid al-Nabī* and the Development of Marīnid Strategies of Legitimation', in Amira K. Bennison (ed.), *The Articulation of Power in Medieval Iberia and the Maghrib* (Oxford: Oxford University Press, 2014), p. 144.

16. Ibid., p. 129.

17. The most comprehensive study of the history of the *mawlid* is Nico J. G. Kaptein, *Muḥammad's Birthday Festival. Early History in the Central Muslim Lands and Development in the Muslim West until the 10th/16th Century* (Leiden: Brill, 1993).

18. On the Fatimid *mawlid* in the works of Ibn al-Ma'mūn, Ibn al-Ṭuwayr and al-Maqrīzī, see ibid., pp. 7–30.

19. Ibid., pp. 13, 15. See also P. Shinar, 'Traditional and Reformist Mawlid Celebrations in the Maghrib', in Myriam Rosen-Ayalon (ed.), *Studies in Memory of Gaston Wiet* (Jerusalem: Institute of Asian and African Studies, Hebrew University of Jerusalem, 1977), p. 373.

20. Kaptein, *Muḥammad's Birthday*, pp. 25–6. Kaptein's observations are based on an essay by Marius Canard, 'Le cérémonial fatimide et le cérémonial byzantine: essai de comparaison', *Byzantion* 21 (1951), p. 375.

21. For the reconstruction of Fatimid court ceremonial and an in-depth analysis of its multiple meanings on the basis of an examination of historical sources, see Paula Sanders, *Ritual, Politics, and the City in Fatimid Cairo* (Albany, NY: State of New York University Press, 1994), pp. 13–82, 104–12.

22. See Nāṣer-e Khosraw, *Book of Travel (Safarnāma)*, trans. W. M. Thackston Jr (Albany, NY: State University of New York Press, 1986), p. 49.

23. See Sanders, *Ritual, Politics, and the City*, p. 105.

24. H. Fuchs and F. de Jong, '*Mawlid*', *EI2*, vol. 6, pp. 895–8.

25. For Ibn K̲h̲allikān's account of the 604/1207–8 *mawlid* in Irbil, see Gustave E. von Grunebaum, *Muhammadan Festivals* (London: Curzon, 1976), pp. 73–6; Kaptein, *Muḥammad's Birthday*, pp. 40–3.

26. Grunebaum, *Muhammadan Festivals*, pp. 74–5.

27. Among the numerous studies on ceremonial at Christian courts during the medieval and Renaissance periods, see Teofilo F. Ruiz, *A King Travels. Festive Traditions in Late Medieval and Early Modern Spain* (Princeton, NJ: Princeton University Press, 2012); Barbara A. Hanawalt and Kathryn L. Reyerson (eds), *City and Spectacle in Medieval Europe* (Minneapolis: University of Minneapolis Press, 1994); J. R. Mulryne and E. Goldring (eds), *Court Festivals of the European Renaissance: Art, Politics and Performance* (Aldershot: Ashgate, 2002); José Manuel Nieto Soria, *Ceremonias de la realeza. Propaganda y legitimación en la Castilla Trastamara* (Madrid: Editorial Nerea, 1993); Panayotis Yannopoulos, 'Les apparitions publiques de l'Empereur Byzantin', *Cuadernos de CEMyR* 17 (2009): 73–96. On ceremonial at medieval Muslim courts, see, for instance, Maribel Fierro, 'Pompa y ceremonia en los califatos del Occidente islámico (S. II/VIII–IX/XV)', *Cuadernos de CEMyR* 17 (2009): 125–52; Barceló, 'El Califa patente'; Anne F. Broadbridge, *Kingship and Ideology in the Islamic and Mongol Worlds* (Cambridge: Cambridge University Press, 2008); Doris Behrens-Abouseif, 'The Citadel of Cairo: Stage for Mamluk Ceremonial', *Annales Islamologiques* 24 (1988): 25–79; Janina M. Safran, 'Ceremony and Submission: Legitimacy in Tenth-Century Al-Andalus', *Journal of Near Eastern Studies* 58(3) (1999): 191–201. For a comparative approach to medieval court ceremonial, see Franz Alto Bauer (ed.), *Visualisierungen von Herrschaft. Frühmittelalterliche Residenzen Gestalt und Zeremoniell* BYZAS 5 (2006); Alexander Beihammer, Stavroula Constantinou and Maria Parani (eds), *Court Ceremonies and Rituals of Power in Byzantium and the Medieval Mediterranean. Comparative Perspectives* (Leiden: Brill, 2013).

28. On the control of sightlines as a means of access to power at Muslim courts, see Gülru Necipoğlu, 'Framing the Gaze in Ottoman, Safavid and Mughal Palaces', *Ars Orientalis* 23 (1993): 303–42; Matthew D. Saba, 'A Restricted Gaze: The Ornament of the Main Caliphal Palace of Samara', in Olga Bush and Avinoam Shalem (eds), *Gazing Otherwise: Modalities of Seeing* special issue, *Muqarnas* 32 (2015): 155–95.

29. Among burgeoning studies on the topic, see Angelika Lampen, 'The Princely Entry into Town, Significance and Change of a Multi-Media Event', in Margriet Hoogvliet (ed.), *Multi-Media Compositions from the Middle Ages to the Early Modern Period* (Leuven: Peeters, 2004), pp. 41–63.

30. For instance, the ceremonial entry of the Mamluk Sultan al-Ẓāhir Barqūq (r. 784–801/1382–99) into Damascus in 793/1391, for which cloth was spread on the paving of the streets to the citadel. Mamluk historians recorded that for this and other public court ceremonies in Cairo, Damascus and Aleppo the city gates and façades along the procession route were decorated with silk brocade. See Yehoshua Frenkel, 'Public Projection of Power in Mamluk Bilād al-Shām', *Mamlūk Studies Review* 11(1) (2007): 39–53.

31. See Kaptein, *Muḥammad's Birthday*, pp. 76–96.

32. See Shinar, 'Traditional and Reformist', pp. 376–7, 394.
33. Ibn Khaldūn, *Histoire des Beni Abd el-Wād rois de Tlemcen* (= *Bughya* II), vol. 2, pp. 40–55. See also Kaptein, *Muhammad's Birthday*, pp. 141–52, esp. p. 144.
34. Yehoshua Frenkel, '*Mawlid al-nabī* at the Court of Sultān Ahmad al-Mansūr al-Saʿdī', *Jerusalem Studies in Arabic and Islam*, 19 (1995): 157–72.
35. Karl Stowasser, 'Manners and Customs at the Mamluk Court', *Muqarnas* 2 (1984): 17; Shinar, 'Traditional and Reformist', pp. 376–77, 394.
36. See Bárbara Boloix Gallardo, 'Las primeras celebraciones del Mawlid en al-Andalus y Ceuta, según la *Tuhfat al-mugtarib* de al-Qastālī y el *Maqsad al-sarīf* de al-Bādisī', *Anaquel de Estudios Árabes* 22 (2011): 79–96; Kaptein, *Muhammad's Birthday*, pp. 129–31.
37. Katz, *The Birth of the Prophet Muhammad*, pp. 50–62.
38. Kaptein, *Muhammad's Birthday*, pp. 98–9.
39. Muhammad b. Ahmad ibn Marzūq, *Al Musnad: hechos memorables de Abū l-Hasan, sultán de los Benimerines*, ed. and trans. María Jesús Viguera (Madrid: Instituto Hispano-Árabe de Cultura, 1977), pp. 133–4.
40. Brown, '*Azafid Ceuta*', pp. 132–3; Kaptein, *Muhammad's Birthday*, pp. 92, 103.
41. Kaptein, *Muhammad's Birthday*, p. 141. I note, however, that Kaptein questions the pomp with which the first *mawlid* was orchestrated, suggesting that Ibn Khaldūn's account may represent a later occasion (p. 144).
42. Quoted in Kaptein, *Muhammad's Birthday*, p. 145, n. 21.
43. Ibn Marzūq, *Al Musnad*, pp. 133–4. See also Kaptein, *Muhammad's Birthday*, pp. 104–11; Brown, '*Azafid Ceuta*'; Stephen Cory, 'Honoring the Prophet's Family: A Comparison of the Approaches to Political Legitimacy of Abū'l-Hasan ʿAlī al-Marīnī and Ahmad al-Mansūr al-Saʿdī', in Bennison (ed), *The Articulation of Power*, pp. 107–24.
44. Katz, *The Birth of the Prophet Muhammad*, p. 144. This understanding of providential occasion was shared by the Christian rulers. Many accounts of festivities at Christian courts, such as dynastic proclamations and investitures, were planned to coincide with liturgical calendrical celebration. For the examination of a pertinent example, see Elizabeth A. R. Brown and Nancy Freeman Regalado, '*La grant feste*: Philip the Fair's Celebration of the Knighting of His Sons in Paris at Pentecost of 1313', in Barbara A. Hanawalt and Kathryn L. Reyerson (eds), *City and Spectacle in Medieval Europe* (Minneapolis: University of Minneapolis Press, 1994), pp. 56–86.
45. Among the extant medieval sources on the relations between the Nasrids and contemporary Christian and Muslim courts, see Ibn al-Khatīb, *al-Ihāta fī ajbār Garnata*; Ibn al-Khatīb, *Al-Lamha al-badriyya fī dawla al-nasriyya* (Beirut edn and Cairo edn, 1928); Ibn al-Khatīb, *Aʿmāl al-ʿAlān*, ed. Evariste Lévi-Provençal (Beirut, 1956); ʿAbd al-Rahmān ibn Khaldūn, *Kitāb al-ʿIbar wa Dīwān al-Mubtada wa al-Khabar* 7 vols (Cairo, 1284 H.), including *Muqaddima*; all in various manuscripts and editions. These and other texts are examined in al-ʿAbbādī, *El reino de Granada*; Arié, *L'Espagne musulmane*; Fernández-Puertas, 'The Three Great Sultans'; Francisco Vidal Castro, 'Historia política', in *Historia de España Menéndez Pidal, vol. 8: 3, El reino nazarí de Granada (1232–1492). Política, instituciones. Espacio*

y economía, ed. María Jesús Viguera Molins (Madrid: Espasa-Calpe, 2000), pp. 115–50.

46. Al-ʿAbbādī, *El reino de Granada*, pp. 17–18; Arié, *L'Espagne musulmane*, pp. 102–5.

47. Al-ʿAbbādī, *El reino de Granada*, pp. 26–7.

48. Ibn al-Khaṭīb, *al-Iḥāṭa* (Caro edn), vol. 1, p. 12; *Al-Lamha* (Caro edn), pp. 108–9, cited in Fernández-Puertas, 'The Three Great Sultans', pp. 14–18.

49. See al-ʿAbbādī, *El reino de Granada*, pp. 43–56; Fernández-Puertas, 'The Three Great Sultans', p. 18. On Muḥammad V's relations with Castile, Aragon and North African polities during his second reign, see al-ʿAbbādī, *El reino de Granada*, pp. 55–118.

50. Kaptein, *Muḥammad's Birthday*, pp. 135–40. Various aspects of the topic have received attention in such studies as María Jesús Viguera Molins, 'La religión y el derecho', in *Historia de España Menéndez Pidal, vol. 8: 4, El Reino nazarí de Granada (1232–1492). Sociedad, vida y cultura*, ed. Viguera Molins (Madrid: Espasa-Calpe, 2000), pp. 167–74; Amina González Costa and Gracia López Anguita (eds), *Historia del Sufismo en al-Andalus: maestros sufíes de al-Andalus y el Magreb* (Granada: Almuzara, 2009); Maribel Fierro, 'Opposition to Sufism in al-Andalus', in Frederick de Jong and Bernd Radtke (eds), *Islamic Mysticism Contested: Thirteen Centuries of Controversies and Polemics* (Leiden: Brill, 1999), pp. 174–206; Boloix Gallardo, 'Las primeras celebraciones'; Robinson and Zomeño, 'On Muḥammad V'.

51. Rubiera Mata, *Ibn al-Yayyāb*, pp. 48, 130 n. 97; Kaptein, *Muḥammad's Birthday*, p. 131.

52. García Gómez, *Foco de antigua luz*, pp. 45–6.

53. Ibn al-Khaṭīb, *Nufāḍa III* in García Gómez, *Foco de antigua luz*, Arabic text, pp. 127–8; Spanish translation, pp. 148–9.

54. Ibid.

55. Ibn Khaldūn, *Histoire des Beni Abd el-Wād rois de Tlemcen*, pp. 43–7.

56. Frenkel, *'Mawlid al-nabī'*, p. 162.

57. Ibid.

58. Ibn al-Khaṭīb, *Nufāḍa III* in García Gómez, *Foco de antigua luz*, Arabic text, pp. 123–4; Spanish translation, pp. 142–4. The interior of the mishwār was altered in several post-Nasrid changes, which started with the addition of the royal apartments on the second floor and the incorporation of a small patio on its north side into the space of the mishwār proper, converting the space of the patio into a Royal Chapel in the sixteenth century. The changes continued throughout the seventeenth century. As a result of these transformations, the original decoration suffered, too: the high cupola supported by the four marble columns was lost, as was much of the decoration of carved stucco and dadoes of ceramic tile mosaics on the walls. For historical documents on the first renovations undertaken in the mishwār between 1492 and 1505, see Vilar Sánchez, *Los Reyes Católicos en la Alhambra*, pp. 110–26. See also Fernández-Puertas, *La fachada*, p. 11; López López and Orihuela Uzal, 'Una nueva interpretación del texto de Ibn al-Jaṭīb', p. 144; Puerta Vílchez, *Leer la Alhambra*, pp. 48–50.

59. Ibn al-Khaṭīb, *Nufāḍa III* in García Gómez, *Foco de antigua luz*, Arabic text, p. 129, Spanish translation, p. 151.

60. Quoted in García Gómez, *Foco de antigua luz*, p. 49.

61. Ibn al-Khaṭīb, *Nufāḍa III* in García Gómez, *Foco de antigua luz*, Arabic text, pp. 128–9, Spanish translation, p. 150.
62. Ibid.
63. Ibid.
64. The design of the remaining rectangular fields in the two single-panel curtains can be found on a number of related textiles fragments, some of them identified by Wardwell; others could be added. See Wardwell, 'A Fifteenth-Century Silk Curtain', pp. 66–7.
65. The three textiles in American collections have received significant scholarly attention. For a discussion of their decorative vocabulary and its development in Andalusī luxury textiles, see Shepherd, 'The Hispano-Islamic Textiles'; May, *Silk Textiles*, pp. 178–82; Cristina Partearroyo [Lacaba], 'Curtain', in Jerrilynn D. Dodds (ed.), *Al-Andalus. The Art of Islamic Spain* (New York: Metropolitan Museum of Art, 1992), pp. 338–9; Partearroyo [Lacaba], 'Los tejidos nazaríes', p. 126; Mackie, *Symbols of Power*, pp. 196–200. For a detailed analysis of the three textiles, including the identification of the motifs that they share with the architectural decoration of the Alhambra, see Wardwell, 'A Fifteenth-Century Silk Curtain'. For a catalogue entry on the double-curtain in Qatar, see Jon Thompson, *Silk. 13th to 18th Century. Treasures from the Museum of Islamic Art, Qatar* (Doha, Qatar: National Council for Culture, Art and Heritage, 2004), No. 1, pp. 18–23.
66. For the dimensions of the doors, see López Pertíñez, *La carpintería*, p. 150, and, on the carpentry of the doors in the Alhambra and elsewhere in Granada during the Nasrid period more generally, pp. 345–89. López Pertíñez lists five original doors from the Alhambra that have been preserved: the interior and exterior doors of the *bāb al-sharīʿa* (Gate of the Esplanade); the door on the west side of the Façade of Comares; the doors of the Hall of Two Sisters (the original is in the Museo de la Alhambra and its copy has been installed in situ); and the doors of the Hall of the Abencerrajes (López Pertíñez, *La carpintería*, p. 373). See also María Carmen López Pertíñez, 'Puertas de madera nazaríes. Estructura y decoración. La Puerta de la Sala de dos Hermanas en la Alhambra de Granada', in *Ante el nuevo milenio: raíces culturales, proyección y actualidad del arte español. XIII Congreso Nacional de Historia de Arte* (Granada: Universidad de Granada, 2000), vol. 1, pp. 145–51; Purificación Marinetto Sánchez, 'Las hojas de una puerta nazarí. La puerta de la calle de la Tiña en el Albaicín', *Anaquel de Estudios Árabes* 11 (2000): 407–12; and the remarks concerning the replacement of the doors of the Sala de la Barca in Bermúdez Pareja, 'Crónica de la Alhambra', pp. 108–10 and pls XX–XXI.
67. For numerous examples of polychromed wood in the Alhambra, see López Pertíñez, *La carpintería*.
68. al-Ṣābiʾ, *Rusūm dār al-khilāfa*, pp. 18–20.
69. Sanders, *Ritual, Politics, and the City*, p. 33. Geniza documents show that middle-class Jews in medieval Cairo, including Moses Maimonides, likewise employed a 'keeper of the curtain' in their homes. See Goitein, *A Mediterranean Society*, vol. 4, p. 119.
70. Ibn Taghrī Birdī, a Mamluk historian, mentions it among the administrative offices of the court. See William Popper, *Egypt and Syria under the Circassian Sultans, 1382–1468 AD* (Berkeley: University of California Press, 1955), p. 95.

71. 'Īsā Ibn Aḥmad al-Rāzī, *Anales palatinos del califa de Córdoba al-Hakam II, por 'Īsā Ibn Aḥmad al-Rāzī (360–364 H./ 971–975 J.C.)*, trans. Emilio García Gómez (Madrid: Sociedad de Estudios y Publicaciones, 1967), p. 70.

72. Juan de Gortz, *Embajada del Emperador de Alemania Otón I al Califa de Córdoba Abderrahman III* (Madrid, 1872), p. 72. For additional textual examples and their analysis for early Muslim courts, see Avinoam Shalem, 'Manipulations of Seeing and Visual Strategies in the Audience Halls of the Early Islamic Period', in Franz Alto Bauer (ed.), *Visualisierungen von Herrschaft. Frühmittelalterliche Residenzen Gestalt und Zeremoniell* BYZAS 5 (2006), pp. 213–32.

73. Al-ʿAbbādī, *El reino de Granada*, p. 153.

74. Other gates in the Alhambra enclosure gave access to the upper sector of the *madīna*: the Puerta de Siete Suelos (Gate of Seven Floors) on the southeast, and the Puerta del Arrabal (Outer Gate) on the northeast. See Jesús Bermúdez López, 'The City Plan of the Alhambra', in Amira K. Bennison (ed.), *The Articulation of Power in Medieval Iberia and the Maghrib* (Oxford: Oxford University Press, 2014), pp. 153–61.

75. Ibid., pp. 155–6.

76. Ibid., pp. 156–7.

77. Luis Seco de Lucena Paredes, *La Granada nazarí del siglo XV* (Granada: Patronato de la Alhambra, 1975), pp. 86–8. For recent archaeological studies of the site, see José Cristóbal Carvajal López, 'Resultados de una intervención arqueológica en la puerta de las Granadas', *Cuadernos de la Alhambra* 45 (2010), pp. 37–42.

78. For an iconographical analysis of the gate's sculptural programme and references to related historical studies, see Nieves Jiménez Díaz, 'Nuevos datos históricos-artísticos tras la intervención en la puerta de las Granadas', *Cuadernos de la Alhambra* 45 (2010): 45–64.

79. Lampen, 'The Princely Entry into Town', p. 58.

80. The Calle Real Alta remains today the principal roadway through the Alhambra, leading from the current tourist entrance in the northeast to the Puerta del Vino in the southwest. Although now free-standing, the Puerta del Vino, originally built during the reign of Muḥammad II or Muḥammad III, was probably the main gate in a wall that would have run in the north–south direction, closing off the royal *madīna* from *al-qaṣaba*. The Calle Real Baja was much altered by the construction of the Palace of Charles V. See Antonio Malpica Cuello, 'La Alhambra que se construe. Arqueología y conservación de un monumento', in José Antonio González Alcantud and Antonio Malpica Cuello (eds), *Pensar la Alhambra* (Barcelona: Anthropos Editorial, 2001), p. 60; Fernández-Puertas, *The Alhambra*, pp. 161–7.

81. Torres Balbás has shown that an open space called *muṣallā* or *sharīʿa* in the immediate vicinity of gates named *bāb al-sharīʿa* were sometimes used for open-air prayers in medieval cities of Western Islam, such as Murcia, Valencia, Fez, Marrakesh and Taza. On the basis of this comparative material, he proposed that the esplanade in the Alhambra that stands very close to the *bāb al-sharīʿa* would have served that purpose. See Leopoldo Torres Balbás, '"Muṣallā" y "sharīʿa" en las ciudades hispanomusulmanas', *Al-Andalus* 13 (1948): 167–80; Leopoldo Torres Balbás, *Ciudades hispanomusulmanas* (Madrid, 1985), vol. 1, pp. 219–26; and Fernández-Puertas, *The Alhambra*, pp. 288–91.

82. Relevant accounts in Ibn al-Khaṭīb's texts are examined in al-ʿAbbādī, *El reino de Granada*, p. 14; Franciscio Vidal Castro, 'Narración, leyenda y política en los últimos siglos de al-Andalus: en torno al magnicidio de tres emires nazaríes', in Raif Georges Khoury, Juan Pedro Monferrer-Sala and María Jesús Viguera Molins (eds), *Legendaria Medievalia. En honor de Concepción Castillo Castillo* (Córdoba: Ediciones El Almendro, 2011), pp. 99–108.

83. al-ʿAbbādī, *El reino de Granada*, pp. 126–7.

84. Ibn al-Khaṭīb, *Nufāḍa III* in García Gómez, *Foco de antigua luz*, Arabic text, pp. 126–7; Spanish translation pp. 146–8. For the identification of the *wasṭ* of Ibn al-Khaṭīb's text with this area, see Fernández-Puertas, 'El *Mawlid* de 764/1362', p. 165; Fernández-Puertas, *The Alhambra*, pp. 283–91; Juan Castilla Brazales and Antonio Orihuela Uzal, *En busca de la Granada andalusí* (Granada: Editorial Comares, 2002), pp. 347–51.

85. For numerous examples of tents as royal gifts and booty, see, for instance, Ibn al-Zubayr, *Book of Gifts and Rarities*, pp. 84–5, 87, 91–8.

86. ʿAbd al-Raḥmān Ibn Khaldūn: *Kitāb al-ʿIbar*, vol. 5, pp. 440–1; Marius Cannard, 'Les relations entre les Mérinides et les Mamelouks au XIVe siècle', *Annales de l'Institut d'Études Orientales* 5 (1939–1941): 56–65; Doris Behrens-Abouseif, *Practising Diplomacy in the Mamluk Sultanate: Gifts and Material Culture in the Medieval Muslim World* (London: I. B. Tauris, 2014), pp. 56–7.

87. Among the most interesting texts was an account written by Ruy González de Clavijo, ambassador of King Henry III of Castile (r. 1390–1406) to the Timurid court in Samarqand in 1404, in which he gives a detailed description of tent 'castles' with towers, gates, domes and multiple, linked tents. See Ruy González de Clavijo, *Clavijo. Embassy to Tamerlane 1403–1406*, trans. and introduction Guy Le Strange (London: Routledge, 1928), pp. 237–52; David J. Roxburgh, 'Ruy González de Clavijo's Narrative of Courtly Life and Ceremony in Timur's Samarqand, 1404', in Palmira Brummett (ed.), *The 'Book' of Travels: Genre, Ethnology, and Pilgrimage, 1250–1700* (Leiden: Brill, 2009), pp. 113–58. For an analysis of tentage in relationship to Safavid architecture, see Bernard O'Kane, 'From Tents to Pavilions: Royal Mobility and Persian Palace', *Ars Orientalis* 23 (1993): 249–68. For a study of tentage in textual sources and manuscript paintings, see Peter Alford Andrews, *Felt Tents and Pavilions: The Nomadic Tradition and its Interaction with Princely Tentage*, 2 vols (London: Melisende, 1999).

88. See Ibn Ḥayyān, *Crónica del Califa ʿAbdarrahman III an-Nasir entre los años 912 y 942 (al-Muqtabis V)*, trans. María Jesús Viguera and Federico Corriente (Zaragoza: Anubar Ediciones, 1981), pp. 337–8; Emilio García Gómez, 'Armas, banderas, tiendas de campaña, monturas y correos en los "Anales de al-Ḥakam II", por ʿĪsā al-Rāzī', *Al-Andalus* 32 (1967), p. 170. García Gómez cites the following terms: *bināʾ* (pl. *abniya*); *khibāʾ* (pl. *akhbiya*); *khayma* (pl. *khiyām*); *surādiq*; *fusṭāṭ* (pl. *fasāṭīṭ*); *qubba* (pl. *qibāb*); *maẓall* (pl. *maẓallāt* and *maẓall*) in 'Armas, banderas, tiendas de campaña', p. 169.

89. Emilio García Gómez, 'Notas sobre la topografía cordobesa en los "Anales de al-Ḥakam II", por ʿĪsā al-Rāzī', *Al-Andalus* 20 (1965), p. 357.

90. Safran, 'Ceremony and Submission', p. 194.

91. Ibn al-Khaṭīb, *Nufāḍa III* in García Gómez, *Foco de antigua luz*, Arabic text, pp. 126–7; Spanish translation, pp. 146–8.
92. Ibid., Arabic text, p. 126; Spanish translation, p. 147.
93. Ibid.
94. Ibid.
95. Ibid.
96. Ibid., Arabic text, p. 127; Spanish translation, p. 147.
97. See García Gómez, *Cinco poetas musulmanes*, p. 53.
98. Ibn al-Khaṭīb, *Nufāḍa III* in García Gómez, *Foco de antigua luz*, Arabic text, p. 127; Spanish translation, p. 148. García Gomez points to the Qur'ānic source in his notes to the text in *Foco de antigua luz*, p. 148.
99. Again, García Gomez notes the correlation to this Qur'ānic passage; see Ibn al-Khaṭīb, *Nufāḍa III* in García Gómez, *Foco de antigua luz*, Arabic text, p. 127; Spanish translation, p. 148. Peter Alford Andrews argues for this interpretation of canopies and other tensile structures over the enthroned emperor during the Mughal period in 'The Generous Heart or the Mass of Clouds: The Court of Tents of Shah Jahan', *Muqarnas* 4 (1987), p. 149. For a discussion of canopies as a form that mediates the relationship between tensile structures and architectural forms with a focus on the reign of the Mughal emperor Shah Jahan, see Olga Bush, 'Canopy', in Anika Reineke, Anne Röhl, Mateusz Kapustka and Tristan Weddigen (eds), *Textile Terms: A Glossary* (Emsdetten/Berlin: Edition Imorde, 2017), pp. 23–7.
100. Said Amir Arjomand, *The Shadow of God and the Hidden Imam: Religion, Political Order, and Societal Change in Shiite Iran from the Beginning to 1890* (Chicago, IL: University of Chicago Press 1984); Manuel Ruiz Figueroa, 'Califato y religión durante los reinados de al-mahdi (775–785), al-Hadi (785–786) y Harún al-Rashid (786–809)', *Estudios de Asia y África*, 41(2) (2006): 233–54.
101. Patricia Crone, *God's Caliph: Religious Authority in the First Centuries of Islam* (Cambridge: Cambridge University Press, 1986), pp. 33–9.
102. Stetkevych, *The Poetics of Islamic Legitimacy*, pp. 271–81, 322–4.
103. Stetkevych's translation; see her discussion in ibid., pp. 271–81.
104. Ibn al-Khaṭīb, *Nufāḍa III* in García Gómez, *Foco de antigua luz*, Arabic text, p. 127, Spanish translation, p. 147.
105. Ibid., Arabic text, p. 125, Spanish translation, p. 145.
106. Ibid., pp. 71–2.
107. Fernández-Puertas, 'El Arte', p. 239.
108. Ibn al-Khaṭīb, *Nufāḍa III* in García Gómez, *Foco de antigua luz*, Arabic text, p. 125, Spanish translation, p. 145.
109. Behrens-Abouseif suggests this more general interpretation of the term in 'The Citadel of Cairo', p. 72.
110. Ibid., pp. 45–66; Stowasser, 'Manners and Customs', p. 17.
111. García Gómez, *Foco de antigua luz*, p. 108.
112. Ibn al-Khaṭīb, *Nufāḍa III* in *ibid.*, Arabic text, p. 135; Spanish translation, p. 160.
113. Nora, 'Between Memory and History'.
114. Ibid., p. 22.
115. Ibid., p. 19.
116. Ibid., p. 22.
117. For the list of authors whose *qaṣā'id* were read on this occasion, see García Gómez, *Foco de antigua luz*, pp. 105–8. Ibn al-Khaṭīb, 'Abd

al-Raḥmān Ibn Khaldūn and Ibn Marzūq, all present at the *mawlid* celebration in the Alhambra, were also in attendance and wrote *mawlidiayyāt* for the celebrations in Fez during Sultan Abū Sālim's reign. See Ahmed Salmi, 'Le genre des poèmes de nativité (*mawludiyya*-s) dans le royaume de Grénade et au Maroc du XIIIe au XVIIe siècle', *Hespéris* 3/4 (1956): 335–435; Kaptein, *Muḥammad's Birthday*, pp. 111–12.

118. Ibn al-Khaṭīb, *Nufāḍa III* in García Gómez, *Foco de antigua luz*, Arabic text, pp. 132–3; Spanish translation, pp. 156–7.

119. Shinar, 'Traditional and Reformist'.

120. For a study of *mawlidiayyāt* written at the Nasrid and Marinid courts from the seventh/thirteenth to the ninth/fifteenth century, see, for instance, Salmi, 'Le genre des poèmes', who included a complete text of only one example, a *mawlidiyya* written by Ibn Zamrak.

121. For a description of the chronometer, see Ibn al-Khaṭīb, *Nufāḍa III* in García Gómez, *Foco de antigua luz*, Arabic text, pp. 131–2; Spanish translation, pp. 154–5. See also Antonio Fernández-Puertas, *Clepsidras y relojes musulmanes* (Granada: Fundación El legado andalusí, 2010), who offers a hypothetical reconstruction of the mechanism of the chronometer used in the *mawlid* in the Alhambra (pp. 59–77).

122. Finbarr Barry Flood, *The Great Mosque of Damascus* (Leiden: Brill, 2001), pp. 114–38; and Fernández-Puertas, *Clepsidras y relojes*.

123. Yaḥyā Ibn Khaldūn, *Histoire des Beni Abd el-Wād rois de Tlemcen*, pp. 47–8. He also described the subsequent Wadid *mawlid* of 769/1368, that is, several years after the ceremonial in the Alhambra, including the texts of the 'Poems of the Hours' recited on that occasion (pp. 270–4).

124. Fernández-Puertas, *Clepsidras y relojes*, p. 61.

125. Ibn al-Khaṭīb, *Nufāḍa III* in García Gómez, *Foco de antigua luz*, Arabic text, p. 132; Spanish translation, p. 155.

126. On panegyric in Arabic poetry and the relationship between poet and patron, see Suzanne Pinckney Stetkevych, 'The Qaṣīdah and the Poetics of Ceremony: Three 'Īd Panegyrics to the Cordoban Caliphate', in Ross Brann (ed.), *Languages of Power in Islamic Spain* (Bethesda, MD: CDL Press, 1997), pp. 1–48; Stetkevych, *The Poetics of Islamic Legitimacy*; Beatrice Gruendler and Louise Marlow (eds), *Writers and Rulers: Perspectives on their Relationship from Abbasid to Safavid Times* (Wiesbaden: Reichert, 2004); Robinson, *In Praise of Song*; Jocelyn Sharlet, *Patronage and Poetry in the Islamic World: Social Mobility and Status in the Medieval Middle East and Central Asia* (London and New York: I. B. Tauris and Palgrave Macmillan, 2011); Christine Woodhead, 'Poet, Patron and Padişah: The Ottoman Sultan Murad III (1574–95)', in Giles E. M. Gasper and John McKinnell (eds), *Ambition and Anxiety: Courts and Courtly Discourse, c. 700–1600* (Toronto: Pontifical Institute of Medieval Studies, Durham University: Institute of Medieval and Early Modern Studies, 2014), pp. 229–49.

127. Ibn al-Khaṭīb, *Nufāḍa III* in García Gómez, *Foco de antigua luz*, Arabic text, p. 136; Spanish translation, p. 165.

128. Stetkevych, 'The Qaṣīdah', pp. 25–6. See also Jo Van Steenbergen, 'Qalāwūnid Discourse, Elite Communication, and the Mamluk Cultural Matrix: Interpreting a 14th-Century Panegyric', *Journal of Arabic Literature* 43 (2012): 1–28.

129. Flood, *The Great Mosque*, p. 138.

130. Ibn al-Khaṭīb, *Nufāḍa III* in García Gómez, *Foco de antigua luz*, Arabic text, p. 139, Spanish translation, p. 166.
131. Ibid., Arabic text, p. 136; Spanish translation, p. 161.
132. María Jesús Rubiera Mata, 'El Califato nazarí', *Al-Qanṭara* 39(2) (2008), p. 294.
133. Fierro, 'The Anṣārīs'; Fernández-Puertas, 'Three Great Sultans'.
134. Fierro, 'The Anṣārīs', p. 241.
135. Bárbara Boloix-Gallardo, 'The Genealogical Legitimization of the Naṣrid Dynasty: The Alleged Anṣārī Origins of the Banū Naṣr', in Bennison (ed.), *The Articulation of Power*, p. 76.
136. Ibid.
137. For the text of the poem, see Puerta Vílchez, *Leer la Alhambra*, pp. 339–40.
138. Rubiera Mata, 'El Califato nazarí'.
139. Ibid., p. 299.
140. Antonio Fernández-Puertas, 'El poema de la Fachada de Mexuar', *Cuadernos de la Alhambra* 41 (2005): 37–57. The English translation cited above is by Fernández-Puertas (p. 158); for the Arabic text of the poem, see Appendix.
141. Although the poem is no longer visible as an inscription, Puerta Vílchez includes the text in *Leer la Alhambra*, pp. 50–1, following García Gómez, *Poemas árabes*, pp. 165–8. For a discussion of the alterations in the *mishwār*, see Chapter 4.
142. Puerta Vílchez, *Leer la Alhambra*, pp. 50–1.
143. Rubiera Mata proposed that this term was also used in the inscriptions in the niches to the Hall of Two Sisters, which are no longer extant. See 'El Califato nazarí', p. 303. For an analysis of the Mirador de Lindaraja, including its poetic programme, see Bush, '"When My Beholder Ponders"'.
144. Puerta Vílchez, *Leer la Alhambra*, pp. 100–2.
145. Ibn al-Khaṭīb, *al-Iḥāṭa fī akhbār gharnāṭa* (Cairo, 1901), vol. 2, p. 230, cited and discussed in Fernández-Puertas, *La fachada*, p. 27.
146. Ibn al-Khaṭīb, *Nufāḍa III* in García Gómez, *Foco de antigua luz*, Arabic text, pp. 133–4; Spanish translation, pp. 157–8.
147. Ibid., Arabic text, p. 138; Spanish translation, p. 164.
148. Ibid., poems 1, 3 and 9, pp. 133–4, 135, 139; Spanish translation, pp. 157–8, 159–60, 165.
149. Ibid., poems 5 and 9, Arabic text, pp. 136, 139; Spanish translation, pp. 161–2, 165.
150. Ibid., Arabic text, p. 134; Spanish translation, p. 159.
151. Ibid., poems 7 and 9, Arabic text, pp. 138, 139; Spanish translation, pp. 163, 165.
152. Ibid., Arabic text, p. 140; Spanish translation, p. 167.
153. Ibid., Arabic text, pp. 140–1; Spanish translation, pp. 167–8.
154. Ibid., Arabic text, p. 141; Spanish translation, p. 168.

Appendix

Note: all texts in Arabic are after Puerta Vílchez, *Leer la Alhambra*; all translations into English are the author's.

(1) Ibn Zamrak, poem on the west niche of the entrance arch to the Sala de la Barca (Puerta Vílchez, *Leer la Alhambra*, p. 107):

1 أَنَا مِحْرَابُ صَلَاةٍ	سَمْتُهُ سَمْتُ السَّعَادَة
2 تَحْسبُ الإِبْرِيقَ فِيهِ	قَـائِماً يَقْضِي عِبَادَه
3 كُلَّمَا يَفْرَغُ مِـنْها	وَجَبَتْ فِيهَا الإِعَادَه
4 وَبِمَوْلَايَ ابْـنِ نَصْرٍ	شَـرَّفَ اللهُ عِبَادَه
5 قَدْ نَمَاهُ سَيِّدُ الْخَزْرَج	سَـعْـدُ بْنُ عُبَادَه

(2) Ibn Zamrak, poem on the east niche of the entrance arch to the Sala de la Barca (Puerta Vílchez, *Leer la Alhambra*, p. 107).

1 أَنَا مَجْـلَاةُ عَـرُوسٍ	ذَاتُ حُـسْنٍ وَكَمَال
2 فَـانْظُرِ الإِبْرِيقَ تَعْرِفْ	فَضْلَ صِدْقِي في مَقَال
3 وَاعْتَـبِـرْ تَاجِي تَجِدْهُ	مُـشْبِهاً تَاجَ الهِلَال
4 وَابْنُ نَصْرٍ شَمْسُ مُلْكٍ	في ضِيَاءٍ وَجَمَـال
5 دَامَ في رِفْـعَـةِ شَأْنٍ	آمِـناً وَقْـتَ الزَّوَال

(3) Ibn al-Jayyāb, poem 1 in the *Qalahurra* of Yūsuf I (Puerta Vílchez, *Leer la Alhambra*, p. 309; the words in grey have been preserved in the *dīwān* only).

1	بـرجّ عـظيم الشأن في الأبراج	قـد بـاهت الحمراء مـنه بتاجِ
2	قـلهرةٌ ظـهرتْ لنا واستبطنتْ	قَصْـراً يُـضيءِ بـنُورِه الوَهَّاج
3	فـيها بَدائعُ صَنْعَةٍ قَدْ / نُوظِرَتْ	نِـسَباً مِـن الأفْـرَاد والأزْوَاج
4	فَـصَنَائعُ الـزُلَّيْج فـي حِيطانِها	وَالأرْضِ مِـثْل بَـدائع الدِّيباج
5	وَكَفى بعزّ الدين/ أن قد سُخّرَتْ	فـيها مماليك مـن الأعـلاج
6	لَبِستْ طِراز الفخر لِـمّا أن بدا	فـيهَا اسْم مَـوْلانا أبي الحَجَاج
7	مَـلك الجلالة والبَسالة والندى	غَوث الصريخ بهِ / وَغَيث الرَّاجي
8	مِـن آل سَعْد من بني نصرٍ ومَن	نَـصَرُوا وآوَوا صَـاحب المِعراج

1. Of this tower (*al-burj*), which is grand among the towers, the Alhambra is proud, like a crown.
2. *Qalahurra* on the outside, while it conceals within a palace (*al-qaṣr*) that emits a burning light.
3. In it there are marvels of workmanship, single (*afrād*) and paired (*azwāj*),
 That were made comparable in terms of proportions (*nisab*).
4. Skilfully-made ceramic tiles in its walls
 and floor are like marvels of brocade (*al-dībāj*).
5. It has been an honour to the faith that, forced,
 captive slaves built it.
6. Dressed in *ṭirāz* of glory, as in them [walls] appears
 the name of Our Lord (*mawlānā*) Abu al-Ḥajjāj.
7. The magnanimous, brave, generous king [is]
 sustenance to the one who implores, rain to the one who hopes.
8. Of the family of Saʿd and of the Banū Naṣr tribe, who helped (*naṣarū*)
 and sheltered the one who "ascended the Ladder" (*ṣāḥib al-miʿrāj*).

(4) Ibn al-Jayyāb, poem 2 in the *Qalahurra* of Yūsuf I (Puerta Vílchez, *Leer la Alhambra*, p. 310).

فَــحَديثُهُ في كُلِ صقعٍ قَدْ فَشا	مَا مثلُ هذا المصنَع الأعْلى / نشا 1
سَامٍ وحَامٍ فَــاحذرُوا أن يَبْطِشَا /	للهِ مِـــن بُـــرْجٍ إلى الأسَدِ انْتَمَى 2
تُزهي بُحُسْن حُلاه زهوَ مَن انْتشا	زيّنتْ بِـــهِ الحَمراء حَتّى انّــهَا 3
فَلكٍ فَــجاوَرَت / الثريّا والرشَا	قَـــلهُرَّة زحَمتْ نُجُوم الجو في 4
فالصنع فِيها قَدْ تأنّق كَيفَ شَـــا	أمّـــا مَبَانيهَا / فَفَرْعُ حِجَارة 5
شَمْساً ولاكِن ليسَ يْحجبها العِشَا /	أبْدَتْ عَليْنا مِـــن مُحَيّا يُوسفٍ 6
وَبِـــهِ كفينا كُـــل خَطْبٍ أدْهَشَا	فِـــيه حُبِـــينا كُـــل خيرٍ سَرّنا 7
سَعْدٍ فيبني مَـا شَــاء كَما يَشَا /	مِـــن آل نصْرٍ دَامَ في نصْرٍ وفي 8

1. Never has there arisen so great a monument (*al-maṣnaʿ*):
 its fame spread through every land.
2. God has a tower (*al-burj*) that looks like the lion,
 great and ardent, so beware of its attack.
3. Alhambra is embellished by it to the extent that it
 takes pride in its beauty like someone who is drunk.
4. *Qalahurra* inlaid among the celestial bodies,
 it is next to Pleiades and Piscis.
5. In its fabrication and ceiling of carpentry
 it unfurled skilfully as much art as it desired.
6. It [the tower] reveals Yūsuf to us, his face
 like the sun that a night can never hide.
7. Because of it we love everything that delights us;
 and [with it] we are protected from everything that
 bewilders us.
8. May it always – the blood of Naṣr – in triumph (*naṣr*) and
 happiness (*saʿdin*)
 build whatever it wants wherever it wants.

(5) Ibn al-Jayyāb, poem 3 in the *Qalahurra* of Yūsuf I (Puerta Vílchez, *Leer la Alhambra*, p. 311).

1 قَــدْ زَيَّنِ الْحَمْرَاءَ هَـــذَا الْمَصْنَعُ / ‏ ‏ هُـــوَ لِـــلْمِسَالِمِ وَالْمَحَارِبِ مَرْبَعُ

2 قَـــلَهُرَّةٌ قَـــدْ أُودِعَتْ قَصْراً فَقُلْ ‏ ‏ هِيَ مَـــعْقِلٌ أَوْ لِلْمَسَرَّةِ مَجْمَعُ

3 قَصْرٌ / تَقَسَّمَتِ الْبَـــهَاءَ سَمَاؤُهُ ‏ ‏ وَالْأَرْضُ مِـــنْهُ وَالْجِهَاتُ الْأَرْبَعُ

4 فِـــي الْجِصِّ وَالزُّلَيْجِ مِنْهُ بَـــدَائِعُ ‏ ‏ لَاكِنْ نِجَارَةَ / سَقْفِهِ هِيَ أَبْدَعُ

5 جُمِعَتْ / وَبَعْدَ الْجَمْعِ أُحْكِمَ رَفْعُهَا ‏ ‏ لِـــلنَّصْبِ حَيْثُ لَهَا الْمَحَلُّ الْأَرْفَعُ

6 يُـــحْكِي بَدِيعَ الشِّعْرِ مِـــنْهُ مُجَنَّس ‏ ‏ وَمُـــطَبَّق وَمُغَصَّن وَمُـــرَصَّعُ /

7 أَبْـــدَى لَـــنَا مِن وَجْهِ يُوسُفَ آيَةً ‏ ‏ فِـــيهَا تَـــكَامَلَت الْمَحَاسِنِ أَجْمَعُ

8 مِـــن خَزْرَجِ الْفَخرِ الْأُلَى آثَارُهُمْ ‏ ‏ فِـــي الدِّينِ صَاعِقَةٌ بِنُورٍ تَسْطَعُ

1. This monument (*al-maṣnaʿ*) embellishes the Alhambra,
 It is the abode of the man of peace and of the warrior.
2. *Qalahurra* was set as a palace (*al-qaṣr*)
 So, say: it is a stronghold or gathering place for happiness.
3. The beauty (*bahāʾ*) of the palace (*al-qaṣr*) is distributed
 between its four directions (*jihāt*), sky (*samāʾ*), and earth
 (*ard*).
4. Marvels of stucco and tiles
 [it] holds, but the carpentry of its ceiling is even more
 marvellous.
5. In storing so much treasure it triumphed
 in going up and in rising to the highest heights.
6. It [*qalahurra*] speaks *badīʿ* poetry: paronomasias,
 antitheses, caesuras and *murassaʿ* (*mujannas*, *muṭabbaq*,
 mugaṣṣan, *murassaʿ*).
7. If Yūsuf is there, his face is a marvel
 that accumulates all enchantments.
8. The main glory [comes] from Khazraj, whose traces
 in the religion are a thunder with light that spreads.

(6) Ibn al-Jayyāb, poem 4 in the *Qalahurra* of Yūsuf I (Puerta Vílchez, *Leer la Alhambra*, p. 312; the words in grey have been preserved in the *dīwān* only).

1 قَدْ شَرّفَ الْحَمْراءَ بُرجٌ مُشْرِفُ / في الجَوّ دَبّـرَهُ الإِمَامُ الأَشْرَفُ

2 قَـلَهُرّة فـي ضِمْنها قَصْرٌ فَقُلْ هِـيَ مَعْقِلٌ أو للبَشَائِر مَألَفُ

3 حِـيـطَانُهَا / فيها رُقُومٌ أَعْجَزَتْ أَمَد البَلِيغ فَحسْنُها لا يُوصَفُ

4 رَاقَب وَنـاظَرَ كُلَّ شَكْلِ شَكلهُ في نـسبة فـموشّح ومصنّف

5 مهما لحظتَ رأيتَ نقشاً وُشِّيَتْ / أنْـوَاعُهُ فَـمُذَهّبٌ وَمُزَخْرَفُ

6 مَبْنى بَدِيعٌ أَبْـرَزَتْـهـ حِـكْمَةٌ مَـا حَازَهَا إلا الخَلِيفَة يُوسُفُ

7 مَلِكٌ إذَا / افْتَخَرَ المُلوكُ فَفَخْرُه في الذِكْرِ يَتْلُوهُ عَلَيْنا المُصْحَفُ

8 مِن نُخْبَةِ الأنصَارِ دَامَ لِـمُلْكِهِ نَصْرٌ لَهُ في الدين سَعْيٌ مزلف

1. It honours the Alhambra, this tower (*al-burj*) that dominates the skies and which was conceived by the most noble *imām*.
2. *Qalahurra* outwardly, on the inside a palace (*al-qaṣr*) So, say: it is a stronghold or a dwelling for happy tidings.
3. Its walls (*ḥīṭān*); in them there are markings (*raqūmun*) that disarm the most eloquent And their beauty (*ḥusn*) is ineffable.
4. They surprise; and each part equals another part in proportion (*nisba*), and so it is a poem (*muwashshaḥ*) and a literary work (*muṣannaf*).
5. Wherever you look there are different designs (*nuqūsh*) always: either polychromed (*muzakhraf*) or gilded (*mudhahhab*).
6. A marvellous edifice was made to manifest [itself] by wisdom that which only the caliph Yūsuf achieved.
7. If the kings compare their glories, his [glory], the Qurʾān itself tells us.
8. Because he is the chosen of the Ansār, may his kingdom always continue to have triumph and may he continue to lead in the religion.

(7) Ibn Zamrak, poem on the Façade of Comares (Puerta Vílchez, *Leer la Alhambra*, p. 71).

1 مَنصبي تاجٌ وبابي مَفرقُ يَحسُدُ المغربَ فيَّ المشرقُ

2 والغني بالله أوصاني أنْ أسْرَعَ الفتحَ لفتحٍ يطرُقُ

3 فأنــا مُنْتَظِرُ طَلعــتِه مثل ما يُبْدي الصباحَ الأفقُ

4 أحْسَنَ الله له الصُّنعَ كما حَسُنَ الخُلْقُ له والخُلُقُ

(8) Poem on the exterior, south wall of the *mishwār* over the door (Puerta Vílchez, *Leer la Alhambra*, p. 46).

1 يــا منصب الملك الرفيع ومحرز الشكل البديع

2 فُتحــتَ للفتح المبــين وحسن صنع أو صنيع

3 أثــر الإمــام محمّد ظِــلّ الإله على الجميع

Bibliography

ʿAbbādī, Aḥmad Mukhtār al-, *El reino de Granada en la época de Muhammad V* (Madrid: Publicaciones del Instituto de Estudios Islámicos en Madrid, 1973).

ʿAbbādī, Aḥmad Mukhtār al-, *Mushāhadāt Lisān al-Dīn ibn al-Khaṭīb fī bilād al-Maghrib waʾl-Andalus* (Alexandria: Mūʾassasat Shabāb al-Jāmiʿah, 1983).

Abu Deeb, Kamal, 'Al-Jurjānī's Classification of *Istiʿāra* with Special Reference to Aristotle's Classification of Metaphor', *Journal of Arabic Literature* 2 (1971): 48–75.

Abu Deeb, Kamal, *Al-Jurjānī's Theory of Poetic Imagery* (Warminster: Aris & Phillips, 1979).

Abu Deeb, Kamal, 'Literary Criticism', in Julia Ashtiany, T. M. Johnstone, J. D. Latham, R. B. Serjeant and G. Rex Smith (eds), *ʿAbbasid Belles-Lettres* (Cambridge: Cambridge University Press, 1990), pp. 339–87.

Ajmar-Wollheim, Narta, '"The Spirit is Ready, but the Flesh is Tired": Erotic Objects and Marriage in Early Modern Italy', in Sara F. Matthews-Grieco (ed.), *Erotic Cultures of Renaissance Italy* (Farnham: Ashgate, 2010), pp. 141–69.

Almagro Cárdenas, Antonio, *Estudio sobre las inscripciones árabes de Granada* (Granada, 1879).

Álvarez Lopera, José, 'La Alhambra entre la conservación y la restauración (1905–1915)', *Cuadernos de Arte de la Universidad de Granada* 24(29/31) (1977): entire volume.

Álvaro Zamora, María Isabel, 'La cerámica andalusí', *Artigrama* 22 (2007): 337–70.

Andaloro, Maria (ed.), *Nobiles Officinae: perle, filigrane e trame di seta dal Palazzo Reale di Palermo*, 2 vols (Palermo: Guiseppe Maimone Editore, 2006).

Andalusī, Ṣāʿid, al-, *Science in the Medieval World. 'Book of the Categories of Nations'*, ed. and trans. Semaan I. Salem and Alok Kumar (Austin: University of Texas Press, 1991).

Anderson, Ruth Matilda, *Hispanic Costume 1480–1530* (New York: Hispanic Society, 1979).

Andrews, Peter Alford, 'The Generous Heart or the Mass of Clouds: The Court of Tents of Shah Jahan', *Muqarnas* 4 (1987): 149–65.

Andrews, Peter Alford, *Felt Tents and Pavilions: The Nomadic Tradition and its Interaction with Princely Tentage*, 2 vols (London: Melisende, 1999).

Arié, Rachel, *L'Espagne musulmane au temps des Nasrides (1232–1492)* (Paris: E. de Boccard, 1973).

Arjomand, Said Amir, *The Shadow of God and the Hidden Imam: Religion, Political Order, and Societal Change in Shiite Iran from the Beginning to 1890* (Chicago, IL: University of Chicago Press, 1984).

Aṭraqjī, Wājida Majīd ʿAbdullāh al-, *al-Marʾa fī adab al-ʿaṣr al-ʿAbbāsī* (Baghdad: Dār al-Rashīd, 1981).

The Arts of Islam Hayward Gallery, 8 April–4 July 1976 (London: Arts Council of Great Britain, 1976).

Ashtiany, Julia, T. M. Johnstone, J. D. Latham, R. B. Serjeant and G. Rex Smith (eds), *ʿAbbasid Belles-Lettres* (Cambridge: Cambridge University Press, 1990).

Ayora-Cañada, María José, Ana Domínguez Vidal, María José de la Torre López and Ramón Francisco Rubio Domene, 'Plasterwork Research by Infrared and Raman Spectroscopy: Identification of Pictorial Materials *in situ* and in the Laboratory', in *REMAI, Actas*, pp. 637–44, available at: http://remai.alhambra-patronato.es/es/content/actas-del-congreso-remai, last accessed 15 December 2013.

Badía, Domingo (Alí Bey), *Viajes por Marruecos*, ed. Salvador Barberá (Madrid: Editora Nacional, 1984).

Baeza, Gonzalo de, *Cuentas de Gonzalo de Baeza, Tesorero de Isabel la Católica*, ed. Antonio de la Torre and E. A. de la Torre, 2 vols (Madrid: Consejo Superior de Investigaciones Científicas, 1957).

Baker, Patricia, *Islamic Textiles* (London: British Museum Press, 1995).

Barceló, Miquel, 'El Califa patente: el ceremonial omeya de Córdoba o la escenificación del poder', in Antonio Vallejo Triano (ed.), *El Salón de ʿAbd al-Raḥmān III* (Córdoba: Imprenta San Pablo, 1995), pp. 153–76.

Barrios Rozúa, Juan Manuel, 'La Alhambra de Granada y los difíciles comienzos de la restauración arquitectónica (1814–1840)', *Boletín de la Real Academia de Bellas Artes de San Fernando* 106/107 (2008): 131–58.

Barrios Rozúa, Juan Manuel, 'Una polémica en torno a los criterios para restaurar la Alhambra: Salvador Amador frente a Narciso Pascual y Colomer (1846–1849)', *Reales Sitios* 180 (2009): 42–70.

Barrios Rozúa, Juan Manuel, *Alhambra romántica: Los comienzos de la restauración arquitectónica en España* (Granada: Universidad de Granada/Patronato de la Alhambra y Generalife, 2016).

Bastawi, Mona R., 'Vestidos femeninos en el *Lisān al-ʿarab* de Ibn Manẓur', in Manuela Marín (ed.), *Tejer y vestir de la antigüedad al Islam* (Madrid: Consejo Superior de Investigaciones Científicas, 2001), pp. 239–53.

Bauer, Franz Alto (ed.), *Visualisierungen von Herrschaft. Frühmittelalterliche Residenzen Gestalt und Zeremoniell* BYZAS 5 (2006).

Becker, John, *Pattern and Loom. A Practical Study of the Development of Weaving Techniques in China, Western Asia and Europe* (Copenhagen: Rhodos International, 1987).

Behrens-Abouseif, Doris, 'The Citadel of Cairo: Stage for Mamluk Ceremonial', *Annales Islamologiques* 24 (1988): 25–79.

Behrens-Abouseif, Doris, *Practising Diplomacy in the Mamluk Sultanate: Gifts and Material Culture in the Medieval Muslim World* (London: I. B. Tauris, 2014).

Beihammer, Alexander, Stavroula Constantinou and Maria Parani (eds), *Court Ceremonies and Rituals of Power in Byzantium and the Medieval Mediterranean. Comparative Perspectives* (Leiden: Brill, 2013).

Bellamy, Patricia Catherine and María José Calvín Velasco, 'Identification of Decorative Techniques Used in Nasrid Plasterwork through the Restoration of Plasterwork Fragments from the Generalife Palace', in

REMAI, Actas, pp. 653–61, available at: http://remai.alhambra-patronato.es/es/content/actas-del-congreso-remai, last accessed 15 December 2013.

Belting, Hans, *Florence and Baghdad: Renaissance Art and Arabic Science*, trans. Deborah Lucas Schneider (Cambridge, MA: Harvard University Press, 2011).

Bennison, Amira K. (ed.), *The Articulation of Power in Medieval Iberia and the Maghrib* (Oxford: Oxford University Press, 2014).

Benveniste, Émile, 'The Nature of Pronouns', in *Problems in General Linguistics*, trans. Mary Elizabeth Meek (Coral Gables, FL: University of Miami Press, 1971), pp. 217–22.

Benveniste, Émile, 'Subjectivity in Language', in *Problems in General Linguistics*, trans. Mary Elizabeth Meek (Coral Gables, FL: University of Miami Press, 1971), pp. 223–30.

Bermúdez Pareja, Jesús, 'Crónica de la Alhambra', *Cuadernos de la Alhambra* 1 (1965): 99–115.

Bermúdez Pareja, Jesús, 'Crónica de la Alhambra: Obras en el Cuarto Dorado', *Cuadernos de la Alhambra* 1 (1965): 108–10.

Bermúdez López, Jesús, 'The City Plan of the Alhambra', in Amira K. Bennison (ed.), *The Articulation of Power in Medieval Iberia and the Maghrib* (Oxford: Oxford University Press, 2014), pp. 153–61.

Blair, Sheila S., 'Inscribing the Square: The Inscriptions on the Maidān-i Shāh in Iṣfahān', in Mohammad Gharipour and Irvin Cemil Schick (eds), *Calligraphy and Architecture in the Muslim World* (Edinburgh: Edinburgh University Press, 2013), pp. 13–28.

Blair, Sheila S., *Text and Image in Medieval Persian Art* (Edinburgh: Edinburgh University Press, 2014).

Blair, Sheila S. and Jonathan Bloom, *Cosmophilia: Islamic Art from the David Collection, Copenhagen* (Boston, MA: Charles S. and Isabella V. McMullen Museum of Art, Boston College, 2006).

Boloix Gallardo, Bárbara, 'Las primeras celebraciones del Mawlid en al-Andalus y Ceuta, según la *Tuḥfat al-mugtarib* de al-Qastālī y el *Maqṣad al-sarīf* de al-Bādisī', *Anaquel de Estudios Árabes* 22 (2011): 79–96.

Boloix-Gallardo, Bárbara, 'The Genealogical Legitimization of the Naṣrid Dynasty: The Alleged Anṣārī Origins of the Banū Naṣr', in Amira K. Bennison (ed.), *The Articulation of Power in Medieval Iberia and the Maghrib* (Oxford: Oxford University Press, 2014), pp. 61–85.

Bombaci, Alessio, *The Kufic Inscription in Persian Verses in the Court of the Royal Palace of Masʿūd III at Ghazni* (Rome: IsMEO, 1966).

Bonebakker, S. A., 'Ibn al-Muʿtazz and *Kitāb al-Badīʿ*', in Julia Ashtiany, T. M. Johnstone, J. D. Latham, R. B. Serjeant and G. Rex Smith (eds), *ʿAbbasid Belles-Lettres* (Cambridge: Cambridge University Press, 1990), pp. 388–411.

Borges, Victor (Hugo López), 'Nasrid Plasterwork: Symbolism, Materials, Techniques', *V&A Conservation Journal* 48 (2004): 10–14.

Brill, Robert H., *Chemical Analyses of Early Glasses*, 2 vols (Corning, NY: Corning Museum of Glass, 1999).

Broadbridge, Anne F., *Kingship and Ideology in the Islamic and Mongol Worlds* (Cambridge: Cambridge University Press, 2008).

Brown, Elizabeth A. R. and Nancy Freeman Regalado, '*La grant feste*: Philip the Fair's Celebration of the Knighting of His Sons in Paris at Pentecost of 1313', in Barbara A. Hanawalt and Kathryn L. Reyerson (eds), *City and Spectacle in Medieval Europe* (Minneapolis, MN: University of Minneapolis Press, 1994), pp. 56–86.

Brown, James A. O. C., '"Azafid Ceuta, *Mawlid al-Nabī* and the Development of Marīnid Strategies of Legitimation', in Amira K. Bennison (ed.), *The Articulation of Power in Medieval Iberia and the Maghrib* (Oxford: Oxford University Press, 2014), pp. 127–51.

Bunt, Cyril, *Hispano-Moorish Fabrics* (Leigh-on-Sea: F. Lewis, 1966).

Burgio, Lucia, 'Microscopy Analysis of Hispano-Moresque Samples from the Alhambra', *V&A Museum Science Report* (June 2004): 1–23.

Bush, Olga, 'Architecture, Poetic Texts and Textiles in the Alhambra', PhD dissertation, Institute of Fine Arts, New York University, 2006.

Bush, Olga, '"When My Beholder Ponders": Poetic Epigraphy in the Alhambra', in Linda Komaroff (ed.), *Pearls from Water, Rubies from Stone: Studies in Islamic Art in Honor of Priscilla Soucek*, Artibus Asiae 66(2) (2006): 55–67.

Bush, Olga, 'A Poem is a Robe and a Castle: Inscribing Verses on Textiles and Architecture in the Alhambra', in *Textiles as Cultural Expressions: Proceedings of the 11th Biennial Symposium of the Textile Society of America*, Honolulu, Hawai'i, 2008, available at: http://digitalcommons. unl.edu.

Bush, Olga, 'The Writing on the Wall: Reading the Decoration of the Alhambra', *Muqarnas* 26 (2009): 119–47.

Bush, Olga '"Designs Always Polychromed or Gilded": The Aesthetics of Color in the Alhambra', in Sheila Blair and Jonathan Bloom (eds), *And Diverse Are Their Hues: Color in Islamic Art and Culture* (New Haven, CT: Yale University Press, 2011), pp. 53–75.

Bush, Olga, 'Textile Fragment [cat. No. 48]', in Maryam D. Ekhtiar, Priscilla P. Soucek, Sheila R. Canby and Navina Najat Haidar (eds), *Masterpieces from the Department of Islamic Art in the Metropolitan Museum of Art* (New Haven, CT: Yale University Press, 2011), pp. 81–2.

Bush, Olga, 'Textile Fragment [cat. No. 49]', in Maryam D. Ekhtiar, Priscilla P. Soucek, Sheila R. Canby and Navina Najat Haidar (eds), *Masterpieces from the Department of Islamic Art in the Metropolitan Museum of Art* (New Haven, CT: Yale University Press, 2011), pp. 82–3.

Bush, Olga, 'Prosopopoeia: Performing the Reciprocal Gaze', introduction, in Olga Bush and Avinoam Shalem (eds), *Gazing Otherwise: Modalities of Seeing In and Beyond the Lands of Islam*, special issue, *Muqarnas* 32 (2015): 13–19.

Bush, Olga, 'Canopy', in Anika Reineke, Anne Röhl, Mateusz Kapustka and Tristan Weddigen (eds), *Textile Terms: A Glossary* (Emsdetten/Berlin: Edition Imorde, 2017), pp. 23–7.

Bush, Olga, 'Poetic Inscriptions and Gift Exchange in the Medieval Islamicate World', *Gesta* 56(2) (2017): 179–97.

Bush, Olga and Avinoam Shalem (eds), *Gazing Otherwise: Modalities of Seeing In and Beyond the Lands of Islam*, special issue, *Muqarnas* 32 (2015).

Cabanelas [Rodríguez], Darío, *El techo del Salón de Comares en la Alhambra. Decoración, policromía, simbolismo y etimología* (Granada: Patronato de la Alhambra, 1988).

Cabanelas Rodríguez, Darío, 'Fachada de Comares y la llamada "Puerta de la Casa Real" en la Alhambra', *Cuadernos de la Alhambra* 27 (1991): 103–18.

Cabanelas Rodríguez, Darío, 'Dos tesis aparentemente innovadoras en la historia de la Alhambra', *Boletín de la Real Academia de Bellas Artes de Granada*, 2 (1991): 37–48.

Cabanelas Rodríguez, Darío, 'Cronología de edificaciones de Muhammad V en la Alhambra', in *Realidad y símbolo de Granada*, exhibition catalogue (Bilbao: Banco Bilbao Vizcaya, 1992), pp. 189–202.

Cabanelas Rodríguez, Darío and Antonio Fernández-Puertas, 'Inscripciones poéticas del Partal y de la Fachada de Comares', *Cuadernos de la Alhambra* 10/11 (1974/5): 117–200.

Cabanelas Rodríguez, Darío and Antonio Fernández-Puertas, 'Los poemas de las tacas del arco de acceso a la sala de la Barca', *Cuadernos de la Alhambra* 19/20 (1987): 61–152.

Cabañero Subiza, Bernabé, 'La Aljafería de Zaragoza', in Gonzalo M. Borrás Gualis (ed.), *Arte andalusí* (Zaragoza: Universidad de Zaragoza, 2008), pp. 103–29.

Cabañero Subiza, Bernabé and Valero Herrera Ontañón, 'La techumbre de la ampliación de al-Hakam II de la mezquita aljama de Córdoba. Análisis técnico y estudio formal de su policromía', *Cuadernos de Madinat al-Zahra* 5 (2004): 391–412.

Calatrava, Juan, 'Owen Jones: Diseño islámico y arquitectura moderna', in Juan Calatrava, Mariam Rosser-Owen, Abraham Thomas and Rémi Labrusse (eds), *Owen Jones y la Alhambra* (Granada: Patronato de la Alhambra y Generalife and Victoria and Albert Museum, London, 2011), pp. 9–41.

Calatrava, Juan and María González-Pendás, 'Leopoldo Torres Balbás: Architectural Restoration and the Idea of "Tradition" in Early Twentieth-Century Spain', *Journal of Historic Preservation, History, Theory, and Criticism* 4(2) (2007): 40–9.

Calatrava, Juan, Mariam Rosser-Owen, Abraham Thomas and Rémi Labrusse, *Owen Jones y la Alhambra* (Granada: Patronato de la Alhambra y Generalife and Victoria and Albert Museum, London, 2011).

Calero Secall, María Isabel and Virgilio Martínez Enamorado, *Málaga, ciudad de al-Andalus* (Málaga: Ágora, 1995).

Calvo, Susana, 'El arte de los reinos taifas: tradición y ruptura', *Anales de Historia del Arte* Volumen Extraordinario 2 (2011): 69–92.

Canard, Marius, 'Les relations entre les Mérinides et les Mamelouks au XIVe siècle', *Annales de l'Institut d'Études Orientale* 5 (1939–1941): 41–81.

Canard, Marius, 'Le cérémonial fatimide et le cérémonial byzantine: essai de comparaison', *Byzantion* 21 (1951): 355–420.

Canepa, Matthew P., 'Inscriptions, Royal Spaces and Iranian Identity: Epigraphic Practices in Persia and the Ancient Iranian World', in Antony Eastmond (ed.), *Viewing Inscriptions in the Late Antique and Medieval World* (Cambridge: Cambridge University Press, 2015), pp. 10–35.

Capitan-Vallvey, Luis, Eloisa Manzano and Víctor J. Medina Florez, 'Estudio comparativo de algunos zócalos pintados nazaríes localizados en diversos edificios de Granada', *Cuadernos de la Alhambra* 28 (1992): 231–51.

Carboni, Stefano, 'Cylindrical Ivory Boxes with Open Decoration: Mamluk, Nasrid or Something Else?' *Journal of the David Collection* 2(2) (2005): 214–25.

Carboni, Stefano and Carlo Maria Suriano (eds), *La seta islamica: temi ed influenze culturali* (Florence: Museo Nazionale de Bargello, 1999).

Cardell-Fernández, Carolina and Carmen Navarrete-Aguilera, 'Pigment and Plasterwork Analyses of Nasrid Polychromed Lacework Stucco in the Alhambra (Granada, Spain)', *Studies in Conservation* 51(3) (2006): 161–76.

Carvajal López, José Cristóbal, 'Resultados de una intervención arqueológica en la puerta de las Granadas', *Cuadernos de la Alhambra* 45 (2010): 29–45.

Castera, Jean Marc, 'La cupola a mouqarnas della sala delle due sorelle dell'Alhambra di Granada', in Michele Emmer (ed.), *Matematica e cultura* (Berlin: Springer, 2005), pp. 101–10.

Castera, Jean Marc, 'El decorado de la Alhambra: una geometría viva', in José A. González Alcantud and Abdellouahed Akmir (eds), *La Alhambra: Lugar de la memoria y el diálogo* (Granada: Editorial Comares, 2008), pp. 152–63.

Castilla Brazales, Juan and Antonio Orihuela Uzal, *En busca de la Granada andalusí* (Granada: Editorial Comares, 2002).

Celestial Pen, The: Islamic Calligraphy, exhibition catalogue (New York: Metropolitan Museum of Art, 1982).

Clavijo, Ruy González de, *Clavijo. Embassy to Tamerlane 1403–1406*, trans. and introduction Guy Le Strange (London: Routledge, 1928).

Clinton, Jerome W., 'Image and Metaphor: Textiles in Persian Poetry', in Carol Bier (ed.), *Woven from the Soul, Spun from the Heart. Textile Arts of Safavid and Qajar Iran (16th–19th Centuries)* (Washington: Textile Museum, 1987), pp. 7–11.

Codding, Mitchell A., Mencia Figueroa Villota, John O'Neil and Patrick Lenagham (eds), *The Hispanic Society of America. Tesoros* (New York: Hispanic Society of America, 2000).

Cole, Peter (ed. and trans.), *The Dream of the Poem: Hebrew Poetry from Muslim and Christian Spain, 950–1492* (Princeton, NJ: Princeton University Press, 2007).

Contreras, Rafael, *Estudio descriptivo de los monumentos árabes de Granada, Sevilla y Córdoba, o sea la Alhambra, el Alcázar y la Gran Mezquita de Occidente* (Madrid, 1878).

Conway, Bevil R., Akiyoshi Kitaoka, Arash Yazdanbakhsh, Christopher C. Pack and Margaret S. Livingstone, 'Neural Basis for a Powerful Static Motion Illusion', *Journal of Neuroscience* 25(23) (2005): 5651–6.

Cory, Stephen, 'Honouring the Prophet's Family: A Comparison of the Approaches to Political Legitimacy of Abū'l-Ḥasan ʿAlī al-Marīnī and Aḥmad al-Manṣūr al-Saʿdī', in Amira K. Bennison (ed.), *The Articulation of Power in Medieval Iberia and the Maghrib* (Oxford: Oxford University Press, 2014), pp. 107–24.

Crang, Mike and Nigel Thrift (eds), *Thinking Space* (New York: Routledge, 2000).

Crary, Jonathan, *Suspensions of Perception: Attention, Spectacle, and Modern Culture* (Cambridge, MA: MIT Press, 1999).

Crone, Patricia, *God's Caliph: Religious Authority in the First Centuries of Islam* (Cambridge: Cambridge University Press, 1986).

Crowther, Paul, *Phenomenology of the Visual Arts (even the frame)* (Stanford, CA: Stanford University Press, 2009).

Curiger, Bice, *The Expanded Eye: Stalking the Unseen*, exhibition catalogue, Kunsthaus, Zurich, 16 June–3 September 2006 (Ostfildern: Hatje Cantz Verlag, 2006).

de Argote, Simón, *Nuevos paseos históricos, artísticos, económico-políticos, por Granada y sus contornos*, 3 vols (Granada, 1807).

de la Torre López, María José, Ramón Francisco Rubio Domene and María José Campos Suñol, 'Mineralogical-petrographic Study of Islamic Plasterwork: Textural and Compositional Aspects', in *REMAI, Actas*, pp. 586–94, available at: http://remai.alhambra-patronato.es/es/content/actas-del-congreso-remai, last accessed 15 December 2013.

de Man, Paul, *The Rhetoric of Romanticism* (New York: Columbia University Press, 1984).

de Man, Paul, *The Resistance to Theory* (Minneapolis: University of Minnesota Press, 1986).

Denny, Walter B., 'Lattice-Design Carpet', in Maryam D. Ekhtiar, Priscilla P. Soucek, Sheila R. Canby and Navina Najat Haidar (eds), *Masterpieces from the Department of Islamic Art in the Metropolitan Museum of Art* (New Haven, CT: Yale University Press, 2011), pp. 84–5.

Dickie, James, 'The Palaces of the Alhambra', in Jerrilynn D. Dodds (ed.), *Al-Andalus. The Art of Islamic Spain* (New York: Metropolitan Museum of Art, 1992), pp. 134–151.

Díez Jorge, María Elena, 'Purificación y placer: el agua y las mil y una noches en los baños de Comares', *Cuadernos de la Alhambra* 40 (2004): 123–50.

Díez Jorge, María Elena (ed.), *La Alhambra y el Generalife: guía histórico-artística* (Granada: Universidad de Granada, 2006).

Díez Jorge, María Elena, 'Los alicatados del baño de Comares de la Alhambra, ¿Islámico o Cristiano?', *Archivo Español de Arte* 80(317) (2007): 25–43.

Dodd, Erica Cruikshank and Shereen Khairallah, *The Image of the Word: A Study of Quranic Verses in Islamic Architecture*, 2 vols (Beirut: American University of Beirut, 1981).

Dodds, Jerrilynn D. (ed.), *Al-Andalus. The Art of Islamic Spain* (New York: Metropolitan Museum of Art, 1992).

Dodds, Jerrilynn D., María Rosa Menocal and Abigail Krasner Balbale, *The Arts of Intimacy. Christians, Jews, and Muslims in the Making of Castilian Culture* (New Haven, CT: Yale University Press, 2008).

Dold-Samplonius, Yvonne, 'Calculating Surface Areas and Volumes in Islamic Architecture', in Jan P. Hogendijk and Abdelhamid I. Sabra (eds), *The Enterprise of Science in Islam. New Perspectives* (Cambridge, MA: MIT Press, 2003), pp. 235–65.

Ecker, Heather, *Caliphs and Kings. The Art and Influence of Islamic Spain* (Washington, DC: Arthur M. Sackler Gallery, Smithsonian Institution, 2004).

Ecker, Heather, 'Jarrón', in *Los Jarrones de la Alhambra* (Granada: Patronato de la Alhambra and Junta de Andalucía, 2006), pp. 166–7.

Eggleton, Lara, 'History in the Making: The Ornament of the Alhambra and the Past-facing Present', *Journal of Art Historiography* 6 (2012): 1–29.

El-Bizri, Nader, 'A Philosophical Perspective on Alhazen's Optics', *Arabic Sciences and Philosophy* 15(2) (2005): 189–217.

El-Bizri, Nader, 'Classical Optics and the *Perspectiva* Traditions Leading to the Renaissance', in Charles Carman and John Hendrix (eds), *Renaissance Theories of Vision* (Aldershot: Ashgate, 2010), pp. 11–30.

Errera, Isabelle, *Catalogue d'étoffes anciennes at modernes* (Brussels: Musées Royaux des Arts Décoratifs de Bruxelles, 1927).

Ethington, Phillip J., 'Sociovisual Perspective: Vision and the Forms of the Human Past', in Barbara Maria Stafford (ed.), *A Field Guide to a New Meta-Field: Bridging the Humanities–Neuroscience Divide* (Chicago, IL: University of Chicago Press, 2011), pp. 123–52.

Fāghiyyah, Saʿadiyyah (ed.), *Lisān al-Dīn Ibn al-Khaṭīb, Nufāḍat al-jirāb fī ʿulālat al-igtirāb* (Casablanca, Maṭbaʾa al-Najāḥ al-Jadīda, 1989).

Feliciano, María Judith, 'Muslim Shrouds for Christian Kings? A Reassessment of Andalusi Textiles in Thirteenth-Century Castilian Life and Ritual', in Cynthia Robinson and Leyla Rouhi (eds), *Under the Influence: Questioning the Comparative in Medieval Castile* (Leiden: Brill, 2005), pp. 101–32.

Fenoll Hach-Alí, Purificación and Alberto López Galindo, *Simetría en la Alhambra. Ciencia, belleza e intuición* (Granada: Universidad de Granada – Consejo Superior de Investigaciones Científicas, 2003).

Fernández-Puertas, Antonio, 'Un paño decorativo de la Torre de las Damas', *Cuadernos de la Alhambra* 9 (1973): 37–52.

Fernández-Puertas, Antonio, *La fachada del Palacio de Comares* (Granada: Patronato de la Alhambra, 1980).

Fernández-Puertas, Antonio, 'Memoria de la excavación realizada en el sector N. del mexuar del Palacio de Comares', *Cuadernos de la Alhambra* 18 (1982): 231–8.

Fernández-Puertas, Antonio, 'Calligraphy in al-Andalus', in Salma Khadra Jayyusi (ed.), *The Legacy of Muslim Spain* (Leiden: Brill, 1992), pp. 639–76.

Fernández-Puertas, Antonio, *The Alhambra* (London: Saqi, 1997).

Fernández-Puertas, Antonio, 'The Three Great Sultans of al-Dawla al-Ismāʿīliyya al-Naṣriyya Who Built the Fourteenth-Century Alhambra: Ismāʿīl I, Yūsuf I, Muḥammad V', *Royal Asiatic Society of Great Britain and Ireland* 7(1) (1997): 1–25.

Fernández-Puertas, Antonio, 'El Arte', in María Jesús Viguera Molins (ed.), *Historia de España Menéndez Pidal, vol. 8: 4, El reino nazarí de Granada (1232–1492). Sociedad, vida y cultura* (Madrid: Espasa-Calpe, 2000), pp. 191–284.

Fernández-Puertas, Antonio, 'El poema de la Fachada de Mexuar', *Cuadernos de la Alhambra* 41 (2005): 37–57.

Fernández-Puertas, Antonio, *Clepsidras y relojes musulmanes* (Granada: Fundación El legado andalusi, 2010).

Fernández-Puertas, Antonio, 'El *Mawlid* de 764/1362 de la Alhambra según el manuscrito de Leiden y la *Nufāḍa III* editada', in Celia del Moral and Fernando Velázquez Bazanta (eds), *Ibn al-Jaṭīb y su tiempo* (Granada: Universidad de Granada, 2012), pp. 161–203.

Ferry, Kathryn, 'Printing the Alhambra: Jones and Chromolithography', *Architectural History* 46 (2003): 175–88.

Fierro, Maribel, 'Opposition to Sufism in al-Andalus', in Frederick de Jong and Bernd Radtke (eds), *Islamic Mysticism Contested: Thirteen Centuries of Controversies and Polemics* (Leiden: Brill, 1999), pp. 174–206.

Fierro, Maribel, 'The Anṣārīs, Nāṣir al-Dīn and the Naṣrids in al-Andalus', *Jerusalem Studies in Arabic and Islam* 31 (2006): 232–49.

Fierro, Maribel, 'Pompa y ceremonia en los califatos del Occidente islámico (s. II/VIII–IX/XV)', *Cuadernos de CEMyR* 17 (2009): 125–52.

Flood, Finbarr Barry, *The Great Mosque of Damascus* (Leiden: Brill, 2001).

Frankel, Nicholas, 'The Ecstasy of Decoration: *The Grammar of Ornament* as Embodied Experience', *Nineteenth-Century Art World-Wide* 2(1) (2003): 1–24.

Frenkel, Yehoshua, '*Mawlid al-nabī* at the Court of Sulṭān Aḥmad al-Manṣūr al-Saʿdī', *Jerusalem Studies in Arabic and Islam* 19 (1995): 157–72.

Frenkel, Yehoshua, 'Public Projection of Power in Mamluk Bilād al-Shām', *Mamlūk Studies Review* 11(1) (2007): 39–53.

Fuchs, H. and F. de Jong, '*Mawlid*', *Encyclopedia of Islam*, New Edition (*EI2*) (Leiden: Brill, 1954–2002), vol. 6, pp. 895–98.

Galera Mendoza, Esther and Rafael López Guzmán, *Arquitectura, mercado y ciudad: Granada a mediados del siglo XVI* (Granada: Universidad de Granada, 2003).

García Bueno, Ana and Víctor J. Medina Flórez, 'The Nasrid Plasterwork at "qubba Dār al-Manjara al-Kubrā"' in Granada: Characterization of Materials and Techniques', *Journal of Cultural Heritage* 5(1) (2004): 75–89.

García Gómez, Emilio, 'Un precedente y una consecuencia del "Collar de la paloma"', *Al-Andalus* 16 (1951): 309–30.

García Goméz, Emilio, *Cinco poetas musulmanes* (Madrid: Espasa-Calpe, 1959).

García Gómez, Emilio, 'Estudio del "Dār aṭ-ṭirāz", preceptiva egipcia de la muwashshaḥ', *Al-Andalus* 27 (1962): 21–104.

García Gómez, Emilio, 'Notas sobre la topografía cordobesa en los "Anales de al-Ḥakam II", por 'Īsā al-Rāzī', *Al-Andalus* 20 (1965): 319–79.

García Gómez, Emilio, 'Armas, banderas, tiendas de campaña, monturas y correos en los "Anales de al-Ḥakam II", por 'Īsā al-Rāzī', *Al-Andalus* 32 (1967): 163–79.

García Gómez, Emilio, *Foco de antigua luz sobre la Alhambra. Desde un texto de Ibn al-Jatib en 1362* (Madrid: Publicaciones del Instituto Egipcio de Estudios Islámicos en Madrid, 1988).

García Gómez, Emilio, *Poemas árabes en los muros y fuentes de la Alhambra* (Madrid: Publicaciones del Instituto Egipcio de Estudios Islámicos, 1996).

García Granados, J. A. and Carmen Trillo San José, 'Obras de los Reyes Católicos en Granada (1492–1495)', *Cuadernos de la Alhambra* 26 (1990): 145–68.

Garulo, Teresa, *La literatura árabe de al-Andalus durante el siglo XI* (Madrid: Hiperión, 1998).

Garzón Pareja, Manuel, 'Una dependencia de la Alhambra: la alcaicería', *Cuadernos de la Alhambra* 8 (1972): 65–76.

Gelder, G. J. H. Van, *Beyond the Line. Classical Arabic Literary Critics on the Coherence and Unity of the Poem* (Leiden: Brill, 1982).

Gharipour, Mohammad and Irvin Cemil Schick (eds), *Calligraphy and Architecture in the Muslim World* (Edinburgh: Edinburgh University Press, 2013).

Ghouchani, Abdullah, 'Some 12th Century Iranian Wine Ewers and their Poems', *Bulletin of the Asia Institute* 13 (1999): 141–7.

Goitein, Shelomo Dov, *A Mediterranean Society: The Jewish Communities of the Arab World as Portrayed in the Documents of the Cairo Geniza*, 6 vols (Berkeley: University of California Press, 1983).

Golombek, Lisa, 'The Function of Decoration in Islamic Architecture', in Margaret B. Ševčenko (ed.), *Theories and Principles of Design in the Architecture of Islamic Societies* (Cambridge, MA: Aga Khan Program for Islamic Architecture, 1988), pp. 35–45.

Golombek, Lisa, 'The Draped Universe of Islam', in Priscilla P. Soucek (ed.), *Content and Context of Visual Art in the Islamic World* (University Park, PA: Pennsylvania State University Press, 1988), pp. 25–50.

Gómez Moreno, Manuel, *Guía de Granada* (Granada, 1892).

Gonzalez, Valérie, *Beauty and Islam: Aesthetics in Islamic Art and Architecture* (London: I. B. Tauris, 2001).

González Alcantud, José Antonio and Antonio Malpica Cuello (eds), *Pensar la Alhambra* (Barcelona: Anthropos Editorial, 2001).

González Costa, Amina and Gracia López Anguita (eds), *Historia del sufismo en al-Andalus: maestros sufíes de al-Andalus y el Magreb* (Granada: Almuzara, 2009).

Gortz, Juan de, *Embajada del Emperador de Alemania Otón I al Califa de Córdoba Abderrahman III* (Madrid, 1872).

Grabar, Oleg, *The Alhambra* (Cambridge, MA: Harvard University Press, 1978).

Grabar, Oleg, *The Mediation of Ornament* (Princeton, NJ: Princeton University Press, 1992).

Gruendler, Beatrice and Louise Marlow (eds), *Writers and Rulers: Perspectives on their Relationship from Abbasid to Safavid Times* (Wiesbaden: Reichert, 2004).

Grunebaum, Gustave E. von, *Muhammadan Festivals* (London: Curzon, 1976).

Guest, Gerald B., 'Space', *Medieval Art History Today: Critical Terms*, special issue, *Studies in Iconography* 33 (2012): 219–30.

Gutzwiller, Kathryn, *Poetic Garlands: Hellenistic Epigrams in Context* (Berkeley: University of California Press, 1998).

Gutzwiller, Kathryn, 'Gender and Inscribed Epigram: Herenia Procula and the Thespian Eros', *Transactions of the American Philological Association* 134(2) (2004): 383–418.

Hanawalt, Barbara A. and Kathryn L. Reyerson (eds), *City and Spectacle in Medieval Europe* (Minneapolis, MN: University of Minneapolis Press, 1994).

Harvey, Leonard Patrick, *Islamic Spain 1250 to 1500* (Chicago, IL: University of Chicago Press, 1990).

Hassan, Ahmad Y. al-, 'An Eighth-Century Arabic Treatise on the Colouring of Glass: *Kitab al-durra al-maknuna* [*The Book of the Hidden Pearl*] of Jabir Ibn Hayyan, c. 721–c. 815', *Arabic Science and Philosophy* 19 (2009): 121–56.

Heath, Peter, 'Knowledge', in María Rosa Menocal, Raymond P. Scheindlin and Michael Sells (eds), *The Literature of al-Andalus* (Cambridge: Cambridge University Press, 2000), pp. 96–123.

Heinrichs, W. P., '*Tajnīs*', *Encyclopedia of Islam*, New Edition (*EI2*) (Leiden: Brill, 1954–2002), vol. 10, pp. 67–70.

Heinrichs, W. P., '*Ṭibāq*', *Encyclopedia of Islam*, New Edition (*EI2*) (Leiden: Brill, 1954–2002), vol. 10, pp. 450–2.

Hernández Giménez, Félix, 'La travesía de la Sierra de Guadarrama en el acceso a la raya musulmana del Duero', *Al-Andalus* 38 (1973): 69–187.

Herrero Carretero, Concha, 'Coffin Cover of María de Almenar', in Jerrilynn D. Dodds (ed.), *Al-Andalus. The Art of Islamic Spain* (New York: Metropolitan Museum of Art, 1992), pp. 324–5.

Hillenbrand, Robert, *Islamic Architecture. Form, Function, Meaning* (New York: Columbia University Press, 1994).

Hogendijk, Jan P., 'Discovery of an Eleventh-Century Geometrical Compilation: The Istikmal of Yusuf al-Mu'taman Ibn Hud, King of Saragossa', *Historia Mathematica* 13 (1986): 43–52.

Hogendijk, Jan P., 'Al-Mu'taman's Simplified Lemmas for Solving "Alhazen's Problem"', in J. Casulleras and J. Samsó (eds), *From Baghdad to Barcelona. Studies in the Islamic Exact Sciences in Honor of Prof. Juan Vernet*, 2 vols (Barcelona: Anuari de Filologia XIX–Instituto 'Millás Vallicrosa', 1996), vol. 1, pp. 59–101.

Hoffman, Donald [D.], *Visual Intelligence: How We Create What We See* (New York: Norton, 2000).

Hoffman, Donald D., 'The Interaction of Colour and Motion', in Rainer Mausfeld and Dieter Heyer (eds), *Colour Perception: Mind and the Physical World* (Oxford: Oxford University Press, 2003), pp. 361–77.

Hrvol Flores, Carol A., 'Engaging the Mind's Eye: The Use of Inscriptions in the Architecture of Owen Jones and A. W. N. Pugin', *Journal of the Society of Architectural Historians* 60(2) (2001): 158–79.

Hrvol Flores, Carol A., *Owen Jones. Design, Ornament, Architecture, and Theory in the Age of Transition* (New York: Rizzoli, 2006).

Ibn al-Haytham, *The Optics of Ibn al-Haytham. Book I–III. On Direct Vision*, ed. and trans. Abdelhamid I. Sabra, Studies of the Warburg Institute 40, 2 vols (London: University of London, 1989).

Ibn Ḥayyān, *Crónica del Califa 'Abdarrahman III an-Nasir entre los años 912 y 942 (al-Muqtabis V)*, trans. María Jesús Viguera and Federico Corriente (Zaragoza: Anubar Ediciones, 1981).

Ibn Khaldūn, 'Abd al-Raḥmān, *Kitāb al-'Ibar wa Dīwān al-Mubtada wa al-Khabar*, 7 vols (Cairo, 1284 H.).

Ibn Khaldūn, Abū Zakariya' Yaḥyā, *Histoire des Beni Abd el-Wad rois de Tlemcen jusqu'au règne d'Abou Hammou Mousa II par Abou Zakarya Yahia Ibn Khaldoun*, ed. and trans. Alfred Bel, 2 vols (Algiers: Imprimerie Orientale Pierre Fontana, 1903–13).

Ibn al-Khaṭīb, *al-Iḥāṭa fī akhbār gharnāṭa*, 2 vols (Cairo, 1901).

Ibn al-Khaṭīb, *al-Iḥāṭa fī ajbār Garnaṭa (al-Iḥāṭa*, Escorial MS 1673; and Cairo edn, 1901–2).

Ibn al-Khaṭīb, *al-Lamḥa al-badriyya fī dawla al-naṣriyya* (Beirut edn and Cairo edn, 1928).

Ibn al-Khaṭīb, *A'māl al-'Alān*, ed. Evariste Lévi-Provençal (Beirut, 1956).

Ibn al-Khaṭīb, *Poesía árabe clásica: Antología titulada 'Libro de la magia y de la poesía'*, ed. and trans. J. M. Continente Ferrer (Madrid: Instituto Hispano-Arabe de Cultura, 1981).

Ibn al-Khaṭīb, *Mushāhadāt Lisān al-Dīn ibn al-Khaṭīb fī bilād al-Maghrib wa'l-Andalus*, ed. Aḥmad Mukhtār al-'Abbādī (Alexandria: Mū'assasat Shabāb al-Jāmi'ah, 1983).

Ibn Marzūq, Muḥammad b. Aḥmad, *Al Musnad: hechos memorables de Abū l-Hasan, sultán de los Benimerines*, ed. and trans. María Jesús Viguera (Madrid: Instituto Hispano-Árabe de Cultura, 1977).

Ibn al-Zubayr, Aḥmad ibn al-Rashīd, *Book of Gifts and Rarities = Kitāb al-Hadāyā wa al-tuḥaf*, ed. and trans. Ghāda al-Ḥijjāwī al-Qaddūmī (Cambridge, MA: Harvard University Press, 1996).

Irving, Washington, *The Alhambra: A Series of Tales and Sketches of the Moors and Spaniards* (London, Philadelphia and Paris: Colburn & Bentley, Carey & Lea and Galignani, 1832).

Irving, Washington, *The Tales of the Alhambra* (Leon: Editorial Everest, 1974).

James, Liz, '"And Shall These Mute Stones Speak": Text as Art', in Liz James (ed.), *Art and Text in Byzantine Culture* (Cambridge: Cambridge University Press, 2007), pp. 188–206.

Los Jarrones de la Alhambra: Simbología y poder. Granada, capilla y cripta del Palacio de Carlos V, Conjunto Monumental de la Alhambra y Generalife, octubre 2006–marzo 2007, exhibition catalogue (Granada: Patronato de la Alhambra and Junta de Andalucía, 2006).

Jayyusi, Salma Khadra, 'Andalusī Poetry: The Golden Period', in Salma Khadra Jayyusi (ed.), *The Legacy of Muslim Spain* (Leiden: Brill, 1992), pp. 317–66.

Jiménez Castillo, Pedro, 'Talleres, técnicas y producciones de vidrio en al-Andalus', in Enrique Rontomé Notario and Teresa Carreras i Rossell (eds), *Vidrio islámico en al-Andalus: Real Fábrica de Cristal de la Granja, noviembre de 2006–abril 2007* (San Ildefonso, Segovia: Fundación Centro Nacional del Vidrio, 2006), pp. 51–70.

Jiménez Díaz, Nieves, 'Nuevos datos históricos-artísticos tras la intervención en la puerta de las Granadas', *Cuadernos de la Alhambra* 45 (2010): 45–64.

Jones, Alan and Richard Hitchcock (eds), *Studies on the Muwashshahāt and the Kharja* (Ithaca, NY: Ithaca Press Reading for the Board of the Faculty of Oriental Studies, Oxford University, 1991).

Jones, Christopher, 'Epigrams from Hierapolis and Aphrodisias', *Hermes* 125(2) (1997): 203–14.

Jones, Owen, *The Grammar of Ornament* (London, 1856).

Jones, Owen, *Decorative Ornament* (New York: Tass Press, 2006).

Jones, Owen and Jules Goury, *Plans, Elevations, Sections and Details of the Alhambra. From drawings taken on the spot in 1834 by the late M. Jules Goury and in 1834 and 1837 by Owen Jones Archt. With complete translation of the Arabic inscriptions and an historical notice of the Kings of Granada from the conquest of that city by the Arabs to the expulsion of the Moors by M. Pasqual de Gayangos* (London, 1842–45).

Johns, Jeremy, 'The Arabic Inscriptions of the Norman Kings of Sicily. A Reinterpretation', in Maria Andaloro (ed.), *Nobiles Officinae: perle, filigrane e trame di seta dal Palazzo Reale di Palermo*, 2 vols (Palermo: Guiseppe Maimone Editore, 2006), vol. 2, pp. 324–37.

Johns, Jeremy and Annliese Nef, 'Twenty Block Fragments with Arabic Inscriptions in Praise of Roger II from the Palace in Messina', in Maria Andaloro (ed.), *Nobiles Officinae: perle, filigrane e trame di seta dal Palazzo Reale di Palermo* (Palermo: Guiseppe Maimone Editore, 2006), vol. 1, pp. 765–70.

Johnson, Barbara, *Persons and Things* (Cambridge, MA: Harvard University Press, 2008).

Kalaitzidou, Mariana and Naima Anahnah, 'Universo decorativo en la Alhambra', *El legado andalusí* 27(7) (2006): 64–8.

Kaptein, Nico J. G., *Muḥammad's Birthday Festival. Early History in the Central Muslim Lands and Development in the Muslim West until the 10th/16th Century* (Leiden: Brill, 1993).

Kargère, Lucretia, 'The Use of Lapis Lazuli as a Pigment in Medieval Europe', *The Sherman Fairchild Center for Objects Conservation, The Metropolitan Museum of Art – Spring 2003 Treatment and Research Notes* 4(2) (2003): 5–7.

Katz, Marion Holmes, *The Birth of the Prophet Muḥammad. Devotional Piety in Sunni Islam* (London: Routledge, 2007).

Kenesson, Summer S., 'Nasrid Luster Pottery: The Alhambra Vases', *Muqarnas* 9 (1992): 93–115.

Khemir, Sabiha, 'The Arts of the Book', in Jerrilynn D. Dodds (ed.), *Al-Andalus. The Art of Islamic Spain* (New York: Metropolitan Museum of Art, 1992), pp. 115–26.

Khosraw, Nāṣer-e, *Book of Travel (Safarnāma)*, trans. W. M. Thackston Jr (Albany, NY: State University of New York Press, 1986).

Knysh, Alexander, 'Ibn al-Khaṭīb', in María Rosa Menocal, Raymond P. Scheindlin and Michael Sells (eds), *The Literature of al-Andalus* (Cambridge: Cambridge University Press, 2000), pp. 358–71.

Komaroff, Linda, 'Persian Verses of Gold and Silver: The Inscriptions on Timurid Metalwork', in Lisa Golombek and Maria Subtelny (eds), *Timurid Art and Culture: Iran and Central Asia in the Fifteenth Century* (Leiden: Brill, 1992), pp. 144–57.

Krohn, Deborah L., 'Belt or Girdle with a Woven Love Poem', in Andrea Bayer (ed.), *Art and Love in Renaissance Italy* (New York: Metropolitan Museum of Art, 2008), pp. 128–9.

Lafuente Alcántara, Emilio, *Inscripciones árabes de Granada* (Granada: Universidad de Granada, 2000).

Lampen, Angelika, 'The Princely Entry into Town, Significance and Change of a Multi-Media Event', in Margriet Hoogvliet (ed.), *Multi-Media*

Compositions from the Middle Ages to the Early Modern Period (Leuven: Peeters, 2004), pp. 41–63.

Lane, Edward William, *Arabic–English Lexicon* (London: Williams & Norgate, 2003).

Lavan, Luke, Ellen Swift and Toon Putzeys (eds), *Objects in Context, Objects in Use. Material Spatiality in Late Antiquity* (Leiden: Brill, 2007).

Lichtenstein, Jacqueline, *The Eloquence of Color: Rhetoric and Painting in the French Classical Age*, trans. E. McVarish (Berkeley: University of California Press, 1993).

Lindberg, David C., *Theories of Vision from al-Kindi to Kepler* (Chicago, IL: University of Chicago Press, 1976).

Lintz, Ulrike-Christiane, 'The Qur'anic Inscriptions of the Minaret of Jām in Afghanistan', in Mohammad Gharipour and Irvin Cemil Schick (eds), *Calligraphy and Architecture in the Muslim World* (Edinburgh: Edinburgh University Press, 2013), pp. 83–102.

Livingstone, Margaret S., 'Art, Illusion and the Visual System', *Scientific American* 258(1) (1988): 68–75.

Livingstone, Margaret, *Vision and Art: The Biology of Seeing* (New York: Harry N. Abrams, 2002).

López, Lourdes Blanca and María Dolores Blanca López, 'Technical and Material Study of the Plasterwork and *muqarnas* of the "Corral del Carbón" or *al-fundaq al-yadida* in Granada', in *REMAI, Actas*, pp. 662–73, available at: http://remai.alhambra-patronato.es/es/content/actas-del-congreso-remai, last accessed 15 December 2013.

López Borges, Victor Hugo, 'Origen, coleccionismo y uso de cinco fragmentos de yeserías nazaríes en el Victoria and Albert Museum', in *REMAI, Actas*, pp. 17–34, available at: http://remai.alhambra-patronato.es/es/content/actas-del-congreso-remai, last accessed 15 December 2013.

López Borges, Victor Hugo, María José de la Torre López and Lucia Burgio, 'Caracterización de materiales y técnicas de las yeserías nazaríes a través de la colección del Museo Victoria and Albert Museum', in *REMAI, Actas*, pp. 132–155, available at: http://remai.alhambra-patronato.es/es/content/actas-del-congreso-remai, last accessed 15 December 2013.

López Casares, Matilde, 'La ciudada palatina de la Alhambra y las obras realizadas en el siglo XVI a la luz de sus libros de cuentas', *Revista Española de Historia de la contabilidad* 10 (2009): 3–130.

López de Coca Castañer, José Enrique, 'La seda en el reino de Granada (siglos XV y XVI)', in *España y Portugal en las rutas de la seda* (Barcelona: Universidad de Barcelona, 1996), pp. 33–57.

López López, Angel C. and Antonio Orihuela Uzal, 'Una nueva interpretación del texto de Ibn al-Jaṭīb sobre la Alhambra en 1362', *Cuadernos de la Alhambra* 26 (1990): 121–44.

López Pertíñez, María Carmen, 'Puertas de madera nazaríes. Estructura y decoración. La Puerta de la Sala de dos Hermanas en la Alhambra de Granada', in *Ante el nuevo milenio: raíces culturales, proyección y actualidad del arte español. XIII Congreso Nacional de Historia de Arte* (Granada: Universidad de Granada, 2000), vol. 1, pp. 145–51.

López Pertíñez, María Carmen, *La carpintería en la arquitectura nazarí* (Granada: Fundación Rodríguez-Acosta, 2006).

López Redondo, Amparo, *Los Reyes Católicos y Granada* (Granada, 2004).

López Rodríguez, Silvia, María del Rosario López Rodríguez, Carmen María López Rodríguez and Diego José López Rodríguez, 'Geometría fractal en la Alhambra', *Cuadernos de la Alhambra* 39 (2003): 37–62.

Ma, John, 'The Epigraphy of Hellenistic Asia Minor: A Survey of Recent Research (1992–1999)', *American Journal of Archaeology* 104(1) (2000): 95–121.

Mack, Rosamund E., *Bazaar to Piazza, Islamic Trade and Italian Art, 1300–1600* (Berkeley: University of California Press, 2002).

Mackie, Louise W., 'Increase the Prestige: Islamic Textiles', *Arts of Asia* 26(1) (1996): 82–93.

Mackie, Louise W., *Symbols of Power: Luxury Textiles from Islamic Lands, 7th–21st Century* (Cleveland, OH: Cleveland Museum of Art, 2015).

Makariou, Sophie, 'Étude d'une scénographie poétique: l'oeuvre d'Ibn al-Jayyâb à la tour de la Captive (Alhambra)', *Studia Islamica* 96 (2003): 95–107.

Makovicky, E. and Purificación Fenoll Hach-Alí, 'Coloured Symmetry in the Mosaics of Granada, Spain', *Boletín de la Sociedad Española de Mineralogía* 22 (1999): 143–83.

Malpica Cuello, Antonio, 'La Alhambra que se construe. Arqueología y conservación de un monumento', in José Antonio González Alcantud and Antonio Malpica Cuello (eds), *Pensar la Alhambra* (Barcelona: Anthropos Editorial, 2001), pp. 33–67.

Maran, Joseph, 'Architecture, Power and Social Practice . . . An Introduction', in Joseph Maran, Carsten Juwig, Hermann Schwengel and Ulrich Thaler (eds), *Constructing Power. Architecture, Ideology and Social Practice* (Berlin: LIT Verlag, 2009), pp. 9–14.

Maran, Joseph, Carsten Juwig, Hermann Schwengel and Ulrich Thaler (eds), *Constructing Power. Architecture, Ideology and Social Practice* (Berlin: LIT Verlag, 2009).

Marhuenda, Luciano Rodrigo and Jorge Calancha de Passos, 'Crónica de conservación y restauración', *Cuadernos de la Alhambra* 28 (1992): 369–430.

Marinetto Sánchez, Purificación, 'La policromía de los capiteles del Palacio de los Leones', *Cuadernos de la Alhambra* 21 (1985): 79–97.

Marinetto Sánchez, Purificación, 'Las hojas de una puerta nazarí. La puerta de la calle de la Tiña en el Albaicín', *Anaquel de Estudios Árabes* 11 (2000): 407–12.

Marinetto Sánchez, Purificación, 'El uso de tejido y su decoración en los palacios de la Alhambra', in Amparo López Redondo and Purificación Marinetto Sánchez (eds), *A la luz de la seda. Catálogo de la colección de tejidos nazaríes del Museo Lázaro Galdiano y el Museo de la Alhambra* (Museo Lázaro Galdiano, Museo de la Alhambra and TF Editores, 2012), pp. 19–31.

Marinetto Sánchez, Purificación and Isabel Cambil Campaña, Catalogue entries nos. 106–118 in Enrique Rontormé Notario and Teresa Carreras i Rossell (eds), *Vidrio islámico en al-Andalus: Real Fábrica de Cristal de la Granja, noviembre de 2006–abril 2007*, exhibition catalogue (San Ildefonso, Segovia: Fundación Centro Nacional de Vidrio, 2006).

Martínez Caviró, Balbina, 'El arte nazarí y el problema de la loza dorada', in Jesús Bermúdez López (ed.), *Arte islámico en Granada. Propuesta para un museo de la Alhambra. 1 de abril–30 de septiembre de 1995, Palacio de Carlos V – la Alhambra* (Granada: Junta de Andalucía, Consejería de Cultura: Patronato de la Alhambra y Generalife: Comares Editorial, 1995), pp. 145–63.

Martínez Ruiz, Joaquina Albarracín de, *Vestido y adorno de la mujer musulmana de Yebala (Marruecos)* (Madrid: Consejo Superior de Investigaciones Científicas, 1964).

Mas'ūdī, al-, *Murūj al-Dhahab*, ed. and trans. Barbier de Meynard and Pavet de Courteille (Paris, 1861–77), vol. 7.

May, Florence Lewis, 'Textiles', in *The Hispanic Society of America. Handbook* (New York, 1938), p. 278.

May, Florence Lewis, *Silk Textiles of Spain* (New York: Hispanic Society of America, 1957).

Medina Flórez, Víctor and Ana García Bueno, 'Técnica pictórica empleada en la ejecución de los zócalos de la Alhambra y del Cuarto Real de Santo Domingo de Granada. Estudio comparativo', *Cuadernos de la Alhambra* 37 (2001): 9–20.

Meisami, Julie Scott, 'Palaces and Paradises: Palace Description in Medieval Persian Poetry', in Oleg Grabar and Cynthia Robinson (eds), *Islamic Art and Literature* (Princeton, NJ: Markus Wiener, 2001), pp. 21–54.

Meisami, Julie Scott, *Structure and Meaning in Medieval Arabic and Persian Poetry: Orient Pearls* (London: Routledge/Curzon, 2003).

Meisami, Julie Scott and Paul Starkey (eds), *Encyclopedia of Arabic Literature* (London and New York: Routledge, 1998), s.v. 'Rhetorical Figures'.

Menocal, María Rosa, 'The Newest "Discovery": the *Muwashshahāt*', in María Rosa Menocal, *The Arabic Role in Medieval Literary History: A Forgotten Heritage* (Philadelphia, PA: University of Pennsylvania Press, 1987), pp. 71–114.

Menocal, María Rosa, Raymond P. Scheindlin and Michael Sells (eds), *The Literature of al-Andalus* (Cambridge: Cambridge University Press, 2000).

Mesa Fernández, Elisa, *El lenguaje de la indumentaria. Tejidos y vestiduras en el* Kitāb al-Aghānī *de Abu al-Faraj al-Iṣfahānī* (Madrid: Concejo Superior de Investigaciones Científicas, 2008).

Monroe, James T., *Hispano-Arabic Poetry: A Student Anthology* (Berkeley: University of California Press, 1974).

Montesinos Amilibia, José María, 'Caleidoscopios y grupos cristalográficos en la Alhambra', in Manuel Vela Torres (ed.), *La Alhambra* (Granada: SAEM Thales, 1995), pp. 9–30.

Moral, Celia del, 'La literatura del período nazarí', in Concepción Castillo Castillo (ed.), *Estudios nazaríes* (Granada: Universidad de Granada, 1997), pp. 29–82.

Moral, Celia del and Fernando Velázquez Bazanta (eds), *Ibn al-Jaṭīb y su tiempo* (Granada: Universidad de Granada, 2012).

Moreno León, Eva and Paula Sánchez Gómez, 'Fragmentos de jarrón tipo Alhambra', in *Los Jarrones de la Alhambra* (Granada: Patronato de la Alhambra and Junta de Andalucía, 2006), pp. 175–7.

Motoyoshi Sumi, Akiko, *Description in Classical Arabic Poetry: Waṣf, Ekphrasis, and Interarts Theory* (Leiden: Brill, 2004).

Mulryne, J. R. and E. Goldring (eds), *Court Festivals of the European Renaissance: Art, Politics and Performance* (Aldershot: Ashgate, 2002).

Muñoz Cosme, Alfonso, 'Cuatro siglos de intervenciones en la Alhambra de Granada, 1492–1907', *Cuadernos de la Alhambra* 27 (1991): 151–90.

Navarro Espinach, Germán, 'El comercio de telas entre Oriente y Occidente (1190–1340)', in *Vestiduras ricas. El Monasterio de las Huelgas y su época 1170–1340, del 15 de marzo al 19 de junio de 2005, Palacio Real de Madrid* (Madrid: Patrimonio Nacional, 2005), pp. 89–106.

Necipoğlu, Gülru, 'Framing the Gaze in Ottoman, Safavid and Mughal Palaces', *Ars Orientalis* 23 (1993): 303–42.

Necipoğlu, Gülru, *The Topkapı Scroll: Geometry and Ornament in Islamic Architecture* (Santa Monica, CA: Getty Center for the History of Art and the Humanities, 1995).

Necipoğlu, Gülru, 'The Scrutinizing Gaze in the Aesthetics of Islamic Visual Cultures: Sight, Insight and Desire', in Olga Bush and Avinoam Shalem (eds), *Gazing Otherwise: Modalities of Seeing In and Beyond the Lands of Islam*, special issue, *Muqarnas*, 32 (2016): 23–61.

Nieto Soria, José Manuel, *Ceremonias de la realeza. Propaganda y legitimación en la Castilla trastamara* (Madrid: Editorial Nerea, 1993).

Nora, Pierre, 'Between Memory and History: *Lex Lieux de Mémoire*', trans. Marc Roudebush, *Representations* 26 (1989): 7–24.

Nykl, A. R., 'Inscripciones árabes de la Alhambra y del Generalife', *Al-Andalus* 4 (1936–39): 174–94.

Nykl, A. R., 'The Inscriptions of the "Freer Vase"', *Ars Orientalis* 2 (1957): 496–97.

O'Kane, Bernard, 'From Tents to Pavilions: Royal Mobility and Persian Palace', *Ars Orientalis* 23 (1993): 249–68.

O'Kane, Bernard, *The Appearance of Persian in Islamic Art* (New York: Persian Heritage Foundation, 2009).

Oliver Hurtado, José and Manuel, *Granada y sus monumentos árabes* (Málaga: M. Oliver Navarro, 1875).

Onians, John, *Neuroarthistory: From Aristotle and Pliny to Baxandall and Zeki* (New Haven, CT: Yale University Press, 2007).

Orihuela Uzal, Antonio, *Casas y palacios nazaríes: siglos XIII–XV* (Barcelona: Lunwerg Editores, 1995).

Orihuela Uzal, Antonio, 'La conservación de alicatados en la Alhambra durante la etapa de Rafael Contreras (1847–1890) ¿Modernidad o provisionalidad?', in José Antonio González Alcantud and Abdellouahed Akmir (eds), *La Alhambra: lugar de la memoria y el diálogo* (Granada: Comares, 2008), pp. 125–52.

Paccard, André, *Traditional Islamic Craft in Moroccan Architecture*, 2 vols (Saint-Jorioz: Editions Ateliers 74, 1980).

Panayotova, Stella (ed.), *Colour: The Art & Science of Illuminated Manuscripts*, exhibition catalogue, *Colour*, Fitzwilliam Museum, 30 July–30 December 2016 (Fitzwilliam Museum, Cambridge: Harvey Miller, 2016).

Panayotova, Stella, 'Colour Theory, Optics and Manuscript Illumination', in Stella Panayotova (ed.), *Colour: The Art & Science of Illuminated Manuscripts*, exhibition catalogue, *Colour*, Fitzwilliam Museum, 30 July–30 December 2016 (Fitzwilliam Museum, Cambridge: Harvey Miller, 2016), pp. 304–15.

Partearroyo [Lacaba], Cristina, 'Pluvial', in Jerrilynn D. Dodds (ed.), *Al-Andalus. The Art of Islamic Spain* (New York: Metropolitan Museum of Art, 1992), p. 336.

Partearroyo [Lacaba], Cristina, 'Textile Fragment', in Jerrilynn D. Dodds (ed.), *Al-Andalus. The Art of Islamic Spain* (New York: Metropolitan Museum of Art, 1992), p. 335.

Partearroyo [Lacaba], Cristina, 'Curtain', in Jerrilynn D. Dodds (ed.), *Al-Andalus. The Art of Islamic Spain* (New York: Metropolitan Museum of Art, 1992), pp. 338–9.

Partearroyo Lacaba, Cristina, 'Los tejidos nazaríes', in Jesús Bermúdez López (ed.), *Arte islámico en Granada. Propuesta para un museo de la Alhambra, 1 de abril–30 de septiembre de 1995, Palacio de Carlos V, la Alhambra* (Granada: Junta de Andalucía, Consejería de Cultura/Patronato de la Alhambra y Generalife/Comares Editorial, 1995), pp. 117–31.

Partearroyo Lacaba, Cristina, 'Seda nazarí', in *Ibn Jaldun. El Mediterráneo en el siglo XIV. Auge y declive de los imperios. Exposición en el Real Alcázar de Sevilla, mayo–septiembre 2006*, exhibition catalogue (Fundación José Manuel Lara and Fundación El Legado Andalusí, 2006), pp. 160–1.

Pavón Maldonado, Basilio, *Estudios sobre la Alhambra*, 2 vols (Granada: Patronato de la Alhambra y Generalife, 1977).

Pérès, Henri, *Esplendor de al-Andalus. La poesía andaluza en árabe clásico en el siglo XI: sus aspectos generales, sus principales temas y su valor documental*, trans. Mercedes García-Arenal (Madrid: Hiperión, 1983).

Pérez Gómez, Rafael, '17, 46, ..., 627, ... sinfonías para una loseta: los mosaicos de la Alhambra de Granada', in Julio Samsó and Juan Vernet Ginés Moya (eds), *Al-Andalus: el legado científico. Palacio de Mondragón, Ronda (Málaga), abril 1–julio 15, 1995*, exhibition catalogue (Granada: Fundación El Legado andalusí, 1995), pp. 38–67.

Pérez Gómez, Rafael (ed.), *7 Paseos por la Alhambra* (Granada: Proyecto Sur de Ediciones, 2007).

Pérez Gómez, Rafael, Pablo Gutiérrez Calderón and Ceferino Ruiz Garrido, 'La búsqueda y materialización de la belleza. La geometría del poder', in Rafael Pérez Gómez (ed.), *7 Paseos por la Alhambra* (Granada: Proyecto Sur de Ediciones, 2007), pp. 387–542.

Pinder-Wilson, R. H. and C. N. L. Brooke, 'The Reliquary of St. Petroc and the Ivories of Norman Sicily', *Archaeologia* 104 (1973): 261–306.

Popper, William, *Egypt and Syria under the Circassian Sultans, 1382–1468 AD* (Berkeley: University of California Press, 1955).

Pradel Cara, Trinitat, Glòria Molina Giralt, Judit Molera Marimon and Purificación Marinetto Sánchez, 'Initial Results of the Analysis of Glazed Decorated Nasrid Ceramics: Palatine Ceramics (14th–15th Centuries)', in *REMAI, Actas*, pp. 494–509, available at: http://remai.alhambra-patronato. es/es/content/actas-del-congreso-remai, last accessed 15 December 2013.

Puerta Vílchez, José Miguel, *Los códigos de utopía de la Alhambra de Granada* (Granada: Diputación de Granada, 1990).

Puerta Vílchez, José Miguel, *Historia del pensamiento estético árabe: Al-Andalus y la estética árabe clásica* (Madrid: Ediciones Akal, 1997).

Puerta Vílchez, José Miguel, 'La cultura y la creación artística', in Rafael G. Peinado Santaella (ed.), *Historia del Reino de Granada* (Granada: Universidad de Granada–El Legado Andalusi, 2000), vol. 1, pp. 349–413.

Puerta Vílchez, José Miguel, 'El vocabulario estético de los poemas de la Alhambra', in José Antonio González Alcantud and Antonio Malpica Cuello (eds), *Pensar la Alhambra* (Barcelona: Anthropos Editorial, 2001), pp. 69–88.

Puerta Vílchez, José Miguel, 'La Alhambra y el Generalife de Granada', *Artigrama* 22 (2007): 187–232.

Puerta Vílchez, José Miguel, *Leer la Alhambra: Guía visual del monumento a través de sus inscripciones* (Granada: Patronato de la Alhambra/Edilux, 2011).

Puerta Vílchez, José Miguel, 'La construcción poética de la Alhambra', *Revista de poética medieval* 27 (2013): 263–85.

Puerta Vílchez, José Miguel, 'Speaking Architecture: Poetry and Aesthetics in the Alhambra Palace', in Mohammad Gharipour and Irvin Cemil Schick (eds), *Calligraphy and Architecture in the Muslim World* (Edinburgh: Edinburgh University Press, 2013), pp. 29–45.

Rabat, Nasser, 'Ṭirāz, 3', *Encyclopedia of Islam*, New Edition (*EI2*) (Leiden: Brill, 1954-2002), vol. 10, p. 538.

Rāzī, ʿĪsā Ibn Aḥmad al-, *Anales palatinos del califa de Córdoba al-Hakam II, por ʿĪsā Ibn Ahmad al-Rāzī (360–364 H./ 971–975 J.C.)*, trans. Emilio García Gómez (Madrid: Sociedad de Estudios y Publicaciones, 1967).

Redford, Scott, *Landscape and the State in Medieval Anatolia* (Oxford: Archaeopress, 2000).

REMAI, I Congreso Internacional de la Red Europea de Museos de Arte Islámico (Granada, 25–27 April 2012), *Actas*, available at: http://remai. alhambra-patronato.es/es/content/actas-del-congreso-remai, last accessed 15 December 2013.

Reynolds, Dwight, 'Music', in María Rosa Menocal, Raymond P. Scheindlin and Michael Sells (eds), *The Literature of al-Andalus* (Cambridge: Cambridge University Press, 2000), pp. 60–82.

Ricciardi, Paola and Kristine Rose Beers, 'The Illuminator's Palette', in Stella Panayotova (ed.), *Colour: The Art & Science of Illuminated Manuscripts*, exhibition catalogue, *Colour*, Fitzwilliam Museum, 30 July–30 December 2016 (Fitzwilliam Museum, Cambridge: Harvey Miller, 2016), pp. 26–39.

Ricoeur, Paul, *The Rule of Metaphor* (Toronto: University of Toronto Press, 1977).

Roberts, Michael, *The Jeweled Style: Poetry and Poetics in Late Antiquity* (Ithaca, NY: Cornell University Press, 1989).

Robinson, Cynthia, 'Seeing Paradise: Metaphor and Vision in Taifa Palace Architecture', *Gesta* 36(2) (1997): 145–55.

Robinson, Cynthia, *In Praise of Song: The Making of Courtly Culture in al-Andalus and Provence, 1005–1134 AD* (Leiden: Brill, 2002).

Robinson, Cynthia, 'Marginal Ornament: Poetics, Mimesis, and Devotion in the Palace of the Lions', *Muqarnas* 25 (2008): 187–214.

Robinson, Cynthia and Amalia Zomeño, 'On Muḥammad V, Ibn al-Khaṭīb and Sufism', in Amira K. Bennison (ed.), *The Articulation of Power in Medieval Iberia and the Maghrib* (Oxford: Oxford University Press, 2014), pp. 153–74.

Rontomé Notario, Enrique and Teresa Carreras i Rossell (eds), *Vidrio islámico en al-Andalus: Real Fábrica de Cristal de la Granja, noviembre de 2006–abril 2007* (San Ildefonso, Segovia: Fundación Centro Nacional del Vidrio, 2006).

Rosen, Tova, 'The Muwashshah', in María Rosa Menocal, Raymond P. Scheindlin and Michael Sells (eds), *The Literature of al-Andalus* (Cambridge: Cambridge University Press, 2000), pp. 165–89.

Rosenthal, Earl, *The Palace of Charles V in Granada* (Princeton, NJ: Princeton University Press, 1985).

Rosser-Owen, Mariam, 'Coleccionar la Alhambra: Owen Jones y la España islámica en el South Kensington Museum', in Juan Calatrava, Mariam Rosser-Owen, Abraham Thomas and Rémi Labrusse, *Owen Jones y la Alhambra* (Granada: Patronato de la Alhambra y Generalife and Victoria and Albert Museum, London, 2011), pp. 43–69.

Roux, Jean-Paul (ed.), *L'Islam dans les collections nationales. 2 mai–22 août, 1977*, exhibition catalogue (Paris: Réunion des Musées Nationaux, 1977).

Roxburgh, David J., 'Ruy González de Clavijo's Narrative of Courtly Life and Ceremony in Timur's Samarqand, 1404', in Palmira Brummett (ed.), *The 'Book' of Travels: Genre, Ethnology, and Pilgrimage, 1250–1700* (Leiden: Brill, 2009), pp. 113–58.

Rubiera Mata, María Jesús, 'Los poemas epigráficos de Ibn al-Yayyāb en la Alhambra', *Al-Andalus* 35 (1970): 453–73.

Rubiera Mata, María Jesús, 'Ibn Zamrak, su biógrafo Ibn al-Ahmar y los poemas epigráficos de la Alhambra', *Al-Andalus* 42 (1977): 447–51.

Rubiera Mata, María Jesús, 'Poesía epigráfica en la Alhambra y el Generalife', *Poesía* 12 (1981): 17–76.

Rubiera Mata, María Jesús, *La arquitectura en la literatura árabe: datos para una estética del placer* (Madrid: Hiperión, 1988).

Rubiera Mata, María Jesús, *Ibn al-Yayyāb. El otro poeta de la Alhambra* (Granada: Patronato de la Alhambra y Generalife, 1994).

Rubiera Mata, María Jesús, 'El Califato nazarí', *Al-Qanṭara* 29(2) (2008): 293–305.

Rubio Domene, Ramón, 'La Sala de las Camas del Baño Real de Comares de la Alhambra. Datos tras su restauración', *Cuadernos de la Alhambra* 43 (2008): 152–71.

Rubio Domene, Ramón, *Yeserías de la Alhambra. Historia, técnica y conservación* (Granada: Editorial Universidad de Granada, 2010).

Rubio Domene, Ramón, 'Mould Techniques Used in Nasrid Plasterwork and their Subsequent Evolution', in *REMAI, Actas*, pp. 535–45, available at: http://remai.alhambra-patronato.es/es/content/actas-del-congreso-remai, last accessed 15 December 2013.

Ruggles, D. Fairchild, 'The Eye of Sovereignty: Poetry and Vision in the Alhambra's Lindaraja Mirador', *Gesta* 36(2) (1997): 180–9.

Ruggles, D. Fairchild, *Gardens, Landscapes, and Vision in the Palaces of Islamic Spain* (University Park, PA: Pennsylvania State University Press, 2000).

Ruggles, D. Fairchild, 'Inventing the Alhambra', in David Roxburgh (ed.), *Envisioning Islamic Art and Architecture: Essays in Honor of Renata Holod* (Leiden: Brill, 2014), pp. 1–21.

Rugiadi, Martina, 'Marble from the Palace of Mas'ud III in Ghazni', in Pierfrancesco Callieri and Luca Colliva (eds), *Proceedings of the 19th International Meeting of the European Association of South Asian Archaeology in Ravenna, Italy, July 2007*, BAR International Series 2133: Volume 2, Historic Periods (Oxford: Archaeopress, 2010), pp. 297–306.

Rugiadi, Martina, 'Carved Marble in Medieval Ghazni: Function and Meaning', *Hadeeth al-Dar* 34 (2011): 5–11.

Rugiadi, Martina, '"As for the Colours, Look at a Garden in Spring". Polychrome Marble in the Ghaznavid Architectural Decoration', in *Proceedings of the 7th International Congress on the Archaeology of the Ancient Near East. April 12th–16th, 2010* (Wiesbaden: Harrassowitz, 2012), pp. 254–73.

Ruiz, Teofilo F., *A King Travels. Festive Traditions in Late Medieval and Early Modern Spain* (Princeton, NJ: Princeton University Press, 2012).

Ruiz de la Rosa, José Antonio, 'La arquitectura islámica como forma controlada: algunos ejemplos en al-Andalus', in Rafael López Guzmán and Mauricio Pastor Muñoz (eds), *Arquitectura en al-Andalus: documentos para el siglo XXI* (Barcelona: Lunwerg Editores, 1995), pp. 27–54.

Ruiz Figueroa, Manuel, 'Califato y religión durante los reinados de al-mahdi (775–785), al-Hadi (785–786) y Harún al-Rashid (786–809)', *Estudios de Asia y Africa* 41(2) (2006): 233–54.

Saba, Matthew D., 'A Restricted Gaze: The Ornament of the Main Caliphal Palace of Samara', in Olga Bush and Avinoam Shalem (eds), *Gazing*

Otherwise: Modalities of Seeing In and Beyond the Lands of Islam, special issue, *Muqarnas* 32 (2015): 155–95.

Ṣābiʾ, Hilāl al-, *Rusūm dār al-khilāfa (The Rules and Regulations of the Abbasid Court)*, trans. Elie A. Salem (Beirut: American University of Beirut, 1977).

Sabra, Abdelhamid I. Introduction, commentaries and indices, in Ibn al-Haytham, *The Optics of Ibn al-Haytham*, vol. 2 (London: University of London, 1989).

Sabra, Abdelhamid I., 'Ibn al-Haytham's Revolutionary Project in Optics: The Achievement and the Obstacle', in Jan P. Hogendijk and Abdelhamid I. Sabra (eds), *The Enterprise of Science in Islam. New Perspectives* (Cambridge, MA: MIT Press, 2003), pp. 85–117.

Sabra, Abdelhamid I., 'The "Commentary" that Saved the Text. The Hazardous Journey of Ibn al-Haytham's Arabic *Optics*', *Early Science and Medicine* 12 (2007): 117–33.

Safran, Janina M., 'Ceremony and Submission: Legitimacy in Tenth-Century Al-Andalus', *Journal of Near Eastern Studies* 58(3) (1999): 191–201.

Salmi, Ahmed, 'Le genre des poèmes de nativité (*mawludiyya*-s) dans le royaume de Grénade et au Maroc du XIIIe au XVIIe siècle', *Hespéris* 3/4 (1956): 335–435.

Samsel, Peter, 'The First Pillar of Islam', *Parabola* (Spring 2007): 42–9.

Samsó, Julio, 'Alfonso X', in Thomas Hockey, Virginia Trimble, Thomas R. Williams, Richard A. Jarrell, Jordan D. Marché and F. Jamil Ragep (eds), *The Biographical Encyclopedia of Astronomers* (New York: Springer, 2007), pp. 29–31.

Sánchez Trujillano, María Teresa, 'Catálogo de los tejidos medievales del M. A. N. II', *Boletín del M. A. N.* 4 (1986), entire volume.

Sanders, Paula, *Ritual, Politics, and the City in Fatimid Cairo* (Albany, NY: State of New York University Press, 1994).

Sanders Paula, '*Marāsim*', *Encyclopedia of Islam*, New Edition (*EI2*) (Leiden: Brill, 1954–2002), vol. 6, p. 519.

Schoeler, G., '*Tarṣīʿ*', *Encyclopedia of Islam*, New Edition (*EI2*) (Leiden: Brill, 1954–2002), vol. 10, pp. 304–6.

Seco de Lucena Paredes, Luis, *La Granada nazarí del siglo XV* (Granada: Patronato de la Alhambra, 1975).

La seda en la indumentaria, siglos XVI–XIX, Colección Rocamora, Exposición, Colegio del Arte Mayor de la Seda 23 septiembre–23 octubre (Barcelona: Palacio de Comillas, 1959).

Serjeant, R. B., *Islamic Textiles. Materials for a History up to the Mongol Conquest* (Beirut: Librarie du Liban, 1972).

Serrano Espinosa, Francisco, 'The Contreras Family (1824–1906): Eighty Years of Intervention in the Hispanic–Muslim Heritage and the Dissemination of Alhambrism. New Research', in *REMAI, Actas*, pp. 252–266, available at: http://remai.alhambra-patronato.es/es/content/actas-del-congreso-re mai, last accessed 15 December 2013.

Shalem, Avinoam, 'Manipulations of Seeing and Visual Strategies in the Audience Halls of the Early Islamic Period', in Franz Alto Bauer (ed.), *Visualisierungen von Herrschaft. Frühmittelalterliche Residenzen Gestalt und Zeremoniell* BYZAS 5 (2006), pp. 213–32.

Sharlet, Jocelyn, *Patronage and Poetry in the Islamic World: Social Mobility and Status in the Medieval Middle East and Central Asia* (London and New York: I. B. Tauris and Palgrave Macmillan, 2011).

Shepherd, Dorothy, 'The Hispano-Islamic Textiles in the Cooper Union Collection', *Chronicle of the Museum for the Arts of Decoration of the Cooper Union* 110 (1943): 357–401.

Shinar, P., 'Traditional and Reformist Mawlid Celebrations in the Maghrib', in Myriam Rosen-Ayalon (ed.), *Studies in Memory of Gaston Wiet* (Jerusalem: Institute of Asian and African Studies, Hebrew University of Jerusalem, 1977), pp. 371–414.

Simon, Gérard, 'La psychologie de la vision chez Ibn al-Haytham', in Gérard Simon, *Archéologie de la vision, l'optique, le corps, la peinture* (Paris: Seuil, 2003), pp. 114–30.

Simon-Cahn, Annabelle, 'The Fermo Chasuble of St. Thomas Becket', *Muqarnas* 10 (1993): 1–5.

Smith, A. Mark, 'Alhacen's Theory of Visual Perception: A Critical Edition, with English Translation and Commentary, of the First Three Books of Alhacen's "De aspectibus", the Medieval Latin Version of Ibn al-Haytham's "Kitāb al-Manāẓir": Volume One', *Transactions of the American Philosophical Society*, New Series, 91(4) (2001): entire volume.

Smith, A. Mark, 'Alhacen's Theory of Visual Perception: A Critical Edition, with English Translation and Commentary, of the First Three Books of Alhacen's "De aspectibus", the Medieval Latin Version of Ibn al-Haytham's "Kitāb al-Manāẓir": Volume Two', *Transactions of the American Philosophical Society*, New Series, 91(5) (2001): 339–819.

Smith, A. Mark, 'What is the History of Medieval Optics Really About?' *Proceedings of the American Philosophical Society* 148(3) (2004): 180–94.

Smith, A. Mark, 'Alhacen on the Principles of Reflection: A Critical Edition, with English Translation and Commentary, of Books 4 and 5 of Alhacen's "De aspectibus", the Medieval Latin Version of Ibn-al-Haytham's "Kitāb al-Manāẓir",' *Transactions of the American Philosophical Society*, New Series, 96(2/3) (2006): entire volume.

Solé Urgellés, Ramon and Carmen Alós Trepat, 'Restoration of Islamic Arch Fragments from the Palace of Balaguer (Lérida). Process and Historical Data', in *REMAI, Actas*, pp. 635–73, available at: http://remai.alha mbra-patronato.es/es/content/actas-del-congreso-remai, last accessed 15 December 2013.

Stafford, Barbara Maria, *Echo Objects* (Chicago, IL: University of Chicago Press, 2007).

Stafford, Barbara Maria (ed.), *A Field Guide to a New Meta-Field: Bridging the Humanities–Neuroscience Divide* (Chicago, IL: University of Chicago Press, 2011).

Stetkevych, Suzanne Pinckney, 'The Qaṣīdah and the Poetics of Ceremony: Three ʿĪd Panegyrics to the Cordoban Caliphate', in Ross Brann (ed.), *Languages of Power in Islamic Spain* (Bethesda, MD: CDL Press, 1997), pp. 1–48.

Stetkevych, Suzanne Pinckney, *The Poetics of Islamic Legitimacy. Myth, Gender, and Ceremony in the Classical Arabic Ode* (Bloomington: Indiana University Press, 2002).

Stillman, Yedida K., 'Textiles and Patterns Come to Life through the Cairo Geniza', in Muḥammad ʿAbbās Muḥammad Salīm (ed.), *Islamische Textilkunst des Mittelalters: Aktuelle Probleme* (Riggisberg: Abegg-Stiftung, 1997), pp. 35–54.

Stillman, Yedida K. and Paula Sanders, 'Tirāz', *Encyclopedia of Islam*, New Edition (*EI2*) (Leiden: Brill, 1954-2002), vol. 10, pp. 534–38.

Stowasser, Karl, 'Manners and Customs at the Mamluk Court', *Muqarnas* 2 (1984): 13–20.

Sülün, Murat, 'Qurʾanic Verses on Works of Architecture: The Ottoman Case', in Mohammad Gharipour and Irvin Cemil Schick (eds), *Calligraphy*

and Architecture in the Muslim World (Edinburgh: Edinburgh University Press, 2013), pp. 159–77.

Tabbaa, Yasser, *The Transformation of Islamic Art during the Sunni Revival* (Seattle: University of Washington Press, 2001).

Thompson, Jon, *Silk. 13th to 18th Century. Treasures from the Museum of Islamic Art, Qatar* (Doha, Qatar: National Council for Culture, Art and Heritage, 2004).

Torres Balbás, Leopoldo, 'Gibraltar, llave y guarda del reino de España', *Al-Andalus* 7 (1942): 168–219.

Torres Balbás, Leopoldo, 'Las mazmorras de la Alhambra', *Al-Andalus* 9 (1944): 198–218.

Torres Balbás, Leopoldo, '"Muṣallā" y "sharīʿa" en las ciudades hispanomusulmanas', *Al-Andalus* 13 (1948): 167–80.

Torres Balbás, Leopoldo, 'Alcaicerías', *Al-Andalus* 14 (1949): 431–41.

Torres Balbás, Leopoldo, 'Salas con linterna central en la arquitectura granadina', *Al-Andalus* 24 (1959): 197–220.

Torres Balbás, Leopoldo, 'Diario de obras en la Alhambra 1923–1936', *Cuadernos de la Alhambra* 1 (1965): 75–92; 2 (1966): 89–111; 3 (1967): 125–52; 4 (1968): 99–128; 5 (1969): 69–94.

Torres Balbás, Leopoldo, *Obra dispersa*, 9 vols (Madrid: Colegio Oficial de Arquitectos de Madrid, 1981–85).

Torres Balbás, Leopoldo, *Ciudades hispanomusulmanas* (Madrid, 1985), vol. 1.

Turner, Mark (ed.), *The Artful Mind: Cognitive Science and the Riddle of Human Creativity* (Oxford: Oxford University Press, 2006).

Turner, Nancy K. and Doris Oltrogge, 'Pigment Recipes and Model Books: Mechanisms for Knowledge Transmission and the Training of Manuscript Illuminators', in Stella Panayotova (ed.), *Colour: The Art & Science of Illuminated Manuscripts*, exhibition catalogue, *Colour*, Fitzwilliam Museum, 30 July–30 December 2016 (Fitzwilliam Museum, Cambridge: Harvey Miller, 2016), pp. 88–95.

Valdez Fernández, Manuel, 'Clientes y promotores en la asimilación de modelos andalusíes en la Edad Media', *El legado de al-Andalus. El arte andalusi en los reinos de León y Castilla durante la Edad Media. Simposio Internacional* (Valladolid: Fundación del Patrimonio Histórico de Castilla y Leon, 2007), pp. 19–42.

Van Steenbergen, Jo, 'Qalāwūnid Discourse, Elite Communication, and the Mamluk Cultural Matrix: Interpreting a 14th-Century Panegyric', *Journal of Arabic Literature* 43 (2012): 1–28.

Vendrell, Mario, Josep Roqué, Josefina Pérez-Arantegui and Pilar Giráldez, 'Lustre-decorated Ceramics: A Technical Insight into Medieval Nanotechnology', in *REMAI, Actas*, pp. 525–34, available at: http://remai.alhambra-patronato.es/es/content/actas-del-congreso-remai, last accessed 15 December 2013.

Vestiduras ricas. El Monasterio de las Huelgas y su época 1170–1340, del 15 de marzo al 19 de junio de 2005, Palacio Real de Madrid, exhibition catalogue (Madrid: Patrimonio Nacional, 2005).

Vidal Castro, Francisco, 'Historia política', in *Historia de España Menéndez Pidal, vol. 8: 3, El reino nazarí de Granada (1232–1492). Política, instituciones. Espacio y economía*, ed. María Jesús Viguera Molins (Madrid: Espasa-Calpe, 2000), pp. 77–252.

Vidal Castro, Francisco, 'Narración, leyenda y política en los últimos siglos de al-Andalus: en torno al magnicidio de tres emires nazaríes', in Raif Georges Khoury, Juan Pedro Monferrer-Sala and Mária Jesús Viguera Molins

(eds), *Legendaria Medievalia. En honor de Concepción Castillo Castillo* (Córdoba: Eiciones El Almendro, 2011), pp. 99–108.

Viguera Molins, María Jesús, 'La religión y el derecho', in *Historia de España Menéndez Pidal, vol. 8: 4, El reino nazarí de Granada (1232–1492). Sociedad, vida y cultura*, ed. María Jesús Viguera Molins (Madrid: Espasa Calpe, 2000), pp. 159–90.

Viguera [Molins], María Jesús and Elías Terés, 'Sobre las calahorras', *Al-Qantara* 2 (1981): 265–75.

Vilar Sánchez, Juan Antonio, *Los Reyes Católicos en la Alhambra* (Granada: Editorial Comares, 2007).

Vílchez Vílchez, Carlos, 'Sobre la supuesta fachada meridional del Palacio de Comares', *Cuadernos de Arte de la Universidad de Granada* 22 (1986): 9–21.

Vílchez Vílchez, Carlos, *La Alhambra de Leopoldo Torres Balbás (obras de restauración y conservación, 1923–1936)* (Granada: Editorial Comares, 1988).

Vílchez Vílchez, Carlos, *Baños árabes* (Granada: Diputación de Granada, 2001).

Wardwell, Anne E., 'A Fifteenth-Century Silk Curtain from Muslim Spain', *Bulletin of the Cleveland Museum of Art* 70(2) (1983): 58–72.

Warf, Barney and Santa Arias (eds), *The Spatial Turn: Interdisciplinary Perspectives* (New York: Routledge, 2009).

Washshāʾ [Abuʾl-Tayyib Muḥammad], Ibn Isḥāq ibn Yahya al-, *al-Muwashshā al kitāb al-ẓurafāʾ* (Beirut: Dar Sadir, n.d.).

Washshāʾ al-, *Kitāb al-Muwashshāʾ*, ed. and trans. Teresa Garulo [*El Libro del Brocado*] (Madrid: Alfaguara, 1990).

Washshāʾ al-, *Le Livre de brocart (al-kitāb al-muwashshā) par al-*Washshāʾ, trans. Siham Bouhlal (Paris: Gallimard, 2004).

Weibel, Adèle Coulin, *Two Thousand Years of Textiles: The Figured Textiles of Europe and the Near East* (New York: Hacker Art Books, 1952).

Welch, Carry, *Calligraphy in the Arts of the Muslim World* (Austin: University of Texas Press, 1979).

Woodhead, Christine, 'Poet, Patron and Padişah: The Ottoman Sultan Murad III (1574–95)', in Giles E. M. Gasper and John McKinnell (eds), *Ambition and Anxiety: Courts and Courtly Discourse, c. 700–1600* (Toronto and Durham University: Pontifical Institute of Medieval Studies and Institute of Medieval and Early Modern Studies, 2014), pp. 229–49.

Wordsworth, William, *The Prose Works of William Wordsworth*, ed. W. J. B. Owen and Jane Worthington Smyser (Oxford: Clarendon, 1974), vol. 1, pp. 45–96.

Yannopoulos, Panayotis, 'Les apparitions publiques de l'Empereur Byzantin', *Cuadernos de CEMyR* 17 (2009): 73–96.

Zeki, Semir, *A Vision of the Brain* (Oxford: Blackwell, 1993).

Zeki, Semir, 'Art and the Brain', *Daedalus* 127(2) (1998): 71–103.

Zeki, Semir, *Inner Vision. An Exploration of Art and the Brain* (Oxford: Oxford University Press, 1999).

Zeki, Semir and M. Lamb, 'The Neurology of Kinetic Art', *Brain* 117 (1994): 607–36.

Zozaya, Juan, 'Pyxis', in Jerrilynn D. Dodds (ed.), *Al-Andalus. The Art of Islamic Spain* (New York: Metropolitan Museum of Art, 1992), pp. 266–7.

Zwartjes, Otto, *Love Songs from al-Andalus: History, Structure and Meaning of the Kharja* (Leiden: Brill, 1997).

Illustration Acknowledgements

Figures I.3, I.4, 1.3, 3.22, 3.23, 3.30: adapted from Antonio Fernández-Puertas, *The Alhambra* (London: Saqi, 1997): figs. 1, 3, 64, pls. 17, 13, 14, respectively.

Figures I.6, 1.13, 1.15, 3.5, 3.6, 3.8, 3.9, 4.6, 4.14, 4.17: Archivo de la Alhambra, Granada.

Figure 1.6: SZ Photograph/Scherl/Bridgeman Images.

Figure 4.8: Capilla Real, Granada/Bridgeman Images.

Figures 4.20, 4.21: Galleria degli Uffizi, Florence/Bridgeman Images.

Figures 1.9, 1.11, 4.16: courtesy of the Victoria and Albert Museum, London.

Figure 2.10: courtesy of Catedral Basílica del Pilar, Cabildo Metropolitano de Zaragoza, Zaragoza.

Figure 2.11: courtesy of Freer Gallery of Art, Smithsonian Institution, Washington, DC, Purchase, F1903.206a–b.

Figure 4.23: Biblioteca Monasterio del Escorial, Madrid/Bridgeman Images

Figure 4.24: Myron Bement Smith Collection: Antoin Sevruguin Photographs. Freer Gallery of Art and Arthur M. Sackler Gallery Archives. Smithsonian Institution, Washington, DC. Gift of Katherine Dennis Smith, 1973–1985, FSA A.4 2.12.GN.51.04.

Figures 2.12, 5.10: Museo de la Alhambra, Granada (R. 290 and R. 10230_2, respectively).

Figures 4.1, 4.2: adapted from Antonio Orihuela Uzal, *Casas y palacios nazaríes: siglos XIII–XV* (Barcelona: Lunwerg Editores, 1995), plans 10 and 12, with spaces numbered by the author.

Figure 4.5: Werner Forman Archive/Bridgeman Images.

Figures 4.11, 5.9: courtesy of the Metropolitan Museum of Art, New York (29.22 and 52.20.14, respectively).

Figure 4.9: Textile Museum, Washington, DC (TM 84.29).

Figure 4.10: Edilesa, Burgos, Spain.

Figure 4.12: courtesy of the Hispanic Society of America, New York (No. H921).

Figure 4.6: adapted after M. López Reche, Archivo de la Alhambra, Alhambra, Granada, with the author's construction of geometric measurements.

Figure 4.14: adapted after M. López Reche, Archivo de la Alhambra, Alhambra, Granada, with the author's numbering of decorative areas.

Figure 4.15: Private collection, Stapleton Collection/Bridgeman Images.

Figures 5.1, 5.2: adapted from López López and Orihuela Uzal, 'Una nueva interpretación del texto de Ibn al-Jaṭīb', p. 144.

Figure 5.4: adapted from Juan Castilla Brazales and Antonio Orihuela Uzal, *En busca de la Granada andalusí* (Granada: Editorial Comares, 2002), p. 353.

Figure 5.8: courtesy of the Cleveland Museum of Art (1982.16), Cleveland.

All other photographs are by the author.

Index